Fakers, Forgers and Phoneys

MAGNUS MAGNUSSON

Fakers, Forgers & Phoneys

FAMOUS SCAMS AND SCAMPS

MAINSTREAM
PUBLISHING

EDINBURGH AND LONDON

First published in Great Britain in 2006 by
MAINSTREAM PUBLISHING COMPANY
(EDINBURGH) LTD
7 Albany Street
Edinburgh EH1 3UG

ISBN 1 84596 190 0

A catalogue record for this book is available
from the British Library

Typeset in Garamond and ScalaSans

Printed in Great Britain by
William Clowes Ltd, Beccles, Suffolk

For my wife Mamie, and all my kith and kin,
family and friends, cousins and colleagues.

Acknowledgements

I am indebted to a host of people, both lay and learned, who have helped me with my researches for this book; I have acknowledged their individual contributions in the text and in the notes at the end of each of the chapters.

In particular, I would like to give warmest thanks to Christine Moorcroft, educational writer, who gave invaluable assistance tracking down some of the stories and the appropriate illustrations; and to Marion Whitelaw, a former colleague at Scottish National Heritage, for her painstaking scrutiny of the proofs.

I am also grateful to Annie McCaig for her meticulous work on the index.

Contents

Contents

Introduction

> Many years ago there lived an emperor who was so exceedingly
> fond of beautiful new clothes that he spent all his money just on
> dressing up . . .

This is the opening line of perhaps the greatest fable about 'faking it' ever
written: *The Emperor's New Clothes*, by Hans Christian Andersen. It tells
how a vain and spendthrift emperor was well and truly conned by 'two
swindlers' who passed themselves off as weavers and claimed that they
knew how to create the most exquisite and marvellous cloth imaginable:
not only were the colours and the pattern exceptionally beautiful, but
the clothes made from it had the unique quality of being invisible to
every person who was unfit for his post or else was unacceptably stupid.

And so the sting was set up. The emperor was delighted at the thought
that he could find out which of his officials were not suited for the posts
they held – he would be able to distinguish the wise ones from the foolish
– and he promptly ordered the cloth to be woven, at exorbitant cost. The
news of this resplendent cloth and its miraculous powers spread far and
wide, and people were eager to see how incompetent or stupid their
neighbours were.

The swindlers began their task and pretended to be hard at work, night and day, but they had nothing on their looms. They demanded the finest silk and the most magnificent gold thread – all of which they spirited away and sold for their own profit.

The emperor was impatient to find out how the work was proceeding and sent a procession of officials to investigate and report back to him. One by one they filed into the weaving shed to check on the progress of the wondrous cloth; but although they could not see anything, they were afraid to admit it. Instead, they listened to the rapturous descriptions of the new clothes by the two swindlers and repeated them to the emperor as their own observations.

Eventually the emperor went to arrange a fitting. He was dismayed to discover that he could not see anything on the looms – but, like his officials, he did not dare to admit this, lest he were thought to be unfit to be emperor.

'Wonderful!' he cried fervently. 'Exquisite! It has my fullest approval.' All his court dutifully echoed his sentiments. The emperor knighted the swindlers on the spot and bestowed on each of them the title of 'Lord Weaver'.

Come the day of the fitting, and the two charlatans outdid themselves. They clipped the empty air with great big scissors; they sewed away furiously with unthreaded needles. Then they invited the emperor to strip before a mirror and ceremoniously dressed him in the invisible clothes, which were so gossamer-light, they said, that he would think he had nothing on – 'That's the real beauty of it,' they told him.

That was the real beauty of the scam, too. The emperor set out in solemn procession through the town, his courtiers with arms aloft as if holding the train. The crowds lining the streets, mindful of what their neighbours might think of them, affected to be dazzled by the splendour of their emperor's new robes. The two swindlers doubtless slipped away, unnoticed, richer beyond the dreams of avarice.

And all went well. The crowds huzzaed and cheered, the procession marched on in ineffable complacency – until a small child innocently

piped up, 'But he doesn't have anything on at all!' And with that, the transparent bubble of illusion was well and truly pricked.

The Emperor's New Clothes was first published in Denmark in a collection of fairy tales in 1837. Its 'moral' was to point out how the simplicity and honesty of a child could make a laughing-stock of the pretensions of adult stupidity, vanity and, yes, even royal folly. But it is also, to my mind, the ultimate exposé of the strange world of fakers, forgers and phoneys, some of whose exploits are chronicled in the stories in this book.

Why do fakers and forgers do it? Why do so many of them get away with it? Why do artists like Tom Keating forge the works of others (Chapter 1.1 – The Fake's Progress: Tom Keating)? Why do good writers like Thomas Chatterton feel they have to use spurious 'manuscript discoveries' to launch their works (Chapter 4.1 – Thomas Chatterton: The Boy Poet and the Medieval Monk)? The psychology of hoaxers, and of the hoaxed, is as intriguing as their motivations. Greed, a grudge or glory, compulsive opportunism, sibling rivalry, pure mischief, a desire to be someone or something else – all these have been identified as motives for forgery. Yet some of the fakers are every bit as skilful as the people or the works they copy – in art, literature or other professional talents – so why do they need to deceive?

Fakery is a fascinating subject. Frauds make excellent yarns: it is a pleasure to read about the ingenuity and diligence of their perpetrators and the detective work which finally exposes them. Frauds of all sorts are literally fabrications, and are always made to order, as it were: they obligingly fill a particular need and satisfy a particular market, whatever it might be. Some people are sitting-duck targets, or markets, for the hoaxer. These are the people who desperately *want* to believe the hoax. Americans, for instance, *wanted* to believe in the authenticity of the so-called 'Vínland Map' (Chapter 2.3 – The Vínland Map: A Pious Phoney) because it purported to prove that their own unrecorded history started some 500 years *before* the voyage of Christopher Columbus in 1492. The fact is that credulous people can be persuaded to believe anything;

there seems to be no end to people's gullibility, no matter how crude the forgeries might be.

I think people have a sneaking admiration for the rogues and scamps who perpetrate scams and hoaxes. People like to see the hoaxer being found out (unless they were the ones who were duped, in which case they prefer to keep quiet); but they also like to see the hoaxer getting away with it – especially when the hoax pricks the pomposity of learned institutions and self-appointed arbiters of behaviour and taste. We all enjoy the spectacle of nimble-witted knaves confounding the 'experts' – lofty opinion-formers who purport to be so well informed that they know all there is to know and should theoretically be immune to trickery.

Take the story of Johann Bartholomew Adam Beringer, for instance, a pompous professor and physician in eighteenth-century Würzburg. In 1726, Beringer published a massive volume entitled *Lithographiae Wurceburgensis* (*Würzburg Lithography*) which copiously documented, with 21 plates, a remarkable series of 'fossils' he had come across on a mountain near the city. These fossils displayed a vast array of objects exposed in three-dimensional relief on the surface of flattened stones. Most of them depicted organisms complete with soft tissues which would never be preserved in conventional fossils: lizards in their skins, birds complete with beaks and eyes, spiders with their webs, bees feeding on flowers, snails with their eggs, and frogs copulating; others showed heavenly objects – comets with tails, the crescent moon with rays, the effulgent sun with a glowing face at its centre; still others depicted Hebrew letters spelling out the ineffable name of God, UHWH (Jahweh, Jehovah).

Poor Beringer knew that his 'fossils' were not conventional; but he was convinced that they were authentic and had not been carved by modern hands. In fact, he had been comprehensively duped – presumably by his own students playing a prank. When he eventually realised what had happened he was heartbroken. He impoverished himself by trying to buy back all the copies of his book and died a few years later, deeply dispirited. His false fossils have been known ever since as the *Lugensteine* (Lying Stones).

Introduction

As the English physician and amateur palaeontologist James Parkinson (1755–1824), who gave his name to Parkinson's disease, observed in volume one of his *Organic Remains of a Former World* (1804), 'Learning may not be sufficient to prevent an unsuspecting man from becoming the dupe of excessive credulity.'

In this anthology of fakers, forgers and phoneys, of scams and scamps, I have had great fun exploring the shadowy *demi-monde* of fraudsters and fabricators, bringing old stories up to date and new stories to light with the help of experts who have studied individual cases and the psychology of fraud. The stories are illuminated by on-the-spot visits to the places associated with the most spectacular forgeries – for example, Piltdown in East Sussex, site of the celebrated 'missing link' fake skull (Chapter 2.1 – The Missing Link: Piltdown Man), and Glozel in France, the scene of perhaps the most bizarre of all archaeological scams (Chapter 2.2 – The Funny Business at Glozel) – or, where relevant, by interviews with surviving forgers or their relatives – for instance, John Myatt (Chapter 1.2 – Conman and Accomplice: John Drewe and John Myatt) and the descendants of the Tichborne Claimant (Chapter 3.1 – The Tichborne Claimant: Arthur Orton).

Not all 16 stories are about criminal activity. Some are relatively innocent (Chapter 1.4 – The Case of the Cottingley Fairies), whereas Escape from Slavery (Chapter 3.2), the account of two black slaves in Georgia who made a daring dash to freedom in 1848, is a tale of extraordinary courage in the face of the most daunting obstacles and defies classification.

1

Art Forgeries

My interest in art forgeries was kindled by a contestant in the final series of the original *Mastermind* (1997): Leo Stevenson, a serious artist who also paints replicas of Old Masters for art collectors who store the originals in bank vaults for safekeeping. He told me how he avoids any risk of being accused of forgery by putting clues into the 'under-painting' – a Wonderbra for women in old Dutch masterpieces, for instance, or a submarine lurking under the waters in Canaletto's *Grand Canal*, or the slogan 'Elvis Lives' around the rim of a Tudor tambour. As a farewell present at the conclusion of the 25-year run of *Mastermind* in 1997, Leo painted a splendid, almost full-scale pastiche of William Frederick Yeames' celebrated painting entitled *And When Did You Last See Your Father?*, which is the pride and joy of the Walker Art Gallery in Liverpool. It seems at first glance to be a copy of the Yeames original, until you look more closely and see that the faces are those of former Masterminders and people from the *Mastermind* production team, with myself as the chief interrogator. Leo entitled it, simply, *PASS*; it is one of my most treasured possessions.

It was Leo who introduced me to the shadowy world of art forging, which, in turn, led me to the story of Tom Keating, the cheerful cockney

house painter turned art restorer who became a national television celebrity when his trial at the Old Bailey on charges of forgery was stopped because of his deteriorating health. The story of his life, as told by himself, by his daughter, by his lovers and by the auctioneers who sold his pictures for thousands of pounds, is a real eye-opener (Chapter 1.1 – The Fake's Progress: Tom Keating).

It also took me in pursuit of John Myatt, who has demonstrated that art fraud can be a very lucrative business. Chapter 1.2 (Conman and Accomplice: John Drewe and John Myatt) tells the story of Myatt, an impecunious artist who started painting fakes for a suave conman named John Drewe in what has been called Britain's art scam of the twentieth century. I found Myatt making a cheerful living by selling 'Genuine Fakes' and brought him face to face, for the first time, with the New Scotland Yard Detective Chief Inspector (DCI) of the Art and Antiques Squad who had masterminded his exposure. It's an oddly heart-warming tale.

The third section in the first chapter (Chapter 1.3 – The New Vermeer: Han van Meegeren) brims with irony. Han van Meegeren was a competent Dutch artist who painted near-perfect imitations of Holland's great seventeenth-century Old Master, Jan Vermeer; he was only exposed because he was accused of selling stolen genuine Vermeers to the Nazis during the Second World War and, in order to escape a charge of treason, he had to confess – and then prove – that he had forged the paintings himself.

The tailpiece in this section is the charming story of two English schoolgirls who, in 1917, photographed fairies at the bottom of their garden (Chapter 1.4 – The Case of the Cottingley Fairies). It was a relatively innocent hoax: the girls had cut out some pictures of fairies and secured them to a bank of earth with hatpins – just to dupe their parents. The hoax got out of hand and developed into a lengthy dispute which was to embroil some very eminent names indeed – including that of Sir Arthur Conan Doyle (1859–1930). It was not until 1983, shortly before their deaths, that the two culprits confessed – although

they stoutly maintained that they really had seen fairies at the bottom of their garden and had merely wanted to prove it.

There are so many other vignettes I was tempted to include in the chapters which follow. For instance, the versatile Scots novelist and script-writer William Boyd[1] was one of a merry band of literary conspirators in a beautiful little hoax which made monkeys of the New York *glitterati*. Boyd was the ringleader, but his associates included the novelist and critic Gore Vidal (b.1925), art critic John Richardson (b.1924) – Picasso's highly acclaimed biographer – and rock musician and songwriter David Bowie (b.1947) – a fellow member, with Boyd, of the board of *Modern Painters* magazine and one of the directors of 21 Publishing.

On 1 April 1998, Boyd published *Nat Tate – An American Artist: 1928–1960*, an elegiac monograph about a talented, alcoholic artist in the hectic milieu of 1950s New York. According to the blurb, Boyd had visited a group show during an assignment in New York, and there he chanced upon a drawing by an artist named Nat (Nathwell) Tate. Intrigued by what he saw, he began to unravel the fascinating story of this Abstract–Expressionist painter, this neglected genius, whose brief career had ended tragically, and almost without trace, at the age of 31.

Nat Tate, according to the book, was born in New Jersey in 1928, the illegitimate child of a housemaid. Shy and depressive, he was taken in by a rich businessman and travelled to France, where he met avant-garde artists such as Georges Braque (who graciously corrected his pronunciation of 'van Gogh') and Pablo Picasso (who barely spoke to him). Back in the States he became the lover (albeit briefly) of the fabled art collector Peggy Guggenheim (1898–1979) and produced a set of paintings inspired by *The Bridge*, a long symbolic poem by Hart Crane (1899–1932) – also an alcoholic. Later, Tate reclaimed as many as he could of his paintings from his friends, on the pretext of needing to rework them, and destroyed them on a bonfire; only two canvases survived, and these were reproduced in the book. Hart Crane had committed suicide in 1932 by leaping from a steamboat into the

Caribbean Sea on his way from Mexico to the USA; Nat Tate followed suit by throwing himself off the stern of the Staten Island ferry in 1960. His body was never recovered.

David Bowie hosted the gallery launch party for top arts writers on the day of the book's publication. John Richardson recounted Nat Tate's fleeting contact with Picasso. Gore Vidal, smooth as ever, hailed the book as 'a moving account of an artist too well understood for his time' and called him 'an essentially dignified drunk who had nothing to say'.

It worked. No one at the launch party admitted to having never heard of the artist, and many established members of the Manhattan art world agreed that his faded reputation was long overdue for restoration. Extracts from the book were printed in several British newspapers, including the *Sunday Telegraph*. For a time, everyone was taken in; but the art critic of *The Guardian* smelled a rat when he realised that none of the galleries mentioned in the book existed. After a fortnight, the conspirators owned up, and the phantom painter was 'outed'. Boyd told *The Independent*, 'It's a little fable now and for any time . . . I think it's particularly relevant now when, almost overnight, people are becoming art celebrities.'

When the book was revealed as an April Fool's Day spoof on the art world, it was hailed as a minor masterpiece, a profound investigation into the blurred line between the authentic and the invented: what makes something real as opposed to fiction? The answer lay in the way it was presented, using out-of-focus monochrome photographs of unidentifiable people purporting to be Tate and his circle of friends, reproductions of drawings (sketched by Boyd himself), reminiscences by other respected figures, carefully documented footnotes, meticulous acknowledgements, copyright declarations and permissions, and the 'monograph' format itself.

Above all, it is the pretentious art-speak jargon of the spoof work, allegedly from the 'journal' of a fictional British writer and critic (Logan Mountstuart), which makes it as nearly perfect a pastiche as one can possibly imagine. What a gem!

* * *

Or take another delightful yarn. In 1918, one of the greatest art museums in the world, the New York Metropolitan Museum of Art, purchased for $40,000 (a huge sum at the time) a giant terracotta figure of an Etruscan warrior, more than 7 ft tall and weighing more than 1,000 lb. It was not until 40 years later that the Met realised it had been comprehensively conned. The Etruscan warrior, it turned out, was a very clever forgery indeed.

It had been made by a family of highly sophisticated forgers living in Orvieto – the Riccardis: brothers Pio and Alfonso Riccardi and three of their six sons. But it was only one of a series of literally gigantic forgeries with which they fooled the world.

They had begun their careers in a small way, when a Roman art dealer named Domenico Fuschini hired them to forge fragments of Etruscan pottery and, later, complete vases. Having mastered the technique, the Riccardis then produced their first major forgery – a complete bronze chariot. In December 1908, the British Museum was told that a *biga* (two-horse chariot) had been found on an Etruscan site at Orvieto. After its supposed burial of 2,500 years it needed cleaning, and the British Museum was told that the work had been carried out by the Riccardis. The museum bought the chariot from Domenico Fuschini and officially announced the acquisition in 1912.

The Riccardis now embarked on an ambitious series of monumental statuary, helped by a master sculptor named Alfredo Fioravanti. The first was a terracotta entitled the 'Old Warrior'. This figure stands more than 2 m high and wears a plumed helmet, a breastplate and armour on its calves. It is naked from breastplate to knees, and the right arm and left thumb are missing. Apparently, the forgers had argued so much about the positioning of the right arm that in the end they discarded it. This piece was sold to the Metropolitan, which also acquired the gang's next major forgery – a piece called the 'Colossal Head', which measured 1.5 m from the neck to the top of its helmet. Experts who examined it thought it had formed part of a statue nearly 7 m high. The price for the two works amounted to only a few hundred dollars.

Then came the jackpot for the forgers: the 'Big Warrior', which was the last they completed. This was the piece which was bought for $40,000 in 1918; after the sale, the gang separated.

The forgers' technique was to assemble the giant pieces from prefabricated parts, then smash the statues to fragments and piece them together again. The end result was covered with scratches and cracks: an Etruscan antiquity.

The Met put the three Riccardi Etruscans they had purchased on display in 1933. Many Italian experts doubted their authenticity, but it was not until 1937, when the museum published a paper about them, that the conflict came into the open. Even so, another 22 years passed before the museum started an inquiry into the allegations. By this time, new scientific analysis techniques were available. After exhaustive tests, it was found that the glaze of the three pieces contained manganese – a colouring agent which was unknown in the Etruscan era.

The museum authorities were still not convinced that they had been duped, however. The proof they sought came a year later, from experts who also examined genuine Etruscan artefacts. They found that the Etruscans had always made and baked their pottery in one piece and had left vents in them to allow proper airing while they were in the kiln. The Riccardis had made their statues in sections and had not left any vents.

But it was left to Alfredo Fioravanti, the sculptor who had helped to fashion the statues, to put the issue beyond doubt. On 5 January 1960, at the age of 75, he went to the American Consulate in Rome and signed a confession. And to prove that he was telling the truth, he took from his pocket the missing left thumb of the 'Old Warrior' – a souvenir which he had kept for more than 40 years.

The American artist and forger Elmyr de Hory, who rejoiced in the sobriquet of 'The Maker of Masterpieces', is one of the most mysterious figures in the annals of twentieth-century forgery. Before he died (or at least disappeared) in 1976, he claimed to have faked more than a thousand classics of modern art now hanging in the world's museums;

his fakes sold throughout North America, Europe and Japan for more than $100 million. He was a man of so many aliases (he used as many as a hundred pseudonyms) that no one knows what his real name was. His biography, entitled *Fake*, was concocted in collaboration with another notorious forger, the writer Clifford Irving (author of a phoney autobiography of the millionaire recluse Howard Hughes). Elmyr's story was the subject of the last film made by Orson Welles (*F for Fake*, 1974), a documentary about fraud and fakery. It is a profound and complex meditation on the nature of art and fiction. In a labyrinthine setting, a real film-maker (Welles) films a dodgy interviewer (Clifford Irving the biographer) interviewing the master art-forger Elmyr de Hory. Orson Welles claimed, 'Everything in that movie was a fake'; the same goes for Elmyr de Hory.

A final note, and just for fun: in 1935 the New York Museum of Modern Art held a van Gogh exhibition. Prankster Hugh Troy moulded a piece of beef, placed it in a velvet box and smuggled it into the museum as an exhibit. The label read:

> This is the ear which Vincent van Gogh cut off and sent to his mistress, a French prostitute, Dec. 24, 1888.

It attracted more attention than any of the paintings!

1.1 – The Fake's Progress: Tom Keating

The headstone in the corner of the peaceful, cypress-haunted country churchyard is plain and unadorned:

In Loving Memory

Of

TOM KEATING

Artist

1st March 1917 – 12th February 1984

It stands in the south-eastern extension of the churchyard of the impressive Church of St Mary the Virgin, the parish church of the picturesque village of Dedham, near Colchester in Essex. Here is the last resting place of one of the most intriguing, and controversial, characters in the annals of art fakery: Tom Keating, the bearded, apple-cheeked cockney house painter turned art restorer who became a popular folk hero for his feats as a faker. He cheekily cocked a snook at the art establishment – and got away with it.

Dedham is in the heart of Constable country, beside the River Stour, where John Constable (1776–1837) painted some of his most renowned works, such as *The Haywain* (1821). Indeed, the parish church houses a very unusual Constable painting – not a landscape, but a religious oil painting of the Ascension (1822). Constable also made a sketch of the north front of the church in 1815. But the church also houses, in the locked muniments (archive) room up a cramped curving staircase above the north porch, a striking painting by Tom Keating: a Bisto-coloured moonlit scene called *The Good Shepherd of Dedham*, painted in the style of his favourite painter, the visionary English artist Samuel Palmer (1805–81). On the back is the scrawled inscription, 'For the villagers of Dedham, with thanks for friendship: Tom Keating 1982'.

It was in Dedham that Tom Keating spent the last eight years of his life,

staying in a dank cottage on the edge of the village, painting prolifically under his own name in a shack in the garden and blossoming into a national TV celebrity. He is now a Dedham legend; and in this comfortable, old-fashioned village, which is rapidly becoming part of the stockbroker commuter-belt in south-east England, more than 20 years after his death, and when his ramshackle garden studio has long since been pulled down, he is still remembered in Dedham with pleasure and affection.

While Tom Keating was living in Dedham, he was always happy to play his part in the life of the community, and his neighbours were always willing to help him. He looked like an impish pixie and reminded people irresistibly of Walt Disney's cartoon character of Happy in *Snow White and the Seven Dwarfs*. And the legend keeps growing. Keating's family intimates tell me that he had given up drinking and smoking several years before he died; yet the former barmaid at The Sun Inn, where Keating spent many an evening getting cheerfully plastered, becomes almost moist-eyed at the thought of him: 'Everyone knew he was a bit of a rogue, but he was a lovely man.'

His 'lady friend' in Dedham told me that Tom Keating was never a womaniser: 'He treated ladies with courtesy, consideration, affection and respect, and they loved him in return – and he was always faithful to the women with whom he shared his life'; yet a local builder, with many a nudge and a wink, remembers Tom as a congenial drinking companion and a 'Jack the Lad' with a keen eye for the ladies: 'He was a hell of a character, that one.'

The vicar of Dedham parish church who befriended Keating thinks he was his own worst enemy, the architect of his own misfortunes – 'but he had greatness in him'. And a retired army major and his wife who bought one of his paintings at a church charity auction remember him with pleasure as a ready contributor to the auction.

But most strikingly, perhaps, on the day on which I went to Dedham to pay my respects at Tom Keating's grave, there was a basket of fresh flowers nestling at the foot of the headstone beside a rather bedraggled 'Old Master' rose long past its best.

'Did you put the flowers there?' I asked the verger, George Beeken.

'Not I,' he replied. 'I find fresh flowers regularly on the grave, but I have no idea who puts them there.'

Other villagers, however, seem to know perfectly well, but they are not for telling. For a romantic like myself, it speaks volumes about Tom Keating the man and Tom Keating the legend.

A fake's progress

The story of Tom Keating is one of the most remarkable in the annals of art fakery (or 'Sexton Blakery', as Keating preferred to call it in cockney rhyming slang – he resented having the term 'forger' applied to him). He started faking paintings and drawings in the 1950s – not primarily for profit, he claimed, but to show up the art world, against which he bore a long grudge. Eventually, he boasted of having faked some 2,000 works of art in the styles of Rembrandt, Constable, Renoir and others, but nobody rumbled him for many years. He was eventually exposed in 1976 by investigative journalist Geraldine Norman and confessed all in an autobiography called *The Fake's Progress*, ghost-written by Geraldine's late husband Frank Norman (the author of works like *Fings Ain't What They Used T'be*). Keating was put on trial for conspiracy to defraud and criminal deception at the Old Bailey, but the trial was abandoned after he was injured in a motorcycle accident. Keating then turned adversity to great advantage, and by the time of his death in February 1984, he was held in huge public affection and esteemed as a lovable rogue who had fooled the great and the good (and the not so good) of the art world.

Tom Keating was born at 3 Herschell Road in a terrace house in the Forest Hill district of south London, near Brockley; his father was a house painter. At infant school his only interest was in art. At the age of seven he won a box of paints for swimming a width underwater at the local baths, and this became his most treasured possession. At the age of 14 he passed an exam to go to St Dunstan's College in south-east London but was refused entry because his parents could not afford £14 annually for books and clothes. Instead, young Tom Keating had to go

to work: delivering wireless accumulators and working as a lather boy in a barber's shop, as a lift-boy at the Capitol Cinema in the Haymarket, and as a bell-boy at the Russell Hotel. Eventually, he followed his father and brothers into the building trade as a house painter, where he learned many of the skills he would employ in later life: graining, marbling and other decorative arts. He attended evening classes at the Camberwell School of Art and read avidly in an attempt to make up for the education he had been denied at St Dunstan's.

With the outbreak of the Second World War, Keating was conscripted as a naval stoker and painted in his spare time (which raised a few eyebrows among his shipmates). His wartime service was not a happy period in his life, and he was honourably discharged with shock and nervous strain in 1944. In that year, he married Ellen Graveney, a young hairdresser who was then a munitions worker. At the time, Ellen was recovering from the loss of her fiancé on board Lord Mountbatten's ship HMS *Kelly*; the young man had been a mate of Tom Keating's, and nothing seemed more natural than that Tom and Ellen should get together and marry. They set up house in a prefab in Brockley, and then moved (much against Ellen's wishes) to a ground-floor flat in a big Victorian house in Westbourne Drive, Forest Hill, where Tom set up a studio in a room which led on to a big garden. They had two children: Douglas, born in 1945, and Linda, who was born in 1948.

In 1948, Tom Keating was awarded an ex-serviceman's two-year rehabilitation course as a full-time art student at Goldsmith's College in London (one of his fellow-students was the fashion-designer Mary Quant), and he did decorating jobs at nights and weekends to make ends meet. He had a burning ambition to become a great and recognised painter and was prepared to endure any financial hardships to achieve this goal.

By now, Tom Keating had come into contact with the seedy world of fringe art dealers in Soho and elsewhere, and was able to supplement his meagre income by a spot of cleaning and 'restoring' of old paintings on the side – no questions asked. His exposure to the dealers who exploited

their clients, their customers and their staff, and the condescending collectors who patronised him, left Keating with a life-long grudge against the art world. To him, they were rogues every bit as much as he was – and he had a score to settle with them all.

Keating, however, failed his National Diploma at Goldsmith's College – twice. With that diploma he could have embarked on a respectable career as an art teacher; without it he could only rely on casual teaching jobs at private schools. He also embarked on a career in art restoration, working for Hahn's of Albemarle Street, among others. And it was then that he started systematically getting his own back on the art establishment for its sins, past and present. As he wrote in his ghosted autobiography, talking about the French Impressionists, 'It seemed disgraceful to me how many had died in poverty. All the time they had been exploited by unscrupulous dealers. I was determined to do what I could to avenge my brothers, and it was to this end that I decided to turn to Sexton Blaking.'

He became known as a competent painter, but one with a chip on his shoulder against the art world. He resented the fact that he hadn't been properly educated in art, and in order to acquire good taste and style in painting, he voraciously read every art book on which he could lay his hands. He also started copying the works of the Old Masters and the French Impressionists, something which all painters have done for centuries in their desire to learn from the artists who have lived and worked before them.

'The gentle art of Sexton Blakery' soon became his chief occupation. In the early 1950s, he bought a vanload of old canvases, frames and panels to work on. He started on seventeenth-century Dutch genre painters in bulk – artists like Pieter de Hoogh (c.1629–84), Gabriel Metsu (1630–67), David Teniers the Younger (1610–90) and Adriaen Brouwer (1605–38), who favoured scenes of ice-skating, ladies reading letters at spinets or tavern interiors. These he would sell to local people around Forest Hill or to visitors to his studio in Westbourne Drive but never directly to dealers. Apart from old Dutch oil paintings, Keating

also had a great partiality for the English water-colourist Thomas Girtin (1775–1802), who died of tuberculosis at the age of 27 and was much admired by giants such as Constable and Turner. Keating made several drawings, mainly to learn Girtin's technique, but always worked in a hidden signature or a poor patch of painting so that they could be recognised as fakes if anyone ever wanted to know.

The Sexton Blakery soon developed into a business. He made a speciality of faking works by Cornelius Krieghoff (1815–72), the pioneering Dutch-born Canadian landscape painter. Conveniently for Keating, Krieghoff made many versions of the same picture, so a few more were not going to attract too much attention. Keating made about 200 pastiches of Krieghoff's work in the mid-1950s, which he would sell for a fiver or so. During the 1950s and 1960s, as occasion arose, he imitated nearly all the major English artists of the late eighteenth and early nineteenth centuries: John Constable, the landscape painter David Cox (1783–1859), Thomas Gainsborough (1727–88), J.M.W. Turner (1775–1851), the caricaturist Thomas Rowlandson (1756–1827) and others. Keating copied them extensively and variously – quantities of sketches, pen-and-wash drawings, oils and watercolours, landscapes and portraits. He also started on a big series of imitations of Old Master drawings of the Dutch school (especially Rembrandt) and the eighteenth-century Venetians such as Francesco Guardi (1712–93); he also specialised in the Spanish painter Francisco Goya (1746–1828). But perhaps his favourite subjects were the French Impressionists: Edgar Degas (1834–1917), Édouard Manet (1832–83), Pierre-Auguste Renoir (1841–1919), Alfred Sisley (1839–99) and many, many others.

On one occasion in the early 1960s, a dealer in south London told Keating that he had an outlet for German Expressionists: 'Do me some.' Not many people at that time knew a great deal about the German Expressionists – Ernst Ludwig Kirchner (1880–1938), Emil Nolde (1867–1956), Max Pechstein (1881–1955) and others – so they were a relatively 'easy' target. Keating dashed off a large number of them at great speed, often in acrylic, all taken from one small paperback about

the German school – he had never seen any of their paintings in the flesh, as it were.

Keating always claimed that he did not do fakes in order to make money: all he wanted to do was to emulate the Masters. He just wanted to learn how to paint like them. He also said that in his best paintings he often felt the spirits of the great Masters actually guiding his hands: he would go into a hallucinatory trance, often traumatic, during which a painting would 'happen' even though he might have no memory of doing it. It happened with a Degas self-portrait, a van Gogh and several Palmers. Indeed, in the case of Samuel Palmer, he wrote, 'With Sam's permission I sometimes signed them with his own name, but they were his work not mine.' Self-justification – or self-deception?

Overall, the range of Keating's output showed astonishing versatility. However, with the benefit of hindsight, his methods bordered on the ludicrous: his Rembrandt drawings were executed with seagull-feather quills, the brown juice made from simmered apples or walnuts and a spoonful of Nescafé coffee powder 'to give the appearance of age', and his French Impressionists were done with poster paint mixed with house-painter's emulsion or egg white – 'anything which would make a cheap, thick paint'. How on earth did he get away with it for so long, one might think? Keating would have answered, 'Because people wanted to be fooled.'

By now, however, Keating's marriage was disintegrating. In June 1956, when Linda was eight years old, he announced that he was going to Scotland for a couple of weeks to restore some paintings in a castle near Inverness. In fact, after the work in the castle was finished, he stayed in the north of Scotland for three years as an itinerant picture restorer, knocking around from castle to castle and picking up odd commissions for landscapes or portraits; two Lord Provosts of Inverness, for instance, commissioned cut-rate official portraits of themselves. Whenever he had funds, he would send money back to his family in London, but his marriage was creaking under the strain of the long separation. Stories circulated that he had a woman with him in Scotland, although

Keating would later deny any impropriety. However, when he returned to London from Scotland in 1959, after what he called his 'Highland fling', Tom Keating and Ellen divorced. Over the years, says his daughter Linda, Keating seemed to feel badly about having left Ellen with the children and did what he could to help her. He never painted a portrait of her, but Linda feels that many of the women Keating painted looked a bit like Ellen – she fancies that she can see her mother in many of the pictures.[2]

In 1960, Keating landed a commission in picture restoration which brought him enormous pleasure: restoring the vast painted panels of the soaring walls of Marlborough House on the north side of St James's Park. Marlborough House, one of London's royal palaces, had been built in 1709–11 by Christopher Wren, for Sarah, wife of the Duke of Marlborough, but had been empty since the death of the widowed Queen Mary in 1953 and had fallen into disrepair; it was now to be converted into a Commonwealth Conference and Research Centre. Keating loved the challenge of developing his own techniques for peeling away the accumulated dirt and frequent varnishings which had all but obliterated the great military murals painted by Louis Laguerre (1663–1721) to commemorate the battlefield triumphs of the Duke of Marlborough at Blenheim (1704), Ramillies (1706) and Malplaquet (1709). Keating used to love telling a story about how he once nearly dropped a pot of paint on the Queen Mother's head. Linda Keating remembers taking a bus at weekends and going to watch him at work in Marlborough House: 'Dad was a brilliant restorer.'

In the early summer of 1963, Tom Keating was introduced to Jane Kelly, the young woman who was to change his life and cause him a great deal of heartache in the end. Keating was by then a grizzly bearded 46 year old; Jane was a 16-year-old Welsh-born, convent-educated schoolgirl who asked him to give her private lessons in drawing, painting and picture restoring. Her parents agreed to pay £1 a day for the lessons. For the next four years, Keating instructed her nearly every day. As he was later to write, 'They were wonderful years. She was unsophisticated,

unspoiled, highly intelligent, very sensitive, a keen student and a good comrade. And despite the difference in our ages, we became very close and loved each other very much.'

In 1967, after a trial separation period, they decided to go away and live and work together. They moved to Diss in Norfolk, where they set up a picture-restoring business together; the business soon prospered, and Keating had time to do a lot of his own paintings. In June 1971, after a holiday there, they moved to Tenerife, into a house high above the village of Vilaflor. For three years, they enjoyed what seemed an endless idyll in Tenerife; but it was too good to last, and the relationship ended there in 1975 when Jane met a Canadian named Bradley Maurice, whom she married in Toronto the following year. Jane Kelly seems to have been the great love of Tom Keating's life, but, eventually, she was to help bring about his downfall.

Keating's undoing began when he came across a book by Geoffrey Grigson (*Valley of Vision*, 1960) about the little-known nineteenth-century visionary artist Samuel Palmer. The book made a profound impact on Keating, and he read it three times. To Keating, Palmer was 'a gentle, lovely, meek, generous, devout and humorous little painter'.

Palmer was an artist of precocious ability and had exhibited his work at the Royal Academy in 1819 at the age of 15. In the early 1820s, he met William Blake, the great mystic painter of the English Romantic school, and was bowled over by him. From then on, when living in Shoreham, Kent, Palmer began to paint the intensely mystical and visionary landscape watercolours on which his fame was to rest. However, by the time he was 30, his ecstatic muse had deserted him, and nothing he painted after that could recapture those fleeting years; he died in poverty.

Exposure

The story was broken by Geraldine Norman, who was working at the time as the saleroom correspondent of *The Times*. Geraldine was one of the people whom David Gould had alerted about the suspect Palmers;

she had adored Palmer for many years, having been brought up in Oxford, where all the best of the 'Shoreham' Palmers were kept in the Ashmolean Museum, so she had a very particular interest in any painting of his which came up for sale and would write them up in her column in *The Times*. Palmers – especially Palmers from his 'Shoreham Period' – were rarities at auction: only four had been sold over the previous five years. In February 1970, she had noticed an unsigned 'Palmer' in the auction catalogue of a small firm of auctioneers (Arnott & Calver) in Woodbridge, Suffolk, advertising a hitherto unknown Palmer drawing. The sepia ink drawing, now entitled *Sepham Barn*, was bought by the Leger Galleries of Bond Street for £9,400. Geraldine wrote up the story in her column, and a follow-up story in *The Times* was embellished by a four-column illustration of the drawing. At the time, Geraldine had no inkling that there was anything wrong with the picture, but a dealer and restorer with a special interest in Palmer wrote to *The Times*, casting doubt on the attribution to the artist.

Over the next few years, Geraldine Norman came across other 'Palmers' in auction catalogues – especially in 1972, when a flood of them appeared – and started researching them and their alleged provenance: she tracked down surviving members of the Palmer family; she interviewed eminent art experts; she tried to talk to gallery owners and to some of the purchasers who had paid a great deal of money for Palmers at auction. Some of the gallery owners were hostile and threatened legal action if she wrote anything; some of the purchasers did not want to cooperate at all. Geraldine soldiered on, nonetheless, and by July 1976 she felt she had enough evidence to go into print. The editor of *The Times*, William Rees-Mogg (later Lord Rees-Mogg), had a close interest in art, and although he was warned that the paper might lose £100,000 in a court case, he decided to go ahead with publication in the public interest. The first article was published on 16 July 1976, suggesting that thirteen signed Palmers in the art market were, in all probability, fakes; Geraldine named the source for five of them but did not point the finger at any particular forger.

With that, the floodgates opened. A 'paper scientist' named Julius Grant (the man who also exposed the forged 'Hitler Diaries') provided forensic evidence which demonstrated that the paper and the principal colours were modern. Contacts who had previously been unwilling to speak now came forward with information about other Sexton Blakes of Old Masters, which Keating was suspected of having been responsible for. Meanwhile, Geraldine was at last able to pin down the provenance of some of the Palmers which had first aroused her interest. They had been offered to galleries by a young woman who had produced a very plausible story of a family inheritance; it was Jane Kelly, Keating's girlfriend, who had become his accomplice in getting his fake paintings onto the market.

Geraldine Norman was also able to track down the elusive Keating himself. After his lonely return from Tenerife late in 1975, Keating had moved to a rented cottage called Lower Park Farm on the outskirts of the village of Dedham. Keating invited her into his makeshift garden studio and talked freely about his life, but sidestepped all questions about Jane Kelly – and Samuel Palmer. Then he disappeared on his blue Honda 90 motorcycle on a tour of the West Country.

Geraldine now published a second article, on 10 August 1976, naming Tom Keating as the probable fabricator of the Palmers and many other imitations. Linda Keating first heard about it from an item on ITV's *News at Ten*; she woke up to a lawnful of reporters, shouting questions and interrogating her neighbours. Keating himself read the article in a field near Glastonbury. He managed to get a message to Linda through a neighbour: 'Don't worry, I'll be coming back soon, and it will all be sorted out.'

Then, instead of going into hiding, he put his motorcycle on a train to London and phoned Geraldine and her husband Frank. They met for a drink that evening. The Normans urged Keating to write a book about his life and the Palmer affair, and Frank offered to ghost-write it. Keating was non-committal, but next morning he telephoned and invited himself for breakfast. He spent the next fortnight with Frank

Norman, talking and talking. It was the start of his autobiography *The Fake's Progress*, which was snapped up by Hutchinson's, sight unseen.

The book, which was published in June 1977, created a great stir: it blew the gaffe on art dealers, both straight and shady, and on Keating himself. In addition, it was a rattling good read: anecdotal, breezy, boisterous and often very funny:

THE

FAKE'S

PROGRESS

Being the cautionary history

of the

Master Painter & Simulator

Mr TOM KEATING

As recounted with the utmost candour

without fear or favour to

Mr FRANK NORMAN

together with a dissertation

upon the

traffic in works of art by

Mrs GERALDINE NORMAN

Tom Keating's revelations about his fakes threw the art world into a ferment of embarrassment. The popular media delighted in the discomfiture of art dealers and connoisseurs, while the loftier art critics denounced him as 'a sordid and mediocre little forger' (Terence Mullaly in the *Daily Telegraph*). Keating was even invited to open a government Job Centre in Colchester. The BBC transmitted a television programme entitled *A Picture of Tom Keating*, in which Keating demonstrated how he had faked Palmers and attempted to justify his life of forgery. But New Scotland Yard's Art and Antiques Squad was already on his trail; the police had started their inquiries the previous year when the Redfern Gallery in Cork Street, Mayfair, made a formal complaint about a

number of suspect German Expressionist paintings which it had sold in all innocence (but had bought back after doubts about their authenticity had been raised).

Trial – and error

At the end of July 1977, Tom Keating was arrested on nine charges of conspiracy to defraud and inducing persons to sign cheques by deception; an alleged accomplice, an antiques dealer from East Bergholt in Suffolk named Lionel Evans, was charged with four similar offences. Later, Jane Kelly was also charged. By now Jane Maurice, she had become a successful painting restorer in Canada. Rather than await extradition, she returned to Britain voluntarily to face the charges. In January 1979, Keating and Jane Maurice went on trial at the Old Bailey. Jane Maurice was tried first: she pleaded guilty to five charges of criminal deception and conspiracy to defraud. It was alleged that in 1969 she had taken several Keating fakes to an art gallery in Woodbridge, Suffolk, and was paid £8,667 for them. In the 1970s, she had sold four 'Samuel Palmers' to the Leger Gallery for £20,000 (these were later sold on for £40,000). Her defence counsel claimed that she had been a mere 'puppet on a string' under the Svengali-like influence of the much older Tom Keating.

Jane's sentence was postponed by the judge (James Miskin, QC, Recorder of London) until after the outcome of the trial of Keating himself, at which she would give evidence for the prosecution.

Keating pleaded not guilty to all the charges against him. When his trial began the following day, the full extent of his alleged Sexton Blakery was aired by Jane Maurice: she gave evidence of how Keating had faked a series of Old Masters in a locked upstairs room of the house in which they were living together and had kept a notebook of forged signatures of many artists of various periods.

In his ghosted memoirs, Keating had estimated that he had put out some 2,000 works of art in the styles of 121 individual artists, although he denied that he had done so with the intention to defraud. In the dock he used every opportunity to air his pet bugbears and to snipe at the art

world. Whenever he was asked a shrewd question, he would sidetrack it and launch into a diatribe about the overcleaning of Old Masters in art galleries.

The prospect of a jail sentence loomed large, but throughout his trial, the irrepressible Tom Keating was busy making sketches in the dock. Linda Keating attended court every day. She watched him day after day, head down in the dock, wearing his familiar visor and always sketching, sketching, sketching. 'It was an absolute nightmare. Heartbreaking. Dreadful. I watched him in the witness box protecting everyone except himself – people like Jane Kelly and Lionel Evans. It was as if he knew he was going to prison anyway and wanted to use his trial as a platform for his pet obsessions.' Keating wasn't on remand, and Linda was able to talk to him every evening: 'He was always trying to see some humour in it all, but it was a terrible strain on him, I know.'

And then, three weeks after the trial began, Providence – apparently – took a hand. Keating was still giving evidence in his own defence. During the weekend adjournment, when he was returning to his cottage in Dedham on his motorcycle, he skidded on an icy road near his home and injured his leg. Providence indeed. After treatment in hospital, he limped back into the witness box but developed bronchitis; a couple of days later, he was admitted to St Bartholomew's Hospital with a severe case of the pulmonary disease and a heart complaint. When the trial was resumed on 26 February, the court was told that the Attorney General had withdrawn the prosecution's case after studying a report from a consultant physician at St Bartholomew's about the fragile state of Keating's health. The Recorder thereupon dismissed the jury and made a ruling of *nolle prosequi* (not to be followed up), which is neither 'guilty' nor 'not guilty', and Tom Keating was discharged.

Jane Maurice was sentenced to 18 months' imprisonment, suspended for two years; she was commended by the Recorder for having come from Canada voluntarily and was now free to return (she died there, of cancer, in March 1991). Keating's other accomplice, the antiques dealer Lionel Evans, was persuaded to plead guilty to one of the charges against

him (for obtaining £250 for a fake Constable by deception); he was given a sentence of six months, also suspended for two years. With that, the Keating fakes trial came to an abrupt end and with a great many questions still unanswered.

It was the art trade itself which came out of the trial worst, as Keating had hoped. The media gave it lots of stick for being so easily duped. There was much breast-beating and soul-baring by art dealers, who complained about the number of 'fishy' pictures being offered for sale and called for a regulatory body of some sort.

Due to the sheer volume of the fakes Keating had produced, trying to trace all of them in order to remove them from the market has proved extremely difficult. Keating took care not to record his sales (so as to leave no incriminating evidence), and, in addition, he gave paintings away with carefree abandon. To Frank and Geraldine Norman he gave a pastoral scene in sepia ink entitled *Shepherd and His Flock in a Hilly Landscape with Shoreham Church*; on the back he wrote, 'To Geraldine and Frank Norman – my own picture made with respect for Samuel [Palmer]. Tom Keating'. It hangs in the living-room of Geraldine's rambling book-filled flat in London's Great Portland Street.

A star is born

After the aborted trial, Tom Keating started life anew as a painter in his own right. The publicity engendered by the trial had added considerably to the value of his name. He was given a commission by Hennessy's, the cognac producers ('We chose Mr Keating purely on his artistic merit,' they said), to design five advertising posters. And then came the great turning point for Tom Keating. In 1982, Channel 4 celebrated its opening by commissioning a series of six half-hour programmes called *Tom Keating on Painters: Keating Demonstrates How the Masters Painted*. In it, Tom Keating drew on his extensive experience of picture restoration and of all the Sexton Blakery he had perpetrated on the great artists whom he had studied so assiduously and copied so profusely. The programmes consisted of a series of monologues on six great artists, in which Keating

showed the complex techniques and brushwork they had used to create their masterpieces. He began with two 'classics': J.M.W. Turner's own favourite painting, *The Fighting Téméraire* (of which Keating had done a brilliant pastiche), and Titian (*c.*1488–1576) with his *Tarquin and Lucretia*. Then he took four Impressionists: Claude Monet (1840–1926) and his *The Church at Vetheuil*; Pierre-Auguste Renoir and a typical Renoir portrait of a young girl (with the wry aside that Renoir, too, had done signed Sexton Blakes in his youth – 'very naughty'); Vincent van Gogh (1853–90) and an aspect of *Sunflowers*; and a Paul Cézanne (1839–1906) still life.

It was a riveting series. Tom Keating, wheezing a little, self-deprecatory, unimpassioned and paying homage to his subjects, gave a brief historical overview of each painter, shot through with pawky insights into their characters, and then proceeded to replicate their techniques on canvas, thinking aloud as he painted with extraordinary fluency and speed. Before our eyes, the paintings took shape, stage by fascinating stage. The programmes were a revelation: Keating made no concessions to the camera, no hamming it up, no visual tricks to distract the viewer's attention. He emerged as a great natural teacher and a great television natural. The viewing public loved the programmes and loved Tom Keating: a star had been born. And Tom Keating basked in the unexpected limelight of being a television celebrity, almost on a par with art historian Kenneth Clark and his pioneering 1969 BBC television series *Civilisation* but much closer to the coalface of art itself.

But celebrity did not go to Keating's head. He remained the same cheerfully cheeky chappy he had always been. Channel 4 followed up their success with another six-part series in 1983, *Tom Keating on Impressionism*, produced in a similar mould.

The series started with a swift overview of the beginnings of French Impressionism, picking out the portraits of the main protagonists on a board, explaining the relationships in their 'brotherhood' and then taking them individually. First he demonstrated the techniques of the landscape painter Théodore Rousseau (1812–67), the leader of the so-

called Barbizon school of '*en plein air*' painters, moving on to Eugène Boudin (1824–98) and his 'seaside paintings', and then Camille Pissarro (1830–1903) and his style of out-of-doors painting. The second programme focused on Édouard Manet and his painting of the naked courtesan Olympia, which caused a huge scandal at the Paris Salon in 1865. The third programme concerned John Constable and his most celebrated painting, *The Haywain*. Keating demonstrated that in order to celebrate the bicentenary of Constable's birth in 1976, he had painted it in reverse, looking from the haywain to the painter at his easel, using Constable's techniques. In the fourth programme, he tackled Rembrandt (1606–69), perhaps the greatest of all the Old Masters, by combining a portrait of Rembrandt's son Titus with a self-portrait of the great painter himself. The fifth programme focused on Edgar Degas and his use of pastels: Keating took one of his celebrated oil paintings – *The Dance Class* – and rendered it in the different medium.

The final programme was perhaps the most fascinating of all: it concerned restoring old paintings. This was one of Keating's greatest loves (and greatest skills). He started the programme in Marlborough House and showed us one of the giant murals of battle scenes adorning the impressive stair walls flanking the main saloon over which he had laboured so long. Today it is alive with colour and life, but it had become so dirty over the years that the Queen herself told him that she had never realised that they were paintings at all – she had thought they were just brown walls. Then the programme moved to the Marlborough Head in Dedham, where Keating enjoyed the occasional drink and where he had agreed, for demonstration purposes, to clean and restore an old landscape painting much discoloured by its years of hanging in a pub. It was just a potboiler, about a hundred years old. He dismantled the frame, cleaned off the accumulated dirt ('warm water with a tiny touch of ammonia'), removed the old varnish with solvents of varying strengths and then re-varnished it. What a transformation! And what an amazing, if somewhat slapdash, crash course in DIY picture restoration! The people of Dedham were as entranced as everyone else and prouder than most.

The second series added further TV lustre to Keating's name. The two series earned him £11,000, but as so often with television, the spin-offs proved to be far more lucrative: in Keating's case in terms of picture sales.

Keating on sale

Keating was obviously intensely marketable now. And on 12 December 1983 the eminent auction house of Christie's held a Keating auction in their South Kensington salerooms – 137 paintings signed by Keating but 'in the style of' other artists and given Christie's stamp of authority. It was a significant policy change for the auction house – selling 'commercial pictures' by a self-confessed faker – and several of their senior management personnel disapproved of it. But, given Keating's new public popularity, it wasn't such a risky venture. Indeed, the response exceeded the wildest expectations of the auctioneer David Collins (one of the regular experts on *The Antiques Roadshow*). Nearly 800 people packed the salerooms, and every single lot was sold, raising a sum of £72,000 – more than twice the estimated total. The top price of £5,500 was fetched by the painting of Constable's *The Haywain* in reverse, which had been featured in Keating's television series.

Linda Keating remembers the brilliantly stage-managed occasion vividly: 'It was fantastic, unbelievable. I was so proud of Dad – the fact that it was on at all, the fact that it was at Christie's. It was one of the most amazing days of my life. I spent the night at the Basil Hotel, where my father was staying. It was a very emotional evening. He was very sad at dinner – he had personal reasons, he said. He said that this was the pinnacle of his life and that his work was done. He seemed to have a premonition about his death.' (Tom Keating died two months later.)

After the sale, Keating gave David Collins a pen and ink drawing which he had sketched in the dock during his trial at the Old Bailey: *Church at Dedham*. It shows three men in a boat, with Dedham Church in the background.

Keating intended to use the money from the auction to buy himself

a cottage, away from the rundown, rat-ridden one he was renting in Dedham. But in February 1984, before he received the proceeds of the sale, Tom Keating died of a heart attack; he was 66 years old. He never had the chance of buying the cottage upon which he had set his heart. Nor had he been able to write his planned *Treatise on the Techniques of Painting*, in which he hoped to publish his wide knowledge of the techniques of the Masters.

Keating died intestate. What with his television earnings from Channel 4 (£11,000) and the proceeds of the Christie's sale, he died a rich man – his estate was valued at £102,000, which was inherited by Linda Keating and her brother Douglas. He also left hundreds of paintings all over the place, some at Dedham, others still stored by Channel 4 after the TV programmes. Linda and Douglas decided to put them up for sale, after choosing the ones they wanted to keep for themselves.

Five more auctions of his works were held. The first one, in September 1984 at Christie's South Kensington salerooms, was nothing less than a sensational success. More than a thousand people squeezed into the salerooms to bid for the 202 paintings and sketches from his studio at Dedham in Suffolk. The sale fetched a staggering £274,000 (about 20 times higher than the printed estimates in the catalogue). A painting entitled *The Artist and Jane Kelly Working in the Studio* fetched £6,000 (it had been expected to raise £200), £8,500 was paid for *The Flood at Port Marly in the Manner of Sisley* and £7,500 for a self-portrait 'after the style of' Rembrandt, while £5,000 was paid for *Portrait of a Young Girl in the Manner of Renoir* and another £5,000 for *Sunflowers*. The Christie's auctioneer at the time, David Collins, later said, 'The prices paid represented the groundswell of public support for Keating. He was a talented artist and a great character in the art world.'

A sale at Bonhams in December 1989 of the last works from Keating's studio raised £166,000 and achieved a posthumous record for a Keating – £26,400 for his pastiche of Turner's *The Fighting Téméraire*. The joke in this painting is that it shows the artist being arrested by the police and hustled up the steps of the quay.

Another sale at Bonhams in December 1990 was less successful and raised only £109,000 for 51 paintings; only three quarters of the paintings on offer were sold and only one of the 'Samuel Palmers' (known as the 'Faustus Four') which had fooled the Leger Gallery and other dealers in the 1970s. And there was a third sale at Bonhams in August 1991, where Keatings were featured alongside paintings by the American charlatan Elmyr de Hory.

The final sale was held by Vost's of Newmarket in December 1998. It was a collection of 85 Keatings (mainly small, unframed watercolours, pastels and drawings, and a few oil paintings) from the estate of Jane Maurice. It was organised by John Vost, acting for Jane Maurice's executors. Linda Keating objected strongly to the sale, but to no avail. The auction (which was again conducted by David Collins) was entitled 'A Little Bit of Keating' and was held in Layer Marney Tower at Layer Marney, near Colchester, close to Tom Keating's old studio in Dedham. After a preliminary press photo shoot at The Sun Inn in Dedham, it turned into another media circus – which was precisely what John Vost had planned.

The sale had been expected to raise £15,000 at most; in the event, it raised £128,000. More than seven hundred people turned up, and the auction lasted for more than four hours of intensive, sometimes feverish, bidding. The lead picture, a portrait of Jane Kelly dressed as a Turkish concubine – *Odalisque (Jane Kelly the Model), in the Manner of Matisse* (Lot 85) – which was expected to raise £1,200, fetched £6,700. The top price of £7,500 was raised by *At The Races, in the Manner of Degas* (Lot 66), which had an estimated price of only £400. A Modigliani-style watercolour entitled *Portrait of a Woman in a Blue Dress, in the Manner of Amadeo Modigliani* (Lot 75), with an estimated price of £300, fetched £5,800, and an oil self-portrait (Lot 20) estimated at £800 raised £5,000.

It was the final Keating flourish, the last of the formal Keating sales. Subsequent to the 1998 sale, John Vost of the Newmarket firm held a number of sales which featured Keatings, including a Krieghoff which

had been used as an exhibit at Keating's trial and a group of portraits of members of the Royal family. But the big 20 auction houses now shy away from accepting Keatings for auction. John Vost also tells me that fakes of 'Keatings' now exist – surely the ultimate irony in the Keating story.

Linda Keating still owns several of her father's paintings. He never painted Linda's portrait, but today she dearly wishes that he had done.

In the light of the sky-high prices realised at the various sales, the question arises – how good an artist was Tom Keating in his own right? I am no art critic and am not qualified to judge, but in his TV series Tom Keating showed himself to be an immensely fluent and accomplished painter. However, some practitioners and critics tend to be less charitable. Geraldine Norman says that he was 'only an indifferent' representational painter: 'On very rare occasions he had really inspired spells and did some very good imitations of other artists' styles,' she says. 'He used to say on those occasions, "The old man worked through me" – he was quite mystical about it, especially where Samuel Palmer was concerned.' She thinks that three of his 'Palmers' are really first-class – one of them is the pastoral Shoreham scene which hangs in her living-room.

Leo Stevenson says, 'He had a big beard, he had a big palette, and he looked like an artist. "Keating" became a brand name. He was "a fake faker"; he was not so much a conman as a cheerful charlatan capitalising on his celebrity. He enjoyed being the centre of attention. He enjoyed being cast as a real painter. And he had one great achievement to his name – he made art wildly popular on television.'

John Vost, now an independent auctioneer and valuer, has no illusions about Keating the artist. To him, Keating was a commodity created by the media: 'There were hundreds of painters doing what Keating was doing in the 1960s and '70s. Tom Keating seized the attention of the media, and the media attention transformed whatever intrinsic value his works may have had and sent prices rocketing. If another substantial collection of Keatings went on sale – say, Linda Keating's collection

of her dad's paintings – the media interest would guarantee another bonanza auction.'

So the enigma remains. But what does Linda Keating say? 'Obviously, I see all this from the point of view of a daughter who loved him. I knew him as a good person, a kind person, a person who had dedicated his whole life to art. He wasn't trying to become famous – he just wanted to be recognised for the talent he had. I don't believe that his fakes were done primarily for material gain; he had his own views on the "closed shop" art business, and he became famous for other reasons. I don't believe it was intentional. No, it wasn't about money – if it had been, he could have made a lot more money than he did throughout his life. He really wasn't materialistic, believe me. He was doing it for lots of reasons, but money was certainly never the most important.'

Epilogue

I cannot help thinking that the resolution of the enigma of Tom Keating and the 'Fake's Progress' still resides in Dedham. Despite the uncomfortable cottage and studio, despite his ill health and the constant need for medication, Dedham is where Tom Keating found contentment at last. Keating used to walk through the churchyard with Linda and say, 'That's where I want to be.'

That was why, in May 1981, when he heard that there was to be a charity auction (for the Church Tower Fund) of works by local artists, he promptly donated a delicate and charming pastel portrait of a woman, which raised £45.

That was why his pictures sold like freshly baked cakes in a back room of the Essex Rose tearooms in the High Street.

That was why, in 1982, he gave the painting of *The Good Shepherd of Dedham* to Dedham Church. A strange legend has accreted around that painting, too – that it was an advance payment for a burial plot in the churchyard. Keating himself may have said it as a joke (in The Sun Inn, perhaps?), but burial plots at Dedham Parish Church cannot be purchased in advance. So what was the real story? The vicar at Dedham

at the time, the Revd Ron Richards, told me how it all came about. One Christmas Day, when he went to lock up the church for the night, he noticed a man kneeling in prayer in the second row of pews: it was Tom Keating. The vicar waited for half an hour and then tiptoed through the church to have a word with him. 'He was clearly very troubled and wanted to talk,' the reverend told me. 'He invited me to his cottage and showed me all his paintings there, which I admired very much. He wanted to give me one, but I could not accept it; nor would he agree to sell me one. In the end, he agreed to paint one specially for the church.' The painting duly arrived, and the Revd Ron Richards gladly accepted it on behalf of the parish as a thank-you gesture from Keating for the way he had been welcomed by the church and community. Keating 'didn't want any fuss over it', so it was hung discreetly in the vestry. Later, it was moved to the muniment room for security reasons. This gave rise to another legend, of course – that it had been stolen! Indeed, Linda Keating, who makes an annual pilgrimage to the grave, took to writing in the Visitors' Book, 'Where's my dad's painting?'

And that was why, in February 1984, Dedham Parish Church was jam-packed with mourners at his funeral service, while a harpist played the theme tune from Keating's TV series.

And that is also why a secret admirer still puts a posy of flowers on his unassuming grave in Dedham churchyard, more than a score of years after his death. Could there be a more telling epitaph?

1.2 – Conman and Accomplice: John Drewe and John Myatt

It was an opportunity which no veteran journalist could resist: the chance to bring together the reformed art conman and one of the coppers who had put him behind bars – John Myatt, the versatile painter who can imitate the styles of many modern masters, and former DCI Charles Hill, retired head of the Art and Antiques Squad at New Scotland Yard. For nearly ten years, John Myatt was associated with what has been called 'the largest art fraud of the twentieth century', which put at least 200 fake modern paintings on the market; Myatt was eventually caught and sentenced to 12 months in prison for his role in the affair. DCI Charles Hill, now a private art investigator, made his name as Britain's most successful retriever of stolen paintings: working under cover, he was instrumental in the recovery of high-profile thefts such as Vermeer's *Lady Writing a Letter with her Maid* (1993), Edvard Munch's *The Scream* (1994) and, in 2002, Titian's *Rest on the Flight into Egypt* (stolen from Lord Bath at Longleat in 1995).

John Myatt and Charles Hill had never met, but I knew they had considerable respect for one another – and a great curiosity about one another. On a bright autumn day in November 2002, we all met at John Myatt's hospitable home near Eccleshall, Staffordshire, where he now lives with his second wife, Rosemary. And as they talked about 'Operation Kob', as the police called it, the ex-copper and the ex-con got on famously.

John Myatt talked with engaging candour about his part in the 'Great Scam'. He showed Charles Hill the studio where he is still turning out the 'Genuine Fakes', as he calls them, which had once landed him in trouble with the law but are now in huge demand in their own right. Charles Hill, in his turn, told John Myatt the story as the police had seen it. As they talked, the pieces of the bizarre and complex tale gradually fell into place . . .

But looming behind their conversation all the time was the enigmatic figure of the man who was the mastermind of the Great Scam – a dapper, highly articulate man named John Drewe: 'The cleverest criminal we have ever come up against,' according to Charles Hill. John Drewe was the subtle brain behind the scheme which provided John Myatt's fakes with apparently cast-iron provenances which convinced highly respected art dealers, galleries and auction houses in Britain and the USA to pay hundreds of thousands of pounds for 'worthless' paintings made in the style of the modern masters. It was, says Charles Hill, one of the major art frauds of the century; and in 1999, when John Myatt was jailed for a year, John Drewe received a six-year jail sentence.

John Drewe

'John Drewe' has always been a bit of a mystery man, not least where his early activities are concerned. He was born John Cockett in February 1948 in Tonbridge, Kent, and grew up in Uckfield, Sussex, where his father Basil Cockett (a telephone engineer) and his mother Kathleen Barrington-Drew lived in a farmhouse called Pleasant Farm. He was educated at Bexleyheath Grammar School in Kent and left there at the age of 16 with a handful of O levels. Despite a reported IQ of 165, he was only an average student, but there was nothing average about his imagination: he used to tell his friends that he was a direct descendant of the Earl of York and a son of the founder of British Home Stores. One of his school friends, Daniel Stoakes (who would later land up in the dock with him), remembers him as an abnormally well-organised child who kept an enormous library of books and newspaper clippings: 'His room seemed like a laboratory.'

After school, young Cockett obtained a job as a laboratory assistant at the Atomic Energy Authority at Amersham in Buckinghamshire; his boss there, Dr John Catch, found him 'clever but arrogant', and the teenager left after two years, having turned down a chance to study for his A levels on day release. From then on, he slipped out of sight. His official record is a blank: there are no records of employment, tax-payments, criminal

charges or medical treatment. At some stage, he changed his name from Cockett to Drewe, taking the second half of his mother's maiden name and adding an 'e' to it.

However, it was his brief employment in the atomic energy business which seems to have fuelled his later Walter-Mitty alias as a nuclear physicist. Drewe was to claim that in 1968 he joined the student demonstrations in Paris and then studied physics for six years at Kiel University in Germany; he also said that he taught experimental physics at the University of Sussex for a year and was awarded a second PhD in physics from State University of New York (SUNY), Buffalo. But neither Kiel nor SUNY, Buffalo, has ever registered or awarded a degree to a John Drewe or a John Cockett, and the University of Sussex says it has never heard of him.

By 1980, he was working as a part-time supply teacher at the fashionable Channing School, in Highgate, teaching A-level physics. In that year, he was introduced to an Israeli immigrant named Batsheva Goudsmid, the daughter of two Holocaust survivors; she was a children's ophthalmologist who lived in a handsome house in Golders Green, in north London. Drewe courted her assiduously, often arriving in a white Rolls-Royce with huge bouquets of flowers. Drewe told Batsheva that he was an adviser to the Atomic Energy Authority and a board member of British Aerospace; later he told her that he was working for the Ministry of Defence or a munitions company in Woolwich.

Drewe moved into the Golders Green house with Batsheva. They never married, although Drewe often presented her as his wife. They had two children, a boy and a girl, although Batsheva would later claim that her son was not Drewe's child. That relationship was to end acrimoniously in 1994, with ominous consequences for Drewe.

By the late 1980s, Drewe was the very picture of suave London prosperity. He drove a Bentley, and he dined at the most select and expensive restaurants. But Batsheva felt obscurely uneasy – especially when a steady stream of choice paintings, apparently by famous modern artists like Alberto Giacometti (1901–66) and Pablo Picasso (1881–

1973), started coming through her house. Drewe told her that they belonged to a 'John Catch' (the name of his former boss at the Atomic Energy Authority), who, Drewe said, was in reality a peer of the realm and a German baron who wanted Drewe to sell his £2 million art collection for him piecemeal on a commission basis – and to do it quietly.

This was very far from the truth. In fact, the paintings were copies made by John Myatt, whom John Drewe had met in 1986 through a small advertisement in *Private Eye* offering 'Genuine Fakes. Nineteenth- and twentieth-century paintings from £150'. Drewe was by now embarked on a brilliantly audacious art scam which would make headlines all over the world.

John Myatt

John Myatt has now become a celebrity popular painter in his own right, but in the Great Scam he played only a supporting role: the extra to John Drewe's lead as the mastermind of the scheme. At the time they met, Myatt was an impecunious art teacher struggling to bring up two small children single-handedly and desperately in need of money.

John Myatt was born in Stoke-on-Trent in 1945, the son of a determinedly left-wing socialist who worked for his father-in-law's building business until he took up the 'Good Life' as a smallholder. Young John had a good singing voice and at the age of eight he won a choral scholarship to the Worcester Cathedral School, where he later became head chorister. At the age of 16 he went on to the local grammar school and left after two years with three A levels, in English, History and Art.

Music and art were the twin passions of his youth. His central ambition was to become an artist. To that end he attended Stafford Art College, and then Cheltenham College of Art, graduating in 1968 with an excellent degree and a Diploma in Art and Design (DipAD). With an eye on a career in education, he went on to Bristol University where he gained a Postgraduate Certificate in Education (PGCE) in 1969, and started work as a probationary art teacher in Staffordshire at Wilnecote

High School in Tamworth. He did not find teaching entirely to his taste, however, and in July 1970, just short of his 25th birthday, he gave up his job and set up as a professional painter in Lichfield. Why Lichfield? The old post office there was being converted into an arts centre by the Lichfield and District Arts Association, and Myatt found a place for a studio in the former garage. He dutifully painted a portrait of the five founder members of the Arts Association, and he made a mosaic of Lichfield's most famous son, Dr Samuel Johnson (it is still on display in Lichfield City Centre). Oh yes – he also managed to sell one painting. So, to keep body and soul together, Myatt taught afternoon and evening classes in Lichfield Art School. In 1972, he landed a job as a part-time lecturer in architectural illustration in Blackpool – three days' teaching in Blackpool, four days' painting in Lichfield. But in 1974, he contracted meningitis and had to abandon the Blackpool post. It was time for a spectacular career move – into the world of pop music.

John Myatt was a versatile pianist. He had also been writing songs (of a kind) since the age of ten. Now, in his hour of need, he decided to try his luck on the pop scene in London. In 1975, he sent a tape of his 'compositions' to a company in Denmark Street (Southern Music, headed by Barry Kingston – purple suit, white shoes, the whole gamut) and headed for the lights of the big city. He loved it, eventually living in Hyde Park Square and writing songs (and playing as a session musician) for GTO Records in Soho Square. He was befriended by a songwriter named Ken Lewis, of the pop group The Ivy League, who had written 'Funny How Love Can Be' and other hits. Lewis taught Myatt how to 'routine' a song: how to start, how to finish and so on. The culmination of Myatt's music career then came when he co-wrote the song 'Silly Games', which went to No. 1 in the UK charts in 1979, sung by Janet Kay.

In 1981, his pop-song career ended. He married and moved back to Staffordshire, to a converted farmhouse in the village of Sugnall. His wife was Anita Bailey from Chislehurst, who was working in a hamburger bar in Park Lane, of all places; her father owned an employment agency.

In Staffordshire the couple had two children – a daughter named Amy (born in November 1983) and a son named Samuel (1985). But soon after Samuel's birth the marriage turned sour, and Anita left home to live with a parachute instructor in Wolverhampton (Myatt and Anita divorced in 1987). Myatt was left with two very young children to bring up on his own and few visible means of support; he had a job as a supply teacher in Walsall but had to give that up in order to stay at home and look after the children.

'Genuine Fakes': how it all began

At that point, Myatt remembered that when he had been in the pop-music business, Dick Leahy, his boss at GTO Records, had once told him of a business acquaintance who had just bought two paintings by the French artist Raoul Dufy (1877–1953). 'I wish I could afford a couple of paintings like that,' Leahy had said. Myatt casually said that he could supply a couple of Dufys for his boss's home in Richmond. He used ordinary domestic emulsion paint – a fellow student at art school had once suggested it as a cheap substitute for oils – and in three weeks he 'knocked off' a couple of signed 'Dufys' (*Casino at Nice* and *The Orchestra*) for his boss; Leahy paid him £250 each for them – and then spent £1,600 on having them framed.

Was John Myatt committing a crime by signing them with Dufy's name? Technically not, says Charles Hill: it is only a crime if there is an intent to deceive (*mens rea*, the legal phrase for 'a criminal intention or knowledge that an act is wrong'). Myatt, according to Hill, sold the signed Dufys 'specifically as Myatts, not Dufys': artists have always done this sort of thing, calling their work a homage, pastiche or whatever.

Anyway, in 1986, John Myatt was in a bad way, being a single parent with two infants. He received child benefit, of course, and the people in his village were tremendously supportive, but the children were living on hand-me-downs and handouts and John was deeply concerned that Social Services would take them into care.

In extremis, John Myatt recalled the two 'Dufys' he had executed for

his friend and realised that he had a skill to exploit: painting 'copies' (paintings in the style of other painters) could be a source of income which would enable him to work at home and allow him to look after his children properly. This was when he put the celebrated advertisement into *Private Eye* with its ingenious oxymoron: 'Genuine Fakes'.

And with that the telephone started ringing. There were numerous responses to the ad (which was inserted several times) from people wanting paintings for their walls. But, as events turned out, after the third insertion of the ad, the most significant call came from a 'Professor John Drewe', who claimed to be a nuclear physicist working for the Ministry of Defence. Drewe telephoned Myatt saying that he needed paintings to decorate his home and asked if Myatt could 'do a Matisse' for him, based on a print of a female seated figure which Drewe posted to him. Myatt did the painting and took it by train to Euston Station, where Drewe met him on the concourse and handed him the money. Before they parted, Drewe commissioned another painting – a Paul Klee (1879–1940) this time. Then came a request for a Braque, a Picasso and two marine paintings in the style of seventeenth-century Dutch masters.

This was the difference between John Drewe and the other clients: at the end of each transaction he would commission another painting or say that he would be in touch again soon. Other customers came and went, but Drewe became a fixture who kept on coming back for more. When Myatt and Drewe met at Euston they would have a pint together and then drive in Drewe's red Bristol, one of his luxury cars, to Golders Green, where Drewe and his 'wife' Batsheva lived in considerable opulence. There Myatt would see his own paintings hanging on the walls. Over a period of about seven or eight paintings Myatt came to like and admire Drewe very much and to consider him a really good friend: he found Drewe charming, intelligent and well-educated, excellent company – and enviably wealthy. For Myatt it was the start of an astonishingly successful, but secret, career as a professional painter, which would earn him £100,000 (at least) before his downfall.

It was money for old rope as far as Myatt was concerned. He had an extraordinary facility for painting in many styles, often at remarkable speed. Painting quick fakes became an obsession, a kind of addiction. He always used water-based media – mostly quick-drying household emulsion (Dulux Trade) with K-Y Jelly as a means to make it flow; he added teabags and coffee to give an overall yellow veneer, and to dull the surface down a bit.

To start with, he was quite content to provide paintings for John Drewe, no questions asked; it enabled him to work at home and to parent his children all day. He was simply grateful to have landed such a generous and glamorous patron at this low ebb in his life.

John Drewe now changed his tack and asked Myatt what he would like to paint. Myatt replied that he had always liked Cubism and delivered a few examples. Then he produced a version of a Cubist drawing of an army doctor by the French artist Albert Gleizes (1881–1953); Gleizes had made several sketches for it, and Myatt made a painting based on them in the way in which Gleizes would have made it. Drewe later phoned to say that he had taken the painting to Christie's, who had valued it at £25,000! He offered to give Myatt half of that amount, in cash. Myatt jumped at the offer and hastened to London to pick up the money; he thought all his worries were over – all his bills could be paid off. From now on, he would be paid a percentage of any profits.

This was the great turning point, according to Myatt: it was the first painting which he had sold knowing that it was a fake. This was when Myatt realised that he had crossed the line and was consciously breaking the law. He found it both exhilarating and slightly frightening. From then on he knew that the fakes he was painting, signed with the artist's name, were intended to be sold on by Drewe as if they were genuine. 'It was unforgivable, I know,' he now tells Charles Hill. 'It was a dreadful combination of greed and vanity, spiced with the thrill of danger. It was like being in a dream.' Charles Hill nods understandingly.

John Drewe, unlike some other major fraudsters, wasn't interested in making a huge killing with one immensely expensive Old Master fake;

he preferred to deliver low-profile paintings in high volume for much smaller, less spectacular profits which would not attract a great deal of attention. He realised that modern art was much more vulnerable to fraud than the Old Masters were: modern abstract artists were much more productive, much more unpredictable and much more difficult to classify. Another favourite target was Graham Sutherland (1903–80). Myatt would visit Coventry Cathedral to copy Sutherland's studies for his huge tapestry of *Christ in his Glory*. He also loved the Swiss artist Alberto Giacometti (1901–66) and the French artist Jean Dubuffet (1901–85). And he found the abstract painter Ben Nicholson (1894–1982) endlessly fascinating . . .

Meanwhile, Drewe was applying the appropriate ageing touches to Myatt's work. He procured old stretchers to replace the modern ones which Myatt had used for his canvases. He applied salt water to the tacks to make them rust quickly. He also used the contents of a vacuum cleaner, and even mud, to 'age' the paintings.

The unique secret of Drewe's scam, however, lay in an ingenious method he thought up for validating Myatt's fakes through bogus provenances – giving them an apparently authentic history with forged documents of ownership and exhibitions, right down to their alleged current owners. These forged provenances were designed to convince the world of dealers that the paintings were authentic, even though the works might not be artistically convincing. He did this by systematically infiltrating the major art archives of top museums (such as the Institute of Contemporary Art, the Victoria and Albert Museum's National Art Library and the Tate Gallery), altering the provenance of genuine paintings and inserting into art catalogues false references for the pieces which Myatt was producing. He stole and altered catalogues and would smuggle them back into the archives, he made rubber stamps to imitate authenticating seals, he forged receipts of non-existent sales. As he burrowed his way into the heart of Britain's art establishment, Drewe altered – perhaps irrevocably – many galleries' archives; experts believe that the national archive of contemporary art has been permanently harmed.

In 1989, Drewe gained access to the library of the Institute of Contemporary Art in London; he claimed to be a collector interested in the Institute's history and ingratiated himself by donating two paintings to a forthcoming fund-raising auction – a Le Corbusier (1887–1965) and a Giacometti, both by Myatt. From then on, the Institute's letterhead and extracts from its library of twentieth-century art correspondence began to appear in Drewe's forged provenances. This is what duped the experts – this unprecedented use of forged provenances to authenticate forged paintings. One 'Ben Nicholson' by Myatt was sold in New York for £105,000.

Drewe also developed a system for bringing these fake paintings to the attention of art dealers and auction houses by using a network of unsuspecting 'runners', or intermediary salesmen. That was how he introduced, at arm's length, a stream of forgeries to great auction houses such as Christie's, Sotheby's and Phillips, as well as dealers in London, Paris and New York. Drewe brazenly seduced several people – mainly friends or casual acquaintances – into distributing Myatt's forgeries. One of them was an old school friend named Daniel Stoakes, who was down on his luck: his marriage had broken up, he was living in a mobile home and he had a low-paid job as a psychiatric nurse in Exeter. One day, out of the blue, he phoned Drewe to seek help. It was an extraordinary coincidence, because Drewe had been using Stoakes's name as an art owner on forged provenances for years! Drewe drove over to see him and offered him a small percentage for helping to sell a Ben Nicholson. Drewe drafted fictitious letters which Stoakes copied in his own hand, pretending to be the owner of the painting.

On other occasions, Drewe simply invented accomplices – such as 'Len Martin'. Since the 1970s, Drewe had been in correspondence with a professor of physics at Kiel University named H. Heinrich Martin (this was doubtless the source of Drewe's claim that he had studied physics at Kiel for six years). Drewe cut Martin's signature from a letter and refashioned the first name as 'Len'. He also beguiled an order of Roman Catholic priests (the Order of Servite Mary) into producing a letter

which he used to authenticate several Graham Sutherland paintings newly produced by Myatt. He told Jewish neighbour Clive Bellman that he belonged to a syndicate which had 300 works of art to sell – the profits would be used to buy archive material in Russia which proved incontrovertibly that the Holocaust had really taken place. Bellman readily agreed to help.

The most spectacular raid Drewe mounted on Britain's art archives came when he decided to woo the Tate Gallery in 1988. He got Myatt to paint two panels by the French artist Roger Bissière (1886–1964), and offered to present them to the Tate; he took Myatt along as the 'art consultant' who looked after their company, Norseland Research Ltd, which had a utility office in London's Bedford Square. The company operated as a conduit for other collectors to put paintings on the market without alerting everybody else to the fact that they were putting them up for sale. The Tate was intrigued but wary. The paintings were shown to Bissière's son, who felt that the materials were not of the kind his father would have used; nevertheless, the Tate was prepared to be persuaded.

Myatt was horrified when he saw the paintings being wheeled in, on the way to the conservation department for routine cleaning. He knew perfectly well that they would instantly be spotted as fakes painted with household emulsion, despite the varnish he had squirted over them. Myatt took Drewe aside and insisted that the gift must be withdrawn. Drewe was furious but agreed to withdraw the offer. Myatt took the two paintings home and burned them (he wishes now that he had kept them!). Drewe was worried that his credibility with the Tate would be destroyed and quickly moved to restore it by making a donation of £20,000 to the gallery to support cataloguing in the archives. That was enough: John Drewe was now in.

Drewe had applied a similar type of deception with the Victoria and Albert Museum. When he applied for a researcher's ticket there, he listed himself as 'professor of physics'. He gave as a reference a 'Dr John Cockett', who naturally gave him a clean bill of health as 'a man of integrity'. He cast himself variously as a cosmopolitan art collector, a

wealthy philanthropist and patron of the arts, an academic researcher, and a nuclear physicist. Detective Sergeant (DS) Jonathan Searle says of him: 'He conned doctors into thinking he was a doctor, physicists into thinking he was a physicist, archivists into thinking he was an archivist. He creates his own truth and appears to believe in his own creations.'

By 1994, John Myatt wanted out: he realised that he was bound to get caught one day. He dreaded Drewe's insistent phone calls. He also, he says, wanted to start painting again as himself. He went to Drewe and said that it was time to stop: 'All successful criminals do one big job and then pull out.' But Drewe didn't do that; he kept on doing jobs, because, according to Myatt, he *enjoyed* doing them – he *enjoyed* pulling the wool over people's eyes. Myatt, however, just wanted out of it and asked to be released from the partnership. He could see prison beckoning, and he was deeply concerned about what would happen to his children in that event. He had become rather frightened of Drewe, who sometimes carried a gun, and realised that he might be in danger because he knew too much. Yet he didn't break away from Drewe there and then; he did one last piece of work for him, in the style of a Russian minimalist named Cluin – Drewe had sent him the right type of Russian paper and the appropriate Chinese ink. (This is among the many Myatt fakes which have never been recovered.) Myatt did not hear from Drewe for several months, and the payments stopped (although Myatt was sure that Drewe was still selling his work). Towards the end of 1994, Drewe phoned again, from an unnamed motorway service area. Myatt tersely told him to 'Eff off'. He was to hear from Drewe only once again.

For a few months, Myatt allowed himself to breathe more easily, believing that he had slipped free of Drewe's clutches. He even began to think that he might manage to get away with it all, scot-free. But events were beginning to overtake them, whatever Myatt hoped. Drewe had walked out on Batsheva Goudsmid late in 1994 to set up home in Reigate, Surrey, with another woman (Dr Helen Sussman, a medical practitioner whom he was later to marry). After the split, he had left incriminating evidence of his forgeries in the Golders Green home.

Batsheva, furious at his betrayal, eventually went to the police. It was the beginning of the end for Drewe and Myatt. On 25 September 1995, Myatt heard the knock on the door he had been dreading for a long time: the police had arrived with a search warrant – Batsheva Goudsmid had shopped both Drewe and him.

Arrest and trial

In John and Rosemary Myatt's kitchen in Eccleshall, Charles Hill is telling Myatt about his own dealings with Drewe and the lead-up to the arrests . . .

At New Scotland Yard, the Art and Antiques Squad led by Charles Hill had become vividly aware of John Drewe in 1994; Hill at that time had just helped to recover Edvard Munch's *The Scream* for the Norwegian government and was riding high as an art-thief buster. The Yard now received a phone call from John Drewe, 'professor of astrophysics', offering 'information about stolen paintings involving the Mafia'. DS Tony Russell and Charles Hill decided to run with the story.

Drewe arrived flamboyantly, by chartered helicopter, at Battersea heliport. He brought with him photographs of two paintings he said he had been offered for sale by the Mafia: one by the Italian painter Giorgio de Chirico (1888–1978), which was genuine, and one by the Italian Filippo de Pisis (1896–1956), which was decidedly not.

Charles remembers thinking it all 'a bit weird' but arranged to meet Drewe again. A month later, Drewe invited Charles to lunch at Claridge's, just the two of them. Charles remembers in particular Drewe's unblinking, slate-blue eyes. Drewe said he was a major supporter of the mystery plays at Lichfield Cathedral (and showed him an appropriate programme bearing his name). With hindsight, Charles says that Drewe was trying to forestall or second guess the police by establishing himself as a trustworthy police informant in case his art frauds were uncovered.

Charles Hill's job was to arrest criminals, and the best way to do that, in his opinion, was to cultivate informers; so he agreed to take part in a sting, suggested by Drewe, in which Charles would pose as a potential

buyer named 'Chris Roberts'. They arranged to meet at an Italian restaurant in Hampstead to see the proprietor (a man from Gaetae in Italy), who would show him a fake Salvador Dalí (1904–89) sculpture, a genuine de Chirico painting and a fake de Pisis picture.

Hill then despatched DS Jonathan Searle to take over in the role of 'restorer'; Searle was an art expert in his own right and had once studied restoration in Florence. The restaurant proprietor brought out the paintings. The day after the meeting, the police, who had kept the restaurant under surveillance, moved in and arrested three people. The proprietor was charged with dishonest handling. At Southwark Crown Court he claimed that he had been set up by John Drewe and was found 'Not Guilty'. Charles was irate but not entirely surprised.

In the middle of January 1995, Charles Hill heard Drewe's name mentioned again, this time in connection with a mysterious arson attack on a house in Hampstead in which a young Hungarian girl had died in agony in hospital, three days after leaping from the top-floor flat which she was renting; it was a house belonging to a friend of Batsheva Goudsmid. At the time, the police did not know of Drewe's split with Batsheva and the incriminating documents he had left, some of which, Drewe believed, were being kept in the house in Hampstead. (Myatt was later to tell the police that Drewe had phoned him to say that Batsheva was trying to blackmail them and that he was going to burn the house down.) After the fire, Drewe was arrested on suspicion: a witness, a Japanese girl, claimed that she had seen a man lurking in the basement of the house on the day of the fire; at an identification parade, however, she failed to pick him out, apparently because he had changed his appearance – he had shaved off his moustache, cut his hair and removed his spectacles.

In the summer of 1995, word came through, from gallery sources, that many fakes of modern artists were coming on the market – mainly Ben Nicholsons and Graham Sutherlands. Two eminent art dealers (Leslie Waddington, of the Waddington Gallery, and Peter Nahum of the Leicester Gallery) realised that they had been duped over a couple of sales and reported their suspicions to the police.

The big breakthrough in Operation Kob came early in September of that year when Batsheva Goudsmid eventually went to the police with all the documentary evidence she had found of Drewe's criminal activities. One of the people fingered by Batsheva was John Myatt. Charles Hill put DS Jonathan Searle onto the case.

At 6 a.m. on 25 September 1995, John Myatt was awakened by the dreaded knocking on the door of his home in Sugnall: it was DS Jonathan Searle, with ten police officers and a search warrant. Myatt flung open his bedroom window and talked to them, still in his pyjamas. The bottom dropped out of his world; the prospect of five years in jail filled his mind. He went downstairs and made coffee for them all. He asked permission to walk his son to the school bus, and while he was away, the police searched the house. They found a host of what seemed to be paintings by Giacometti, Chagall, Braque and Dubuffet lying around, along with sketched studies for works by Le Corbusier and Ben Nicholson.

At Stafford Police Station, Myatt made no effort to duck the policemen's questions and at once admitted that he had drawn and painted 'innumerable' forgeries in the style of nine modern masters. They asked him when and where he had met John Drewe; Myatt showed them the *Private Eye* advertisement. He admitted that he had earned more than £100,000 for his work (of which £18,000 was still lodged in a Swiss bank account – he quickly agreed to hand it over). Myatt could not tell them how many forgeries he had made (about 200, according to the police), or how much Drewe had made out of them (the police were later to estimate more than £1 million). Myatt, deeply relieved that the whole thing was out in the open, made a full confession and agreed to do all he could to help the police catch John Drewe.

For a day or two he even allowed himself to hope that no further action would be taken against him; but then he was summoned to Belgravia Police Station in London. At the end of the interview, which he described as 'very chummy', DS Searle said that they had not yet decided whether or not to bring charges against him.

Searle, according to Charles Hill, is a gem of a man. He earned the

trust of the art world, in particular of Batsheva Goudsmid, and was able to recover many forged works of arts from the art-dealing fraternity. But his investigation wasn't producing concrete results. So, in January 1996, two other police officers, Detective Inspector (DI) Miki Volpe and DS Nick Benfield, were brought into the investigation. With that, Operation Kob began to close in on John Drewe.

At that point, the Art and Antiques Squad was being reorganised. Charles Hill was 'rusticated', as he puts it, and was sent as the DCI to the Belgravia division, leaving Volpe and Benfield at the Yard to continue the investigation of Drewe with Jonathan Searle. On 6 April 1996, the detectives raided Drewe's new home in Washington Close in Reigate, Surrey, where they found hundreds of documents from the Institute of Contemporary Art, the Victoria and Albert Museum and the Tate – missing catalogues, forged rubber stamps, forged receipts of sales and certificates of authenticity from the estates of newly dead contemporary masters. Drewe was duly arrested and charged with forgery and conspiracy to defraud. After four days of interrogation, during which Drewe refused to admit any guilt, he was released on bail – and promptly disappeared.

He was rearrested two months later when the police followed his mother to his hideout on the south coast. This time he produced a very different story: he claimed that he was a defence specialist who had been selling paintings on behalf of the government in order to finance undercover arms deals to countries like Iran and Iraq.

In 1997, Myatt was charged and given police bail. It was several months before the case came to trial. On three occasions, when Myatt appeared at a magistrates' court, John Drewe didn't turn up. On the third occasion, when Drewe was in custody, he apparently faked a heart attack on his way to the court, and the hearing was postponed again. Eventually, on 23 September 1998, the trial began at London's Southwark Crown Court; the judge was Geoffrey Rivlin, QC.

The courtroom was bedecked with nine of Myatt's forgeries. Three men were in the dock. John Drewe, now aged 50, faced a series of charges – one count of conspiracy to defraud fine art dealers, experts,

auctioneers or collectors between 1 January 1986 and 4 April 1996 (which had allegedly netted him up to £1.8 million), three counts of forgery, one of theft, one of false accounting, and one of using a false instrument with intent; John Myatt faced one charge of conspiracy to defraud; and Drewe's former schoolfriend Daniel Stoakes also faced a charge of conspiracy to defraud.

The trial was expected to last three months. Instead, it lasted for nearly five. On the second day of the trial, Drewe sacked his entire legal team and from then on conducted his own defence – apparently because they refused to present his lurid defence of having been used as a scapegoat by the government to cover up international arms deals.

In his opening statement for the prosecution, John Bevan, QC, claimed that Drewe's primary motive was to make money, but, at the same time, he showed 'an intellectual delight in fooling people and a contempt for experts'. He said that Drewe's ten-year run of falsehood had damaged the reputations of some of the century's leading artists and devalued their work. He said that although some works of art were so well known that their authorship was unquestioned, the vast majority (especially works by modern artists) could be copied or imitated by a skilled painter: this provided 'fertile ground for fraudsmen seeking to dupe experts, collectors, investors and galleries'. Drewe's scheme, Bevan alleged, relied on creating provenances for their paintings, substantially altering and supplementing Britain's art archives to include details of artists' non-existent works, and he had commissioned John Myatt to fake works in the style of Ben Nicholson, Graham Sutherland, Marc Chagall, Henri Matisse, Nicholas de Staël, Alberto Giacometti and others.

Mr Bevan told the jury that archive material stored in institutions like the Tate Gallery and the Victoria and Albert Museum formed an invaluable source of research for the provenance of pictures: 'The integrity of this vast collection of archive material is of obvious and central importance to anyone who cares about this nation's heritage; the purity of the archive material affects not only those who deal in works of art but those who love them and buy them.'

Myatt pleaded guilty – 'I just wanted to get it all over' – and gave evidence for the prosecution. Drewe cross-examined him theatrically ('I put it to you . . .') for a whole week. Myatt claimed that he had become Drewe's 'creature': 'I found you hypnotising, charming, challenging.' His high regard for Drewe was eventually replaced by fear: 'You became a menacing and frightening figure who had weapons, who discussed torture and reprisals, and seemed to have a volcanic temper. You mentioned how people were executed, you walked around in London wearing weapons, you even pointed a gun at me once.' Drewe 'put it to him' that his evidence was nothing but a pack of lies and that the police had offered him leniency in exchange for his turning Queen's evidence. After the cross-examination, Myatt went home on bail, but the trial went on, and on, and on . . .

In his defence, Drewe asserted that he had been the victim of 'a stitch-up': it was arms dealers and countries desperate for foreign currencies who were behind the alleged multimillion-pound international art scam – Israel, South Africa, Russia, Iran, Iraq and Croatia – secretly flooding the art market with fakes to raise money from auctions. A web of deceit, he said, had enabled art dealers to join in 'a horrible conspiracy'.

Early in the trial, on 24 November 1998, Judge Rivlin, exasperated by Drewe's antics, issued an unprecedented statement for the guidance of the media:

> I wish to say, and I wish a transcript of this to be made as quickly as possible so that it can be put up in the press room and communicated to the appropriate liaison press officer, that most unusually, because the defendant is representing himself in this case, a number of allegations, entirely unsubstantiated by any evidence, have been made against a number of people as yet wholly unconnected with this case and certainly totally unconnected with the alleged fraud which this jury is trying . . .
>
> Frankly, and I know that the press will understand that in relation to [these allegations] I am putting the matter in this

way, it is my respectful view that it would be highly irresponsible
for there to be any publicity of allegations of criminal offences
against named people who have absolutely nothing to do with
this case.

After listening to all the evidence for nearly five months, the jury of six
men and six women took only five hours to reach their verdict; they
were praised by the judge for their patience and attention, and excused
from further jury service for the rest of their lives. On 12 February 1999,
Drewe was found guilty of the conspiracy charge, two of the three forgery
charges, the charge of theft and the charge of using a false instrument
with intent, and was sentenced to six years' imprisonment.

John Myatt, who had pleaded guilty to the charge of conspiracy and
had spent the rest of the trial at home in Sugnall, had begun to hope
that he would get away with a suspended sentence. His barrister made a
powerful plea of mitigation, and the judge made a sympathetic summing-
up, noting that Myatt had returned what was left of his ill-gotten gains;
but the judge also told him that his part in the fraud had been 'vital
and significant' and gave him a twelve-month prison sentence. Daniel
Stoakes was cleared of the conspiracy charge after telling the jury that he
had simply been one of Drewe's many victims. And sentencing Drewe,
Judge Rivlin told him that he had been 'the chief architect, organiser and
driving force behind a massive fraud'.

Prison

John Myatt was taken to Brixton to serve his sentence, as inmate BX9603
in A-wing, then G-wing and finally E-wing. His fellow inmates called
him 'Picasso', and Myatt would make portrait drawings of warders,
prisoners, their wives and girlfriends; the main currency in prison was
tobacco or 20-unit phonecards, and the going rate for a portrait was two
HM Prison phonecards, worth £4. John Myatt presented me with one
as a souvenir ('For Use in HM Prisons Only'); I treasure it as one of the
more bizarre mementoes of my life in print and television journalism.

While he was in Brixton, Myatt received a visit from an American journalist, novelist and artist named Peter Landesman, who was writing a major article on the Drewe affair for the *New York Times*. Landesman also went to see Drewe in Pentonville prison, where he was serving his six-year sentence – the journalist was planning to write a film script based on the story. In June 2000, on behalf of the Hollywood actor Michael Douglas, MGM paid £700,000 for the film rights to the script: Douglas wanted to portray Drewe as a Raffles-type conman (with his future wife Catherine Zeta-Jones as Batsheva, perhaps). Landesman came away convinced that Drewe's denials of guilt, his body language and his history of invented personas were classic symptoms of what Landesman called 'an abuse victim'; he was sure that denial and the creation of new identities were the real key to Drewe's personality. John Drewe, however, scuppered the Hollywood deal by threatening to sue if the film was made; whereas Myatt had been delighted at the prospect of the film – but only if he was played by Tommy Lee Jones!

Myatt was a model prisoner in Brixton and was released on probation after four months, on 14 June 1999. He had to wear an electronic tagging device on his ankle, but it was removed at midnight on 11 August 1999 – his 54th birthday.

John Drewe was given early release in January 2001, because of the time he spent on remand awaiting trial. Soon after his release, Geoffrey Rivlin, QC, ordered him to hand over £125,000 of his profits from the art scam: since the case against him had featured only nine forged paintings, the confiscation order was legally confined to the money he had made from those alone. At his trial, the police had estimated that 200 fakes were involved (some by an artist who had not been identified) but that only 60 of them had been tracked down – the remaining 140 were still in circulation.

'Genuine Fakes': the real thing

John Myatt's release from prison was the turning point in his life – the definitive end of his old life, and the start of a new one. Throughout

his trial and imprisonment he had enjoyed unswerving support from the people in his home village. He had also met the woman who was to become his second wife, Rosemary, a divorcée with three children. Myatt had told her all about himself before the trial, but Rosemary had stood by him with steadfast loyalty and had visited him in Brixton; she and members of the local choir had looked after his house for him, fed the cat and tended the garden. During the Easter holidays, his children had stayed with their mother when they came home from boarding school. In November 2001, two and a half years after his release from prison, Myatt and Rosemary were married and moved into their new home in Eccleshall.

Curiously enough, it was the policeman who had arrested him – DS Searle – who was the other catalyst of his salvation. Searle had kept in touch with Myatt in Brixton and had been very sympathetic, giving the incarcerated man advice on how to handle his release: 'Don't get drunk every night: you made a mistake, lots of people make mistakes. Just keep a diary of your feelings and what you're going through.'

As soon as Myatt came out of prison, Searle commissioned a portrait from him. Myatt said he was putting his brushes away for good; he was 'sick of the whole bloody art thing', and was going to try to get back into teaching. Searle persuaded him to take the commission on, however, and to continue painting (on the right side of the law this time). Then the barristers called up, one after the other, saying that they wanted a memento and asking for a couple of Giacomettis to hang in their chambers. These were his first post-Brixton 'Genuine Fakes' – the real thing. What a truly wondrous irony that those who had jailed him should become some of his greatest admirers!

For the next few months, Myatt was able to earn a livelihood from people who called at the house asking for a painting of this and that. E-mails poured in, expressing support, requesting interviews, wanting paintings. The '15 minutes of world fame' stretched and stretched, and continues still. In addition, he did a free painting for everyone who had supported him or written to him while he was in prison; it took him two

years to complete this self-imposed penance – 'this pleasant task', as he called it.

Myatt found his self-confidence returning. He said to himself that he was a good painter, a competent painter, not a second-rater. He acknowledges freely that many of the fakes he had painted illegally were done in such a perfunctory, negligent manner that they could have been done by any second- or third-year art student. Few of them were properly researched; he never bothered about the original canvas or about the right textures and touch. But now he rediscovered his original ambition to become a 'straight' professional painter.

At Eccleshall, John Myatt showed Charles Hill and me his studio, where he paints steadily to the music of Mozart and Bach. It is an 'Aladdin's Cave' of great painting names: there is a Braque on the easel and an almost finished copy of Marc Chagall's *L'aigle, la laie et la chatte* (on wood); Cézanne's *Landscape with Viaduct*; a Giacometti 'sort of self-portrait'; a Monet *Poplars*; a Dufy; a portrait of Rosemary Myatt in the conventional Edwardian manner; a Braque landscape with factory buildings; and Leonardo da Vinci (1452–1519) in the act of painting the *Mona Lisa*.

And then, in September 2002, came an astonishing breakthrough: a one-man show of his 'Genuine Fakes' at a gallery in Warwick. Alan Elkin had been running The Gallery in Swan Street, Warwick, for three years. Early in 2000, he saw a magazine article about Myatt; he liked the look of the artist's work and also had a shrewd eye for the main chance. He wrote to Myatt offering an exhibition if he ever wanted one. Myatt had had other approaches, all of which he had rejected. It was nearly two years before he agreed to discuss Elkin's proposal; he went to Warwick, looked over The Gallery and said, 'Yes.'

The exhibition of John Myatt's 'Genuine Fakes' opened on Saturday, 7 September 2002. There were 78 paintings on show: they were all copies of famous modern painters, but on the back of each canvas Myatt had written in indelible ink, 'John Myatt: Genuine Fake'.

The exhibition was opened by Anne Robinson, of *The Weakest Link*

fame. In 2000, Anne had made a BBC television programme entitled *Fake: Britain's Great Pretenders* which featured, among other fakers, John Myatt. The programme showed Myatt dashing off a portrait of Anne in the style of a celebrated 1937 crayon-on-canvas portrait by Picasso of Dora Maar, Picasso's friend, model and muse. Anne Robinson talked in a mocked-up gallery containing a Monet, a Matisse, a Braque landscape and so on: 'It would be £8 million worth of art, if the paintings were real.' But they weren't: they were all by John Myatt.

The exhibition attracted huge public and media interest: people from all over the country were queuing down the road before the doors opened. Over that first weekend, 90 per cent of the pictures were sold, at prices ranging from £500 to £3,500. The most sought-after painting was a copy of *Morning Ride on the Beach* (1876) by the Dutch artist Anton Mauve (1838–88); it was sold for £2,950, but during the exhibition orders were placed for four more copies. People were highly disappointed if their favourite work was already sold, but Myatt offered to recreate it if the customers were prepared to wait. On the night, the best seller was a Raoul Dufy (*Baie des Anges*); several figure studies in the style of Matisse went for £545. The exhibition closed at the end of September, having done extraordinarily well. Including commission on sales, it raised more than £100,000. It was the most successful exhibition yet held at The Gallery, and a huge boost for it – and, more especially, for John Myatt, the con man who became a genuine 'collectible' by going straight. (An even larger sale exhibition of John Myatt's 'Genuine Fakes' was held in May 2006 in St Paul's Gallery in Birmingham.)

John Myatt now says, 'I'm a very simple sort of chap. I paint pastiches, not forgeries. But what is a painting? You can't eat a painting. A painting doesn't keep you dry when it rains. A painting is only an object of aesthetic pleasure. My work says to people that if you can't afford £25 million or so for a Braque, and you always wanted a beautiful Cubist painting – or any painting – in your house, it's my pleasure to help you to have it.'

Now that the trauma is over, John Myatt is philosophical, even

charitable, about John Drewe: 'In today's art world, where conceptual art predominates as state-sponsored culture, works are usually considered "successful" from the extent to which they challenge accepted notions of such and such (take your pick) – a context, texture, height, width, photographic or painterly quality, or technique. The key word is "challenging".

'I feel that John Drewe missed a chance of being seen as one of history's greatest ever conceptual artists. Other artists have created works which "challenged authority", but Drewe took it right to the heart of the establishment itself. He conceptualised a world in which a fabricated piece of work, created in an offhand manner on a cleared dining table, was able to breach the very portals of art's inner sanctum. That is the ultimate conceptual challenge! As someone once said in *Dad's Army*, "They don't like it up 'em." They challenge *us* – but not the other way round. I think it a real shame that Drewe retreated from reality. Many people would have appreciated and applauded a more truthful account of what he did.'

Meanwhile, at least a hundred Myatt non-genuine fakes are still out there, somewhere, perhaps hanging on the walls of prestigious art galleries, perhaps cherished by private collectors who refuse to believe they were duped.

As for the elusive John Drewe – he has disappeared from sight since he emerged from prison. No one seems to know where he is living or what he is doing. Charles Hill is worried: he is convinced that Drewe will surface again with another surprise up his sleeve and is determined to be ready for it.

1.3 – The New Vermeer: Han van Meegeren

'Yesterday this picture was worth millions of guilders, and experts
and art lovers would come from all over the world and pay to see
it. Today it is worth nothing, and nobody would cross the street
to see it for free. But the picture has not changed. What has?'

Han van Meegeren, talking at his trial in Holland
for fraud in 1947 about a Vermeer he had faked

Han van Meegeren (1889–1947) is considered one of the world's most
dramatically successful art forgers.[3] In the 1930s and early '40s, he
painted a series of faked pictures; for the most part they were forgeries
of the seventeenth-century Dutch master-painter Jan Vermeer of Delft
(1632–75), but he also produced pictures alleged to have been painted by
the Dutch genre painter Pieter de Hoogh and some other Old Masters.
Van Meegeren's forgeries sold for astronomical sums, and he became a
multimillionaire from the proceeds; but eventually nemesis caught up
with him and he was unmasked and sentenced to prison.

What makes van Meegeren's story so exceptional is that he himself
was the deliberate instrument of his own unmasking. There is a huge
irony in this. One of van Meegeren's fakes, a biblical painting known as
Christ and the Woman Taken in Adultery, had been sold to *Reichsmarschall*
Hermann Göring during the Second World War, in 1943, in exchange
for 200 authentic Dutch paintings which the Gestapo had plundered
earlier in the war. When the Germans began to be driven out of the
Netherlands in the autumn of 1944, the Dutch authorities set up a
paramilitary Field Security Service, whose task was to identify Dutch
citizens who had collaborated with the Nazis during the occupation.
The sale to Göring of *Christ and the Woman Taken in Adultery*, allegedly
an iconic national art treasure, aroused their suspicions. The sale was
traced back to van Meegeren, and in May 1945 he was arrested and

detained in jail as a suspected collaborator – a charge which, if proved, could bring the death penalty.

After six weeks in jail, van Meegeren saw no recourse other than to confess that *Christ and the Woman Taken in Adultery* and several other 'Vermeers' had, in fact, been forgeries by his own hand. His confession was met with blank disbelief. In a reversal of roles, van Meegeren sought to prove his own guilt as a forger: he was allowed to paint another 'Vermeer', under police guard; this was the painting *Jesus Among the Doctors*, in which he used the special pigments and techniques which he claimed to have used in his earlier forgeries. The charge of collaboration was dropped, and van Meegeren was charged with fraud instead.

Early years

Henricus (Han) Antonius van Meegeren (to give him his proper name) was born in the historic Hanseatic town of Deventer in the Netherlands on 10 October 1889. In the Middle Ages, Deventer had been a commercial, educational and religious centre, where the humanist scholar Desiderius Erasmus (*c.*1466–1536) and Thomas à Kempis (1379–1471, author of *Imitation of Christ*) received their education; it is now an industrial town manufacturing chemicals and textiles.

Han's father, Hendricks van Meegeren, was a Roman Catholic, a puritanical schoolteacher and a strict disciplinarian; he had gained degrees in English and mathematics at Delft University, and taught English and history at the teacher training college in Deventer. He had been 40 years old when he married a 25-year-old woman named Augusta, who was a delicate, sensitive and timid girl with artistic leanings. The couple had five children: Han was the middle child and the second son.

Han was what might be called the runt of the litter: small, physically frail and highly strung like his mother. When he was eight or nine years old he began to draw profusely, much to his father's disgust – 'art' was a bad word in the van Meegeren household, synonymous with waywardness and dissolute living. When his father found a bundle of drawings by Han, he tore them up and burnt them because he felt 'art' was the cause

of his son's lack of progress in his other school subjects. At the Hogere Burger school in Deventer, Han was taken under the wing of one of his teachers, an old-fashioned artist named Bartus Korteling (1853–1930), who gave the boy his first lessons in drawing and painting. Korteling, who modelled his own work on traditional values from the 'Golden Age' of the great Dutch masters, was to become a lifelong friend; young Han would go home with him after school and watch him at work in his studio, picking up tips on techniques and brushwork. Under Korteling's paternal tuition, 'Little Han', as his father called him, started working hard at other subjects, reading and absorbing books of all kinds with single-minded determination and even attending evening classes in mathematics – and winning prizes at school. His father, recognising that the boy had undoubted talent, removed him from the school as soon as he reached the top form, in order to give him time to prepare for the entrance examination to the Delft Institute of Technology with the help of a private tutor at home.

In 1908, at the age of 18, Little Han passed the entrance exam without trouble and was sent to study architecture at the Institute. Delft had been the headquarters of the Dutch East India Company, and its historic town centre is a marvellously preserved example of a medieval Dutch town with its canals, arched bridges, alleyways, courtyards, churches and mercantile mansions. It had also been the home of the seventeenth-century painter Jan Vermeer, who, after two centuries of neglect and near oblivion, was now recognised as the Old Master of the Golden Age of Dutch painting.

Han was later to say that he enjoyed his time in Delft more than any other period of his life. He devoted much more time to studying art than architecture and spent many of his vacations with his old mentor Korteling, learning how to mix paints for himself, instead of using synthetic ones. And he fell in love. On a summer's evening in 1911, he met a pretty art student named Anna de Voogt at the rowing club. She was of mixed race origin: her mother was a Muslim from Sumatra, her father was a Dutch government official serving in the East Indies. Anna

had come to the Netherlands to stay with her Dutch grandmother. Soon after meeting Han, Anna became pregnant. Han's father was furious but agreed to their marriage on condition that Anna became a Roman Catholic, which she accepted without demur; the couple were married in the spring of 1912.

Han had by now entered his final year at the Delft Institute of Technology. With a baby due in November, followed by the finals in December, Han decided to enter for the Institute's Gold Medal competition, held every five years and awarded for the best painting submitted by a student at the Institute. Han chose to submit a watercolour of an interior of the St Laurens Church in Rotterdam, 25 km away; his choice necessitated numerous visits to the church, cycling there and back, but his architectural knowledge clearly stood him in good stead.

Not surprisingly, with all these distractions, Han failed his finals; on the other hand, in January 1913, he won the art school's Gold Medal – a signal achievement for the only entrant who was not a full-time art student – and Anna gave birth to their first child, a son named Jacques. Han's success gave him a huge confidence boost. His St Laurens watercolour fetched a good price, and Han found it relatively easy to sell other paintings. However, his father was still insistent that he should re-sit the finals and arranged to finance another year at the Institute – but only with a loan which would have to be repaid, with interest, by instalments out of his earnings over the next ten years. However, Han abandoned his architectural course and opted instead for a degree in art at The Hague Academy of Art, where he enrolled briefly for the sole purpose of sitting the examinations. He received his degree on 4 August 1914, the day on which Britain declared war on Germany.[4]

Han was now acclaimed as a young artist of considerable promise. He was soon offered a professorship at The Hague Academy, but he turned it down because it would have left him too little time for his own work. Instead, he accepted a temporary job as the teaching assistant in the departments of Drawing and History of Art at the Delft Institute, and Han and Anna took a flat in the town. Life did not turn out to

be as rosy as Han had expected. His salary was small, and although he succeeded in selling a few paintings, they fetched extremely low prices – barely enough to cover the cost of the paints and canvases. So Han van Meegeren dreamed up a money-making scheme. He had sold his prize water-colour for a handsome price, and he had pawned his Gold Medal to raise money: now he started painting, in secret, a copy of his watercolour which he planned to pass off not as a duplicate but as an original. He was, in effect, planning to forge one of his own works. When Anna found out about the scheme she was appalled; she insisted that the painting should be put up for sale, honestly, as a duplicate. It fetched only a fraction of the sum Han had received for the original.

It was only a temporary setback, however. Within a few months, he had his first work exhibited at a gallery in The Hague; as a result, a local art dealer commissioned him to produce four paintings a month at a salary only slightly lower than his assistant's pay at the Delft Institute. In the following year, 1916, he was able to hold his first one-man show, at a gallery in Delft. His wife Anna, who had by now given birth to their second child, Pauline (later to be called Inez), organised the exhibition, raising the money to finance it from relatives and well-to-do friends. Han worked hard to fill the gallery and produced a tremendously varied collection of works – watercolours, oils, pen-and-ink drawings, charcoal sketches. The exhibition was a success, and all the paintings were sold. Han van Meegeren was now a local celebrity.

Buoyed with this success, the van Meegerens moved to The Hague in 1917, where Han did well 'chiefly in social circles where the ease and mastery with which he executed his drawings, watercolours and portraits was appreciated'.[5] He gave expensive lessons to well-to-do aspiring amateurs (mainly good-looking young girls) in his rented studio.

One of the lessons he gave involved painting a pet deer which happened to belong to Queen Juliana of the Netherlands; somehow or other he had arranged to have it brought from the royal palace to his studio every week as a model for his students. At each visit, van Meegeren made several sketches of the animal in between correcting those of his young

ladies; after six months of this, one of his pupils teasingly suggested that he should know it well enough by now to draw it in ten minutes. Van Meegeren took up the challenge and accomplished the drawing in nine. This turned out to be his best-known original work – *Queen Juliana's Pet Deer* – and became the most frequently reproduced print in the Netherlands.

The 1920s saw Han van Meegeren at the height of his success as a 'social' painter, if that is the right word. He was accepted by society as an artist and a witty *homme du monde*, and he was elected a member of the select *Haagsche Kunstring* (Hague Arts Circle), whose members met each week in the *Ridderzaal* for discussion and the exchange of ideas. He was painting portraits of worthy citizens and their wives as photographic likenesses, subtly improved or romanticised, for high fees. In 1921, he held another one-man show in the Kunstzaal Pictura gallery in The Hague; this time, all the canvases were of biblical subjects, painted in traditional style, including a portrayal of the young Christ teaching in the temple (*Jesus Among the Doctors*) – the subject he chose for his 'trial' painting to prove his own guilt as a forger. Once again, all his pictures were sold. He was also obtaining lucrative commissions to produce posters and advertising work. Life was easy, the money was easy and van Meegeren happily succumbed to the lure of plump pickings for undemanding work. He succumbed equally happily to extravagant living and sexual temptation; he began to drink heavily and womanise promiscuously.

His favourite mistress (who would later become his second wife) was a sophisticated and celebrated actress named Johanna (Jo) van Walraven Oerlemans, who was married to a leading art critic, Dr Karel de Boer. He had met her when her husband came to interview him after his first one-man show in Delft in 1916; van Meegeren asked permission to paint the critic's wife in return. The portrait took a very long time to complete, and by the end, Jo and he had become lovers.

Van Meegeren's lifestyle was driving him apart from his wife; they were divorced in 1923, and Anna moved with their two young children

to Paris. And now van Meegeren's glittering prospects showed signs of dimming. The art critics who had lauded his arrival on the scene became less fulsome in their praise – even disparaging at times – because van Meegeren was painting in a staid, old-fashioned style during a period when modern art was all the rage. Van Meegeren was furious. With two like-minded boon companions (a painter and a writer) he launched a vituperative monthly journal in April 1928, *De Kemphaan* (*The Gamecock*), designed to demolish critics and their views and to expose the venality of their ways (demanding payment for a notice and so on). The journal folded within two years.

In 1929, at the age of 40, van Meegeren married Johanna Oerlemans, his on/off mistress for the past 13 years, who was now divorced from her art critic husband. This marriage brought a certain stability to Han's life. Jo had a cool business head; she acted as his unofficial agent, organising his finances and negotiating his commissions. She turned a blind eye to his occasional drinking bouts and casual infidelities, and seems to have believed in her husband's creative talent – his genius, even – as obsessively as he himself did. In October 1932, disgusted by the critics' failure to appreciate Han's work, the couple abandoned the Netherlands and moved to Roquebrune, a village on the French Riviera between Menton and Monaco. It was there, in a house named the Villa Primavera, that he embarked seriously on his career as a forger; he was later to claim that his motive was to humble the critics who had denigrated his work by duping them into accepting his work as products of the great Masters.

A *pigment of the imagination*

The villa in Roquebrune was a perfect setting: delightfully situated with a view across the village to the sea and completely isolated in its garden of roses and orange trees. There were plenty of well-heeled potential clients among the visitors to the *Côte* prepared to pay handsomely for old-fashioned likenesses of themselves, and the van Meegerens were able to live comfortably off the proceeds.

But Han van Meegeren had larger fish to fry. During a holiday in Italy

he had done the rounds of the galleries and had seen one of three versions of Caravaggio's (1571–1610) *Christ at Emmaus*. He also owned a copy of a book by Dr Dirck Hannema, director of the Boymans Museum in Rotterdam, on Dutch painting in the seventeenth century, which emphasised the 'non-Dutch' qualities of early Vermeers such as *Christ in the House of Martha and Mary*. Here, perhaps, lay the inspiration for van Meegeren's audacious scheme: to forge a major work by Vermeer from a period of his life about which little was known. Vermeer's *Christ in the House of Martha and Mary* (now in the National Gallery of Scotland in Edinburgh) was completely different in style as well as subject from any of Vermeer's other works; it had been identified in 1901 in a castle in Scotland[6] by Dr Abraham Bredius (d.1946), the flamboyant director of the Mauritshuis Museum in The Hague and the leading art critic in the Netherlands. Bredius postulated that, as a young man, Vermeer must have travelled to Italy, where he had fallen under the spell of Caravaggio and had returned to paint a series of religious paintings, of which *Christ in the House of Martha and Mary* was the sole survivor. Bredius was by now the 'Grand Old Man' of art criticism in the Netherlands, affectionately known as 'The Pope', a man in his late seventies, severely myopic and, by coincidence, living in retirement only a few miles from Roquebrune.

Van Meegeren now set out to put his scheme into effect. It would involve four years of arduous study and experimentation, using home-made pigments and genuine old canvases, and several 'dummy runs', before he had perfected the techniques he needed to produce a fake Vermeer which would fool the art critics, including, above all, The Pope himself, Abraham Bredius.

Van Meegeren was already well aware, through his training in art history and occasional work as an art restorer, of the chemical properties of paint. Conventional oil paints, made with drying oils such as linseed oil, dry very slowly, and pictures painted with them take a century to achieve hardness. During the long drying period, the process of evaporation and the contractions and expansions of the canvas and its stretcher cause 'crackle' to form; this crackle penetrates any undercoats all

the way to the surface layer of paint, and the minute cracks become filled with dust. Van Meegeren had to find, or invent, a medium which would dry quickly and give a painting a hard surface with crackle consistent with its supposed age.

Van Meegeren had to ensure that the pigments he used were consistent with those created by Vermeer. Vermeer had ground all his own pigments; his ultramarine (the deep blue which was one of his favourite colours) was ground from lapis lazuli, which in its powdered form was rare and expensive. Nonetheless, van Meegeren bought large supplies of it and then ground it by hand. Indigo, now almost always synthetic, was made from the juice of plants such as *Isatis tinctoria* (the woad of the ancient Britons) and was easy to obtain. Vermeer's yellows were made either from gamboge (a resinous gum obtained from tropical Asian trees) or from yellow ochre earth which had to be ground and washed. White (from white lead), vermilion (from cinnabar), red (from burnt sienna), black (from carbon black), brown (from burnt umber) – all the raw materials for these pigments were to be found in the Villa Primavera. Van Meegeren had to experiment with these ingredients in order to find the correct proportions to ensure that the colours would not alter in the heating process. To bind the pigments he used a synthetic mixture of phenol and formaldehyde – the basis of Bakelite – dissolved in a spirit such as turpentine and/or an essential (i.e. non-fatty) oil such as oil of lilac or lavender.

The heating process was crucial. He had to avoid blistering the pigments and also allow crackle to develop, as if naturally. For how long were the pigments to be baked and at what temperature? After much trial and error, using a special oven he had constructed in the basement of the Villa Primavera, van Meegeren found that the optimum temperature was 105 °C and the optimum time two hours. This would change the chemical composition of the resin permanently and render it insoluble in alcohol or other common solvents.

To appear authentic, the picture would have to be painted on a genuine seventeenth-century canvas, which meant that he had to buy a work of

the period by a minor or unknown painter. The original painting would be partially removed with pumice stone, care being taken to retain the old network of crackle. Next, a so-called 'levelling' layer of paint would be applied, and this would form the ground for the final painting before baking. The picture would be varnished then 'distressed' so that the original crackle broke through to the surface. Indian ink would be spread over the picture to seep into the cracks, to simulate the dust of centuries. Next, the ink and varnish would be removed from the surface of the picture, which would then be re-varnished to provide the finished article.

Christ and the Disciples at Emmaus

In the summer of 1936, van Meegeren and his wife went on a long-delayed holiday to, curiously enough, the Olympic Games in Berlin. He had completed all his 'dummy runs' – his trial canvases, one might call them. They were not intended to be sold and were never offered for sale. Two were 'Vermeers': *A Woman Reading Music* and *A Guitar Player*, which were discovered in van Meegeren's studio after his arrest. The other two were a pastiche of the seventeenth-century Dutch artist Gerard ter Borgh (1617–81) called *Portrait of a Man* and a rather jolly picture of a woman drinking in the style of Frans Hals (1582–1666), signed with the monogram 'FH'.

Van Meegeren was now ready to start on the task for which he had been preparing so assiduously over the previous four years. It was to be a much more ambitious project: not just to copy Vermeer's style (as in *A Woman Reading Music*), but to create a totally new 'Vermeer' on a biblical subject: *Christ and the Disciples at Emmaus*. It would take him six months, working in virtual seclusion at the Villa Primavera.

He had already chosen the canvas he would use: he had bought a genuine seventeenth-century painting, *The Raising of Lazarus* (still on its original stretcher), by the Dutch artist Hendrik H. Hondius (*c.*1573–1649). He cut a 50-cm strip off the side of the canvas; he planned to use this as evidence of forgery, to be produced triumphantly when he

had fooled the art establishment into accepting his work as a genuine Vermeer. He removed all but the ground of the original, leaving intact the bottom layer with its all-important crackle. He gave the canvas two undercoats to provide a smooth working surface on which to paint his *Emmaus*. When the painting was done, he took it down to the basement where he baked it for two hours.

The next stage of the deception was vital – getting it onto the market as an authentic but hitherto unknown Vermeer. He conned an acquaintance in the Netherlands, a respected solicitor and Member of Parliament named Dr G.A. Boon, who had an active interest in the arts. Van Meegeren spun him a story about the provenance of the *Emmaus* painting. It belonged, allegedly, to one of his mistresses, a woman named 'Mavroeke', a survivor of an old Dutch family which had moved to Italy years earlier from their ancestral home in Holland with a marvellous collection of 162 paintings by Old Masters such as Hans Holbein (1497–1543), El Greco (1541–1614), Rembrandt, Frans Hals and others; they had been handed down in her family since the seventeenth century. Mavroeke, said van Meegeren, was planning to emigrate and had asked him to sell some pictures for her on commission (keeping her name out of the transaction, of course). Van Meegeren had come across a painting which he believed to be a Vermeer and had smuggled it out of Italy – 'smuggled' because the export of great artworks was forbidden by Mussolini's Fascist government.

Dr Boon swallowed this fiction whole. His role now was to approach Abraham Bredius, on commission of course, to authenticate the painting as a Vermeer. Van Meegeren had explained that he could not make the approach himself, because of a long-standing animosity between the two (which was true). On 30 August 1937, Dr Boon wrote to Bredius, outlining the story but suppressing van Meegeren's name and the name of 'Mavroeke'. Bredius suspected nothing and invited Dr Boon to bring the painting to his home in Monaco.

The opportunity offered by Dr Boon was too much for Bredius. Here was the chance to secure the glittering crown of his distinguished

academic career – to find the Vermeer masterpiece which he had always hoped existed, ever since he had come across *Christ in the House of Martha and Mary* in 1901. Bredius studied the forged painting for 48 hours. He may (or may not) have had some basic scientific tests done, but mainly he drew on his intuition and his 'feel' for Vermeer, and wrote and signed a glowing certificate of guarantee to testify that it was genuine:

> This glorious work of Vermeer, the great Vermeer of Delft, has emerged – thank God! – from the darkness where it lay for many years, untouched, and just as it left the artist's studio. Its subject is almost unique in his œuvre; a depth of feeling springs from it such as is found in no other work of his. I found it hard to contain my emotions when this masterpiece was first shown to me, and many will feel the same who have the privilege of beholding it. Compassion, expression, colour – all combine to form a unity of the highest art, the highest beauty. (Bredius, September 1937.)

Bredius followed this up with an effusive article in the *Burlington Magazine* entitled 'A New Vermeer' (November 1937):

> It is a wonderful moment in the life of a lover of art when he finds himself suddenly confronted with a hitherto unknown painting by a great master, untouched, on the original canvas and without any restoration, just as it left the painter's studio! And what a picture! Neither the beautiful signature 'I.V. Meer' (I.V.M. in monogram), nor the *pointillé* on the bread Christ is blessing, is necessary to convince us that we have here a – I am inclined to say *the* – masterpiece of Johannes Vermeer of Delft and, moreover, one of his largest works (1.29 m by 1.17 m), quite different from all his other paintings and yet every inch a Vermeer . . .
>
> In no other picture by the great Master of Delft do we find

such sentiment, such a profound understanding of the Bible story
– a sentiment so nobly human expressed through the medium of
the highest art.

Bredius had walked straight into the trap so cleverly baited by van
Meegeren. There were a few dissenting voices, to be sure. But using the
Netherlands' leading art dealer, D.A. Hoogendijk, Dr Boon succeeded
in selling the *Emmaus* to the Boymans Museum in Rotterdam for the
modern equivalent of some £2,000,000[7] in December 1937; most
of the money was put up by a wealthy and philanthropic Rotterdam
industrialist named W. van der Vorm. When the painting was put on
display in the Boymans Museum in the summer of 1938 it was hailed as
'the greatest Vermeer' and 'the art find of the century'. Van Meegeren's
triumph over his enemy, the art establishment, seemed complete.

Having achieved his declared aim by duping the art establishment
so comprehensively – and thereby proving (to himself, at least) that he
was a great creative artist – van Meegeren might have been expected to
declare to the world that he, the despised van Meegeren, was the man
who had painted the *Emmaus*. But no. Now that the time had come, van
Meegeren remained silent. Why?

Van Meegeren had received nearly two-thirds of the sale total – about
£1,300,000; the balance was shared by Dr Boon and the art dealer
Hoogendijk. It was much the largest sum of money van Meegeren had
ever handled, and he had never been good at handling whatever he
earned. He banked the cheque and started spending as if there were no
tomorrow. He could have renounced the money in a blaze of publicity,
retrieved the *Emmaus* and sold it as a scandalous fake; he could have
made a fortune from his autobiography, say, or by selling reproduction
rights for the *Emmaus*. Instead, he went on a spending spree: a week in
Paris with a Swedish cabaret girl whom he showered with expensive gifts,
lavish presents for his wife, reckless gambling in the casino at Monte
Carlo and so on. In a month of riotous living he reached the point where
there was no turning back – he could not possibly repay the fortune he

was squandering. His cover story to explain his sudden wealth was that he had won the jackpot in the national lottery – twice, even.

To celebrate his windfall, in the summer of 1938 he moved from the Villa Primavera in Roquebrune to a magnificent mansion he bought in Nice called the Villa Estate. Situated high above the centre of the city, it had a dozen bedrooms and five large reception rooms, extensive grounds and wonderful views of the sea; in a separate wing there was a gallery, a music room and a library, which became van Meegeren's studio and laboratory. The couple furnished their new home with every luxury money could buy, and they hung a number of elegantly framed – and genuine! – van Meegerens on the walls.

In his last months at Roquebrune, van Meegeren had painted a fake Pieter de Hoogh, *Interior with Drinkers*, which he signed 'P.D.H.1658'. A year later, this forgery was sold, via another respected Dutch dealer, to a wealthy Rotterdam shipowner and art collector named D.G. van Beuningen for the equivalent of £166,000.

The van Meegerens spent a year in Nice. During this time, he painted at least two fakes. One was a de Hoogh (*Interior with Cardplayers*), which would be purchased by the industrialist van der Vorm for £55,000. The other was a much more ambitious project – a fake Vermeer, now known as the 'first' *The Last Supper*; this painting disappeared from sight until it resurfaced in September 1948, eight months after van Meegeren's death. Later, van Meegeren would paint a 'second' *Last Supper* (see below).

Late in July 1939, van Meegeren and Jo left Nice to pay a short visit to the Netherlands. The purpose of the visit is unknown, but it may well have been to arrange another sale – presumably the *Interior with Cardplayers*, because they had taken it with them. They certainly intended to return to Nice, because they made no arrangements to sell or let the Villa Estate. But, with the outbreak of the Second World War, events overtook them. The van Meegerens decided that the safest course of action was to stay where they were; they would never see their palatial home in Nice again.

The Second World War: rise and fall

The war, which brought such appalling privations to so many millions, was anything but a disaster for van Meegeren. During the Nazi occupation of the Netherlands, life was strictly regulated, everything was in short supply and black markets flourished everywhere. It was an easy place to spend money, if you had enough of it, and van Meegeren had lots and lots of it. He was a very rich man when he arrived in the Netherlands before the outbreak of war. He and Jo stayed in a hotel in Amsterdam for a few weeks and then, early in 1940, he bought a large villa in the village of Laren on the outskirts of the city. He had money left over from the sale of the *Emmaus*, and he still had the fake de Hoogh (*Interior with Cardplayers*) to sell. This house now became his home and the new base for his operations.

Here van Meegeren embarked on a career as a full-time serial forger. During the following four years, he painted no fewer than five 'Vermeers', all of which he sold at ever-escalating prices, for a grand total of the equivalent of £10.5 million. The extraordinary aspect of these forgeries was that their quality deteriorated dramatically with every picture, while the selling price kept rising. His last 'Vermeer', *The Washing of Christ's Feet*, painted at Laren in 1943, which was sold to the Dutch State for £3,200,000, was such a ludicrously shoddy piece of work it is hard to believe that anyone could be fooled into thinking it a genuine Vermeer.

The first forgery at Laren was a modest project: a small piece called *Study for an Unknown Work* (now referred to as the *Head of Christ*) which was bought early in 1941 for £130,000 by the wealthy Rotterdam shipowner van Beuningen, who had bought the first of the fake de Hooghs, *Interior with Drinkers*. Through his intermediaries, van Meegeren suggested that the *Head of Christ* looked like a preliminary study (signed with a Vermeer signature) for an unknown major work which had not yet been discovered – that it was a trial study, in effect (which, in a way, it was). Van Meegeren had almost had to start from scratch again, building a new oven in his basement to age the painting, experimenting with crackle and temperatures. He probably had not intended to sell it (in

fact, he did not infiltrate it into the marketplace for a year); technically it was a failure, in that the paintwork began to deteriorate very seriously soon after it was sold.

In the meantime, van Meegeren was hard at work on the 'undiscovered major work' he had adumbrated: a second version of *The Last Supper*. But he was becoming more and more slipshod. He did not bother to remove very much of the under-painting (a hunting scene by a minor seventeenth-century Dutch artist), which would show up clearly on X-rays which were taken before his trial.

Van Meegeren was now in need of a new intermediary: although the art dealer Hoogendijk was still, in all innocence, handling his forgeries, Dr Boon, the front man, had fled from Europe ahead of the German Army advance and would never be heard of again. Van Meegeren picked up on an acquaintance from his Deventer days, a small-time estate agent named R. Strijbis, who knew nothing about art but who jumped at the opportunity of making a lot of money (van Meegeren offered him 15 per cent of the proceeds). To Strijbis, van Meegeren repeated his old spiel about the genteel owner who wished to remain anonymous. In February 1941, Hoogendijk duly took the *Head of Christ* to the Rotterdam shipowner van Beuningen, and a sale was concluded without difficulty for some £750,000.

A couple of months later, in April 1941, Strijbis went back to Hoogendijk with the story that he had now obtained (from the same anonymous source) the major Vermeer work for which the *Head of Christ* was presumed to be a preliminary study. Once again, Hoogendijk fell for the story and offered the painting to van Beuningen for some £5,000,000. It was a huge price, but Hoogendijk played an important card by referring to the danger of the Nazis getting their hands on such an important national treasure. That seems to have done the trick; after some haggling, van Beuningen agreed a price of approximately £4,000,000, to be paid in kind: half a dozen less important works from his existing collection, including the recently purchased *Head of Christ*. With the advantage of hindsight, the dramatic appearance of a long-lost

masterpiece on cue seems much too providential, much too *pat*, but with the example of the *Emmaus* fresh in people's minds, it is perhaps understandable that both Hoogendijk and van Beuningen were duped.

Van Meegeren now judged it safe to dispose of the second de Hoogh fake, *Interior with Cardplayers*. This time the target purchaser was van der Vorm, the industrialist who had put up most of the money for the acquisition of the *Emmaus* by the Boymans Museum. Van der Vorm snapped it up for £550,000. This meant that in a single year (1941) three of van Meegeren's forgeries had grossed some £5,000,000, of which he had received two-thirds.

With all that money in the bank, van Meegeren could have retired and lived in luxury for the rest of his life. But he did not 'retire' for nearly two years, in mid-1943. By then he had forged, and sold, another three 'Vermeers', each one more slipshod technically than the last and each one less aesthetically pleasing, culminating in a sale to the Netherlands State itself. First came *Isaac Blessing Jacob*, which was bought by van der Vorm in 1942 for £3,150,000; then came *Christ and the Woman Taken in Adultery*, which was sold to Reichsmarschall Hermann Göring in 1943 for the equivalent of about £4,000,000; and finally came *The Washing of Christ's Feet*, which was sold to the Dutch State in 1943 for £3,200,000, despite the fact that one of the purchasing panel denounced it as a forgery and none of the others admired it as a painting.

Perhaps van Meegeren thought that this was the last gesture he needed to make. He had fooled the Dutch art establishment, he had fooled a major Dutch museum and he had fooled the Dutch State. By now he was enormously wealthy. He had invested some of the money in property and owned more than 50 houses and hotels, as well as a small collection of genuine Old Masters. But he did not enjoy his 'retirement'. He leased out the villa at Laren and moved to a large four-storey mansion at Keizersgracht 321 in a fashionable suburb of Amsterdam. But there was no contentment to be found. He was drinking and womanising again; what is more, he had started taking morphine and had become an addict. And he must have been aware of a ticking time bomb which

could blow up in his face at any time – the sale of his forged 'Vermeer', *Christ and the Woman Taken in Adultery*, to Reichsmarschall Hermann Göring.

Denouement

Christ and the Woman Taken in Adultery, which he painted at Laren in 1942, was the only forgery which caused van Meegeren any unease after his 'triumph' with the *Emmaus*. He had entrusted the sale to a new agent, Rienstra van Strijvesande, with strict instructions that it should not end up in German hands; he was well aware that any trading with the enemy would create serious problems when the war was over.

Van Strijvesande was a risky choice, because he was known to have dealings with Bavarian banker Aloys Miedl, who had an office in Amsterdam. Miedl passed news of this newly discovered 'Vermeer' to one of the many agents employed by the Nazis to acquire major works of art for the aggrandisement of the Third Reich, a Dr Walter Hofer. From that moment on, the destination (and destiny) of *Christ and the Woman Taken in Adultery* passed out of van Meegeren's control.

When the Germans realised that their homeland was in imminent danger of invasion and defeat, the Nazi authorities started hiding their looted art treasures, no doubt hoping to be able to redeem them after the war was over. In the middle of April 1945, troops attached to the Allied Art Commission found a Nazi treasure repository hidden deep underground in the ancient Steinberg copper mine in Germany: an elaborate vault – temperature- and humidity-controlled – housed hundreds of art treasures looted from galleries all over Europe. A week later, another huge hoard of uncatalogued artworks was found in a sealed salt mine near Alt Aussee, high in the Austrian Alps; the Old Masters included works from the Rothschild Collections from Paris and Vienna, the renowned Ghent altarpiece by the van Eyck brothers and a portion of Göring's treasures.

One painting in this collection of Old Masters aroused particular interest among the members of the Allied Art Commission; it carried a

prominent Vermeer signature in the top left-hand corner and reminded them of the *Emmaus*. None of them had ever seen the picture before; the unknown Vermeer was the painting known as *Christ and the Woman Taken in Adultery*. The provenance of this national treasure was soon traced back to Dr Hofer, from Hofer to Aloys Miedl, and from Miedl to van Strijvesande. Van Strijvesande promptly named Han van Meegeren as the man who had originally brought him the 'Vermeer' to sell.[8]

On 28 May 1945, two uniformed officers of the paramilitary Netherlands Field Security Service, which had been set up to investigate Dutch citizens who had collaborated with the Nazis during the occupation, called on van Meegeren in his mansion at Keizersgracht 321 in Amsterdam. They wanted to know where van Meegeren had obtained the Vermeer which had been sold to Hermann Göring. It was the first time anyone had subjected his elaborate story about its provenance (and the need to protect the owner's anonymity) to pointed questions. Van Meegeren refused to answer their questions, and on the next day, 29 May 1945, he was arrested on suspicion of trading with the enemy and of being a collaborator – a charge which, if proved, could land him in prison for life, or even worse.

For six long weeks he languished in solitary confinement in jail, deprived of the morphine to which he had become addicted. Then, on 12 July 1945, he suddenly broke his silence. 'Fools!' he raged at his interrogators. 'You are fools like the rest of them! I sold no great national treasure – I painted it myself!'

They didn't believe him. So van Meegeren babbled on, claiming that he had also painted the five other Vermeers and the de Hooghs. He signed a confession stating that he had faked no fewer than 14 paintings by Dutch masters. The Field Security policemen thereupon challenged him to paint a copy of the *Emmaus*, in order to prove his claims and thus prove his innocence of the charge of collaborating with the enemy. Van Meegeren made a counter-proposal: he asked to be given his freedom and access to his own studio and all the materials he required (including alcohol and morphine).

Van Meegeren was released under house arrest and started painting (almost literally) for his life, using the special pigments and techniques he had developed. Working under close police supervision, and in front of six independent witnesses, he took two months to complete his tenth 'Vermeer': *The Young Christ Teaching in the Temple* (also known as *Jesus Among the Doctors*, the theme of one of his biblical paintings in his one-man show at the Kunstzaal Pictura gallery in The Hague in 1921). He cooperated with the police until he learned that he would probably be charged with fraud rather than collaboration; he then refused to sign the picture or to 'age' it.

In December 1945, van Meegeren was declared bankrupt. It was a pre-emptive move by the fiscal authorities when it became apparent that possible claims against him from people he had duped amounted to far more than the value of his remaining assets. The first petitions had been filed in November by the Dutch State and the Boymans Museum: the State was claiming for the money it had paid for *The Washing of Christ's Feet* and *Christ and the Woman Taken in Adultery*, as well as unpaid income tax and capital gains tax on his undeclared earnings and profits as a forger since 1937; and the Boymans Museum was claiming back the price it had paid for the *Emmaus*.

The trial

Van Meegeren's trial was at first set for May 1946, ten months after his confession, but it was to be postponed several times as the authorities waited for investigations to be carried out on the allegedly faked paintings. In June 1946, a special commission was sworn in; its remit was to subject the disputed paintings to detailed scientific examination. This was the Coremans Commission, chaired by Dr Paul Coremans, director of the Institut Royal du Patrimoine Artistique in Belgium. The commission carried out intensive physical tests – microscopically, chemically and by X-ray – on some dozen paintings and various materials. Van Meegeren cooperated with the commission, divulging many details of his methods and techniques.

The paint of all of them was found to contain traces of the phenol formaldehyde resin. Various traces of the original seventeenth-century pictures, painted over by van Meegeren, were detected by radiography. Cross sections of the various pictures were taken and photographed to reveal the various layers of paint.

Traces of cobalt blue – an artificial paint not manufactured until the nineteenth century – were detected in *Christ and the Woman Taken in Adultery* and *The Woman Reading Music.* This may have been due to adulteration of the very expensive natural ultramarine used as a blue pigment by van Meegeren (as it was by the artists of the seventeenth century).

The matching of the wood fragment found in van Meegeren's studio with the stretcher of the *Emmaus* was held to be additional proof that the picture was a fake, as was the fact that the left-hand side of the canvas had straight threads, whereas the other three had 'wavy' threads, consistent with the pull of the tacks securing the canvas to the stretcher. This seemed to confirm that the left-hand piece of canvas had been removed, as van Meegeren claimed.

After nine months' work, the commission reported in March 1947 that all the paintings under examination, including eight pictures which had been sold (six 'Vermeers' and two 'de Hooghs'), were indisputably modern and could well be the work of Han van Meegeren.

By this time, van Meegeren had become something of a national hero – someone who had pricked the bubble of pretentiousness of the self-appointed gurus of the art establishment and shown them to be fallible and small-minded. The public admired him for his audacity. Also, there was irony in the sale of *Christ and the Woman Taken in Adultery* to Hermann Göring. The Reichsmarschall had paid not in cash, but in kind: he had handed over to Miedl more than 200 paintings which had been stolen from the Netherlands by the occupying Germans; so van Meegeren had fooled the hated German occupiers, too, and saved 200 genuine Dutch paintings for the nation. The authorities were also very wary about bringing him to trial for fraud, because so many of the

expert witnesses would be the very people who had been taken in by the forgeries.

The trial eventually began on 29 October 1947, in the fourth chamber of the District Assize Court in Prinsengracht in Amsterdam. It had become a major cause célèbre, and the world's press was there – from Britain, from the United States, from France, from all over. No more than 200 spectators could be accommodated, and competition for places was fierce. The courtroom was bedecked like an art gallery: the judge's podium was flanked by the *Emmaus* and *The Last Supper*, and the rest of the disputed paintings decked the other walls.

The undoubted star of the show was 58-year-old Han van Meegeren, grey-faced and wizened but jauntily dressed in a dark blue suit with pale blue shirt and tie. He walked briskly from his house to the courthouse, surrounded by photographers and reporters. Inside the courtroom he smiled, waved to his friends and posed for photographs like a film star. But he was putting on a brave face. He was very ill by now and had been in hospital that summer suffering from angina.

The charges were that the defendant had obtained money by fraud and, secondly, that he had put false names or signatures 'on certain paintings' to make them appear as the work of others, contrary to Articles 326 and 326B of the penal code. The judge asked van Meegeren if he admitted the charges. 'I do,' said van Meegeren.

The trial would have lasted for several weeks if the defendant had pleaded 'Not Guilty'. But in the event it lasted less than a day – only five and a half hours. The morning session was mainly taken up with evidence from members of the Coremans Commission. Another 'expert witness', the art dealer D.A. Hoogendijk, who had handled many of van Meegeren's fake Vermeers (*Emmaus, Head of Christ, The Last Supper* and *Isaac Blessing Jacob*), was disarmingly frank about his own position. Talking about his acceptance of *Isaac Blessing Jacob*, he said, 'It's difficult to explain. It is unbelievable that it fooled me. But we all slid downwards – from the *Emmaus* to *The Last Supper*, from *The Last Supper* to the *Blessing of Jacob*. When I look at them now, I do not understand how it

could possibly have happened; a psychologist could explain it better than I can. But the atmosphere of the war contributed to our blindness.

'It should be remembered that the *Emmaus* was declared authentic by experts with a world-wide reputation. The subsequent fakes were concatenated links of the same chain. That is why sales were more easy. There was also the desire to keep the paintings in Holland.'

In the afternoon session, the judge questioned the defendant about his motives – and the high prices he had charged for his forgeries:

> Van Meegeren: I had no alternative. If I had sold them at a low price, it would have been an a-priori indication that they were false.
>
> Judge: Why did you continue after the *Emmaus*?
>
> Van Meegeren: I found the process so beautiful. I came to a condition in which I was no longer my own master. I lost my will, I became powerless. I was forced to continue.
>
> Judge: But at least you made a very pleasant little profit.
>
> Van Meegeren: I had to, Mr President. I had been so belittled by the critics that I could no longer exhibit my work. I was systematically and maliciously damaged by the critics, who don't know the first thing about painting.
>
> Judge: So you acted from no desire for financial gain?
>
> Van Meegeren: I did not do it for the money, which brought me nothing but trouble and unhappiness. I acted only from a desire to paint. I decided to carry on after the *Emmaus* not primarily from a desire to turn out forgeries but to make the best use of the technique I had developed. I intend to continue using that technique. It's an excellent one. But I will never again age my paintings nor offer them as Old Masters.

Van Meegeren fired a final, withering shot against the popes and prelates of the art establishment: 'Yesterday this picture was worth millions of guilders, and experts and art lovers would come from all over the world

and pay to see it. Today it is worth nothing, and nobody would cross the street to see it for free. But the picture has not changed. What has?'

The public prosecutor summed up for an hour but did not press his case with undue vigour; indeed, much of what he said was curiously favourable to van Meegeren. He did not call for the maximum sentence of four years, as allowed by the Dutch penal code; instead, he called for only half the maximum term, taking into account the defendant's health and 'certain other extenuating circumstances'.

Defending counsel pointed out that van Meegeren had never claimed that the paintings *were* Vermeers or de Hooghs – that had been left to the dealers or the buyers to decide. The signatures were a problem, admittedly, but they were not very important as a guide to authenticity. He called for an acquittal on the first charge (obtaining money by fraud) and 'conditional punishment' on the second (the forged signatures), suggesting that the 'utmost leniency' would be appropriate.

The judge reserved judgement and said that the verdict and sentence (if any) would be announced in two weeks, on 12 November. Thereupon the court was adjourned, and van Meegeren walked back to his home in the Keizersgracht.

On 12 November, van Meegeren was found guilty on both charges and sentenced to a minimal term of 12 months' imprisonment. However, he never went to prison. He was given two weeks in which to appeal. But on the last day for lodging an appeal (26 November) he was admitted to the Valerius Clinic after collapsing in the morning. In the clinic he rallied briefly, but on 29 December he suffered a massive heart attack. He died the next day, on 30 December 1947.

Envoi

On 7 July 2004, a 'lost' Vermeer came under the hammer at Sotheby's in London and was sold for £16,245,600 – apparently to a billionaire Las Vegas property developer. It was a tiny painting, measuring only 25 cm by 20 cm, entitled *Young Woman Seated at the Virginals*, believed to have been painted in 1672.

The painting had a chequered past. It was one of two faded Vermeers bought by diamond magnate Alfred Beit in the 1890s.[9] The van Meegeren scandal caused the art world to reconsider 'questionable' Vermeers, and in 1948 it was dismissed as a fake and 'de-attributed', as the phrase has it. In 1960, it was consigned to a London gallery, where it was sold to Belgian art collector Baron Frédéric Rolin, who traded it for four of his own paintings. In 1993, Rolin's heirs took it to Sotheby's and asked Gregory Rubinstein, the firm's expert on Old Masters, to investigate it.

An international committee of art historians and restorers was assembled to study the painting. Certain parts of it seemed not to be by Vermeer, but when the picture was cleaned it emerged that these were later retouchings. The ultramarine pigment was made from ground particles of lapis lazuli; furthermore, the canvas was from the same bolt of linen used for Vermeer's *The Lacemaker* painting (now in the Louvre in Paris).

It is unlikely that the authenticity of the *Young Woman Seated at the Virginals* will ever be challenged again. But Vermeer himself will not cease to inspire fascination – even obsession.

The artist Leo Stevenson, my friend and fellow Masterminder, is a Vermeer worshipper. The Dutch Master is his favourite painter – his artistic hero. On one wall of his cluttered studio in Brockley, in southeast London, hangs a Vermeer which Leo 'invented' – an imaginative recreation of a Vermeer which was sold in 1696 and has never been seen since. The floor of Leo's studio is patterned in black and white, diagonally laid tiles, like those featured in so many of Vermeer's works. There is a stool crafted by Leo from Dutch walnut – an exact copy of the painter's stool in Vermeer's infinitely complex *The Allegory of Art*. In 1990, he painted a copy of *The Allegory of Art* ('arguably Vermeer's greatest painting') for a British Museum exhibition entitled *Fake: The Art of Deception*; it took him 800 hours, sitting in front of the painting in the Kunsthistorisches Museum in Vienna, and he loved every one of those hours.

He has a sneaking sympathy for van Meegeren the forger; Vermeer

hit all van Meegeren's buttons – but Vermeer was just too difficult to fake: 'Vermeer is, technically and aesthetically, the Mount Everest of painters. Nearly all his images are so perfect. That's why making a copy of a Vermeer is such a tremendous challenge – impossible, really. No one and nothing can produce the true Vermeer aura, even though there may be no discernible physical difference to pinpoint.

'Copying is like wanting to inhabit another skin. It's as if the copier wants to be someone else, wants to hide behind the mask of that someone else, like an actor taking on a role. And that's easier than being the real you, because your entire cultural references are done for you, whereas if you're doing your own stuff, you're working in a cultural void, you're doing your own stuff from your own personality, with all the inhibitions you normally feel; and that makes you feel super creative, because you have all this other stuff to draw on.

'It's a myth, of course. But van Meegeren began to believe in his own myth and that destroyed whatever talent of his own he might have had.'

M. Kirby Talley, Jr., of the Rijksdienst Beelende Kunst in The Hague, summed it all up very neatly[10]: 'Had van Meegeren been a better artist he might never have felt the urge to fake; or he might just have succeeded in producing some "Vermeers" which would have fooled more people longer than the ones he created.'

1.4 – The Case of the Cottingley Fairies

Every time a child says 'I don't believe in fairies', there is a little fairy somewhere that falls down dead.

J.M. Barrie, *Peter Pan*, 1911

What would the redoubtable Sherlock Holmes (or his even cleverer brother Mycroft) have made of the 'Case of the Cottingley Fairies' – the photographs which purported to prove the existence of fairies at the bottom of the garden? It was a story which excited speculation for nearly 70 years and was only resolved (apparently) by a confession from the guilty parties.

In the summer of 1917, two young girls – 16-year-old Elsie Wright and her 10-year-old cousin Frances Griffiths – took a photograph by the stream at the bottom of the garden of Elsie's home in the village of Cottingley, on the outskirts of Bradford in West Yorkshire, which depicted Frances facing a group of what seemed to be flying fairy creatures.

The story is one which provokes endless fascination. How was it that, in the early years of photography, two young girls could take a picture (and take four others on subsequent occasions) which fooled the world for so long?

Let's go back to the month of July in that summer of 1917. Frances Griffiths had just arrived in England from South Africa with her mother to spend the summer with Frances' aunt (Elsie Wright's mother) at Cottingley. The girls' mothers reprimanded their daughters for playing beside the 'beck' (stream) at the bottom of the long garden behind the house, because they kept getting their feet and clothes wet; the girls responded by saying that they only went there to look at the fairies. To prove it, they said, they would take a photograph of them. Elsie's father, Arthur Wright, who was a keen amateur photographer, agreed to lend

them his camera; it was his pride and joy, a Midg quarter-plate, and he set it for them at 1/50s and f/11. After some rudimentary instructions on how to operate the camera, the two girls went off into the area where the beck ran among the trees behind the family home.

Half an hour later, they returned triumphant. Later that afternoon, Arthur Wright, who was one of the earliest qualified electrical engineers, agreed to develop the plate. As Elsie watched, a picture emerged. It showed Frances in the garden with a little waterfall in the background and a bush in the foreground. Four fairies were dancing upon the bush. Three of them had wings; the fourth was playing a long, flute-like instrument. Frances was not looking at the fairies in front of her but straight at the camera, posing with her chin on her hand. The waterfall was blurred, suggesting a slow shutter speed, but the fairies were not blurred, even though they were leaping in the air.

Elsie's father was unimpressed and asked what those 'bits of paper' were doing in the picture. When he was told that they were fairies, he dismissed them as cardboard cut-outs; he knew that his daughter Elsie had an artistic bent and had briefly done some casual work in a photographer's studio.

Two months later, in September 1917, the girls borrowed the camera again and took a second picture. This one, taken by Frances, showed Elsie sitting on the lawn, her wide skirt spread around her, against a background of trees in the garden. She was reaching out her hand to a friendly looking gnome, about a foot high and with wings, who was stepping daintily onto the hem of her skirt. Exasperated by what he considered nothing but a prank, Mr Wright refused to lend the girls his camera again. Elsie's mother, Mrs Polly Wright, however, was convinced of the photographs' authenticity. Prints of the pictures were circulated among friends and neighbours, but interest in the odd affair began to peter out as the girls refused to confess to their prank.

That would have been the end of it, except that in the summer of 1919, Elsie's mother, who was interested in the occult, attended a meeting of the Theosophical Society in Bradford. The lecture was on

'Fairy Life'. When the meeting was over, she showed the speaker prints of the two 'fairy photographs'. The photographs were shown at the annual theosophist conference at Harrogate that autumn and came to the attention of Edward Gardner, a leading theosophist. Gardner had the prints 'clarified': he had new negatives made from the positives of the originals, sharper in definition and more conducive to printing. Then he sent these prints and the original glass-plate negatives to a photographic expert named Harold Snelling and asked him to examine them; he was told that 'what Snelling doesn't know about fake photographs isn't worth knowing'.

On 31 July 1920, Snelling wrote to Edward Gardner with his 'considered judgement' on the pictures:

> These two negatives are entirely genuine, unfaked photographs of single-exposure, open-air work. They show movement in all the fairy figures, and there is no trace whatever of studio work involving card or paper models, dark backgrounds, painted figurers, etc. In my opinion, they are both straight, untouched pictures.

In June 1920, the pictures were shown by Edward Gardner to Sir Arthur Conan Doyle, the creator of Sherlock Holmes, that most renowned of fictional detectives. Conan Doyle was a convinced member of the spiritualist movement and believed passionately that the dead could communicate with the living. He wanted to believe that the two photographs were evidence of a world beyond physical reality. It so happened that he was in the middle of writing an article on fairies for the *Strand Magazine*.[11] The fairy photographs must have seemed a godsend. On 30 June 1920, he wrote to Elsie Wright:

> Dear Miss Elsie Wright,
> I have seen the wonderful pictures of the fairies which you and
> your cousin Frances have taken, and I have not been so interested

for a long time. I will send you tomorrow one of my little books, for I am sure you are not too old to enjoy adventures. I am going to Australia soon, but I only wish before I go that I could get to Bradford and have half an hour's chat with you, for I should like to hear all about it.

On the same day he wrote a very business-like letter to Elsie's father:

Dear Mr Wright,

I have seen the very interesting photos which your little girl took. They are certainly amazing. I was writing a little article for the *Strand* upon the evidence for the existence of fairies, so that I was very much interested. I should naturally like to use the photos, along with other material, in my article but would not of course do so without your knowledge and permission. It would be in the Xmas number. I suggest

1. That no name be mentioned, so that neither you nor your daughter be annoyed in any way.

2. That the use be reserved for the *Strand* only until Xmas. After that it reverts of course to you.

3. That either £5 be paid to you by the *Strand* for the temporary use, or that if you don't care to take money, you be put on the free list of the magazine for five years.

The articles appear in America in connection with the *Strand* publication. I would, if you agree, try to get you another £5 from that side. If this is all agreeable to you I or my friend Mr Gardner would try to run up & have half an hour's chat with the girls.

Arthur Wright, who had been highly sceptical about the girls' photographs, was obviously impressed that a man of Conan Doyle's renown should have taken a hand in the business, but he declined to accept the offer of payment, saying that if the photographs were genuine, they should not be soiled by being paid for.

It was decided that a second opinion should be sought on the authenticity of the photographs. To that end, Kodak was approached. The manager of Kodak, his studio chief and two other expert photographers examined the negatives at some length. The results of the inspection were issued in a unanimous and cautious report (I summarise):

1. The negatives were a single exposure.
2. The plates showed no sign of being faked work but could not be taken as conclusive evidence of genuineness.
3. Kodak was not willing to give any certificate concerning them because photography lent itself to a multitude of processes, and some clever operator might have made them artificially.
4. The studio chief added that he thought the photographs might have been made using the glen features and the girl as a background; following this, the prints could have been enlarged and the pictures painted in; and the process completed by then taking half-plate and finally quarter-plate snaps, suitably lighted. All this, he agreed, would be clever work and would take time.
5. A remark made by one of the panel was that 'after all, as fairies couldn't be true, the photographs must have been faked somehow'.

As a further check, Conan Doyle showed the prints to the eminent physicist Sir Oliver Lodge (1851–1940), who, in addition to his pioneering work on wireless telegraphy, gave much of his time to psychical research. Lodge thought them fakes – perhaps involving a troupe of dancers masquerading as fairies. And doubt was expressed regarding the distinctly 'Parisienne' hairstyles of the fairies.

Despite Oliver Lodge's misgivings, and Kodak's refusal of a certificate of authenticity, Conan Doyle was in no mind to give up. He was too busy with his planned visit to Australia to go to Bradford in person.

Instead, he despatched his 'Dr Watson' (in this case Edward Gardner) to Cottingley to interview the Wright family. Gardner spoke to Mrs Polly Wright and Elsie, who answered his questions, in his opinion, 'willingly and candidly'. He also spoke separately to Mr Wright and found him to be 'of forthright speech and character and having a cheerful disposition'. Mr Wright told Gardner that he had been so convinced at the time that the figures must be made of paper, or something like paper, that while the children were out he searched their attic bedroom and waste-paper basket for scraps of pictures or cut-outs; he also searched the glen and the area around the beck. Neither in the house nor in the glen did he find anything 'incriminating'.[12]

Gardner reported back that the family seemed honest and thoroughly respectable. Conan Doyle thereupon decided to put the matter beyond question by having further fairy photographs taken. Gardner was sent back to Bradford with two Cameo cameras and twenty-four secretly marked photographic plates for Elsie and Frances; he showed them how to operate the camera and asked them to supply more photographs of the fairies.

The Cottingley girls waited impatiently for clear weather to try out the cameras. It was not until 19 August 1920 that the weather was right. They insisted that the fairies would not be photographed if anyone else were watching. Elsie's mother obligingly went to her sister's for tea, leaving the girls alone in the house. When Mrs Wright returned, the girls had taken several exposures, but only two of them showed fairies:

Photo number three, *Frances and the Leaping Fairy*, showed a slightly blurred profile of Frances with a winged fairy suspended in mid-air just in front of her nose. Photo number four, *Fairy Offering Posy of Harebells to Elsie*, showed a fairy hovering, apparently in mid-air, or standing tiptoe on a branch, offering a flower to Elsie.

Two days later, they tried again. Mrs Wright reported to Edward Gardner:

> They went out again on Saturday afternoon and took several
> photos but there was only one with anything on and it's a queer

one, we can't make it out. Elsie put the plates in this time, and Arthur developed them next day.

This was photo number five, *Fairies and Their Sun-Bath*; it was very blurred and looked as if it could have been an accidental double exposure – or a deliberate one.[13]

The marked plates were packed in cotton wool and sent back to London. Edward Gardner was delighted to receive them and sent an ecstatic telegram to Conan Doyle, who was in Melbourne by that time. Conan Doyle wrote back:

> My heart was gladdened when out here in far Australia I had your note and the three wonderful pictures which are confirmatory of our published results. When our fairies are admitted, other psychic phenomena will find a more ready acceptance . . . We have had continued messages at seances for some time that a visible sign was coming through . . .

When Conan Doyle returned to England, he published the three new pictures in a second article in the *Strand Magazine* in March 1921. In it he advanced a detailed, if somewhat over-elaborate, view of that enigmatic photo number five:

> Seated on the upper left-hand edge with wing well displayed is an undraped fairy apparently considering whether it is time to get up. An earlier riser of more mature age is seen on the right possessing abundant hair and wonderful wings. Her slightly denser body can be glimpsed within her fairy dress.

That summer, Conan Doyle arranged for the clairvoyant and theosophist writer Geoffrey L. Hodson to go to Cottingley and sit with the girls, in the hope that even stronger shapes would materialise. In August 1921, Hodson reported seeing wood elves under some beech trees, as well as

dancing fairies in a field. He published his conclusions in a book, *Fairies at Work and Play*, in 1925. In it he stated:

> I am personally convinced of the bona fides of the two girls who took these photographs. I spent some weeks with them and their family, and became assured of the genuineness of their clairvoyance of the presence of fairies, exactly like those photographed, in the glen at Cottingley, and of the complete honesty of all parties concerned.

What happened to the two girls at the centre of the story? Frances Griffiths moved to Scarborough with her parents after the First World War; in 1928 she married a soldier named Sydney Way, and after several postings overseas, the couple settled in Ramsgate. Elsie Wright, who was always sketching and painting fairies and was described by neighbours as being 'a bit strange, perhaps a bit otherly', worked at several jobs, mainly with an artistic background, and eventually emigrated to the USA, where she met her husband, Frank Hill. They moved to India and lived there until 1949; they then settled back in England, in the Midlands, with their son and daughter.

Over the years, Elsie would always say that although the fairies were wonderful, she was trying to forget about them – she was fed up with talking about them.

But still the story refused to go away. In 1966, Peter Chambers of the *Daily Express* tracked down Elsie Wright Hill in the Midlands in order to update the story. Elsie told him that the fairies might have been 'figments of my imagination', but it was unclear whether this was an admission that she had indeed faked the photographs or that she believed she had somehow photographed her thoughts. In 1971, Elsie was persuaded to appear on the BBC1 television programme *Nationwide*, but she remained evasive: 'I've told you that they're photographs of figments of our imagination, and that's what I'm sticking to.'

In September 1976, Austin Mitchell interviewed the two cousins

(both of them grandmothers by that point) for Yorkshire Television. They had lost none of their pert self-confidence. 'A rational person doesn't see fairies,' Austin Mitchell pressed; the two women agreed blandly but stoutly denied that they had fabricated the photographs. Mitchell clearly believed that it had all been done by cardboard cut-outs; the studio was decorated with a row of fairy figures set against a background of greenery, which he flicked with a finger. QED, he was saying: they were 'simple cardboard cut-outs, done by our photographic department and mounted on wire frames. They discovered that you really need wire to make them stand up – paper figures droop, of course. That's how it could have been done.'

Then, in interviews for an article by Joe Cooper entitled 'Cottingley: At Last the Truth' in a publication named *The Unexplained* (No. 117, 1983), Elsie (who died in 1988) and Frances (who died in 1986) admitted that all the photographs had been faked – although both contended that they really had seen fairies at the bottom of the garden. They also admitted that they had 'played along' the clairvoyant Geoffrey Hodson, out of mischief.

The hoax had, apparently, been carried out very simply. Elsie had copied pictures of fairies from a very popular children's book called *Princess Mary's Gift Book* (1914) by Claude Arthur Shepperson.[14] With a sharp pair of scissors belonging to Frances' mother (who worked as a seamstress in Bradford) they had cut the figures out and secured them to a bank of earth with hatpins. Then they dropped the cut-out fairies into the beck and went indoors. It was as easy as that – as Elsie Wright's father had suspected right from the start.[15]

It surely wouldn't have taken the coldly logical Sherlock Holmes nearly so long to solve the problem. He would doubtless have deduced that for the true explanation of these fairy photographs, what was required was not a knowledge of photography, or an interest in the occult, but an understanding of children.

Chapter 1 Notes

1. William Boyd arrived on the literary scene with *A Good Man in Africa* (1981), which won the Whitbread First Novel Award and the Somerset Maugham Award. He has also written *An Ice-Cream War* (1982), *Stars and Bars* (1984), *School Ties* (1985), *The New Confessions* (1987), *Brazzaville Beach* (1990), *The Blue Afternoon* (1993), *Armadillo* (1998) and *Any Human Heart: The Intimate Journals of Logan Mountstuart* (2002). *Bamboo*, his latest book, was published in 2005.

2. Ellen Keating died in 2001.

3. This chapter relies heavily on the information detailed in *Van Meegeren: Master Forger* (New York, 1967) by the Irish peer and author Lord Kilbracken.

4. Van Meegeren tried to enlist in the army but was turned down because of his bad eyesight and poor physique.

5. P.B. Coremans, *Van Meegeren's Faked Vermeers and de Hooghs* (Amsterdam, 1949).

6. The castle has not been identified. Another story suggests that Bredius spotted the painting in the window of an art gallery in London.

7. Computing the relative value of an old commodity in modern terms is not an exact science. I have used the Retail Price Index (RPI) as a general guide; but the RPI computes the price of a general 'bundle' of goods and services which itself changes over time. Another measure is the national Gross Domestic Product (GDP), based on the economy's total output of goods and services in money terms, which would yield much higher figures. But that, too, has its variants: per capita GDP (the average share of a person in the total income of the economy) and the GDP deflator (an index of all prices in the economy). At least the values quoted in this chapter using the RPI are consistent with one another.

8. There is some confusion about the story of the unmasking of the *Christ and the Woman Taken in Adultery*. Another version suggests

that it was not found in April 1945 in the salt mine near Alt Aussee but some weeks later, among Göring's possessions at Berchtesgaden.

9. The other Vermeer was *Lady Writing a Letter with her Maid*, now in the National Gallery in Dublin.

10. In *Fake? The Art of Deception*, edited by Mark Jones (British Museum Publications, 1990).

11. Conan Doyle published his article on fairies – including the two photographs – in the Christmas issue of the *Strand Magazine* in December 1920 ('Fairies Photographed. An Epoch-Making Event'). It created a worldwide sensation, such was his towering literary reputation.

12. Arthur Wright died in 1926, still puzzled by the whole affair. He had always had a high opinion of Conan Doyle, but, afterwards, he found it hard to believe that so intelligent a man could be bamboozled 'by our Elsie, and her at the bottom of the class'.

13. Later, Elsie coloured some prints of the five photographs – colouring was a passion with her.

14. By an intriguing coincidence, Shepperson's book, which is a compilation of short stories and poems for children by various authors, includes a short story by Conan Doyle entitled 'Bimbashi Joyce'.

15. The 'fairy photographs' were sold at auction by Bonhams of Knightsbridge in March 2001. The archive of glass plates and other negatives fetched £6,000 – nearly twice as much as had been expected.

2

Archaeological Frauds

For a long time, archaeology was a trade seeking to become a profession, an art seeking to become a science. Like medicine, it developed its own mystique. Archaeologists dig up artefacts which they then interpret according to shifting contextual timescales; new scientific techniques are hailed as the definitive answer to subjective assessment, only to be doubted by other disgruntled practitioners. As Sir Mortimer Wheeler (1890–1976), that 'Grand Old Man' of British archaeology, once put it, 'Archaeology is neither an art nor a science – it's a vendetta.' It is ground ripe for misunderstanding and obfuscation. Dig up anything which looks old and preferably obscure, and people will believe anything said about it if the excavator has the appropriate aura of authority (and, sometimes, even if he or she doesn't). Critical consideration is blunted – even suspended altogether.

While I was travelling the world for the BBC2 television series *Chronicle* (1968–82) on world history and archaeology, the most intriguing stories I covered were fraud stories – like that of the Kensington Stone, in Wisconsin, USA. Around the turn of the first millennium, Norse seafarers and would-be settlers from Iceland and Greenland reached the

eastern coasts of North America – the first Europeans known to have explored the 'New World', approximately 500 years before Christopher Columbus. They called the country Vínland – the Land of Wine – and had come across hostile Native Americans, whom they called *Skrælings* (Wretches). The snag is that no one can be sure precisely *where* those early Norsemen went, and this has given rise to a huge and lucrative scholarly (and unscholarly) industry and an abundance of wishful thinking – fertile ground for fakes and forgeries of 'Viking relics'.

The largest, and perhaps the most preposterous, of these 'relics' is the Kensington Stone. It now sits on a ceremonial plinth, draped with cloth of white-fringed royal blue, in the entrance hall of the Alexandria Agricultural Museum in Douglas County, Minnesota. Above it hangs a map purporting to show the Norsemen's route to Minnesota via the St Lawrence River and the Great Lakes. Outside, in the nearby Runestone Park, stands a monstrous reproduction of the Kensington Stone weighing some 18,000 kg. In Main Street, the eye is gladdened by the sight of a mammoth concrete depiction of a Viking warrior (horned helmet and all) with a targe (shield) emblazoned with the words 'Alexandria – Birthplace of America'. In the site museum, questing pilgrims are welcomed by young women carefully programmed to deal with doubters and sceptics.

The Stone originally came to light in 1898. It had allegedly been found embedded in the roots of a poplar tree in a field near the village of Kensington in western Minnesota, the most Nordic state in the USA. The man who claimed to have found it was a Swedish immigrant farmer named Olof Ohman, who had been farming the land since 1890. It was dark grey in colour and shaped like a rough-hewn grave-slab, about 76 cm high, 40 cm wide and 13 cm thick; it weighed about 90 kg. On the upper half of the face and along one of the edges there was an exceptionally long and elaborate inscription in what looked like medieval runic lettering.[1] It turned out to be written in a bizarre mixture of modern Swedish, Norwegian, Danish and English, with an overlay of curiously inconsistent archaisms. Tidied up, an English translation might read something like this:

. . . eight Goths [Swedes] and twenty-two Northmen on a
journey of exploration westward from Vínland. Our camp was
by two skerries one day's journey home from this stone. We were
out fishing one day. When we came home, found ten men red
with blood and dead. AVM [Ave Maria?] save us from evil. Have
ten men by the sea to look after our ships, fourteen days' journey
from this island. 1362.

The runic inscription on the Stone was promptly and brusquely dismissed
by the leading Scandinavian scholars of the day as an inept forgery. In
1907, however, it was acquired by a Wisconsin writer, impresario and
self-styled 'runologist' named Hjalmar Rued Holand. For the next 50
years, Holand used all his formidable skills as a special pleader to argue
the case for the authenticity of the Kensington Stone. Eventually, by sheer
dogged perseverance, he managed to gain acceptance for it from many
not-undistinguished quarters, both lay and learned alike – including the
Smithsonian Institution of Washington, which put it on display in 1948
with the implied imprimatur of its own great authority.

At this point, the Swedish Academy of Sciences commissioned
Professor Sven B.F. Jansson, the doyen of runic scholars, to examine the
Stone at first hand and submit a report. Jansson's verdict was unequivocal:
the Kensington Stone had no significance whatever for runologists. In
1958, a young scholar named Erik Wahlgren, of Wisconsin University,
further pricked the bubble with a devastating exposé of the Holand
fable (*The Kensington Stone – A Mystery Solved*). He took Holand and
all his pretensions to scholarship apart and proved conclusively that the
Kensington Stone was a modern forgery.

So who had been responsible for the fake? Wahlgren took care not
to point an accusing finger at any particular individual, but he made
it pretty clear that the culprit was the finder, the farmer Olof Ohman.
Far from being the ignorant rustic suggested by Holand, Ohman had
been, in reality, a thoughtful, self-tutored man, with a deep interest
in mysticism and numerology. Among the books in his library was a

111

Swedish popular encyclopedia and Carl Rosander's *The Well-Informed Schoolmaster* (*Den Kunskapsrike Skolmastaren*, first issued in Stockholm in 1864). This book had been re-issued in several editions in Sweden and the USA, in particular the Chicago edition of 1893; Ohman's copy was particularly well-thumbed at the section dealing with the history of the Swedish language, from runes onward.

Olof Ohman was clearly the culprit. He answers the questions *who* and *how*. But what about the *why?* We have to remember that the year 1893 saw America in a fever of excitement over the Chicago World Fair ('The Columbian Exposition'), which had dramatically featured an epic voyage of a replica of the renowned Gokstad Ship from Norway to North America. The atmosphere was perfect for a forgery: the world was geared to thinking about the Norsemen in Vínland, and Scandinavian immigrants in particular were in the right mood to accept one. But try telling that to the good people (or the tourist authorities) of Douglas County, Minnesota.

The four stories in this section are all to do with this type of fraud, starting with Chapter 2.1 (The Missing Link: Piltdown Man). In the year 1908, a well-respected Sussex solicitor named Charles Dawson (1864–1916), who was also an enthusiastic amateur antiquarian, found some fragments of what appeared to be a fossilised human skull in a pile of rubble from a gravel pit at Piltdown, near Lewes in Sussex. This find heralded one of the most renowned frauds in the history of science: the alleged discovery of 'Piltdown Man', the 'Missing Link'. The find – including other pieces of bone which came to light nearby over the next few years – was to attract enormous public interest, because it came at a time when the whole scientific world was afire with theories about 'Early Man'. The discovery, in 1856, of the remains of primitive man at Neanderthal in Germany and the publication of Charles Darwin's theory of evolution by natural selection (*The Origin of Species*, 1859) had started the hunt for the Missing Link between apes and humans which Darwin had postulated. Some finds had been made in Europe and Asia

– 'Cro-Magnon Man' in France (1869), 'Java Man' (1890), 'Heidelberg Man' in Germany (1907) – but none in Britain. It was in this somewhat fevered atmosphere of scientific discovery and nationalistic speculation that Piltdown Man was formally announced in 1912. It created a sensation.

This 'ancient' fossil skull had, in reality, been fabricated from a human skull and the jaw of a modern chimpanzee. It took 40 years to expose it as a hoax and to start correcting the textbooks. No one yet knows for certain who the culprit was; but why did it take so long to acknowledge that a carefully planned fraud had been perpetrated on the scientific community and the public?

The second section (Chapter 2.2 – The Funny Business at Glozel) has the same undertones of nationalistic pride. It all started on 1 March 1924. A 17-year-old farm boy named Emile Fradin, from the tiny village of Glozel near Vichy in the foothills of the Auvergne mountains, was clearing an uncultivated field with his grandfather. According to their story (which varied over the years), one of their cows stumbled into a depression in the ground (or fell into a hole in the ground). While rescuing their cow from the hole, the Fradins found themselves in what they thought might be some sort of tomb. They dug out the 'tomb' and uncovered an oval paving of bricks with stones set around its edge and some lumps of vitrified glass.

For the next two years, Emile Fradin ensured a constant supply of 'finds' – an extraordinary hotchpotch of some 2,500 assorted fragments of pottery, fired but unglazed and incised with pictures or Phoenician letters, and tiny human figurines and bone artefacts, ranging from the palaeolithic to the neolithic to the Bronze Age and on to the ice ages. The discovery was enthusiastically welcomed in France as a sign of the importance of French culture in the prehistoric record, although archaeologists elsewhere denounced it as a crude fraud. The argument over the authenticity of the findings rumbles on to this day.

The third section (Chapter 2.3 – The Vínland Map: A Pious Phoney) is close to my heart and specialised interest – Viking history. It concerns

the so-called 'Vínland Map', which purported to be a pre-Columban chart of the Atlantic depicting the 'lost' Norse country of Vínland in North America. It was published with much pomp and scholarly authority by Yale University in 1965 as proof positive that the Icelandic saga accounts of an attempt by the Norsemen to establish a colony in North America, about 500 years before Columbus, were true. Several decades of academic argument (often very vicious argument, at that) about its authenticity ensued. It is only very recently that the truth has emerged: the Vínland Map is a forgery, fabricated on authentic medieval parchment some 70 years ago by an Austrian Jesuit priest named Joseph Fischer. What a great detective story it makes!

The fourth story (a tailpiece, really) comes from the USA (Chapter 2.4 – The Cardiff Giant of New York State). In 1869, a huge stone statue was excavated by a local farmer when he was digging a well near the hamlet of Cardiff, in the Onondaga Valley in the state of New York. It created a sensation. Bible fundamentalists claimed that it was a petrified giant proving the statement in Genesis that 'there were giants in the earth in those days'. The farmer made a fortune from eager visitors who paid to view the figure. The bubble burst soon enough; it was proved to be a crude statue manufactured in Iowa and deposited in the Cardiff earth by the farmer's brother-in-law. But while it lasted, it was a striking exemplar of wishful thinking (and wistful believing) being exploited by a bold entrepreneur who knew how to make money out of human gullibility.

2.1 – The Missing Link: Piltdown Man

Barkham Manor, a handsome old manorial house in an expanse of rolling farmland, stands near Piltdown Common in East Sussex, north of the county town of Lewes. A long poplar-lined drive leads towards the house and its attendant farm buildings. Where the avenue of poplars ends, 100 m or so from the manor house, a dense hedge takes over. In front of the hedge stands a stone monolith of carboniferous sandstone, about 2 m high, which was paid for by private subscription and unveiled at a small ceremony on 22 July 1938. The bland, carved inscription is barely discernible under its encrustation of lichen:

<div align="center">

HERE

IN THE OLD

RIVER GRAVEL

MR CHARLES

DAWSON FSA

FOUND THE

FOSSIL SKULL OF

PILTDOWN MAN

1912–1913

THE DISCOVERY WAS

DESCRIBED BY

MR CHARLES DAWSON

AND SIR ARTHUR SMITH

WOODWARD IN THE

QUARTERLY JOURNAL

OF THE GEOLOGICAL

SOCIETY 1913–1915

</div>

Just beside the stone pillar a brick-lined trench, now much overgrown, leads through the hedge to an area of grassland covering an old gravel pit which had been quarried to provide material for repairing the farm roads on the estate. It is all that remains of the site where a genial and well-respected Sussex solicitor named Charles Dawson, who was also an enthusiastic antiquarian and amateur palaeontologist of considerable standing and repute, found (so he claimed) fragments of what appeared to be an ancient, fossilised human skull with a chinless, ape-like jaw. This 'find', which was announced at a packed meeting of the Geological Society at London's Burlington House on 18 December 1912, was to herald one of the most renowned frauds in the history of science: the discovery of Piltdown Man, the Missing Link. The newspapers were ecstatic: 'First evidence of a new human type' (*The Times*); 'Palaeolithic skull is missing link – far older than cavemen' (*New York Times*); 'The earliest man? Remarkable discovery in Sussex. A skull millions of years old' (*Manchester Guardian*).

But why Piltdown? And why Barkham Manor?

Finders and keepers

Charles Dawson was born in Lancashire in July 1864, the eldest of three sons of barrister Hugh Dawson, who had inherited wealth from the cotton-spinning industry of Preston, Lancashire. The ill health of Charles's father forced the family to move to the more bracing air of Hastings, in Sussex. Here young Charles Dawson spent his childhood exploring cliffs and quarries in search of fossils. On leaving school (Gosport Royal Academy) at the age of 16, he immediately went into the legal profession; by 1890, he was working in a practice in Uckfield, in East Sussex. In 1900, he took over the practice, and in 1906, with George Hart as a fellow partner, he changed the name of the practice to Dawson Hart & Co., Solicitors.

In 1905, at the age of forty, Dawson married the London society widow Helene Postlethwaite in a stylish Mayfair wedding; Helene had two grown children. Soon after the wedding, the couple moved into the grandiose Castle Lodge, in Lewes.

Dawson was by now a kenspeckle figure in Uckfield civic affairs: clerk of this, secretary of that and trustee of the other. He also acted as steward to a number of large and prosperous local estates, such as the manors of Barkham, Netherall and Camois.

It was at Barkham that the Piltdown business began, according to Dawson, on a day in 1908 when he was presiding at a Court Baron of the manor. Before dinner that evening, he went for a stroll down a farm road in the grounds. He noticed some unusual iron-stained flints in the road surface and, upon making enquiries, learned that flint gravel was being routinely extracted by estate workers from a shallow pit near the 'Big House' for use on farm roads. Dawson talked to the workers and asked them to keep a look out for any fossils or bones and to put them aside for him.

Dawson subsequently made occasional visits to check the site. On one such visit, a worker named Venus Hargreaves handed him a small piece of fossilised bone he had found. It turned out to be part of a left parietal bone from a human skull. Dawson noticed that it was of immense thickness and at once made a further search but could find nothing more. Later, Dawson unearthed two further fragments – parts of the forehead and back skull – which he reckoned had been unwittingly shattered by a workman's pickaxe.

Some months later, in 1909, Dawson met a 30-year-old French palaeontologist named Pierre Teilhard de Chardin (1881–1955), who was an ordained priest assigned by his order in France to pursue further study at the Jesuit seminary near Hastings and was destined to become a world-renowned theologian and philosopher. Dawson told him the story of the enigmatic Piltdown finds, and through their mutual interest in fossils they became friends and made occasional visits to the site together. The Frenchman was to play an important part in subsequent events.

Three years later, in February 1912, Dawson wrote a letter about the first cranial fragments to another friend, the eminent palaeontologist Arthur Smith Woodward (1864–1944), who was keeper of the natural

history section of the British Museum. Dawson thought the fragments of human skull could rival the recently discovered Heidelberg Man and asked Smith Woodward to identify them. Smith Woodward was not an anatomical expert (his speciality was fossilised fish), but he was excited about the news of the finds which, if confirmed, would put Britain into the driving seat of human evolutionary studies.

Bad weather and pressure of work conspired to cause delays, and it was not until May of that year that Dawson brought his finds to the natural history section of the British Museum for examination by Smith Woodward. Smith Woodward was immensely impressed by the sight of the three separate fragments of thick cranium, which suggested to him the characteristics of both man and ape. A proper excavation of the site was urgently needed, in the hope of finding more skull fragments or even some skeletal remains.

In June 1912, Dawson and Smith Woodward mounted a carefully prepared assault on the Piltdown site. The young French palaeontologist, Teilhard de Chardin, was also drafted in. The head shoveller was the estate worker Venus Hargreaves. The plan was not only to dig the undisturbed soil but also to go through all the 'spoil heaps' which lay around the edges of the dig – the soil debris which had been left after the workmen had extracted the flints for road repair.

This systematic excavation was the turning point. On the very first day, Dawson spotted another small chunk of bone in one of the spoil-heaps. A few minutes later, Teilhard de Chardin found a broken tooth of a small stegodon dinosaur. For the next two weekends, Dawson and Smith Woodward toiled at the dig site by themselves (Teilhard de Chardin had returned to France to continue his religious studies). Hours and hours of close inspection turned up nothing except a few worked flints and some further fragments of ancient animal teeth.

And then, on the last Saturday in June – eureka! Right at the end of a long and sultry day, Dawson struck a hard blow at the untouched gravel at the bottom of the pit with his geological hammer 'and out flew a portion of a lower jaw'. This was the most remarkable (and

controversial) portion of the skull they were excavating. With renewed zeal, the digging team was now supplemented by Frank O. Barlow of the British Museum natural history department (he would later prepare plaster casts of the Piltdown skull) and Grafton Elliot Smith, professor of anatomy at Manchester University. Digging went on apace during August, but nothing came up to equal the discovery of the jawbone, although Dawson salvaged three separate skull fragments from the spoil-heaps. From these fragments Smith Woodward made a model of the reconstructed skull, with the conjectured parts in white plaster contrasting starkly with the dark brown of the original bone finds.

What was so startling about the finds was that the skull was recognisably human, without even the heavy brow-bones of the Neanderthal – but the jaw was distinctly ape-like. This model was the centrepiece of the presentation which Dawson and Smith Woodward made to a packed meeting of the Geological Society at Burlington House in London on 18 December 1912. Dawson and Smith Woodward acclaimed the skull as being that of Piltdown Man – an apparently primitive hominid some 500,000 years old, who was half-man, half-ape and constituted the long-lost Missing Link; Piltdown Man was also dubbed the 'First Englishman'. In honour of Charles Dawson, the British Museum officially named this hypothetical hominid *Eoanthropus dawsoni* (Dawson's Dawn Man).

In the lively audience discussion which followed the presentations, two issues predominated: the age of the specimens and the association between the jaw and cranium on the model. On the question of age, most of the speakers called for the decision to be postponed until such time as further data was forthcoming. As to the claim that the jaw and the cranium belonged to the same creature, this was even more controversial. There was another 'missing link' involved: the knob (articular condyle) at the top extremity of the jawbone – where it fits into the skull – which acts as the swivel point for opening and closing the jaw. In man and ape, these are quite different. If it had survived, there would be no problem about deciding whether cranium and jaw really matched; unfortunately,

it was missing. Did they really belong together? Or could this be a chance-in-a-million coincidence which had swept two fossils, one of a man and the other of an ape, into the same pit? This question would continue to be a source of fierce disagreement among the experts.

The Geological Society meeting ended with the announcement that further excavations were planned for the following summer, when it was hoped that other finds would eliminate any lingering doubts.

In the spring of 1913, the Piltdown excavations were resumed. Little was recovered, apart from several thin slivers of bone from Piltdown Man's nose. At the end of August, however, Teilhard de Chardin, on leave from France, made a crucial discovery in the gravel – a canine tooth from the Piltdown jaw. This only served to exacerbate the Piltdown discussions and various experts contradicted one another with increasing ferocity.

The following summer (1914), Smith Woodward unearthed a large bone tool (shaped like a small cricket bat) roughly fashioned from a part of the skeleton of some huge animal; it turned out to be from the femur of a prehistoric elephant larger than a mammoth. Had this enigmatic tool been made by Piltdown Man? Was it, as Smith Woodward claimed, 'the oldest undoubted work of man in bone'?

The outbreak of the First World War in August 1914 took the edge off the national fascination with Piltdown Man, but it did nothing to diminish its international interest. An American geologist, William Gregory, ventured to raise the hitherto-unmentioned possibility that deception and forgery might have been involved. In an article in *The American Museum Journal* in 1914, he wrote:

> It has been suspected by some that the bones are not old at all; that they might even represent a deliberate hoax, a Negro or Australian skull and an ape-jaw, artificially fossilized and 'planted' in the gravel-bed to fool the scientists.

Perish the thought! Gregory was quick to deny the canard: 'None of the

experts who have scrutinized the specimens and the gravel pit and its surroundings has doubted the genuineness of the discovery.'

And then, in February 1917, a new factor entered the equation which would tilt the balance dramatically in favour of the authenticity of Piltdown Man – news of the discovery of a *second* Piltdown Man skull by Charles Dawson.

Piltdown Man II

Charles Dawson died in August 1916 after an incapacitating illness of several months. He was buried in the churchyard of the Church of St John Sub Castro in Lewes. His funeral was a rather grand affair, attended by many colleagues and friends from Sussex and London. Among the mourners, not unexpectedly, was Arthur Smith Woodward of the British Museum.

What no one except Smith Woodward knew at the time was that Dawson had made another spectacular find several months before his death. Throughout 1914, despite failing health, Dawson had been gradually extending his searches outside the original Piltdown area. In January 1915, he reported to Smith Woodward that he had found a small piece of a forehead in a nearby field – 'a fragment of the left side of a frontal bone with a portion of an orbit and root of the nose . . . The forehead is quite angelic!' The new bone, he said, closely resembled Smith Woodward's original restoration. Some weeks later, Dawson reported that, in the same field, he had picked up a small section from the back of the skull. And, in July, he reported that he had come across a molar tooth. These three finds, in his opinion, belonged to at least one more individual of *Eoanthropus dawsoni*.

The problem was that Dawson had never said how, or where, he made these possibly sensational discoveries. Smith Woodward was left to surmise that Dawson had made them on the Sheffield Park Estate, about 10 km from the Piltdown estate.

Perhaps this fuzziness of information caused the delay in announcing the finds; it was not until a meeting of the Geological Society in

London on 28 February 1917 that Smith Woodward made his second, momentous presentation – the discovery of Piltdown Man II. This time the audience response was overwhelmingly positive: the Sheffield Park finds established the incontestable reality of Piltdown Man. American and (particularly) French palaeontologists who had been vociferously sceptical were disarmed and confessed that they had been converted. Dawson's posthumous victory seemed complete.

That was the end of the Piltdown discoveries – and also the highpoint of Piltdown Man's reputation. Soon, other spectacular finds claimed the limelight: the discovery of Rhodesian Man (1921), *Australopithecus* (1924), Peking Man (1929), *Ramapithecus* (1934) and the so-called 'Swanscombe Man' (now thought to have been a woman) near Dartford in Kent, in 1935.[2] In this emerging pattern of human evolution, Piltdown Man came to be seen more and more clearly as an anomaly, and became more and more marginalised. However, Arthur Smith Woodward, who had been knighted on his retirement in 1924, remained stubbornly convinced of the authenticity of Piltdown Man; for a dozen or more years after his retirement, he spent every spring and summer earnestly digging in the old gravel pit in the hope of finding additional bones or flints with which to confirm and expand the Piltdown profile. Only advancing age and ill health persuaded him to give up the search. In the summer of 1938, he had the gravel pit filled in and grassed over, and unveiled the memorial monolith at Barkham Manor. With his eyesight failing, he now dedicated the remaining years of his life (he died in 1944 at the age of 81) to writing a short book about Piltdown Man, which was posthumously published in 1948 under the title of *The Earliest Englishman*.

It so happened that Winston Churchill (1874–1965), having been rejected by the British electorate as Prime Minister in the General Election of 1945, was devoting his prodigious energies to writing history at about this time. His six-volume history *The Second World War* (1948–54) was well on the way; he was now planning his *History of the English-Speaking Peoples*, which would be published in 1956–58. He dashed off a draft

of the first chapter, entitled 'The First Englishman', based on Smith Woodward's work, and sent it to the most eminent archaeologist of the day, Mortimer Wheeler, for his comments. Wheeler counselled caution; he suspected that Piltdown Man did not have long to live. Churchill wisely accepted the advice and quietly ditched his draft first chapter.

Wheeler had been right to counsel caution. Woodward's posthumous book had revived interest in the Piltdown story and the Piltdown site. In 1951, the government's newly formed environmental agency, the Nature Conservancy, purchased the Piltdown site and designated it as a Geological Reserve and National Monument; the citation said that Piltdown was 'a major event in the unfolding of man's remote past'. A 'witness section' – a 10 m brick-lined trench with two sliding plate-glass panels – was dug in a portion of the gravel terrace within which most of the original Piltdown remains had been 'found' so that the public could see and even (under close supervision) touch the famous gravel. Piltdown immediately became a focal point for tourists and school outings. In 1952, the Nature Conservancy placed a conservation order on the site by designating it a Site of Special Scientific Interest (SSSI).[3]

The rumblings of scientific scepticism had never quite subsided, however. In 1925, the geologist F.H. Edmonds, a member of the Geological Survey, had published a paper pointing out that the Piltdown gravels were much younger than Dawson had assumed. In 1951, he returned to the attack with a paper claiming that there was no plausible geological source for the Piltdown animal fossils.

During the inter-war years, the specimens had been kept locked in a safe in the director's office in the Natural History Museum, where access to them was restricted; this was because the exhibits had been attacked by a suffragette who objected to the attribution of maleness to Piltdown 'Man' when the skull could have been that of a female. In 1949, however, Dr Kenneth Oakley (d.1981), a young geologist at the Natural History Museum, was allowed to take minute samples from the bones and subject them to a recently developed chemical test to ascertain their date. This was the fluorine absorption test, based on the

principle that when bones lie buried, they absorb fluorine from water in the ground; the amount absorbed is a good indication of how long they have been buried. It was hoped that this procedure would clarify whether the cranium and the jaw were of the same age.

Dr Oakley's tests apparently established that the two specimens were of the same age but that the fossils were much younger than had been supposed – only 50,000 years or so, not the half-million years which had been claimed. If the tests were accurate (and later tests were to show that they were not), it meant that, far from being the Missing Link, Piltdown Man was an aberration in the sequence of human evolution, an anachronism, an alien throwback. Nevertheless, Oakley did not suspect fraud; he surmised that 'Piltdown Man, far from being an early primitive type, may have been a late specialised hominid which evolved in comparative isolation'. It was making the best of a bad job.

The fraud exposed

On 30 July 1953, 38-year-old Joseph S. Weiner, professor of physical anthropology at Oxford University, was attending an international congress of palaeontologists in London on Early Man in Africa when the penny suddenly dropped. He noticed that Piltdown Man, the celebrated Missing Link of yore, was not discussed at all during the entire proceedings: Piltdown Man simply did not fit into the paradigm of human evolution as it was now perceived. If it was no longer relevant, reasoned Dr Weiner, Piltdown Man could only be a fraud.

Weiner was sitting next to Kenneth Oakley at the end-of-conference dinner and confided his suspicions to him; he was especially concerned about why the crucial site of Piltdown Man II had never been fully excavated. Oakley explained that Arthur Smith Woodward had not been able to identify the site precisely from Dawson's brief letters to him. To Weiner, this news was a bombshell: if the discovery of Piltdown Man II was so questionable, was the original Piltdown discovery at Barkham Manor any less so? And with that, all the old doubts about the linkage between cranium and jaw came to the fore again. In particular, Weiner's

concern focused on the modern-looking ape-jaw and its three teeth – teeth whose pattern of wear was distinctly human, not simian. Weiner was now convinced that fraud must have been involved:

> A modern ape-jaw with flat worn molars and a uniquely worn-down eye-tooth? That would mean only one thing: deliberately ground-down teeth. Immediately this summoned up a devastating corollary: the equally deliberate placing of the jaw in the pit.

Clearly, further investigation was required. To test his hypothesis, Weiner carried out an experiment to produce a fake tooth: he procured a modern chimpanzee molar from Oxford's anatomy laboratory and filed the biting surface flat. Then, using permanganate, he stained the surface of the tooth a dark soil colour. The result looked very similar to the molar from the Piltdown jaw.

Weiner now consulted his departmental head in Oxford, because this was clearly a profoundly sensitive subject which could well affect the reputations of several eminent scientists. His boss was immediately convinced of the fraud, and on 6 August 1953, he telephoned Kenneth Oakley to tell him that the Piltdown jaw was almost certainly a forgery and that Piltdown Man had never existed. Oakley was greatly taken aback but immediately agreed to examine the teeth microscopically for signs of artificial abrasion. Within an hour, Oakley phoned back to say that he had no doubt that the teeth had been artificially abraded.

A full investigation of the teeth was organised. Because they were now actively looking for evidence of forgery (for the first time, it must be said), they found it very quickly. Under a microscope the teeth were seen to be scarred by criss-cross scratches suggesting the use of an artificial abrasive. No one had noticed them before, simply because no one had thought of looking for them. The same applied to the molar of Piltdown Man II. Similarly, new chemical and organic tests proved that the Piltdown jaw and all the teeth were modern. The colouring turned out to have been applied by paint! It was also established that the three Piltdown Man II

finds had been part of the original skull found at Barkham Manor. So Piltdown Man II had never existed, either.

On 20 November 1953, Wiener and Oakley released the startling results of their investigations in an article entitled 'The Solution of the Piltdown Problem' in the *Bulletin of the British Museum (Natural History) Geology*: the jaw and teeth of Piltdown Man had all been forged. Next day it made huge headlines in the press: 'The biggest scientific hoax of the century' (London *Star*). The 'First Englishman' stood revealed as a deliberate and elaborate archaeological fabrication.

Further scrutiny only served to corroborate the exposure. It turned out that the bones had been gathered from a variety of sources and had been manipulated with considerable care to make them appear to be ancient; they had been treated with chromic acid to make them susceptible to staining by a solution containing iron, because fossil bones deposited in gravel pick up iron and manganese. The connection where the jawbone would meet the rest of the skull had been carefully broken so that there would be no evidence of lack of fit.

Dr Oakley now applied further, more advanced tests in order to find out where the bones had come from and how old they were. Far from being 50,000 years old, as had been suggested by Oakley's first tests, the skull fragments turned out to date from medieval times and were only about 620 years old. The controversial lower jaw, which had inspired the half-man, half-ape hypothesis, turned out to be the jawbone of a modern orang-utan, probably from Sarawak; it had been deliberately broken and stained brown with potassium bichromate to make it look old, but the colour was only on the surface. The animal remains which had been found in association with the alleged human remains were of widely scattered origins, and the various flint tools which had been found nearby were now seen to have been shaped with an iron knife. All the finds had clearly been 'salted' in the gravel pit to await 'accidental' discovery.

In June 1954, the investigations were completed. The detailed results were published in another special museum bulletin, entitled 'Further

Contributions to the Solution of the Piltdown Problem'. On 30 June 1954, at a regular meeting of the Geological Society at Burlington House in London (the same venue as had been used for the original announcement on 18 December 1912), the Piltdown site was declared a sham. Piltdown Man, now totally and irrevocably discredited, was finally laid to rest.

But why had the fraud succeeded for so long? How were so many eminent scientists deceived? It must be remembered that the analytical tools available in the early 1900s were very primitive compared with those of the 1950s. Moreover, the team of diggers which had found the specimens all had excellent credentials, so the finds carried the imprimatur of 'authority'. In reality, however, none of the 'experts' was particularly competent in dealing with hominid fossils; their expertise lay elsewhere, and the British Museum people made numerous errors of interpretation and reconstruction. The palaeontological community itself was in no position to doubt the so-called hominid bones; the chemical tests and dating techniques taken for granted today were not available to them. Above all, the finds matched the expectations and theories of the time – and they were British.

One of the common factors in successful frauds is that the finds are allowed to emerge apparently at random, piece by piece, rather than all at once. The timetable of events in the Piltdown scam followed this classic pattern. Also, the history of hoaxes has shown that people are prepared to be deceived, and to deceive themselves, if the deception happens to suit their own hopes or ideas. No matter how intelligent or well-educated people are, they tend to believe what they want to believe, for personal, professional or even patriotic reasons. In that frame of mind, they are willing victims for the forger. And collectors with a greed for owning 'discoveries' provide a market for the forgers when the demand outstrips the supply of genuine finds. One thing is common to all successful forgeries: they only happen when there is a ready-made market and a public appetite for new discovery.

* * *

Apart from the memorial monolith in the grounds of Barkham Manor, there is little to be seen at Piltdown today to recall its infamous past. There is a pub called The Piltdown Man, its sign featuring a skull with a roguish glass eye. The pub was originally named The Lamb but was given its new name to cash in on the notoriety engendered by the alleged discovery of Piltdown Man. Its walls are lined with framed photographs of the excavations almost a century ago. One of its owners, Robert Millward, told me that the pub still received a steady stream of visitors from many different parts of the world, all agog to hear more about 'Piltdown Man'.

By an extraordinary coincidence, on the day I visited the pub one of the patrons enjoying lunch with some friends was a 91-year-old retired solicitor named Ted Sainsbury, the one-time senior partner of Dawson Hart & Co., Solicitors, in nearby Uckfield – the very firm which Charles Dawson had named after himself and a partner in 1900. Mr Sainsbury told me that his old firm had on display a plaster-cast replica of the infamous skull and encouraged me to go to see it; Geoffrey Denton, the present senior partner, had obtained it from the British Museum in 1969. His argument was that since the skull was a fake, could he please have it back? The British Museum, which is not renowned for its readiness to return any objects, was horrified at the thought. The compromise was the gift of a plaster cast, and Mr Denton went to London to collect it.

In the waiting room of Dawson Hart & Co., at 9 Church Street, Uckfield, there stands a small, discreetly curtained glass case (the curtains are there to veil the contents of the case, 'lest it disturb clients of a nervous disposition'). Inside is the piebald plaster cast of the reconstructed skull of Piltdown Man (white for the discovered bits, black for the hypothetical bits). A framed handwritten legend, composed by Mr Denton, tells the story in suitably circumspect words:

> This is a replica of the 'Piltdown' skull which was discovered by
> the late Mr Dawson, the founder of this firm. The original skull
> was for many years kept in the offices of Dawson Hart & Co. but

is now in the British Museum. This plaster cast was presented to this firm by the Trustees of the British Museum on Tuesday 18th November, 1969, through the kind offices of Dr K.R. Oakley, who devoted a considerable number of years of research into the authenticity of the skull as a result of which the 'Piltdown Man' has died a second death. The replica is placed here in admiration of the ingenuity of its creator and the patience of its detector.

Whodunit?

One mystery still lingered: who perpetrated the hoax? Naturally enough, suspicion immediately fell upon Charles Dawson. Within days of making his experimental false tooth in August 1953 and passing the news of his conclusions to Kenneth Oakley, Joe Weiner made the first of several visits to the Lewes area to interview residents about Charles Dawson. The picture which emerged took him by surprise: far from finding fond memories of a genial, popular and kind-hearted solicitor, he was told by several leading lights of the Sussex Archaeological Society that Dawson had, in fact, been ostracised because of his underhand dealings with the organisation (Dawson had bought Castle Lodge, their headquarters, for his private marital home and had evicted the society) and that several people had openly voiced suspicions about the authenticity of the Piltdown material from the outset. These local critics darkly mentioned other 'discoveries' by Dawson – a 'Roman figurine' found near Hastings, for instance, and a 'rare moth' found near Piltdown Pond. Weiner came to the conclusion that Dawson had been implicated for 30 years or more in a number of ingenious archaeological, geological and anthropological deceptions in order to boost his reputation as an antiquarian of note.

When news of the exposure of the fraud made headlines at the end of November 1953, *The Times* had also speculated on the identity of the culprit. As guardedly as possible, it suggested that the mastermind of the fraud could hardly be anyone but Charles Dawson. Surviving members of the Dawson family threatened legal action, and the speculation came to an abrupt end.

129

Once Weiner had completed his investigation of Dawson, he wrote a book about the whole business: *The Piltdown Forgery* (1955). Perhaps influenced by the threats of legal action, Weiner held back on the identity of the perpetrator and contented himself with damning through implication:

> We have seen how strangely difficult it is to dissociate Charles Dawson from the suspicious episodes of the Piltdown history. We have tried to provide exculpatory interpretations of his entanglement in these events. What emerges, however, is that it is not possible to maintain that Dawson could not have been the actual perpetrator; he had the ability, the experience and, whatever we surmise may have been the motive, he was at all material times in a position to pursue the deception throughout its various phases.

It was practically Weiner's last word on the subject. He died in 1982, having published only one further article (in 1979) on the fraud – or the fraudster – he had done so much to expose.

Dawson must be the prime suspect, as the person with the most access to the site right from the beginning. However, over the years, there has been endless speculation about the possibility of a third party, perhaps as the perpetrator or perhaps as Dawson's accomplice, and a long list of suspects has accumulated, including people closely associated with the affair, such as Sir Arthur Smith Woodward.

But two names have been bandied about with particular zest. One is the young French palaeontologist and theologian Pierre Teilhard de Chardin, who had worked on the dig with Dawson on several occasions and been on close terms with him; the other, more surprisingly, is Sir Arthur Conan Doyle.

Teilhard de Chardin, as a member of the excavating team, was an obvious suspect as an accomplice, at least, to the fraud. Some eminent anthropologists, such as Louis Leakey (1903–72) of Olduvai Gorge

(East Africa) fame, were convinced that Teilhard de Chardin had played a very considerable part indeed in the Piltdown forgery. Yet it is hard for a layman to believe that a man of God, who would achieve world fame both as an anthropologist and a theological transcendental philosopher, could have been associated with such skulduggery. But, in 1980, he was formally 'charged' with complicity by a highly respected Harvard anthropologist named Stephen Jay Gould, professor of the history of science, in an article entitled 'The Piltdown Conspiracy' published in the magazine *Natural History* (an official publication of New York's American Museum of Natural History).

Teilhard de Chardin had left England in mid-July 1912 to continue his training as a Jesuit in France, so he was not present at the Piltdown pit for the remainder of the excavations. He was abroad when Dawson announced his finds in November 1912 and (although he returned to England briefly in the summer of 1913 and found the hominid canine tooth which seemed to confirm the authenticity of Dawson's Dawn Man) he took no further part in the excavations. Indeed, apart from a short article in 1920, he maintained a studious silence about the whole business throughout the decades of controversy, right up to the exposure of the fraud in 1953. Surely the man who led the expedition which discovered Peking Man in 1929 and was recognised as one of the world's leading palaeontologists should have had something to say about Piltdown Man? Was his silence a deliberate evasion? A sign of guilt? Or was there some other reason why Teilhard de Chardin wanted to distance himself from Dawson and the alleged discovery of the Missing Link which had made world headlines in 1912?

After the exposure of the fraud in 1953, Kenneth Oakley wrote to Teilhard de Chardin asking for his recollections of the excavations. The priest, who was by then living in the USA and working at the Wenner-Gren Foundation for Anthropological Research in New York, replied with a letter which contained some intriguing inconsistencies in the chronological sequence of the discoveries at Piltdown. Stephen Jay Gould pounced on these inconsistencies to mount his assault on Teilhard de

Chardin's innocence; the Harvard academic reckoned that the Piltdown fraud was an elaborate practical joke which simply got out of hand.

However, this view was refuted by John Evangelist Walsh in his 1996 book *Unravelling Piltdown: The Science Fraud of the Century and Its Solution.* Walsh focused on another sentence in Teilhard de Chardin's letter:

> When we were in the field I never noticed anything suspicious in [Dawson's] behaviour. The only thing that puzzled me, one day, was when I saw him picking up two large fragments of the skull out of a sort of rubble in a corner of the pit (these fragments had probably been rejected by the workmen the year before) . . .

This, according to Walsh, was the germ of a dawning and profoundly uncomfortable suspicion that Teilhard de Chardin's friend Dawson had, in fact, been dishonest and had salted the diggings himself. His silence over the years had not been due to any feelings of remorse or guilt about his own part in the excavations but to his unwillingness to point an accusatory finger at Dawson.

But what of Sir Arthur Conan Doyle, of all people, as the perpetrator of the hoax? It is a speculation which could well have intrigued the great Sherlock Holmes himself, involving interesting coincidences and 'circumstantial evidence' – but no more. The theory was first expounded in 1983 in an article entitled 'The Perpetrator at Piltdown' by American academic John Winslow and published in *Science 83*, the official journal of the American Association for the Advancement of Science:

> There was another interested figure who haunted the Piltdown site during the excavation, a doctor who knew human anatomy and chemistry, someone interested in geology and archaeology, and an avid collector of fossils. He was a man who loved hoaxes, adventure, danger; a writer gifted at manipulating complex plots; and, perhaps most important of all, one who bore a grudge against the British science establishment – Sir Arthur Conan Doyle.

The charge was indignantly rejected by, among others, Conan Doyle's only surviving child, Dame Jean Conan Doyle (1912–97), who objected that the unscrupulous Winslow had taken a noble-hearted man revered by readers the world over and turned him into a trickster.

The theory was given another airing, however, at the Linnean Society of London in 1997 by Richard Milner (a Darwinian scholar attached to the anthropology department of the American Museum of Natural History). But how strong is the accusation? As Sherlock Holmes said in *The Boscombe Valley Mystery*:

> Circumstantial evidence is a very tricky thing. It may seem to point very straight to one thing, but if you shift your own point of view a little, you may find it pointing in an equally uncompromising manner to something entirely different.

The theory seems to be based on little more than the fact that Conan Doyle was one of Dawson's neighbours; in 1907, he had moved into Windlesham House in Crowborough in Sussex, 12 km from Barkham Manor where Dawson was just starting his Piltdown digs. Conan Doyle had for a long time been deeply interested in fossils and archaeology; he certainly visited the site, possibly more than once, and Dawson boasted to a friend that the great man 'seemed excited about the skull. He has kindly offered to drive me in his motor anywhere.' In the autumn of 1911, Conan Doyle invited Dawson to Windlesham; on this occasion, he told Dawson the plot of his new sci-fi adventure entitled *The Lost World*, which he had just completed – 'A sort of Jules Verne book', as Dawson described it. In April 1912, only eight months before Dawson announced to the Geological Society his discovery of the fossilised remains of Piltdown Man, Conan Doyle started serialising *The Lost World* in *Strand Magazine*.

The Lost World was the first of Conan Doyle's stories to feature the irascible zoologist and explorer Professor George Edward Challenger, who leads an expedition to South America to an almost inaccessible

plateau where prehistoric creatures survive from the Jurassic period. The narrator is a naive young reporter on the *Daily Gazette*, Edward D. Malone. In the eyes of his news editor, Challenger is nothing but a fraud, the reincarnation of the celebrated fourteenth-century literary fraudster Sir John Mandeville (the author of a book of fabricated travels to exotic places). Challenger claims to find bones, which the news editor pooh-poohs:

> First one out an Irish stew. Second one vamped up for the occasion. If you are clever enough and know your business, you can fake a bone as easily as you can fake a photograph.

Indeed, Conan Doyle obligingly faked a photograph of Professor Challenger for the book: it was a picture of himself wearing a false beard and eyebrows, and signed, 'Yours truly (to use the conventional lie), George Challenger.'

Conan Doyle was a known prankster. But why this particular 'prank', if he was indeed the culprit? What could have been his motive? The theory goes that he had a grudge against the scientific establishment which mocked his passionate belief in spiritualism; he had, it is claimed, been embittered by the exposure and prosecution in London in 1876 of the famous American spirit-medium Henry Slade (1835–1905) by Ray Lankaster, director of natural history at the British Museum and author of *Extinct Animals* (1906). Perhaps Conan Doyle wanted to discredit the scientific establishment by faking evidence of something they wanted to believe in, thereby showing that scientists knew less than they claimed.

The only problem with that enticing scenario is that, at the time of Piltdown Man, Conan Doyle and Lankaster had become firm friends, and Conan Doyle quoted Lankaster admiringly in *The Lost World*. Furthermore, Conan Doyle did not become a crusading advocate of spiritualism until the year 1916, as a result of the carnage of the First World War. Even more to the point, the hoaxer must have made more than 15 clandestine visits to the site in order to salt it with bogus

specimens of carefully prepared bone, animal teeth and flints; given Conan Doyle's packed schedule of travel, writing and defending noble causes during those years, he simply could not have fitted it all in.

Suspicion has also fallen upon a group of inveterate Cambridge University hoaxers whose ringleader was the wealthy young man-about-town William Horace de Vere Cole, the greatest practical joker of his age. His most spectacular stunt, in April 1910, was to con the Admiralty into receiving a group of Abyssinian princes (accompanied by a high-ranking Foreign Office official and a German interpreter) on a ceremonial visit on board HMS *Dreadnought*, the Royal Navy's mightiest battleship, at Weymouth. Needless to say, the Foreign Office official ('Horace Cholmondeley') was de Vere Cole himself; and the 'Abyssinian princes' who trod the decks in flowing robes, uttering admiring cries of 'Bunga-bunga' at everything they saw, were drawn from de Vere Cole's circle of kindred spirits. One of them, disguised as a slender young prince, was the novelist Virginia Woolf; the 'interpreter' was her brother, Adrian Stephen. Could de Vere Cole have masterminded such a complex and deep-laid hoax as Piltdown Man?

If Piltdown Man had been a practical joke, my money would be on de Vere Cole, but that is surely a frivolous speculation. The accumulation of evidence, such as it is, points pretty squarely at none other than Charles Dawson himself. In his 1996 book, *Unravelling Piltdown*, John Evangelist Walsh concludes with a detailed and damning indictment of Charles Dawson as the fraudster. He assembles all the evidence – of personality, times, dates, opportunity, obfuscation and motive – and makes a compelling case for Dawson's deep-laid manipulation of the Piltdown 'evidence', which had been planted for himself or others to 'discover'.

More recently, Dr John Miles (senior lecturer at Bournemouth University) has published a detailed examination of all the major antiquarian finds associated with Charles Dawson *before* the Piltdown finds: *Piltdown Man: The Secret Life of Charles Dawson and the World's Greatest Archaeological Hoax* (Tempus, 2003). This is the first time that

a proper critical analysis has been made of each of Dawson's early finds: the assortment of neolithic axes, dinosaurs and sea serpents, Roman statuettes and bricks, post-medieval maps and clocks, horseshoes, dog-grates, and so on. He has come to the conclusion that at least 33 of them were clearly fakes, while many others were possible fakes with a direct association with Dawson. He traces Dawson's first fraud to 1891, when he 'doctored' a plagiaulacoid tooth by filing down the crown and creating a wholly new species – 'the first of many "missing links" or transitional forms that were to play such a prominent part of his antiquarian career'. Sir Arthur Smith Woodward accepted this 'evidence' uncritically and named the new creature *Plagiaulax dawsoni* in honour of its finder – shades of things to come, indeed.

In every case, Dr Miles concludes that Dawson was working alone, without accomplices; even his devoted wife Helene knew nothing about his extramural activities.

Dr Miles's book could well be the last word on one of the most ambitious and infamous forgeries in the history of archaeology. But I doubt it. Piltdown Man is the most enduringly fascinating of fakes and forgeries.

2.2 – The Funny Business at Glozel

'When a fact appears opposed to a long train of deduction, it
invariably proves to be capable of some other interpretation.'

Sherlock Holmes, in *A Study in Scarlet* (Arthur Conan Doyle, 1887)

It has a timeless air of antiquated French rural charm, this place. It is
called Glozel, a tiny hamlet – barely a hamlet, even, only a 'locality' –
not far from Vichy, nestling in a sheltered hollow in a patchwork of fields
and woodlands in the foothills of the Auvergne mountains. Little has
changed, one feels, for years and years; and yet, more than 80 years ago,
it was the setting for the discovery of an astonishing number of buried
antiquities covering a period of some 4,000 years. 'Glozel' became a
spectacular enigma in the archaeological world, which has not yet been
entirely resolved to everyone's satisfaction.[4]

In 1924, Emile Fradin was just an ordinary 17-year-old farm boy.
More than 80 years on, in 2006, he is celebrated as 'le personnage de
Glozel', a robust 99 year old still basking in the notoriety he achieved
when he and his father and grandfather were ploughing a steeply sloping
field known as the Duranthon field. The story goes that one of the beasts
pulling the plough put a foot through a hole in the ground. When they
freed the animal's foot, they discovered a subterranean cavity with walls
of clay bricks and a floor consisting of 16 clay tiles. They explored the
cavity and found a few bones (including a human skull) and some crude
ceramic vases and pottery fragments.

The field, which is now known as the *Champ des Morts* (Field of the
Dead), lies some 500 m north of the Glozel farmstead but is not easy
for the casual visitor to find. There are plenty of signs, marked 'Champ
des Morts', stencilled or painted on pieces of an old enamelled kitchen
cooker, but getting there is, nonetheless, a bit of an obstacle course.
Time has obscured the signs in lush foliage; the narrow path which leads
to the site is hemmed in by trees and electrified fences and punctuated

with homemade gates fashioned from old bedsteads. Near the end of the trek the path plunges steeply towards the famous field; it is a 'D'-shaped clearing and slopes sharply down to the tree-lined bank of the meandering River Vareille. It is slightly under a hectare in area.

When one arrives, the field looks ordinary enough. It is an attractive space with ankle-deep grass, carpeted with wild flowers: serenely pastoral and tranquil. There are no display panels or interpretive literature, only an official-looking sign which proclaims:

SÉCRÉTARIAT D'ÉTAT À LA CULTURE.
Service des Fouilles [archaeological excavations] et Antiquités.
Direction Régionale des Antiquités Préhistoriques d'Auvergne.

In the field itself can be seen two oval-shaped hollows (described on the Glozel website as 'tombs'[5]): overgrown shallow pits outlined with small rough boulders. These are presumably the remains of two of the early excavations.

Back at Glozel, Emile Fradin is waiting at the door of his farmhouse, still looking every inch the farmer. Beside him is the entrance to the tiny museum which was set up to display the finds. A notice declares 'Musée de Glozel. Entrée 3 Euros'. Emile Fradin points to it meaningfully. Inside, he seats himself behind a table with a proprietorial air. In reply to questions about the story he indicates a copy of his book *Glozel et ma vie* (1990) and extols it enthusiastically. The least one can do is to purchase a copy at 22 Euros. He is happy to pose for a photograph outside the Museum.

The Musée de Glozel is a private museum. It is housed in what used to be the front room of the farmhouse. It is a relatively small room, measuring about twelve paces by seven. There is a visitors' book ('Livre d'Or') which was begun in 1996. Some 40 pages have been filled; they mention numerous school visits and 'lots' of visitors during the summer months, but no records are kept. What visitors come to see is the extraordinary collection of 2,500 artefacts which the shallow soil

of the Champ des Morts yielded in such astonishing profusion in the 1920s, arrayed on red cloth in crowded, old-fashioned wooden display cases and wall cabinets, identified by small typed labels. Here are the fading remains of the story which set the pre-war archaeological world in Europe at loggerheads. But how did it all come about?

The story starts

The finds which young Emile Fradin started unearthing in 1924 seemed unremarkable at first, and that might well have been the end of the story, except that Emile and his grandfather Claude reported the experience to the village schoolteacher, Adrienne Picandet. Mlle Picandet paid a visit to the site and did a little more digging there with Emile Fradin. Their efforts revealed a paved floor, some fragments of glass and, curiously enough, a genuine neolithic polished stone axe-head. In accordance with official guidelines, Mlle Picandet wrote a report about the site, with the comment that she thought it was the remains of a cremated urn-burial – a tomb, in effect. The Société d'Emulation du Bourbonnais heard of Mlle Picandet's report and deputed Benoit Clément, a local member and schoolteacher in La Guilleymie, to undertake a preliminary examination of the site.

M. Clément was a young man with an enthusiastic interest in archaeology and prehistory. He visited the site on 9 July 1924 and fell in with the burial hypothesis without hesitation. He returned on 18 July and broke up the remains of the walls around the tombs with a pickaxe. Two weeks later, Fradin received a letter saying that the objects were simply Gallo–Roman, like many of the old objects found in the area, which was known to have been a site for medieval glass-kilns.

It was, seemingly, this report which triggered the mysterious events which ensued. The report, by endorsing the tomb theory, suggested that the site could well yield discoveries of not only considerable importance but also considerable financial value.

Over the next three years, the field would be renamed the Champ des Morts as young Emile Fradin unearthed an extraordinary assemblage of

artefacts from different periods – some 2,500 finds which are now on display in the little museum on the Fradin farm. The artefacts included masses of assorted fired but unglazed clay vessels, pottery incised with pictures of reindeer and panthers (both extinct in France since the ice age), urns with faces, clay tablets inscribed with characters vaguely resembling the Phoenician alphabet, tiny human figurines, little bone artefacts of animal figures, dozens of bricks or clay tablets covered with letters from some unrecognised ancient alphabet, and even two 'graves' filled with coarsely made pots and pieces of human bone. Apart from the sheer quantity of the finds, what was astonishing was the apparent range of the material. Some of it seemed to be palaeolithic in origin, dating from the emergence of primitive humans down to the end of the last ice age (10,000 BC) and reminiscent of early hunter-gatherer cave art. There were artefacts which looked like neolithic polished stone axes (the start of settled farming after the ice age, *c.*8,000–3,500 BC). The pottery could not date from the ice age (pottery did not develop in the West for several millennia thereafter) and looked vaguely Bronze Age in provenance (3,500–500 BC); moreover, many items were completely intact, which is most unusual for pottery recovered from archaeological sites.

However, the most intriguing feature of the Glozel assemblage consisted of the dozens of inscribed bricks or tablets, many of them covered with whole texts. They looked a little like the baked clay tablets found in the early civilisations of Mesopotamia, where writing first made its appearance around 3,500 BC. The signs on the Glozel tablets were thought to be related to Phoenician writing – but they have resisted all attempts at translation.

The first 'patron'

Fradin's first 'patron' in his archaeological career was the enthusiastic schoolteacher Benoit Clément, who had been deputed by the Société d'Emulation du Bourbonnais to inspect the site in July 1924. The schoolmaster was very taken with the young and relatively unschooled

Emile Fradin, who was resentful of the hard labour of farm work. However, Clément found him to be intelligent and an attentive pupil, with a flair for drawing. He started feeding Fradin's interest in the past by showing him his own small collection of antiquities and lending him various books on prehistory and archaeology.

One of the objects from his collection he showed to young Fradin was a lump of schist (quite common in the district) which was a by-product of the manufacture of bracelets in the Bronze or early Iron Age. This particular lump, which may have been carried as an amulet, had been engraved at some period unknown with a sign like an arrow and the letters 'S T X'. The collection also contained a diorite axe inscribed with what Clément believed to be a cross and the Greek letter lambda.

Not long afterwards, on 13 October 1924, M. Clément sent a letter to the President of the Société d'Emulation reporting that Fradin had just forwarded to him a schist pebble with three engraved signs, which looked very like the letters 'S T X'; it had been found near 'the grave'.

Two months later, Fradin 'timidly' offered Clément 'a piece of rough polished axe of black schist'. M. Clément sent it to the Société on 31 December 1924, with a request for a grant of 50 francs to fund further excavations. The Société, however, demurred; the finds were not interesting enough. Immediately there appeared 'further remarkable objects' which were announced to the Société by Clément on 30 January 1925; it seemed that 'upon further examination', one of the original bricks of the paving of the floor of the cavity had been found to be incised with inscriptions vaguely reminiscent of scratches engraved on megaliths. The Société d'Emulation smelled a rat and denounced it as a forgery. It was the first time that the word 'forgery' had been mentioned in connection with the Glozel findings.

Enter Dr Morlet

In April 1925, a new protagonist appeared on the Glozel scene: Dr Antonin Morlet. A doctor with a small country practice, he had recently come to live in Vichy, where he specialised in thermal and hydropathic

cures in the spa town. He also had a side interest in archaeology. He had apparently just excavated in his own garden some sort of tomb with large tiles and a well-preserved skeleton, and a quantity of fine glass vases. He had also done some excavating on a Gallo–Roman site.

Dr Morlet had heard of the excavations at Glozel and of the refusal of a grant by the Société d'Emulation. He asked M. Clément to show him the finds and was introduced to Emile Fradin. Dr Morlet was bowled over: he declared that here was 'a discovery which would attract to Glozel the savants of the whole world, more compelling than was even the Java skull'. He said that a wire fence should be erected round the field and a charge made for admission. This was music to the ears of the Fradins, as it was a means of making money out of their field. Dr Morlet also made them a tempting offer: he promised to pay them a fee of 200 francs a year (instead of the 50 francs refused by the Société) and to pay Emile Fradin for any further finds he unearthed. In return, Dr Morlet would be given the sole rights to excavate and publish the site, while the Fradins retained control over the objects.

It is a cardinal rule in archaeology never to hold out the prospect of money in return for making finds – it only encourages the production of material 'made to order'. Two days later, Dr Morlet was handed a pot base made of badly puddled clay and inadequately fired. It was the birth of Glozelian pottery.

Dr Morlet at once ruthlessly sidelined M. Clément and ensured that he had no further access to the excavations. He jealously prevented the site from being properly tested and examined by any prehistorians who might prove 'off-message' or might attempt to steal his thunder. And he personally undertook all the excavations at Glozel, always in the company of Emile Fradin, who was allowed to excavate on his own whenever Dr Morlet could not be present. At the same time, Dr Morlet passed on to his young colleague all the archaeological books he could lay his hands upon.

The floodgates were now open. For the next two years, the field yielded a constant supply of heterogeneous artefacts which were put on display in a makeshift little museum in the Fradins' farmhouse.

Meanwhile, Dr Morlet was hastening to cash in on his privileged position vis-à-vis Glozel. Faced with a bewildering array of artefacts, apparently spanning thousands of years, Dr Morlet focused on the neolithic period and the 'Phoenician' inscriptions and rushed into print in September 1925 with his first published account of the finds in a book entitled *Nouvelle station néolithique* (*A New Neolithic Site*). It was a clever choice: the early neolithic period (8,000 BC) – from the end of the last ice age, covering the start of settled farming and town dwelling in Europe – was poorly documented in the archaeological record. So meagre was the record for this period that archaeologists of the time gave it the title 'The Hiatus'. This was the chance for France to stake a claim to being the birthplace of the earliest neolithic culture; the tablets, inscribed with what could be the earliest writing in the world, represented a landmark which predated the process of civilisation in the Middle East. Dr Morlet, showing an unerring flair for attracting publicity, ignored the Société d'Emulation completely and assiduously wooed the French local media – and they loved him.

The French archaeological establishment was highly sceptical of the Glozel finds – at first. But one eminent (if eccentric) old scholar and archaeological authority named Salomon Reinach, who was the director of the Musée des Antiquités Nationales at Saint-Germain-en-Laye near Paris, became a convert. Reinach had a particular interest in reindeer in France in early times and was greatly taken by the reindeer depictions (and even bones) allegedly found at Glozel. He had doubted their authenticity at first, but on 24 August 1926 he was taken to Glozel and saw unearthed (providentially, as it seemed) before his very eyes by young Fradin a complete series of the 'best products of the locality'. The old scholar was overjoyed as he was shown, practically to order, everything he had said he wanted to see, including a fresh supply of reindeer material. Two days later, he announced to the Académie des Inscriptions that he could 'state without hesitation that all these objects are authentic, have not been tampered with and are from the same site', adding that the theory of some deliberate mystification 'is for the future

untenable'. On the evidence of the reindeer and the 'Phoenician' texts, he dated the objects to 4,000 BC and developed the hypothesis that it was Glozel and not the Orient which was the true birthplace of civilisation in neolithic times. France's honour was at stake and so was M. Salomon Reinach's professional reputation; from then on, he would not accept the finds as anything but genuine.

M. Salomon Reinach's dramatic conversion had an interesting domino effect within the French scientific and archaeological establishment. One by one, various eminent and not-so-eminent savants hastened to Glozel and pronounced themselves convinced of the authenticity of the finds. The Glozel site had apparently triumphed, and Glozel became a renowned tourist draw.

England suspects . . .

The Glozel finds attracted little attention in Britain until 27 September 1926, when Salomon Reinach published a startling letter in *The Times* about the strange objects found at Glozel. In it he claimed that the inscribed clay tablets and other finds showed that the palaeolithic period in France might have lasted until 5,000 BC.

One scholar in Britain who was intrigued by this claim was the archaeologist O.G.S. Crawford, founder and first editor of *Antiquity* in 1927. If these finds were genuine, and if they belonged to any of the various remote pre-Roman periods claimed for them, they would revolutionise current thinking about these periods. Forthwith, he set off for Vichy to investigate matters for himself. He met Emile Fradin and Dr Morlet and inspected the site and all the finds. Although he was never enamoured of France and French archaeology, he leant over backwards to be courteous to his French colleagues in the 'Notes & News' section of the first issue of *Antiquity* (March 1927) but came to the reluctant conclusion:

> It is always a thankless and unpleasant task to bring an accusation
> of forgery; but when such far-reaching conclusions are involved

it becomes a duty. We went to Glozel hoping for the best but prepared for the worst. We saw the site, the method of excavation and the objects found; and we were not favourably impressed. We do not say that none of the objects found are genuine; but when a site has been 'salted', it ceases to interest, though not to amuse, the serious student.

In the next issue of *Antiquity*, the editor presented a longer account of his visit to Glozel, under the title 'L'Affaire Glozel'. It was a devastating demolition of the Glozel claims. He analysed the finds and savaged the interpretations placed on them by Dr Morlet and Salomon Reinach; he castigated the shoddy, unscientific and unsupervised way in which patches of the field had been 'excavated'. His summary was forthright and uncompromising:

> I came to the conclusion that the majority of the objects were quite certainly forgeries. That being, in my opinion, so, it becomes unnecessary to waste time discussing the remainder, whose character was not so immediately apparent.

Crawford later elaborated on his claim that 'the majority of the objects' were forgeries. The only 'genuine' objects, in his opinion, were the bricks, crucibles, glass fragments and other debris from the glass kiln, together with a few minute flint chips: 'All except the last we say plainly are of quite a late date and irrelevant to the main issue. I never had the least doubt that the rest of the stuff was all of it forged.'

From then on, British archaeologists regarded Glozel as nothing more than a joke – which naturally infuriated Dr Morlet and the French media. But in France, too, a scepticism about the value of the site was simmering below the surface among those most closely in touch with prehistory and epigraphy. One by one, the heavyweights of the archaeological establishment came out with their considered views. In September 1927, M. Dussaud, an eminent epigraphist and academician,

demonstrated to the Académie française the spurious character of the inscriptions and of the whole site of Glozel. M. Vayson de Pradenne, the president of the Prehistoric Society of France, went to Glozel where he not only studied the 'finds' but was allowed to make two excavations at the site – one unsupervised, the other supervised by Dr Morlet. He found everything about the excavation and the artefacts deeply unsatisfactory. He published his findings in the *Bulletin de la Société Préhistorique* in September 1927; this report would form the basis of a much more detailed account of the funny business at Glozel in an article in *Antiquity* in 1930 (see below).

But it was not just the heavyweights who weighed in. Visiting archaeologists reported signs of suspicious disturbance in the shallow soil of the site and suggested that some of the bone and stone objects had been worked with modern metal tools. The curator of a museum in Villeneuve-sur-Lot, M. Vergne, asserted that when he was sheltering from a sudden storm in a stable at the Fradins' farm in September 1927, he had come across some half-finished 'Glozelian' artefacts and some inscribed (but as yet unbaked) clay tablets.

The Glozel Commission of 1927

The controversy escalated to such an extent that in September 1927 the International Institute of Anthropology, meeting in Amsterdam, appointed an international commission of seven distinguished archaeologists to investigate the Glozel site, do some excavations of their own and prepare a definitive, objective report. The commission included three Frenchmen, a Belgian, a Swiss, a Spaniard and a representative from England. The English member was a young archaeologist named Dorothy Garrod (1892–1968), then in her 30s and later to become the first woman professor of archaeology at Cambridge University, in 1939.[6]

It was a serious professional event which, nonetheless, had elements of the circus, or even comic opera, about it. The members of the commission met in Vichy early in November, where they were put up

in a sumptuous palace hotel as guests of the municipal council; Dorothy Garrod was uneasy about accepting such lavish hospitality, because the Vichy authorities were clearly expecting that confirmation of the Glozel finds would make the area an even greater tourist draw.

The plan was for the commission members to make daily sorties to Glozel to examine the finds and carry out excavations of their own; they would return to the hotel each evening to confer behind locked doors. This was an attempt to counter the attentions of the French press, whose eager representatives were following the work with undisguised patriotic fervour.

On that first day's visit to Glozel, they met the star of the show, Emile Fradin. The group decided to look at the museum only after examining the site, so that they could not be influenced by the objects. Then they changed into their blue overalls (the *combinaisons* which were virtually the uniform of French field archaeology). After that they went to the Field of the Dead. It was now scarred by the debris of various excavations which had been allowed by Salomon Reinach and Dr Morlet. They chose their own spots for investigation by randomly throwing stones in the field and electing to dig where they fell.

On their first day of digging, they found absolutely nothing. This was par for the course at Glozel – Dorothy Garrod noted that the hoaxers had not yet had time to furnish the holes with the necessary finds. Overnight, however, some pieces of bone with scratched incisions made their appearance in pockets of disturbed soil in the commission's excavations, along with a soft clay tablet or slab. Unsettled by the attentions of the journalists breathing down their necks from the edge of the excavation pits, the excavators resolved to work in total silence and show no reaction at all when they scrutinised whatever objects they found. This silence infuriated the French journalists, who were looking desperately for signs that the archaeologists were impressed by their finds.

The commission members had no doubt that there was skulduggery afoot – that the dig was being 'salted' overnight – and were determined to take precautions against any further nocturnal tampering. It was this

decision which led to the most dramatic and controversial moment of the whole affair.

The commission decided that before they left their site in the evening, and when the journalists had left, they would powder the face of the section with plaster, in the belief that any interference in the night would leave telltale traces. They poked holes in the plaster with a stick, making a complex pattern which Dorothy Garrod copied onto paper.

Early next morning, the commission headed for Glozel before the crowds arrived. As the youngest and nimblest of the members, Dorothy Garrod was deputed to run on ahead and see if the plaster had been disturbed. She was in the act of checking the pattern on the section wall when she heard a furious voice raised behind her. It was Dr Morlet, who was incandescent with rage. He harangued her with a series of angry allegations: 'You made these holes yourself! You are trying to salt this site and then suggest that it is I, Dr Morlet, who has tampered with it.' Dorothy Garrod tried in vain to explain what she had been doing, but Dr Morlet would not listen. The confrontation became a heated free-for-all. The members of the commission now began to take off their combinaisons and said that there was nothing left for them to do except to go back to Paris.

Calmer counsels prevailed, however. The commission members realised that to leave in a huff would be a mistake. The row was patched up, Dr Morlet agreed that there had been a misunderstanding, and he and Dorothy Garrod, somewhat reluctantly, posed for a photograph, shaking hands. It was agreed that the press would not be informed of the storm which had blown up.

The commission worked on for the rest of the day and then closed down their investigations for the last time. Huge pressure was put on them to make a pronouncement at this point, but they refused point-blank, trying hard not to give anything away by the expressions on their faces. With that, they went up to the farmhouse museum to look at the finds on display. Dorothy Garrod took up the story in her interview in *Antiquity* (1968):

I must say that a more improbable collection of objects one could not imagine. Extraordinary vases, and extraordinary tablets all made of half-baked clay and practically falling to bits, and extraordinary engravings on bone purporting to be upper palaeolithic. We looked at them all but said nothing. We returned to Vichy that night and made our final decision, namely that the whole of Glozel was a fake.

The commission issued its report on 24 December 1927. It was long and detailed – and ruthless: all the objects from Glozel were forgeries, apart from the polished axes, some hard-fired sherds from the upper excavation level, the glass-covered objects and the kiln. The report caused a great storm. Dr Morlet was particularly incensed and broke the agreement over the on-site row with Dorothy Garrod; on 27 December he published a vitriolic article in the *Echo de Paris* in which he accused Garrod of having used 'fraudulent manoeuvres', by making deep holes which would make people think they had been used to insert objects intended for discovery, to cast suspicion on the site. He even claimed that she had been caught in flagrante delicto and that, brought before witnesses, she had admitted the attempt at deception. It was all totally untrue, and a series of eminent archaeologists wrote to protest, but the calumny became part of the Glozelian 'armoury'. The acrimony lasted for a very long time: after Dorothy Garrod's death, the charge was repeated by Emile Fradin in his book *Glozel et ma vie*. It left an enduringly sour taste in the mouths of British archaeologists.

In court

The Société Préhistorique de France decided that the only thing to do was to have a police inquest at Glozel. This had to be kept very quiet so that no one, especially Emile Fradin, would know what was afoot. In February 1928, the police moved in and mounted a dawn raid on the Fradin family's farm. They searched the premises and seized more than 100 objects from the museum display cabinets and sent them to Paris

for forensic examination. The examination, by M. Bayle (director of the Service d'Identité Judiciaire), revealed that some of the pottery was soft and would disintegrate in water in a matter of hours, and therefore could not have survived in shallow soil on a rain-washed hillside for thousands of years. There were chlorophyll traces in some of the pots, which was considered quite impossible in ancient fired clay (indeed, the forensic report dated the Glozel pottery at no more than five years old). There were unexpected foreign bodies in much of the clay, such as mosses and bits of cotton. Moreover, the 'neolithic' objects had been shaped with a modern iron file.[7]

In June 1929, Emile Fradin was charged with fraud and interrogated by the examining magistrate for 63 hours. His mail was intercepted, and the police kept him under constant surveillance in the hope of catching him red-handed. However, when the case against Emile Fradin was eventually brought to court two years later, the charge was dismissed. The court ruled that there had certainly been fraud by a person or persons unknown, but Fradin was exonerated. Fradin had also been accused of charging entry money (four francs) without having an entertainment licence, but no conviction followed; the court ruled that Fradin had been entitled to claim compensation in the form of entry fees for the loss of time he had suffered at the hands of the thousands of visitors who had poured in to see the finds.

The Fradins now sued for criminal libel and won – but the damages they received amounted to one franc (the then equivalent of being awarded a farthing damages in Britain).

In 1930, as if to draw a line under the events at Glozel, M. Vayson de Pradenne published in *Antiquity* an article entitled 'The Glozel Forgeries' which contained a detailed analysis of the chronology of the finds and indicated not only the when but also the how and the why of the discoveries. He noted the unwitting role of the naive schoolmaster M. Clément, who showed Emile Fradin objects from his own collection – only for Fradin promptly to unearth copies of them. And when the

Société d'Emulation had rejected the next 'find' as a forgery, the finds dried up for a time. A year after the first finds in March 1924, not a lot had happened; M. Vayson de Pradenne commented:

> Such moderation at the outset was undoubtedly one of the factors which contributed largely to the success of the hoax. The forger was prudently and patiently sharpening his native peasant wit. Thus he made up for his ignorance and lack of technical skill; he was able to find out gradually how to act and how best to avoid suspicion.

In effect, the forger was learning from the people he was hoaxing; but the situation changed dramatically with the arrival of Dr Morlet. Suddenly, the field began to yield a veritable cornucopia of finds. Nor were these as random as they seemed. M. Vayson de Pradenne noted a distinct pattern to the course of events after Dr Morlet arrived on the scene. From M. Clément's letters and Dr Morlet's publications, it was clear that the different classes of objects appeared in succession, the technique of manufacture (particularly of the pottery) gradually improved and the forger's output corresponded closely to the documents provided by his sponsors, to the wishes they expressed and to the objections and criticisms of opponents and detractors. The forger was learning and reacting to the needs of the time.

With the publication of M. Vayson de Pradenne's devastating critique in *Antiquity*, the Glozel affair was to all intents and purposes over. The archaeological establishment was (almost entirely) anti-Glozelian, but a few diehards, led by Dr Morlet and Salomon Reinach, kept insisting on the significance and veracity of the finds. Dr Morlet (who died in 1965) kept on digging at Glozel for a few more years, and the locality continued to do well out of it. Emile Fradin opened a café, and the tourist trade boomed as never before; a local baker made a small fortune turning out *briques néolithiques* – in marzipan. In 1941, France passed the Carcopino Act on the conservation of archaeological heritage, which specified that

the subsoil belonged to the State and banned all unauthorised digging. This put an end to all further excavations at Glozel.

In April 1945, at the age of 36, Emile Fradin married a woman named Marie-Thérèse Côte. They had three children – Jacqueline (b.1946), Marie-Odile (b.1947) and Jean-Claude (b.1951). By the time they were born, the 'funny business' at Glozel no longer excited any curiosity and had passed into the realm of weird and wonderful crankery. For example, Glozel had been a secret underground chamber of esoteric knowledge collected by the Knights Templar; it had been the repository of an Israelite treasure hoard lost after the Exodus from Egypt; some of the pictures showed aliens from outer space; the 'Phoenician' alphabet represented the language of lost Atlantis; and so on. In 1959, Canon Léon Côte, Fradin's brother-in-law, published 'the first complete history of the whole affair', entitled *Glozel trente ans après*, followed by *Glozel, ou la guerre des briques* (1967); but the story was now apparently dead and buried. Meanwhile, the Fradin children played at being guides in the museum or made furtive illicit digs in the Champ des Morts. In his book, Emile Fradin claimed that daughter Jacqueline had unearthed a superb vase ('one of the most beautiful found at Glozel') when she was 15 years old; it is said to be on display in the museum.

And then, in 1974, came a bombshell which resurrected the whole question and created a new Glozel mystery.

The thermoluminescence bombshell

'Thermoluminescence', the dating method for ancient artefacts (often abbreviated to TL), is a hybrid neologism derived from the Greek for 'heat' and the Latin for 'light'. As the word suggests, this method has to do with light glow engendered by heat. Although it sounds rather complex, the principle is relatively simple. Paul Jordan explained it in his chapter on Glozel in the BBC book *Chronicle* (1978):

> Pots and fired pottery products of all kinds are made of clay, and
> most clays and soils contain very tiny quantities of radioactive

impurities (including uranium, which gives off a pretty constant flux of radiation). Clays and soils also contain grains of various minerals like quartz and feldspar; the radiations from the radioactive elements pass through these grains, losing some of their energy in the form of detached electrons.

A few of these detached electrons become trapped inside the mineral grains and will stay trapped for thousands and thousands of years, unless they are shaken free by thermal variation of the crystal lattice of the mineral grains with the application of heat.

When a man-made pot is first fired, at a temperature somewhere in the range of 300–500 °C, the heat vibration shakes off all the trapped electrons in its mineral grains – setting the clock to zero, as it were. As the years roll by, the radioactive elements in the clay of the pot . . . continue to despatch their alpha particles, beta particles and gamma rays.

These radiations again lose some of their energy as they pass through the mineral grains, and a new accumulation is built up in the crystal lattices of those grains. If at any stage you can count how many electrons have been accumulated, and relate this number to the known propensity of the mineral grains to trap electrons and the known radiation level of the radioactive elements, you can, roughly, know how long ago it is since the pot was last fired – in most cases, since some human being made that pot.

The electron-trap theory of phosphorescence and thermoluminescence had been formulated in 1940 by the young New Zealand-born biophysicist Maurice Wilkins (1916–2004), in his doctoral thesis at Birmingham University in 1940.[8] By 1974, the technique was well established and widely accepted by the archaeological establishment.

In that year, however, the Glozel controversy, for so long apparently dead and buried, was spectacularly resurrected. At the beginning of the year, the archaeological grapevine was heavy with rumour that

thermoluminescence tests had been applied to some objects from Glozel which indicated that the clay had been fired some 2,000 years ago; some of the tests had been applied in Denmark. Indirect confirmation of these startling rumours came when Emile Fradin appeared in *Paris Match*, grinning broadly and exulting, 'I was down for 50 years, but now I shall die happy. They've just written to me from Denmark: Glozel is authentic!'

His delight was understandable, but perhaps premature. However, confirmation of the gist of his claim was not long in coming. In April 1974, a symposium was held in Oxford to discuss scientific methods of dating and identifying archaeological finds. The crucial lecture was delivered by two physicists who had been working on some Glozel finds independently: Dr Hugh McKerrell of the National Museum of Antiquities of Scotland and Dr Vagn Mejdahl of the Danish Atomic Energy Commission. Both scientists had been invited independently to examine material from Glozel: Dr Mejdahl's samples had been sent through a friend of Dr Morlet's widow, whereas Dr McKerrell had been sent samples by someone anxious to nail the Glozel case to the final satisfaction of both archaeology and science. Their conclusions stunned the archaeological world:

> The thermoluminescence investigation of a wide range of ceramic objects from Glozel shows that none of them can be the modern forgeries generally believed, and the site dates to within the range 700 BC to AD 100 . . .
>
> The very early dates for Glozel that Morlet and Reinach thought to be likely are not borne out by the present study. A La Tène or Gallo–Roman dating seems more certain.

When the paper was published in *Antiquity* in December 1974, the archaeological establishment was thrown into disarray. No one questioned the validity of the thermoluminescence tests, but there was every archaeological reason for believing that Glozel was a bundle of

forgeries. On 2 December 1974, *The Times* carried an article by its archaeological correspondent, which concluded:

> What is certain is that archaeologists will now have to revise their opinions about Glozel, or about the accuracy of the thermoluminescence dating, or about both.
>
> The present range of possibilities seems to be that the objects are genuine, in their original context, and mixed with earlier material there; that they are genuine but were brought to Glozel and buried in the 1920s for purposes of hoax or fraud; or that they are modern in both manufacture and context, in which case the assumptions on which the present acceptance of thermoluminescent dating tests will have to be radically re-examined.

On 15 January 1975, the BBC transmitted a *Chronicle* programme entitled 'The Great Glow-Curve Mystery'. The programme interviewed the two scientists who had produced the paper. Dr Hugh McKerrell repeated his conviction that dates of around the time of Christ could be assigned to the material so far tested; he warned that the TL determinations were pretty loosely bracketed but that something within the range of AD 0, plus or minus 500 years, could be relied upon. The programme also interviewed Emile Fradin, who was jubilant at his vindication by the boffins: 'It's official – this tablet is 3,000 years old . . . about!'

The programme also took to Glozel three of the 'Big Beasts' of the British archaeological jungle: Lady Olwyn Brogan (a leading authority in the Gallo–Roman field), Professor Glyn Daniel of Cambridge (then editor of *Antiquity*) and Professor Richard Atkinson of Cardiff. Only Glyn Daniel had visited Glozel before. They all deplored the quality of the original excavations ('like digging up potatoes'); they all recognised that the assemblage of finds was, archaeologically speaking, simply impossible to believe; and they all focused on the dismaying rift which had opened between archaeologists and archaeological scientists.

Professor Colin Renfrew (now Lord Renfrew, one-time Disney Professor of Archaeology at Cambridge) reflected on this rift in a note on 'Glozel and the two cultures' in *Antiquity* (September 1975):

> What interests me at the moment, however, is the way in which the controversy is developing, betraying, as it does, a serious lack of communication between archaeologist and scientist. At first my feelings were that unduly sweeping claims of an archaeological nature were being made by the archaeo-physicists on the basis of insufficient scientific data. Now I find it extraordinary that no specialists in the European Iron Age have come forward to comment on the situation . . .
>
> The whole story is a colourful one, and it would be a brave man who would dismiss the work that has recently been done, or cast aspersions on the thermoluminescence method in general. I have considerable respect for both but feel it is time the serious and weighty objections were set out.

He had to wait a long time. As the controversy between science and archaeology simmered on, the Glozelians seized the initiative. To the embarrassment of many French archaeologists, Glozel was promoted to the hilt. The 1990 edition of the *Dictionnaire Archéologique de la France* presented an entirely favourable account of the site, especially in its captions. France's leading popular magazine on archaeology, *Archéologia*, devoted a totally uncritical edition to the site under the offensive title of 'Glozel: L'Affaire Dreyfus de l'Archéologie' and then published Emile Fradin's memoirs in 1990. As for Fradin, in June 1990 he was awarded the Palmes Académiques and the Medal of the Conseil Général de l'Allier.

However, the Glozelian tide began to turn in the 1980s. Between 1983 and 1990 the French Ministry of Culture carried out a campaign of fieldwork and laboratory analysis to reach a conclusion (in part, perhaps, because French-born nationalists had begun to use Glozel as

evidence that Europeans, rather than the Semites of the Near East, had invented writing and civilisation). The report, published in 1995, which was featured on the Canal Plus television channel, concluded:

> The handful of sites peripheral to Glozel which were supposed to have yielded 'Glozelian' finds in the past were all found to contain absolutely nothing earlier than medieval and modern material.
>
> The only examples of 'Glozelian' objects found in the 'Field of the Dead' in 1983 were in sediments which had been disturbed by early excavations or subsequently. Indeed, one half of a lamp was found, clearly inserted recently into a trench of 1974, while the other half was awaiting the investigators on the grass in front of their tent when they returned to camp for lunch.
>
> The investigation was unable to find an intact archaeological layer containing Glozelian objects *in situ*.
>
> Pollen analysis reveals that the site's sediments date to the subatlantic period (i.e. the medieval period and the present) and excludes the presence of an environment corresponding to the neolithic period, let alone to a palaeolithic period featuring reindeer.
>
> Physical and chemical analysis of the site's deposits show that the absence of carbonates, the scarcity of calcium and the acid pH of all levels preclude the conservation of bones for any length of time. Hence, if any bones in the field are prehistoric in date, they must have been placed there far more recently.

Colin Renfrew celebrated (if that's the right word) these findings by jointly contributing a chapter with Paul Bahn entitled 'Garrod and Glozel: The End of a Fiasco' to the book *Dorothy Garrod and the Progress of the Palaeolithic* (1999). In it the authors recounted with undisguised relish the further findings of the Ministry of Culture – especially, that the thermoluminescence technique is subject to great uncertainties at Glozel, where the background radioactivity is high and varies from

place to place. Nineteen new TL dates were obtained from Glozelian objects. They fell into three groups: the Iron Age/Gallo–Roman period; medieval; and modern (at least four, and probably six, dates fall into the first half of the twentieth century).

The report's conclusions were that the hypothesis of a prehistoric culture at Glozel must be definitively rejected. Furthermore, the site had not produced the slightest evidence of Gallo–Roman occupation, other than the TL dates (whereas there are abundant remains of that period in the region). It therefore stated that '*l'hypothèse de manipulations modernes reste d'actualité*' – 'the assumption of modern interference is soundly based'.

It was an extremely gratifying result for the archaeologists. In the conclusion to their chapter, Renfrew and Bahn turned their attention to the archaeological scientists who had so muddied the waters in the 1970s; clearly, the memory of that period still rankled:

> A good number of professional archaeological scientists were evidently inclined . . . to belittle the views of those archaeologists who, on plain typological grounds, regarded the finds as fraudulent and questioned the implications of the thermoluminescence determinations . . .
>
> What is one to make of the extraordinary failure of the archaeological scientists back in the 1970s, and particularly the thermoluminescence specialists, to come to a clear conclusion on the matter? And of their continuing failure now to explain what went wrong? . . . Were the TL determinations themselves in error? Or had the fraudulent objects been made from ancient materials? Or had they been partially re-fired, or subject to re-radiation? We simply do not know . . .
>
> Is it not time that the TL specialists began to work out some of the answers? It is surely incumbent upon those who set out to investigate material which had been declared fraudulent nearly 50 years earlier, and who used their scientific techniques to

declare it genuine, to explain to the archaeological and scientific world just what went wrong.

The ghost of Glozel will not finally be exorcised until this second 'affaire Glozel' is decently disposed of.

I asked Colin Renfrew (an old friend and colleague from my *Chronicle* days) if the funny business at Glozel has been 'decently disposed of' virtually 80 years after the event and more than 75 years after the negative findings of the Glozel Commission:

> Sadly, it is difficult to consider that it has. There has been no effective public judgement passed by the French archaeological establishment. This is strange, since I do not imagine that there are many professional or otherwise qualified archaeologists who take the site or the finds seriously. Certainly those archaeological scientists who once claimed that the thermoluminescence dates showed Glozel to be ancient seem to have fallen silent, although none has explained adequately how they came to reach the conclusions which they did reach back in 1974 and 1975. Their 'plea for patience' has outstayed its welcome.
>
> It is difficult to see why there has not been a more public consensus of condemnation, unless it arises simply out of respect for the considerable age of the 'finder' of all these strange and unbelievable things – Emile Fradin, now a venerable figure in his 90s. In human terms, one can see that this is perhaps not the moment to make a fuss. But when the time comes for him to meet his 'Maker', I hope that the French archaeological establishment will pronounce a more audible verdict on the affair than they have yet done. That will perhaps be the time for the final disposal of Glozel. Meanwhile, one can only salute M. Fradin for his creativity and, indeed, for his longevity.

The jury is still out. Since 1966, a series of annual conferences has been held in Vichy to re-evaluate the site from different perspectives. And now another Glozelian has recently joined the fray: Alice Gerard with a book entitled *Glozel, Bones of Contention* (2005). She and her husband Sam worked for ten years on the subject and hope to see a re-opening of excavations at the site to prove that the Glozel finds are genuine after all.

Envoi

Meanwhile, the tiny hamlet of Glozel continues in its undisturbed way of life, entranced by time, heedless of the fierce disputations which its very name once attracted. The Fradin family no longer farms the surrounding fields – the only land it still owns is the Champ des Morts itself, the narrow fenced track which leads to it and, of course, the farmhouse with its museum. It is a private museum which belongs to Emile Fradin; it is private because the discoveries were made before the 1941 Carcopino Act and therefore the objects unearthed belong to him and not to the State. The French government would have liked Fradin to hand over the finds to the Ministry of Culture, but Fradin has always refused to countenance such a suggestion, and Fradin's only son, Jean-Claude Fradin, a history teacher, is determined to keep the museum going as a private venture. If Jean-Claude has anything to do with it, the museum will become as timelessly antiquated as the hamlet of Glozel itself.

2.3 – The Vínland Map: A Pious Phoney[9]

We descended on Newfoundland from all over the world to attend the Viking Millennium International Symposium in late September 2000 – more than 100 eager academic pilgrims. Our destination was a tiny fishing village called L'Anse aux Meadows, on the tip of the Great Northern Peninsula of Newfoundland. Beside it is an archaeological site which was discovered and excavated in the 1960s and is now recognised as the earliest European settlement in the 'New World'. It is thought of as the 'gateway to Vínland', 'Vínland' (Wineland) being the name given to a northern area of the New World which Norse pioneers explored and sought to colonise early in the eleventh century. This was almost five centuries before Christopher Columbus reached the Caribbean.

Our symposium was hugely enjoyable and stimulating, a feast of fascinating addresses and presentations to celebrate the millennial anniversary of one of the world's great feats of exploration; for those of us who had not been there before, the pilgrimage was a very special occasion indeed.

But for me, and for many others, the high point of the conference concerned another sensational 'Vínland' artefact: the so-called Vínland Map, which was published by Yale University Press in 1965, while the site at L'Anse aux Meadows was in the process of being excavated. Yale University Press claimed that it was an authentic Norse map of the world, dating from around 1440 and purporting to delineate the 'Vínland' discovered by the Vikings, and that it was indisputably the earliest extant map of North America.

'Indisputably' is a risky word to use in the groves of Academe. In fact, many scholars were deeply sceptical about the map from the outset and suspected that it might be a modern forgery. But who could have forged it, when could it have been done and why? Those were the questions hanging over the whole Millennium Symposium as we continued our

pilgrimage from Newfoundland and Labrador in our search for the truth about Vínland.

It was not until the final presentation on the last formal day of the symposium that we were to get the answer, from a Norwegian-born scholar named Kirsten A. Seaver.

The Vínland venture

> The researches of many commentators have already thrown much darkness on this subject, and it is probable that if they continue we shall soon know nothing at all about it.
>
> Attributed to Mark Twain

It is one of the world's great adventure yarns: the discovery and attempted colonisation of an area in North America by Norsemen from Iceland and Greenland around and after the year 1000.

The Norse discovery of America was for a long time dismissed as pure fable; but for me, as an Icelander (which means that I am scarcely unbiased!), the evidence has always been compelling. Basically, that evidence is contained in two medieval Icelandic sagas, written in the first half of the thirteenth century: *Grænlendinga saga* (*Greenlanders' Saga*) and *Eiríks saga rauða* (*Saga of Eiríkur the Red*). Back in the 1960s, I studied these two sagas extensively and translated them (with my late friend and mentor Hermann Pálsson of Edinburgh University) for the Penguin Classics series (*The Vínland Sagas*, 1965).

These two Vínland sagas are the only documentary sources which give narrative accounts of the Norse discovery and exploration of the New World. It is perhaps their uniqueness, along with a certain confusion about the nature of the Icelandic sagas as a literary genre, which led to the casual assumption that there was no valid basis for believing that the Norse Vínland was part of North America.

The medieval Icelandic sagas are not, strictly speaking, historical chronicles; they should be regarded as historical novels. Most of them were written in the thirteenth and fourteenth centuries and were based

on the real-life stories of people and events from the early settlement of Iceland in the tenth and eleventh centuries.

The two Vínland sagas are linked – they cover much of the same ground in a series of episodic stories – but they are not two versions of the same saga; they are two separate sagas incorporating different and sometimes conflicting traditions about the Vínland venture. There are major discrepancies about the accounts of Vínland in the two sagas – especially over who was said to be the first *discoverer* of North America and who was the first *explorer* of North America.

At the risk of oversimplifying, I shall attempt to outline the story told in the two sagas, in their different ways. To begin with, there was a man named Eiríkur *rauði* (the Red), who came to Iceland as an exile from Norway around the year 960. From his nickname, he must surely have had red hair and a red beard. But what marked him out from others was not just his colouring but also his prickly pride and his refusal to bow down to anyone – especially when he established his new home in Iceland.

Imagine, if you will, conditions on the west coast of Iceland around the year 980, just before the end of the first millennium. Iceland had been settled for only a century or so, but already it was well populated with farmers, their families and slaves, and with craftspeople, traders and poets – but no princes: Iceland was a newly minted republic, a commonwealth, the only nation in Europe at that time not to have a monarchy. The picture it conjures up is one of tough people in a tough frontier world, just like the pioneering days of the Wild West, when people took the law into their own hands until they were either run out of town or summarily hanged.

Eiríkur the Red married and built a new homestead in the west of Iceland. Here he had a son, destined to be one of the main protagonists of the Vínland adventure: Leifur Eiríksson, known by his nickname of *heppni* (the Lucky) and officially celebrated in the United States as the 'Discoverer of North America' on Leif Erikson Day (9 October).

But Eiríkur and his hasty sword were soon in trouble again, and after

some further killings, he was sentenced to three-year outlawry in 981. Since he could not return to Norway, he decided to go west into unknown waters to seek out a country which had allegedly been spotted 80 years earlier by a storm-driven Icelandic mariner. What Eiríkur found was a huge, snow-capped country, which he nevertheless named Greenland, 'because', he said, 'people would be much more tempted to go there if it had a good name'; and after spending three years exploring it, he went back to Iceland to raise a colonising expedition. His public relations ploy worked, and in 986, a fleet of optimistic colonists sailed from Iceland for Greenland, where they put down roots in two large settlements on the west coast, with Eiríkur the Red as their patriarchal leader.

That same summer, a young Icelandic merchant named Bjarni Herjólfsson, whose father had gone to Greenland with Eiríkur the Red in the spring, decided to follow his emigrant father. On his voyage to Greenland he ran into foul weather and was blown blindly past his destination south-west across the Atlantic, where he sighted unknown lands. He did not stop to explore them but made his way to Greenland in a parabola of landfalls towards the north-east.

The Greenland settlements took root and flourished. Eventually it was the turn of the next generation to be pioneers. Leifur the Lucky decided to explore the lands far to the west which Bjarni Herjólfsson had sighted some 15 years earlier. He bought Bjarni's ship, trusting in the old adage that 'ships know the way back', and put to sea with a crew of 35 men. He retraced Bjarni's route from the west, sailing past Baffin Island and Labrador. The most southerly point he reached, two days' sail farther south, was a large island on which he built some houses – later to be known as *Leifsbúðir* (Leifur's Booths)[10] – which would become a focal point for subsequent Norse visitors.

This is a key section in the Vínland story. When the explorers landed, the saga says:

> They went ashore and looked about them. The weather was fine. There was dew on the grass, and the first thing they did was

to take some of it in their hands and put it to their lips, and it seemed to them the sweetest thing they had ever tasted.

What a wonderful evocation of the spontaneous reaction of seafarers wearied of the cramped confines of their ship, coming ashore at last on the Promised Land!

Grænlendinga saga then offers the first recorded description of the New World; it is brief but immensely telling:

> There was no lack of salmon in the river or the lake, larger salmon than they had ever seen before. The country seemed to them so good that the livestock would need no winter fodder: there was no frost all winter, and the grass hardly withered at all. In this country, night and day were of more even length than in either Greenland or Iceland; on the shortest day of the year, the sun was already up by 9 a.m. and did not set until after 3 p.m.

Later, an exploring party found grapes growing wild. So Leifur ordered his men to gather grapes and vines, and to fell trees to make a cargo of timber for his ship. He had no intention of staying any longer. When spring came, they sailed back to Greenland. Then, the saga says, 'Leifur named the country after its natural qualities and called it Vínland' – the land of wine or grapes.

The geographical implications of these accounts in *Grænlendinga saga* place Vínland somewhere south of the latitude 50 degrees north and north of latitude 40 – anywhere between the Gulf of St Lawrence and New Jersey. Wild grapes have never grown north of the Gulf of St Lawrence, and salmon are not found on the Atlantic coast of North America south of the River Hudson.

Further voyages of exploration followed, led by other members of Eiríkur the Red's family and using Leifur's Booths as a base. None led to settlement, but, significantly, some of the later explorers encountered

native tribes – Native Americans – whom they called, contemptuously, Skrælings.

Before I go on to the next and culminating phase of the Vínland venture, it should be emphasised that the major difference between the two Vínland Sagas is the identity of the first *accidental* Norse discoverer of North America. In *Grænlendinga saga* it was the merchant Bjarni Herjólfsson and his report of a chance glimpse of North America which was followed up by a *planned* voyage of exploration by Leifur Eiríksson. However, in *Eiríks saga rauða* (which seems to be the later, and certainly the more sophisticated, of the two sagas), it was Leifur Eiríksson who made the first chance discovery. There is no mention at all in *Eiríks saga rauða* of Bjarni Herjólfsson.

The scene is now set for the climax of the Norse Vínland venture – the determined attempt not just to *explore* Vínland but to *colonise* it, led by a wealthy young Icelandic merchant named Þorfinnur Karlsefni (Makings of a Man). He arrived in Greenland around the year 1020 and resolved to found a permanent Norse colony in Vínland, the new world of apparently limitless potential and resources. The story has it that his spirited young bride Guðríður also went with him.

According to *Eiríks saga rauða*, Þorfinnur and Guðríður set sail with three ships carrying one hundred and sixty people, including five women (in *Grænlendinga saga* it was one ship with a crew of sixty men and five women). It was a strictly mercantile enterprise. They took with them livestock of all kinds, because the intention was to found a permanent settlement in the country. And where did they go? According to *Grænlendinga saga*, Þorfinnur Karlsefni spent the first winter at Leifur's Booths, which Leifur had leased to him.

The following summer, the would-be colonisers had their first encounter with the Skrælings and started bartering. But the barter quickly turned sour, and hostilities broke out the following winter. The Native Americans lost many of their men before retreating. That was the end of the encounter – and, to all intents and purposes, the end of the colonising venture.

Þorfinnur and his band spent their third winter in the New World and prepared to return to Greenland in the spring. They had one thing to celebrate, at least. In the first autumn of the expedition, Guðríður had given birth to a son, Snorri Þorfinnsson – the first European child we know of to be born on the continent of North America.

With spring came the final curtain. The Norsemen loaded their belongings and set sail for Greenland. It was the end of a remarkable story – the first serious attempt we know of to found a permanent European settlement in North America, almost 500 years before Christopher Columbus found his way to South America in 1492.

These would-be settlers had all too soon realised that they were hopelessly outnumbered by the indigenous inhabitants. Their lines of communication with their northern homelands were far too stretched. Although their iron weapons were superior to the Stone Age implements of the Native Americans, they were not superior enough. And so, with considerable regret, no doubt, Þorfinnur Karlsefni turned his back on the alluring concept of Vínland and sailed back, first to Greenland and then to Iceland, with a rich cargo of valuable produce to sell – and an even richer cargo of exotic yarns and stories to tell. The Vínland enterprise was over.

Such, in the barest outline, is the story of the Vínland adventure as recounted in the two Vínland Sagas. And what an adventure it had been! But it is clear that Europe was not yet ready to colonise North America, not yet able to establish a permanent base on a hostile shore so far from home. According to the *Icelandic Annals*, an attempt to rediscover Vínland was made by bishop Eiríkur Gnúpsson of Greenland in 1121, but it is not known whether or not he ever returned from his voyage.

L'Anse aux Meadows

But where was Vínland? More importantly, where did the Norsemen think Vínland, this paradisal land of plenty, actually was? That was one of the things we millennium Viking pilgrims were wanting to find out in Newfoundland.

The medieval Norsemen did not make maps, but the Icelanders of the Middle Ages showed considerable sophistication in their written image of the geography of the northern world. As for maps, the earliest known authentic map illustrating the Norse experience of the Atlantic seaboard of North America was not made until 1590 (the so-called 'Skálholt Map', by an Icelander named Sigurður Stefánsson). It is a very crude sketch drawn on the basis of the saga 'evidence' and has little geographical value, but at least it was rooted in an old geographical tradition. It shows a long littoral studded with headlands named *Helluland* (Baffin Island), *Markland* (Labrador) and *Skrælinge land* (Land of the Skrælings). To the south of that is a sharp peninsula, spearing northwards, which Sigurður Stefánsson called *Promontorium Winlandiae* (Vínland Promontory) – not, let it be noted, Vínland itself.

The Skálholt Map is a historical curiosity, nothing more. How could it be otherwise? The navigational and topographical indications in the Vínland Sagas are so vague and equivocal that Vínland has been located by enthusiasts in areas as far apart as Hudson Bay to the north and Virginia to the south. Hunting for Vínland on the basis of the saga 'evidence' has for long been a challenge for the adventurous and the imaginative, but, ultimately, it can only be an exercise in futility.

The modern search for Vínland has focused on the tantalising references to Leifur's Booths, which Leifur Eiríksson ('America's first realtor', as he has been called) was said to have built as a temporary encampment and then leased to later explorers. This place, real or imagined, became the target for archaeological ambitions. And in the 1960s, archaeology came to the rescue, in the form of the Norwegian adventurer Helge Ingstad and his archaeologist wife Anne Stine.

Helge Ingstad, who died in 2001 at the ripe old age of 101, had had an adventurous career in his first 60 years. He was a barrister by profession, but when he was 27 years old, he left his practice to explore the Arctic. He lived as a trapper in arctic Canada, studied Apache Native Americans in Arizona, led an expedition to the Sierra Madre mountains in Mexico in search of a 'lost tribe' and lived with the Inuit of northern

Alaska. After an expedition to Greenland in 1953, he wrote a part-travel, part-history book entitled *Land Under the Pole Star*. He had caught the Vínland bug and started looking for tangible evidence of the presence of Norsemen in the New World.

In 1960, basing his geographical calculations on a selection of sailing times and directions culled from the two Vínland Sagas and from fourteenth-century accounts, and guided by the 1590 outline chart by Sigurður Stefánsson, Ingstad scoured the coastline from New England northwards, ending up on the west coast of Newfoundland, the large island separated from Labrador by the Strait of Belle Isle. On the north coast of the island he visited a tiny fishing village called L'Anse aux Meadows – the modern name is thought to be a corruption of L'Anse au Medée (the creek of the ship *Medée*), the original name given to it by the French in the sixteenth century.[11] Here a local fisherman told Ingstad about an area of humps and bumps near Black Duck Brook, which by tradition was known as the 'Indian Camp'. The fisherman, George Decker, took Ingstad to the place; it was a walk of only ten minutes along the shore of Épaves Bay. The Norwegian explorer was shown an ancient marine terrace (a former beach), lying about 100 m from the present shore, some 3 or 4 m above the level of the shallow, shelving bay. It had a number of indistinct overgrown elevations, perhaps five or more.

It was an unlikely site for Norsemen to favour. The sea is extremely shallow for a long way out, and it is not a natural harbour, although the gently shelving beach would make it easy to haul boats ashore. The landscape is flat and featureless and has none of the sheer lushness of the Vínland of the sagas: no wild grapes, no self-sown wheat and certainly no frost-free winters. Nevertheless, Helge Ingstad was convinced that this was it: L'Anse aux Meadows was Vínland.

Helge Ingstad and his wife started excavating the following year (1961), sponsored by *National Geographic* magazine. What they found encouraged them to return in 1962, this time with a party of Icelandic and Canadian archaeologists. And in the autumn of 1964, Ingstad

ecstatically reported in *National Geographic*, 'Vínland ruins prove Vikings found the New World'.

The site the Ingstads were excavating proved to be Norse, beyond any doubt, and in 1978, after corroboratory re-excavation, it was designated as the first UNESCO World Heritage Site. It was also claimed as the original site of Leifur's Booths. While it *may* have been the original site of Leifur's Booths, it was certainly *not* the Vínland envisaged in the traditions enshrined by the saga writers.

Enthusiasts have twiddled the texts, selected from the texts, conflated the texts and compromised the texts in endless attempts to create a coherent story which will 'prove' their particular hypothesis for the true location of Vínland. But, frankly, the sailing directions which dozens of eager researchers have tried to follow are not much more explicit than the old Icelandic adage for getting to North America: 'Sail south until the butter melts, and then turn right.' It is impossible to find any kind of geographical Vínland which would make sense, because we have no idea how large it was, where it began or where it ended.

I have no doubt whatsoever that when the sagas refer to a place called Vínland, they are referring to some area on the North American littoral, but I am also sure that by the time the Vínland sagas came to be written in the thirteenth century, the precise location of this Vínland had long been forgotten. I believe that, by that time, Vínland as a geographical place had merged into the realms of legend. The Vínland of vines and grapes had blurred.

I also have a lurking suspicion that Vínland never existed as an *actual place*; or if it did, it very quickly became a legend. The name itself – 'Vínland the Good', as it came to be called – carries too many overtones of paradise and romance and fable: fables of El Dorado, of the Hesperides, of the Fortunate Isles (*Insulae Fortunatae*), of the Irish *Immrama* (Voyages). To me, Vínland the Good smacks much more of a wistful and wishful concept than of a geographical reality.

And put it down to Norse pragmatism, if you wish, but what commercial good, on treeless Greenland and Iceland, were grapes

compared to timber? Wine was relatively cheap to import – from Germany, say – but timber from Norway for building ships and houses was not; you would be a fool to buy timber from Norway when there were vast amounts of it there for the taking in the New World.

Then, in 1965, to the surprise, delight and consternation of many, along came the so-called 'Vínland Map'. And that really fanned the flames of controversy about Vínland.

The Vínland Map

On 11 October 1965 (the day before Columbus Day and two days after Leif Erikson Day), Yale University Press published, with much publicity, pomp and panoply, a document purporting to be the first Norse map of America – a manuscript map of the world which, it was claimed, was the only known example of medieval Norse cartography and 'recorded in graphic form the only documented pre-Columban discovery of America'. Remember, this was less than a year after Helge Ingstad had announced that he had found incontrovertible archaeological evidence of Norse ruins at L'Anse aux Meadows, and the Norse discovery of Vínland was exciting great interest, particularly in America. In this atmosphere of heightened expectation, the Yale publication (which came out under the intriguing title of *The Vínland Map and the Tartar Relation*) was the academic publishing sensation of the 1960s.

The map had apparently surfaced in the European antiquarian market in 1957. It was bound in a relatively modern calfskin binding, along with 21 pages of a paper-and-parchment copy of a previously unknown account of a papal mission to the Mongol court in 1245–7 by a Franciscan friar and diplomat named John de Plano Carpini entitled *The Tartar Relation*.[12] This was hailed in some quarters as a highly significant historical document in its own right, but it was the 'Vínland Map' accompanying it which attracted the most attention.

The map is a pen-and-ink drawing of the world on a sheet of much-scraped, but genuine, fifteenth-century parchment, light greyish-brown in colour, measuring just over 27 cm by 42 cm and folded in two. It is an

unprepossessing-looking document, spattered with exotic geographical names and Latin legends, and marred by wormholes. On the outside front of it there is a cryptic Latin inscription: 'Delineation of the first part, the second part [and] the third part of the *Mirror* (*Speculum*)'. The import of this inscription was not immediately apparent.

Much of the map seems to be based on a copy (or even a copy of a copy) of a world map drawn by the Venetian cartographer Andrea Bianco in 1436. What made it such a sensational 'find' is the addition, in the extreme north-western corner, of the Norse Atlantic settlements: a rather haphazardly depicted Iceland (*Isolanda Ibernica* – Irish Island), a remarkably accurate Greenland (*Gronelanda*) and a vast lumpy island with two deep inlets labelled *Vinilanda* (or *Vimlanda*) *Insula*, obviously purporting to be the Vínland of the Icelandic sagas. This final label is accompanied by a short Latin legend, which says that the island had been 'discovered by Bjarni [Herjólfsson] and Leifur [Eiríksson] in company' (*a byarno reperta et leipho socijs*). This note is supplemented by a longer legend:

> By God's will, after a long voyage from the island of Greenland to the south, towards the most distant remaining parts of the western ocean sea, sailing southward amidst the ice, the companions Bjarni [*byarnus*] and Leifur Eiríksson [*leiphus erissonius*][13] discovered a new land, extremely fertile and even having vines, the which island they named Vínland.

The authors of the Yale volume claimed that the map must have been made around 1440 by a monk working in a scriptorium in the Upper Rhineland; he had evidently modified his copy of the Bianco world map with some hitherto unknown chart made by a (presumably) Norse cartographer in the thirteenth century, based on the saga accounts of the voyages to Vínland.

The story of how it had reached Yale University is a long and devious one, with a bizarre cast of characters from the undergrowth of the

antiquarian book trade, and it has taken many years to come to light. In 1957, a colourful Italian bookseller (but long-time resident in Barcelona) named Enzo Ferrajoli de Ry started touting *The Tartar Relation* book containing the map on the antiquarian book market; he claimed that he had bought it from 'a private collection' but declined to say any more about its provenance.[14]

The first known attempt to sell it was to the British Museum, in 1957, through a London dealer named Irving Davis. Specialists at the museum needed only a cursory inspection before rejecting it as suspect on several grounds – chiefly because of the lack of proper provenance. If genuine, the map was obviously a spectacular catch – 'of so arresting a character as to prompt suspicion, if not incredulity' – but in the opinion of the British Museum experts it could not be regarded as such.

Later, in Geneva, the volume was shown to a young rare-book dealer from New Haven, Connecticut, named Laurence C. Witten, Jr., an alumnus of Yale University. Witten, who was just embarking on his career as an antiquarian book dealer, bought the slim volume 'on spec' for $3,500. He now offered it to Yale University Library, but their experts also declined it, mainly on account of the mismatching wormholes; they were also disconcerted by the enigmatic legend on the map's outside front. Thereupon, Witten, apparently saddled with an unsaleable item, gave the volume containing the map and *The Tartar Relation* to his wife as a present.

And now the long arm – the very, very long arm – of coincidence reached out. The curator of medieval and Renaissance literature at the Yale University Library at the time was Thomas E. Marston. Marston was in the habit of buying manuscripts, both for himself and for the rare books collection at Yale University; he and Witten were clearly in cahoots, because they would also sell manuscripts to one another to drive up the price before they were offered to a third party.[15]

Some months after Witten had tried in vain to sell *The Tartar Relation* and its accompanying map to Yale University Library, Marston (according to his own account) was leafing through a catalogue of antiquarian

offerings from the London dealer Irving Davis when he spotted a rather dilapidated and incomplete section (four books) of a fifteenth-century manuscript of a medieval historical work called the *Speculum Historiale* (*Mirror of History*) by Vincent of Beauvais. Irving Davis had bought it (fortuitously, it was claimed) from Enzo Ferrajoli de Ry, from the same private collection which had provided the map and *The Tartar Relation*. Marston now bought it for a song ($75) as a routine acquisition.

Soon afterwards, Witten just happened to drop by his office, and Marston showed him the *Speculum Historiale* manuscript. Witten asked to be allowed to take it home to scrutinise it at leisure. On his way home, he stopped at the Yale Library to study a four-volume work on watermarks by an eminent authority. When he got home, he looked at the unsaleable volume containing the map and *The Tartar Relation* which he had given to his wife – and lo and behold, he found that the *Speculum Historiale* had a watermark identical to the watermark on *The Tartar Relation*! What's more, it seemed to relate to the problem of the Latin inscription on the front of the map.

Witten reported all this to Marston by telephone in great excitement. He also said that if you shuffled the portions around, the wormholes matched as well. The *Speculum Historiale* manuscript was still in the mid-fifteenth-century binding which had also once contained *The Tartar Relation* and the parchment on which the map was drawn.

This providential linking seemed to provide the proof of authenticity which the map's lack of provenance had previously denied it and increased its value spectacularly – to $1 million, no less. Marston, meanwhile, had given the *Speculum Historiale*, too, to Mrs Witten, so she now owned all the ingredients. The price would be far beyond the means of Yale University Library, so Witten and Marston approached a mega-wealthy Yale alumnus named Paul Mellon, the son of a multimillionaire banker. Mellon was a generous benefactor of his old university, and he enthusiastically (and anonymously, at first) provided the necessary $1 million so that the map could be donated to Yale University Library. (The map is now said to be insured for about $25,000,000.)

It was later to emerge that Ferrajoli, Davis and Witten had all secretly retained a financial interest in the map in the event of a resale. The scam (if scam it was, and few people now doubt that it was) had been an extremely lucrative one for the people involved.

The map under attack

For eight years a team of three scholars laboured over the map to prove that it was a genuine fifteenth-century artefact, just like the two texts associated with it. One of the experts was none other than Thomas E. Marston – the man who had helped to provide the map. Another was R.A. Skelton, superintendent of the map room at the British Museum. The third was George D. Painter, assistant keeper of printed books at the British Museum. They worked in conditions of high secrecy. Only a few other scholars were allowed to see the map and then only in the strictest confidence.

Then, in 1965, in a worldwide blaze of publicity, the map was published in the Yale University Press book entitled *The Vínland Map and the Tartar Relation*, which proclaimed the legitimacy of the find before other cartographic specialists had been given a chance to examine it. But the circumstances of the reunion of the pieces seemed just too pat. Various scholars attacked aspects of the map. Cartographic scholars were particularly sceptical of the depiction of Greenland as an island (a geographical fact which had not been established until the early twentieth century). Palaeographic experts claimed that the writing in the three documents was not done by the same hand. Old Norse scholars pointed out the map-maker's manifest unfamiliarity with Old Norse usage and language, and pounced on the map's perplexing claim that Bjarni Herjólfsson and Leifur Eiríksson had discovered Vínland 'in company', whereas the Vínland sagas distinguished carefully between the two men's voyages. The ink on the map, too, aroused suspicion – two scientists at the British Museum research laboratory found, in 1967, that the ink used on the Vínland Map differed in appearance and behaviour from the common medieval iron-gall ink used in European medieval

manuscripts (including *The Tartar Relation* and the *Speculum Historiale*), but they were not given the opportunity to analyse the ink further or to publicise their findings.

Eventually, in 1972, Yale University allowed the three manuscripts to be subjected to hi-tech scientific analysis by a team of specialists headed by Dr Walter C. McCrone and his wife Lucy, partners in Walter McCrone Associates Inc. of Chicago. Micro-samples of the inks from all three manuscripts were taken and subjected to advanced electron-microscope tests to reveal their crystalline structure. The results, announced in 1974, were unequivocal and devastating: the ink of *The Tartar Relation* and the *Speculum Historiale* was a conventional medieval iron-gall mixture, whereas the ink of the map contained microscopic spherules of titanium oxide in a molecular form, developed in Fredrikstad (Norway) for the commercial paint industry. It was not patented until 1917. Ergo, the map was a twentieth-century fake.

In January 1974, Yale sent out a sorrowful news release:

> Yale University Library reported today that its researches suggest that the famous Vínland Map may be a forgery. This conclusion is based on exhaustive studies initiated by the Yale Library taking advantage of techniques of chemical analysis only recently developed by scientists . . .

But that was by no means the end of it. In 1989, a new study was published by two scientists (Thomas Cahill and Bruce Kuslo) at the University of California at Davis, using a different scientific technique. This technique detected all the substances in the ink and parchment, and apparently identified the presence of anatase said to be occurring naturally in a variety of medieval manuscripts. This study has now been dismissed as irrelevant, but at the time the whole question of the map's authenticity was thrown wide open again. In 1995, in an attempt to rehabilitate 'one of history's most important cartographical finds', Yale University Press issued a second edition of its notorious 1965 publication,

containing five additional essays. The advertisement read, 'Recently the map has been rehabilitated, for reappraisals of both scientific and humanist evidence have re-established its authenticity.' But the new edition contained no new Norse or cartographical research and failed to convince any doubters.

When the Smithsonian Institution mounted its massive millennial exhibition on 'Vikings' for display in Washington, New York and London in 2000, the imposing catalogue (*Vikings: The Norse Atlantic Saga* – a major compendium of scholarly articles) made no bones about the fact that the Vínland Map was believed to be a modern forgery.

Poor Yale University seems to have fallen victim to a scam which had been planned with remarkable care and patience. Its success depended on the cunning way in which the trap had been baited for the gullible: the 'innocent' purchases, on the cheap, of two apparently unrelated manuscripts which were later identified as having been part of the same book – an alleged relationship which blunted critical consideration and sent its price soaring.

The forger unmasked: enter Kirsten Seaver

But a major question remained: if the map was a fake, who had forged it? Could anyone identify the person who had set the academic world in uproar for nigh on 50 years? That is precisely what Kirsten A. Seaver did on the last day of the Viking Millennium International Symposium in Canada in September 2000 in an electrifying address entitled *Fact, Fiction and Fakery: The Story of the Vínland Map*.

Kirsten Seaver is a Norwegian-born historian and cartographical scholar, as well as a translator and novelist. She was born in Fredrikstad, in the south of Norway, in 1934, graduated with a BA from Bryn Mawr College in Pennsylvania in 1956, and joined Harvard University Library as secretary to the head of acquisitions and consultant for its Scandinavian collections. In 1975, she moved with her husband Paul Seaver (a historian specialising in the Tudor and Stuart periods in Britain) to Stanford University, where she taught Norwegian while raising their

family. She has translated copiously from modern Norwegian, including some early work by the playwright Henrik Ibsen. She has published historical novels in Norwegian about the Norse world of Greenland and Vínland, including *Gudrids saga* (the story of Guðríður Þorbjarnardóttir, the far-travelled Icelandic woman who bore the first European child in Vínland). As what one might call a 'freelance academic', she has published scholarly articles galore about the economics, commerce and exploration of the far north. Her *magnum opus*, which was published in 1995, was entitled *The Frozen Echo: Greenland and the Exploration of North America Between c.1000 and 1500.*

It was her experience during her research into that subject which brought her into close contact with the Yale University Press publication of the Vínland Map, and for years her main preoccupation was cartographical detective work: specifically, finding the forger of the suspect Vínland Map.

What had concerned Kirsten was not so much the presence of the disputed map itself (like many other scholars, she had always been suspicious about its authenticity); what had irritated her, like a piece of grit in the eye, was the quality of the Norse scholarship in the Yale publication. Not one of the three authors of the Yale book, although eminent in their own fields, had been a Norse specialist; yet people believed that it was a book of expert Norse scholarship and kept citing from it as such, whether or not they believed that the map was genuine. It was essential to distinguish between the map and its suspect authenticity and the Yale book and its suspect scholarship about the Norse world, even though the two were so closely intertwined.

The authors of the Yale book had simply taken the map and its information at face value as a snapshot in time of the discovery and exploration – and subsequent abandonment – of 'Vínland'. Yet it is clear, from archaeological and other evidence, that Norse Greenlanders continued to cross to the Baffin Island/Labrador region for several centuries to fetch home iron and timber and to hunt land and sea animals. The Norse had no cartographic tradition and made no attempt

to create a coherent geographical image of the many countries to which they sailed; and even if they had passed on information about the New World to continental cartographers in the mid-fifteenth century, they would not have concentrated on a single visit to Vínland in the early eleventh century. Nor would they have united Eiríkur the Red and Bjarni Herjólfsson as *companions* in a joint voyage of exploration (for which there is no documentary source whatsoever).

So what had been the source of the information contained on the map? That was Kirsten Seaver's starting point in her investigation into the provenance of the document. She was not starting from scratch. She could assume that the map was a twentieth-century forgery because of the tests carried out on the ink, which could not be older than the development of industrially modified anatase – that is to say, post-1917. She knew that the forger was extremely knowledgeable about early maps. She knew that he was fluent in Latin and was steeped in medieval papal church history but had very little knowledge of Old Norse or the history of the Norse voyages of exploration.[16] She suspected that the forger must have been a serious scholar and thought it likely that he would have published something about his work during his career – or, at least, she hoped so. Such was the identikit picture she built up; she knew that there could not be a very large number of suspects who matched it. And with that in mind, she began a painstaking search of library sources across Europe, analysing the record of every scholar in the field between the late nineteenth century and 1957.

First, there was the matter of the map's Latin legend and its claim that Bjarni Herjólfsson and Leifur Eiríksson had discovered Vínland 'in company', contrary to what the historical sources said. Kirsten Seaver tracked the source of this confusion to a German Moravian Brother named David Crantz, who published a two-volume history of Greenland in 1765; it was intended as a report on the new German missions in Greenland but included a perfunctory summary of the country's Norse period. Crantz could not read any of the Scandinavian languages and had glaringly misinterpreted the earlier sources about Vínland which he had cited in his footnotes.

Crantz could not have been the forger of the map (he was much too early), but the mistake he made about Eiríkur the Red and Bjarni was still repeated uncritically in many subsequent works published around 1900, when there was a growing interest in the culture and achievements of the Norsemen. Kirsten Seaver realised that the cartographical and historical ideas evident in the map were typical of Continental Norse scholarship around that time, and this narrowed her area of search considerably.

A front-runner in early speculation about the identity of the forger had long been a Dalmatian Franciscan friar named Luka Jelic (1863–1922), who held that, from their base in Greenland, the Norsemen had created *several* American colonies which required the attention of Christian missionaries. His Franciscan zeal seemed to be mirrored in the map's emphasis on the reach of Rome's missionaries throughout the known world, both to the west and to the east. He also betrayed, alongside his fluent command of Latin, an abysmal ignorance of Old Norse. The only snag with this identification was that Jelic never showed much interest in, nor knowledge of, maps – and the forger clearly knew a great deal about cartography.

Kirsten Seaver now homed in on an Austrian contemporary of Luka Jelic's, a cartographic historian named Father Joseph Fischer (1858–1944), a Jesuit. The son of a decorative painter and gilder, he developed a sense of religious vocation and veered in academic directions early in his life. He had a long career as a teacher of the history of geography and cartography at the Austrian Jesuit college of Stella Matutina in Feldkirch (near the German/Austrian border) until 1939, when he moved to Munich.

Kirsten found that Fischer was constantly being cited as an authority on Old Norse – which he most certainly was not. Like Jelic, Father Fischer was highly proficient in Latin but also extremely ignorant about Old Norse. He had a strong interest in the Norse discovery of the New World, and, unlike Jelic, he had a professional interest in cartography, particularly in *world* maps of the fifteenth and early sixteenth centuries. As a young man, he had discovered the first printed map, dated 1507, to

name 'America' (the so-called Waldseemüller Map, which was purchased in the summer of 2001 by the Library of Congress for $10 million). In 1902, he published a treatise on the Norse discovery of Vínland in which he hypothesised the existence of cartographic evidence about it; he was convinced that the Norse had reported cartographically on their voyages to Vínland – either by making maps themselves or by providing information which would enable knowledgeable cartographers to delineate the position of Vínland accurately.

Father Fischer was an extremely clever and erudite man. But he was also inflexibly rigid in his views: once he had made up his mind, he was, like many other scholars, quite incapable of changing it. As soon as he was convinced that there had been some cartographic record of the voyages to Vínland, there was no way he was going to shift from that stance.

In a document like the Vínland Map, Father Fischer's two passions – for early cartography and for the Roman Catholic Church – came together very snugly. The map enabled Fischer to make much of the role of the Church and the long arm of Christian missionary activity. He was aware that the early Icelandic historians had noted that before the Norsemen discovered Iceland in the late ninth century, some Irish hermits had settled there. It was his view that these Irish monks had also gone to Greenland. This explains the odd name given to Iceland – *Isolanda Ibernica* (Irish Island) – and to Ireland – *Ibernia* – in the Vínland Map.

Kirsten Seaver also made a minute examination of the handwriting on the map and compared it with samples of Fischer's handwriting. She came to the conclusion that they were those of one and the same person.

Father Fischer: means and motive

Kirsten Seaver assembled a list of some 40 criteria which the maker of the Vínland Map would have to fulfil, and she gradually became convinced that Father Josef Fischer was the only possible culprit. Then, in the spring

of 1995, she published her opinion in the first of two articles in *The Map Collector*, a specialised learned journal for cartographers.

But *how* did Fischer do it? Kirsten Seaver is now sure about *when* he did it and *where* he obtained the medieval parchment on which he drew the map. She noted that, as a respected teacher and cartographic historian at the Stella Matutina College, Father Fischer had easy access to all the important libraries in his area. One of them was the magnificent library belonging to the princely family of Dietrichstein at Mikulov Castle in Mikulov near Brno. Fischer knew the library well and made several visits to it (indeed, a book about the Mikulov collection, published in London in the 1930s, was dedicated to him). In 1931, the library was dissolved by the family and put up for sale by private tender; the remainder was sold off at prestigious auctions in Switzerland and Austria in 1933 and 1934. Fischer knew the auction firm involved and was given generous access to a very valuable manuscript by the auctioneers in return for 'promotional' articles about it – he was even allowed to take the work home for study before the auction. He would easily have had the opportunity to acquire dilapidated old pieces of parchment which the librarians were prepared to discard. Given that Fischer was familiar with the library at Mikulov Castle and the auction house, and given that he was on respectfully friendly terms with the library's princely Catholic family, it seems reasonable to posit that when it was decided to dissolve the library, this ageing scholar and Jesuit priest was given the opportunity to acquire (free or for a nominal sum) one or more items of interest to him but of little value otherwise.

Kirsten Seaver is convinced that *The Tartar Relation* was lying in front of the person who made the Vínland Map. Since Fischer is the only conceivable person who could have made the map, he must have had *The Tartar Relation*, and if he had *The Tartar Relation*, he would have had the *Speculum Historiale* chapters as well – both in their old binding. She believes that Fischer acquired, in 1932 or 1933, the book containing *The Tartar Relation* and the *Speculum Historiale* chapters on behalf of the library of Stella Matutina College from the Dietrichsteins' library. The

Vínland Map parchment has been dated to the mid-fifteenth century and is likely to have come from the same fragmented volume. So the *means* were there. But what about the question of *motive*?

Motives are seldom simple or clear-cut. It so happened that in 1933, Father Fischer had just completed his *magnum opus* on Greek Ptolemaic map manuscripts held in the Vatican Library. He was immensely proud of the work – indeed, it had earned him a gold medal from the Pope. But the book was comprehensively slaughtered in a review by the most eminent cartographical scholar in the Germanic world of the time, Leo Barrow. Fischer was devastated. He could not sleep. He had finished his great academic endeavour, which had now been panned. His life's work had been called into question. In addition, Adolf Hitler had just come to power and had started his vendetta against the Catholic Church, and against Jesuits in particular. Fischer was in Austria, but conditions there were equally precarious for churchmen. What was he to do?

Imagine, if you will, this venerable old scholar, sitting in his austere study in 1933. He has just acquired an old volume which contained *The Tartar Relation* and the *Speculum Historiale*. And he had extra pieces of old parchment to hand. With one grand gesture he could justify his life's work *and* make a subtle remonstrance against the hated Nazi authorities at the same time.

Fischer carefully cleaned the old sheet of parchment. Now he could make a map of the kind which he was sure must have existed and certainly wanted to have existed. His map reflected a church-centred cartographical image which Fischer believed was appropriate to those medieval times. He probably would not have seen it as being dishonest, as deliberately falsifying the cartographic record – he was merely repairing the ravages of time. He certainly never intended to make a profit out of it, and he never did; the profits were made later by the skulduggery of much more commercially motivated men.

That was one of his possible motives. The other was more obscure, perhaps. Father Fischer, like all his fellow Jesuits, felt threatened by the orchestrated intimidation of the society by the Nazi authorities – people

who associated the Aryan superiority of the Third Reich with a perverted version of ancient Norse culture – and he wanted to confound them. His forgery harnessed the only opportunity for defiance available to him: his map, festooned with saints' names, staked a powerful claim about the dominion of the Catholic Church long before the Third or any other Reich. If the Nazis confiscated the Stella Matutina library, the map would be found by German scholars working for the occupying forces, and he hoped that it would cause them a headache: they would be attracted by the idea of documentary 'proof' that the Norsemen had discovered America but repelled by the image of Catholic domination of 'their' Aryan world. This 'tease' – if tease it was – could have been a pious old scholar's quiet protest against the inhumanity of those terrible years.

Can Fischer's forgery – or phoney, or protest, or tease – be justified on religious, ethical or moral grounds? If Fischer were still alive and stood trial on charges of 'intent to deceive', would he be found guilty (albeit with mitigating circumstances)? On that, I think, the jury is still out – and perhaps always will be.

Today the 'Vínland Map' is only a shadow, literally, of its former self, because of the fugitive nature of the ink. Despite careful conservation, the entire ink structure has continued to crumble and fall away; only the smallest particles of the ink are now visible. The success of the forged map has proved to be as ephemeral as that of so many other forgeries.

2.4 – The Cardiff Giant of New York State

In October 1869, the peaceful rural region of the Onondaga Valley in the heart of New York State was convulsed by the news that a great stone statue (or petrified giant) had been dug up at the little hamlet of Cardiff, near the southern end of the valley. An eyewitness, writer Andrew D. White, described what he saw when he hastened along roads crowded with buggies and carriages to the scene of the find, the farm belonging to a Mr Newell:

> In the midst was a tent, and a crowd was pressing for admission. Entering, we saw a large pit or grave, and, at the bottom of it, perhaps five feet below the surface, an enormous figure, apparently of Onondaga grey limestone. It was a stone giant, with massive features, the whole body nude, the limbs contracted as if in agony. It had a colour as if it had lain long in the earth, and over its surface were minute punctures, like pores. An especial appearance of great age was given it by deep grooves and channels in its under side, apparently worn by the water which flowed in streams through the earth and along the rock on which the figure rested. Lying in its grave, with the subdued light from the roof of the tent falling upon it, and with the limbs contorted as if in a death struggle, it produced a most weird effect. An air of great solemnity pervaded the place. Visitors hardly spoke above a whisper.

Andrew White was told that the farmer who lived there had discovered the figure when digging a well. White was instantly suspicious. It must be a hoax. Why should the farmer be digging a well in a spot so far from the house and the barn, when there was a spring and ample running water much closer to hand? What was the figure, anyway? Not a statue,

surely – although it was vaguely reminiscent of a massive Michelangelo creation; besides, there was no pedestal. Nor could it be a fossilised figure, despite the minute pores which the carver had punctured in the surface.

Over the next few weeks, the arguments against the possibility of a hoax built up. The farmer had neither the ability nor the means to devise such a fraud. His family had lived there steadily for many years and were ready to declare under oath that they had never seen it, or known anything of it, until it was accidentally discovered. The neighbours had never seen it or heard of it, and it was preposterous to suppose that such a massive stone artefact could have been brought and buried in the place without someone noticing something. In no time at all, a syndicate of local entrepreneurs and dealers was formed to exploit the curiosity the find had excited. High admission charges were levied. Negotiations to purchase the figure and exhibit it were begun, and an impresario appointed.

In the absence of a hoax theory, myth and legend sprang up with remarkable rapidity. The neighbouring Onondaga Native Americans had abundant traditions of giants who formerly roamed the surrounding hills, and it was reported that an Onondaga squaw had declared that the statue was 'undoubtedly the petrified body of a gigantic Indian prophet who flourished many centuries ago and foretold the coming of the palefaces and who, just before his death, said to those about him that their descendants would see him again'. Others reflected sagely on the words of the Bible: 'There were giants in the earth in those days' (Genesis 6:4). Here, surely, was the proof. Clergymen delivered sermons:

> Is it not strange that any human being, after seeing this wonderfully preserved figure, can deny the evidence of his senses and refuse to believe, what is so evidently the fact, that we have here a fossilized human being, perhaps one of the giants mentioned in Scripture?

A deputation of eminent regents from Albany State University opined, 'Altogether, it is the most remarkable object brought to light in this country, and, although not dating back to the Stone Age, is, nevertheless, deserving of the attention of archaeologists.' They also stated that if it weren't a petrified giant, as a statue it was a work of art of sublime merit.

The statue was next raised from its grave and put on show in Syracuse and various other cities (including New York). And then the balloon began to lose its air, and a healthy scepticism began to replace awed and wishful admiration. A distinguished palaeontologist and art critic from Yale University examined the figure and pointed out that it was not made of hard grey Onondaga limestone but a soft, friable sulphate of lime – a form of gypsum – which must have been brought from some other part of the country. 'It is of very recent origin, and a most decided humbug,' he declared.

Other suspicions now arose. It emerged that Farmer Newell had just remitted several thousand dollars (the result of admission fees to the booth containing the figure) to his brother-in-law Hull, who lived somewhere out west. Neighbours remembered seeing a tall, lanky individual who was a frequent visitor to the Newell farm. Other farmers now recalled meeting Hull at various staging points on the turnpike road leading south to Binghamton; he had been driving a wagon carrying a huge box which he claimed contained some tobacco-cutting machinery en route to Syracuse. Further inquiries revealed that the wagon had never gone farther than Cardiff.

The good people of the Onondaga Valley, most of whom had bought shares in the enterprise, were dismayed and issued a pamphlet entitled *The American Goliath*. Then Phineas T. Barnum, the king of showmen, offered to buy the giant but was refused. Barnum responded by making an exact replica of the figure and exhibiting it as 'The Cardiff Giant', and with that, the credit of the discovery fell sharply.

The end was now nigh. Affidavits from witnesses established the fact that the figure had been made at Fort Dodge, Iowa, from a huge block

of gypsum which had been found there. This block was transported by wagon to the nearest railway station, but on the way the wagon broke down, and a portion of the block had to be cut off. The surviving piece was taken to Chicago, where a German stone-carver gave it its final shape; because of the shortening of the block, the lower limbs had to be drawn up, thus giving it its strikingly contracted and agonised appearance. It was then pitted with minute pores, by means of a lead mallet faced with steel needles, and stained to give it an appearance of great age. Finally, it was driven to Cardiff and buried. In order to protect his family from the risk of perjury, Newell had sent them off on an excursion while he buried it.

Realising that the game was up, Hull (because it had all been his idea, of course) bowed to the inevitable and acknowledged that the whole thing was a swindle. He had made more money out of it than he had expected – but why had he embarked on the scam in the first place? One should always be wary of accepting at face value anything a forger says, but Hull claimed that he had once been worsted at a Methodist revival meeting when he had rashly raised the subject of 'those remarkable stories in the Bible about the giants'. Ever since then, he said, he had wanted revenge – and this he had achieved with his phoney 'giant', which had rendered all the Bible-bangers ridiculous.

Chapter 2 Notes

1. Runes were the basis of the system of writing, incised on bone, wood or stone, which was used by the Norsemen before the introduction of the Roman alphabet. The runic alphabet, known as *futhark* from the values of its first six symbols, consisted originally of sixteen twig-like letters. Runes were mostly used for memorial inscriptions and were also believed to have magical significance.

2. Swanscombe Man was an incontrovertibly authentic fossilised skull from the lower palaeolithic period, dating from *c.*420,000 and 200,000 years ago. The first fragment of skull was discovered in Barnfield Pit on 29 June 1935; two others were found in 1936 and 1937. It is still regarded as one of the oldest known human remains from anywhere in Europe, although an even earlier British hominid skull has recently been discovered (Boxgrove Man). The Swanscombe site was declared a National Nature Reserve in 1954 and is now a designated Heritage Park. In 1985, I had the honour of unveiling a special commemorative plaque at Barnfield Pit to celebrate the 50th anniversary of the discovery.

3. The land was rather hastily returned to its owner (in 1954) and the SSSI later de-designated (in 1963).

4. I am indebted to an old friend and BBC colleague for his guidance and help with the composition of this chapter – Paul Jordan, a producer on the BBC2 *Chronicle* series in history and chronology which I presented for many years (1966–80). In 1975, Paul directed a *Chronicle* programme on Glozel entitled 'The Great Glow-Curve Mystery', which explored the thermoluminescence 'crisis' which exploded on the Glozel mystery in 1974. He also contributed an essay on Glozel to a BBC commemorative book on *Chronicle* (1978). He has published several books on history and archaeology, including *The Seven Wonders of the Ancient World* (2002) and *North Sea Saga* (2004).

5. The Glozel Museum website – http://www.museedeglozel.com/ Chamfoui.htm – is run (at his own expense) by a family friend in Vichy called Joseph Grivel, who teaches modern literature to senior pupils and is an indefatigable supporter of the Glozel site.

6. Shortly before her death in 1968, Professor Garrod recorded a filmed interview for *Chronicle* in which she reminisced about the sometimes lurid events surrounding the work of the Glozel Commission. An edited version of the interview was published in *Antiquity* in September 1968.

7. In September 1929, before M. Bayle had time to complete his report, he was assassinated by a criminal whose activities had been unmasked by the work of the Service d'Identité Judiciaire. It was a sorry footnote to this murky business.

8. Wilkins would later be awarded the 1962 Nobel Prize for physiology and medicine jointly with the pioneers of DNA, Francis Crick and James Watson. But it was not for his formulation of the thermoluminescence dating method; the Nobel Prize was awarded for his X-ray data of DNA fibres, from which Crick and Watson deduced their double-helix model of DNA.

9. I am indebted to the historian Kirsten A. Seaver for her unstinting assistance with the preparation of this chapter. Her own book on the subject, *Maps, Myths and Men: The Story of the Vinland Map*, was published by Stanford University Press (Stanford, CA) in May 2004.

10. *Búð* (booth) was the Icelandic term for temporary accommodation at assemblies and other gatherings. A booth was a stone-and-turf enclosure which could be roofed with cloth for occupation.

11. I am grateful to Dr Birgitta Wallace, staff archaeologist emeritus for Parks Canada, for providing me with the latest academic thinking on the derivation of this puzzling name.

12. The Tartars, or Tatars (Mughals), had been a very considerable threat to eastern Europe in the thirteenth century under Genghis Khan and were becoming a threat again in the fifteenth century.

13. This Latinisation of the name 'Leifur Eiríksson' betrays a total

ignorance of the Norse patronymic system of personal nomenclature: *erissonius* should have been *Erici filius* – 'son of Eiríkur'.

14. This was a time, remember, in the chaotic conditions of post-war Europe, when Nazi loot was coming onto the market, and unscrupulous buyers did not inquire too deeply into an item's provenance – people turned a profit wherever they could.

15. This informal 'ring' only became apparent in the 1980s when Barbara Shailor, now head of the rare books collection (the Beinecke Library) at Yale, made a careful catalogue of all the Yale manuscripts which had been acquired through Thomas Marston.

16. The mistranslation of 'Eiríksson' as *erissonius* rather than *Erici filius* (cf. footnote 13) is a case in point.

3

Secret Lives: Impostors and Hoaxers

The secret lives of impostors who have passed themselves off as other people – and not necessarily for profit – make fascinating reading. Many of the perpetrators wanted to leave their old lives and escape from situations which were causing them such conflict that they felt they could not resolve them, and the only way to deal with their problems was to wipe the slate clean. By living a lie, or lies, they could open doors of opportunity and create new lives for themselves which turned secret ambitions into reality.

Some philosophers assert that the concept of 'identity' is nothing but an irrelevant abstraction of no significance, but the real identity of a person claiming to be someone else can have profound ramifications and can inspire extraordinarily contradictory testimonies from friends, colleagues and family members, for whatever motives – especially where money and status are at stake.

The story of the 'missing survivor' of the murder of Tsar Nicholas II and his family at Yekaterinburg in July 1918 has fascinated the world for many years. The story inspired two major films in 1956 (*Anastasia*, with Ingrid Bergman, and a German film called *Anastasia – Die Letzte Zarentochter*

with Lilli Palmer; it was released in the USA as *Anastasia: The Czar's Last Daughter* and in the UK as *Is Anna Anderson Anastasia?*); there was also an award-winning TV series in 1986 (*Anastasia: The Mystery of Anna*, with Amy Irving), as well as a host of books and articles.

In 1920, a patient in a psychiatric hospital in Dalldorf, Germany, who was reading an article about the execution of the Romanov family, noticed a strong resemblance between a photograph of the youngest of the daughters (she was 17 at the time) and a teenage patient who had been admitted some weeks previously. This girl had been dragged semi-conscious from a canal in Berlin after a failed suicide attempt; she had papers identifying her as 'Anna Tschaikowski'. As soon as she regained her strength in hospital she claimed to be Anastasia. The hospital summoned one of the late Tsarina's ladies-in-waiting, now living in Berlin, to check the possible identification – and she confirmed it: the patient was indeed the Grand Duchess Anastasia, who must have miraculously survived the massacre of her family by the Bolsheviks. At least a dozen Romanov relatives agreed; but Anastasia's French tutor, Pierre Gaillard (whose wife had been Anastasia's nurse), her godmother and various other Romanovs declared with equal conviction that she was *not* Anastasia.

There was much at stake. A large proportion of the immense Romanov fortune was reputed to have been smuggled out of Russia just before the Revolution and deposited in banks in the West. Some estimates put the family's wealth in cash alone at £800 million; estates in Germany would add a great deal more.

The story Anna had to tell was the very stuff of legend: she had been rescued, more dead than alive, from the cellar in which her family had been butchered, by two of the Bolshevik guards; these two guards (brothers named Tschaikowski) had smuggled her out of Russia. With money obtained by selling a pearl necklace and uncut emeralds sewn into her dress, she and her companions reached Bucharest, where she married one of the brothers and had a baby by him. Soon afterwards, her husband was recognised by Bolshevik agents and assassinated; Anna had a nervous breakdown, and her child was taken away to be adopted.

Her brother-in-law Sergei took her for safety to Berlin, but on the day they arrived, he disappeared, and she decided, in despair, to end her life by jumping into the canal . . .

No trace was ever found of the Tschaikowski brothers or of Anna's child. But for the next ten years, having adopted the name 'Mrs Anna Anderson', she lodged claims for the return of her title and family fortunes, and made contact with Tsarist sympathisers. Her knowledge of the very smallest details of the royal family life won her many supporters.

In 1933, a court in Berlin made the presumption that Anastasia had died at Yekaterinburg and granted a document of inheritance for the Tsar's property in Germany to six surviving relatives. The campaign for Anna's recognition as Anastasia was renewed. Anna underwent searching medical examinations in hospital: X-rays revealed serious skull injuries which could have been caused by a rifle-butt; bunions on her feet were in the same place as those of the Tsar's daughter; and a scar on her right shoulder blade, where a mole had once been cauterised, was similar to one shown in Anastasia's medical records. Another small scar on the middle finger of her left hand was claimed to be the damage caused by a careless footman who had slammed the door of a coach on her – an incident corroborated by a former lady-in-waiting. Despite all that evidence, however, several Romanov relatives who stood to gain by the Berlin court's order denounced Anna Anderson as an impostor – not least because this potential First Lady of the old Russian aristocracy spoke no Russian (in her autobiography, written in German, Anna claimed that her sufferings had made Russian repugnant to her).

In 1938, Anna's lawyers brought an action to have the 1933 court order annulled. The outbreak of the Second World War prevented the action being heard, however. Eventually, in May 1968, a court in Hamburg ruled against her. Anna Anderson thereupon went to the USA and married Dr John Manahan, a former history professor.

But if not Anastasia, who actually *was* 'Anna Anderson'? In 1927, a private detective produced a Berlin landlady who identified Anna as Franziska Schankowska, a peasant girl who had disappeared from her

lodgings at the same time as Anna had been rescued from the canal. A member of the Schankowski family also declared Anna to be her sister, although this was never proved to the satisfaction of a court of law.

In 1995, however, after Anna's death, DNA tests on her remains apparently proved conclusively that Anna Anderson was not the person she claimed to have been: she was not the Grand Duchess Anastasia.

I am also fascinated by the story of 'Dr James Barry', a pioneering nineteenth-century physician who lived and worked publicly as a male doctor. Dr Barry was (to paraphrase W.G. Gilbert's ditty in *The Pirates of Penzance*) the very model of a modern army medico; he was also a very distinctive nineteenth-century oddity – because through his long medical career, Dr Barry succeeded in concealing the fact that 'he' was actually a woman. It was only after his death in 1865, when the body was being prepared for burial, that the morgue attendant realised that Dr Barry was a female – a female, what's more (judging by the tell-tale stretch marks), who had given birth to a baby in her youth.

Dr Barry graduated from Edinburgh University in 1812 and then served an excellent apprenticeship at Guy's and St Thomas's Hospitals before taking up a series of high-profile postings in the growing British Empire, from the Cape Colony to Malta. Progressive and scientific, he set out to improve hygiene, develop new surgical techniques and enhance nursing care. He advocated clean water, good food and sanitation for health in the tropics. He held enlightened views on leprosy, prostitution and slavery, and performed one of the world's first successful Caesarean section operations. At postings in the Cape, St Helena (to treat Napoleon), Corfu and Canada he won praise for his medical prowess but created enemies among the administrators whose work he slated unsparingly.

He was snobbish and self-righteous, quick to take offence and to fight pointless duels. He dressed like a Regency dandy, with thigh boots, long coat and dyed hair. He guarded his privacy fiercely (no wonder, one can say with hindsight) and kept a black servant.

Women fell for him, but he avoided them and seemed to have little

empathy with them; indeed, in the Crimea he delivered an astonishingly severe public dressing down to Florence Nightingale for her hospital standards. He attracted curiosity because of his effeminate looks and survived a scandal when the governor of the Cape was accused of having a homosexual relationship with him.

But who was 'James Barry' and why did he/she carry out this long deception? Had she been a hermaphrodite, with a pair of undeveloped testicles which had arrived at puberty? It's not impossible. Was she a lesbian who assumed a male identity to get close to women? That seems unlikely. Did she ever have a baby? It's possible but not proven.

Perhaps she was simply a woman with a burning desire to be a doctor at a time when that profession was totally barred to females – Britain's first woman doctor, Elizabeth Garrett Anderson, did not qualify as a medical practitioner until 1865, the year of Dr Barry's death. Certainly, throughout her career, she proved that women could be just as good at medicine as men and better than most of them.

If anyone deserves the title of 'Prince of Impostors', it is a man named Ferdinand Waldo Demara (1921–82). What an extraordinary story his is. From a very early age, Demara had wanted to devote himself to the Catholic Church. In 1935, at the age of 14, he ran away from home and asked to be admitted to a Trappist monastery. He stayed for two years, earning his habit and hood, and was named Frater Mary Jerome. He loved the life and was stricken to the heart when the monks eventually told him he was not 'the right stuff' for monastery life. Faced with this rebuff he started to create new personae for himself. He became adept at borrowing identities, filching letterhead stationery, forging official certificates and composing bogus references in order to live out other people's lives. He had a phenomenal memory and an extraordinary ability to study and master whatever disciplines he required for his impostures: medicine, rational psychology, theology, metaphysics, cosmology, ethics . . .

The remarkable thing about Demara was that he proved to be

exceptionally good at all his impostures. He did not just use false names – he assumed the identities to the full and proved himself remarkably skilled at doing their jobs. Despite having had no formal training, he became a naval surgeon, a prison warder and psychiatrist, a schoolteacher, a clergyman, and a religious counsellor – all with noteworthy success. As a naval surgeon ('Dr Joseph Cyr') he never lost a patient and certainly saved lives – in one case he operated successfully to remove a bullet lodged in the tissue surrounding a wounded sailor's heart. As a prison warder ('Ben W. Jones') at Huntsville Prison in Texas (known as the 'Alcatraz of the South'), he greatly impressed the governor with his skill in handling psychologically unstable prisoners; on one occasion, he disarmed a violent and unbalanced man by dint of gentle reasoning alone, and on another, he single-handedly defused a potential prison riot. As a schoolteacher he was held in such high regard that when he was arrested for teaching under false pretences, a delegation of parents pleaded not only for his release but also for his reinstatement – he was the best teacher, they claimed, their children had ever had.

As a result of his escapades, he became a celebrity throughout North America, which made further impostures difficult. So, in 1970, he turned up under his own name as the Revd Dr Fred Demara, taking to the pulpit at the San Juan Baptist Church, Friday Harbor, Washington, and, in 1978, he worked as a religious counsellor to the sick and dying in Anaheim, California. Only ill health caused him to give up. He died of heart failure at the age of 60. For Ferdinand Waldo Demara, one life had not been enough.

The story of the dapper little English accountant who became notorious as 'the Laird of Tomintoul' in Scotland would almost be funny if it wasn't so serious. Anthony Williams, from suburban Surrey, lived a sedate life as an accountant in the Metropolitan Police, which he had joined as a civilian clerical officer in 1959 at the age of 20. For the next 25 years, he rose slowly up the ranks of the Met's civil division; he married, fathered two daughters, got divorced and adopted gold-rimmed spectacles. By

1986, having remarried, he had risen to the post of deputy finance director, with a reputation for solid dependability. However, he had been siphoning off, unnoticed, small sums from the civilian staff welfare fund. Williams was also in charge of a slush fund (the so-called 'Strategy Fund'); it was his responsibility to sanction payments for information helpful in anti-drug and terrorism operations from this source. Few supergrasses provide receipts, and Williams dispensed Met funds at his own discretion. He was the underworld's banker, unhindered by accountability or audit – in effect, he had a blank chequebook and a bottomless supply of cash. And for 12 years, he systematically embezzled £5.3 million from this unaccountable account.

In 1987, Williams began making the cheques out to himself. He used the cash to pay off his private debts because, secretly, this quiet, model accountant had a yen for the high life. His spending grew more lavish, until he bought much of the Highland village of Tomintoul, in Banffshire; the chocolate-box serenity of the place had captivated him during a holiday in nearby Ballater. He also purchased a feudal title – the Barony of Chirnside – for £60,000 at an auction, enabling him to call himself 'Lord Williams'.

The locals welcomed this tartan tycoon, as they dubbed him, for the 40 new jobs he was providing. He started by buying a run-down property on the village green called Mallory Cottage for £6,000 and spent £400,000 on its renovation – and then the real spending spree began.

He formed a company, Tomintoul Enterprises, which (for £200,000) bought the dilapidated 29-bedroomed Gordon Arms Hotel which superintends the village square and spent an estimated £1.5 million on refurbishing it. Williams also spent £500,000 on purchasing and developing the nearby Clockhouse Restaurant. He bought Gordon Lodge, a bungalow on the outskirts of the village, which is now the manse of the local kirk. He bought the site of the old fire station and a transport depot. He sponsored the local Highland games. Finally, he bought the Old Manse, a picturesque three-storey building, ten miles

from the village and overlooking Glenlivet, where he planned to live out his fantasy-life retirement as a benevolent Highland laird.

Meanwhile, he was spending money freely elsewhere – for example, a £370,000 mansion at Haslemere in Surrey and a £140,000 luxury villa in Malaga on the Costa del Sol.

Few of the villagers of Tomintoul apparently questioned where all the money was coming from, although rumour was rife enough; they probably had no wish to look this free-spending gift horse in the mouth. Williams enjoyed all the trappings of a millionaire lifestyle: a Coutts Bank gold credit card with 'Lord Williams' embossed on it, a fleet of luxury cars and a stable of horses. The villagers were more than thankful that an outsider had come to the village and was transforming its run-down commercial heart.

The Laird of Tomintoul was eventually exposed in July 1994. His assets were frozen but only about £1 million of the missing £5 million was recovered. At the end of his trial in 1995, he was sentenced to seven and a half years in prison. A local brewery celebrated by producing a beer it named 'The Laird of Tomintoul'!

The four chapters in this section look at the false-identity issue from four very different perspectives. How on earth did an obese cockney adventurer resident in Australia succeed in passing himself off, in 1854, as a slim young English aristocrat who had disappeared ten years earlier (Chapter 3.1 – The Tichborne Claimant: Arthur Orton)? This ludicrous imposture, which involved a large inheritance, only worked because the missing heir's mother so desperately wanted to believe that her son was still alive. Orton got his come-uppance: after losing a long and acrimonious court case, he was charged with perjury and given a 14-year jail sentence.

Ellen Craft, the black slave who 'passed' as white, is the subject of a moving story which tells of the deep yearning of oppressed slaves in the southern states of the USA to free themselves of their shackles (Chapter 3.2 – Escape from Slavery: Ellen and William Craft). It is only one of a

large genre of 'passing' stories (passing oneself off as someone else) which chronicle this tragic period of American history. But what a riveting tale it is. In 1848, Ellen Craft, whose skin was comparatively pale, escaped from Georgia disguised as a white man, with her husband acting as her black slave. After a nightmare journey by train, in an agony of terror and with frequent hair-raising escapes from discovery, they reached relative safety in first Philadelphia and then Boston. Even in these two northern cities they were pursued by bounty hunters, until they eventually found haven in England. Three years after the end of the American Civil War, the Crafts returned to the United States, but their attempts to establish a cooperative farm and school in Georgia foundered.

Chapter 3.3 (The Turk in the Cabinet: The First Chess Automaton) traces the way in which a stage illusion – a mechanical chess-playing automaton invented to amuse the Viennese court in 1769 – was appropriated by an impresario in 1804 and touted around the world as a genuine, thinking chess-playing machine – a nineteenth-century Deep Blue, in effect. The automaton defeated some of the best chess players in the world. But how was it done? It was 30 years before the trick was rumbled, by a young journalist named Edgar Allan Poe.

But perhaps the most striking story of a secret life is that of a man who today is known only by the unlikely name of George Psalmanazar (Chapter 3.4 – The False Formosan: George Psalmanazar). Where he came from, no one knows, but early in the eighteenth century he arrived in London claiming to be a native of the (then) little-known island of Formosa (now Taiwan). He made a mint from a totally fictitious account of his 'native' island and became a society celebrity. However, he eventually confessed to his imposture and became a pious, hard-working Grub Street hack. He later enjoyed the undying admiration of that arch-scourge of impostors, Dr Samuel Johnson.

It takes all sorts . . .

3.1 – The Tichborne Claimant: Arthur Orton

> Some men has plenty money and no brains, and some men has
> plenty brains and no money. Surely men with plenty money and
> no brains were made for men with plenty brains and no money.
>
> Written in the Tichborne Claimant's pocket book

The big house at Tichborne Park, near Winchester in Hampshire, stands four-square and elegant in the middle of its parklands. It is the ancestral home of what was once one of the wealthiest Roman Catholic families of post-medieval England, reaching back to beyond the Norman Conquest.[1] The baronetcy has now lapsed, but a Tichborne descendant still owns it: Anthony Loudon, a young stockbroker who lives in London but weekends at Tichborne. He and his wife Catherine cherish the house, the history and the romance of the Tichborne inheritance – and, not surprisingly, they have a very special interest in one of the most lurid episodes in the family's long and distinguished history. In the second half of the nineteenth century, Tichborne was at the epicentre of a spectacular story whose legal ramifications shook and fascinated Victorian England – a claim by a butcher from London's Wapping to be the missing heir to the Tichborne title and estates.

To explain: in April 1854, Roger Charles Tichborne, the young heir to the Tichborne fortune, disappeared when a cargo boat on which he was sailing from Rio de Janeiro to Jamaica foundered with the presumed loss of all lives on board. It would give rise to one of the most spectacular – and longest – trials in English legal history.

But there is another Tichborne story, much older and even more mysterious, which seems to be intertwined with the 'Tichborne Claimant' business: the story of the so-called 'Tichborne Dole'. To me, it adds another, almost eerie, dimension to the story of the Tichborne Claimant.

The Tichborne Dole

A magnificent seventeenth-century painting by the Flemish artist Gillis van Tilborch (1625–78), which hangs in the dining room of Tichborne House, records the traditional tale of the Tichborne Dole. It depicts the third Tichborne baronet, Sir Henry Tichborne, distributing loaves of bread to the poor at Tichborne House on the feast of the Annunciation (Lady Day) on 25 March 1670. The painting was no doubt commissioned as a piece of propaganda in the troubled years of the reign of King James II, in order to prove the patriotism and loyalty of a prominent Roman Catholic family which had the good of the country at heart.

So what was the Tichborne Dole? Legend has it that the dole was established, back in the thirteenth century, by Lady Mabella Tichborne. As she lay on her deathbed, she asked her curmudgeonly husband to grant her the means to leave a charitable bequest of a dole of bread to be distributed to any poor folk who should apply for it at Tichborne House on Lady Day. Her husband was reluctant, but, in the end, he cynically agreed to allow a bequest of the corn from all the land his dying wife could cover while holding a burning brand. Too weak to walk, Lady Mabella succeeded in crawling around a 23-acre field just north of Tichborne Park; it is called 'The Crawls' to this day.

Legend also has it that Lady Mabella laid a curse on any of her successors who failed to distribute her charitable dole: the penalty for such failure would be a generation of seven sons followed by a generation of seven daughters – there would be no male heirs, the family name would die out and the ancient house would fall down. Just an old superstition, you think? The fact is that the dole was temporarily discontinued in 1796, by which point 'Dole Day' had become a very rowdy affair with vagrants and paupers converging on Tichborne from all over. And what happened? Part of the old Tichborne House fell down in 1803; Sir Henry Tichborne (d.1821), the seventh baronet, produced seven sons; and his eldest son, the eighth baronet (Sir Henry Joseph Tichborne), produced seven daughters . . .

It goes against all rational thinking to believe that the Tichborne Dole

curse is anything more than an old wives' tale. But there are Tichborne descendants who half-believe in it, at least, to this day. They point to the fact that the central, tragic, character in the Tichborne Claimant business, Roger Charles Tichborne, the heir who never succeeded, was born in 1829, during the time when the dole was suspended, whereas his younger brother, Alfred Joseph Tichborne, who *did* succeed as the 11th baronet, was born in 1839, *after* the dole had been reinstated in an attempt to ward off the 'Dole Curse'. Whatever the truth of it, it makes a riveting story.

Roger Charles Tichborne

Dole Curse or not, by the beginning of the nineteenth century, the future of the ancient family was looking rather precarious. The seventh baronet, Sir Henry Tichborne, who died in 1821, had seven sons – including Henry Joseph (the eighth baronet) – and there seemed little danger of a failure of male heirs. However, everything went wrong. Was the curse beginning to take effect? The eldest son, Sir Henry Joseph, succeeded to the baronetcy as the eighth baronet; he had seven daughters but no sons. The second son, Benjamin Edward (1780–1810), a captain in the army, died unmarried at the age of 30. The third son, Edward (1782–1854), who would change his name to Tichborne-Doughty, had no male heir. The fourth son, James Francis (1784–1862), seemed destined to remain a bachelor. The fifth son was killed during the Indian Mutiny in 1806 at the age of 18. The sixth son died at the age of thirteen. The youngest of the seven sons, Robert Tichborne, was married but had no male children.

When the seventh baronet, Sir Henry Tichborne, died in 1821, he was succeeded by his eldest son, Henry Joseph, as the eighth baronet. Henry Joseph died in 1845, having produced seven daughters but no sons. He was succeeded as the ninth baronet by his eldest surviving brother, Edward. Edward had already inherited a huge fortune (including lands in Lincolnshire and Dorset, a square mile of High Holborn and much of Edgware Road in London, and a large town house in Kew) from an

elderly cousin named Elizabeth Doughty, the unmarried granddaughter
of the fourth baronet; a condition of the inheritance was that he should
change his name to 'Doughty', which he did. When he succeeded as the
ninth baronet, he changed his name again, to 'Tichborne-Doughty'. He
married a daughter of Lord Arundell of Wardour. The couple had one
son who died, alas, at the age of six in 1836, but they also had a daughter
named Katharine Doughty, who would become an unwitting catalyst in
the Tichborne Claimant story.

Dole Curse or no (again!), since Sir Edward Tichborne-Doughty did
not have a male heir, the hopes of survival for the name of this ancient
family through the male line now depended entirely on his younger
brother, James Francis Tichborne, the fourth son of the seventh baronet.
James Francis had never entertained any hopes of succeeding to the title
and had remained a bachelor for many years. But, in 1827, at the age of
43, he married Henriette Felicité Seymour, a beautiful and flighty 20-
year-old French woman, the illegitimate daughter of a landed Wiltshire
squire and a member of one of the most distinguished families in France,
the Bourbon Contis. With her, James Francis Tichborne produced two
sons who would shore up the succession. Their elder son was Roger
Charles Tichborne, who was born on 5 January 1829 (while the dole
was suspended, incidentally), and the younger son was Alfred Joseph
Tichborne, born in 1839 (*after* the dole was resumed). There were also
two daughters, both of whom died in infancy.

With the birth of his two sons, the Tichborne succession could be
considered secure when James Francis Tichborne succeeded his brother
Edward as tenth baronet in 1853. But what sort of succession would
it be? The marriage of James and Henriette Felicité turned out to be
a stormy, unhappy affair. Henriette Felicité, whose handsome portrait
hangs in Tichborne House, was imperious and demanding. She disliked
England and the English quite intensely; she also had a particular dislike
for her English in-laws. She insisted that she and her husband should
make their home in France, not Hampshire, and he, poor fellow, with
the limited income of a younger son, could only agree. When Roger was

born in Paris in 1829, he was not to enjoy the traditional upbringing of English landed gentry; at their home in the Rue St Honoré, his mother saw to it that he and (later) his younger brother were brought up as typical homebred French boys. Roger's health was considered delicate, and his mother refused to allow him to attend school. As a result, his education was sketchy, to say the least.

James Tichborne, however, wanted his elder son, the heir apparent to the Tichborne inheritance, to be given the kind of English education which would enable him to take his place as a leading member of the Hampshire gentry. The opportunity did not arise until Roger was 16 years old. When the eighth baronet, Sir Henry Joseph, died in 1845, Roger's father used the occasion of his elder brother's funeral to take the boy to England; once there, behind his wife's back, he enrolled him at Stonyhurst College in Lancashire, the leading Catholic public school in England.[2] In their Paris home, Mrs Tichborne was beside herself with fury, but the deed was done, and young Roger spent three happy years there, participating enthusiastically in team sports such as hockey ('bandy', as it was called at Stonyhurst) and learning to be an English Roman Catholic gentleman, if little else. He was taught the rudiments of Greek and Latin, and a little mathematics, and he learned to speak English fluently, although he never lost his French accent.

When Roger left Stonyhurst, he joined the army – once again, much against his mother's wishes. He obtained a commission in the prestigious 6th Dragoon Guards (the Carabineers), joining his regiment as a subaltern in October 1849. He spent three years with the regiment but never succeeded in making a good cavalry officer. His pronounced French accent made him the laughing-stock of the officers' mess and the butt of endless practical jokes; he is said to have had a genital malformation (his penis was retracted), and he was nicknamed 'Tich', of course. In December 1852, he quit the army. He had set his heart on an overseas posting on active service, but when this was not forthcoming, he sent in his papers.

You see, young Roger Tichborne was in the toils of love sorrow. At

Stonyhurst he had spent his holidays (and later his army leave) with his relatives in England, especially with his uncle Sir Edward Tichborne-Doughty and aunt Katharine at Tichborne or at Upton, their seat in Dorset. Gradually, he had formed a deep attachment to his enchanting first cousin, Katharine Doughty. Both Sir Edward and Lady Doughty, who treated him like their lost son, were extremely fond of him and recognised that his Tichborne prospects made him a desirable husband for their daughter, but there were serious drawbacks: in the first place, according to Roman Catholic church law, first cousins were not allowed to marry without papal dispensation; and in the second place, Roger was developing a reputation for instability and dissipation, smoking and drinking to excess. After a Christmas visit in 1851, Sir Edward Tichborne-Doughty – no doubt regretfully – told him he could not sanction a marriage and advised Roger to go away quietly. The lovers had a tearful parting, and Roger returned to his regiment. In less than a fortnight, however, their hopes were revived. On what Sir Edward Tichborne-Doughty believed to be his deathbed, he summoned Roger and gave his consent to an engagement, provided that a papal dispensation was obtained and that Roger's parents gave their approval. The engagement did not last long, however. Sir Edward Tichborne-Doughty rallied, and further scurrilous stories about Roger reached Lady Doughty's ears. In some alarm, the Tichborne-Doughtys insisted that their daughter should be free for three years and that there should be no communication between the sweethearts for that period.

In June 1852, Roger Tichborne met his cousin for the last time. He had not abandoned his hopes of ultimate success, and he gave Katharine a piece of paper which contained his declaration of intent:

> I make on this day a promise that if I marry my cousin, Katharine Doughty, this year, before three years are over, at the latest, to build a church or chapel at Tichborne to the Holy Virgin, in thanksgiving for the protection which she has thrown over us, and in praying to God that our wishes may be fulfilled.

A copy of this document, which Roger deposited in a sealed envelope marked 'Private and Confidential' and left with a close confidant (Vincent Gosford, steward of the Tichborne estates), would later have a considerable bearing on the trial of the Tichborne Claimant.

Roger Tichborne, however, was resolved to go abroad to cope with his love sorrow and decided on a long trip to South America. Since coming of age in 1850, he had been financially secure, with a yearly allowance of £500. He went to Paris to take leave of his parents, and in March 1853, he sailed from Le Havre in a French vessel bound for Valparaiso, the chief seaport of Chile. He must have felt considerable relief. Apart from the pain of his love life, his Paris home had become what he called 'a hell upon earth' because of the unhappiness caused by his mother's ferocious temperament.

When he reached Valparaiso in June 1853, he learned of the death of his uncle, Sir Edward Tichborne-Doughty; James Francis, Roger's father, succeeded to the baronetcy as Sir James Doughty-Tichborne. The news was perhaps not entirely unwelcome: Roger's allowance from his parents of £500 a year was immediately doubled after his uncle's death, and he may have felt that his marriage prospects had been enhanced as well. He wrote to his newly widowed aunt to say that he planned to travel for 18 months in South America and then go on to India.

For a year and more, Roger travelled all over South America. He kept a diary of his travels and sent copious, chatty letters home about his adventures to his parents and relatives (especially to his aunt, Lady Doughty). He also sent back to Tichborne a varied collection of stuffed birds, skins of exotic animals and other curios.

Eventually, he reached Rio de Janeiro. His next destination was to be Jamaica. On 20 April 1854, he took passage on an English ship, the *Bella* from Liverpool, en route for Kingston. Four days later, her longboat was found floating upside down, and articles of wreckage which belonged to the ship were found in the vicinity. There seemed little doubt that the *Bella* had foundered with the loss of all lives. Despite exhaustive enquiries by Lloyds of London, nothing more was heard of the ship or

those on board. The insurance money was duly paid, the owners settled with the relatives and, in July 1855, Roger Tichborne's will (which he had drawn up in 1852) was proved. Sir Roger Tichborne was now legally dead.

What happened to the other players in the drama? In the same year as the *Bella* foundered, Katharine Doughty, Roger's great love, married Percy Radcliffe, the wealthy heir to a Yorkshire baronetcy. In June 1862, Sir James Doughty-Tichborne died and was succeeded in his title and estates by his only surviving son, Roger's younger brother Alfred, who assumed the additional name of Doughty as his father had done before him. Sir Alfred Doughty-Tichborne was an alcoholic and recklessly extravagant, landing himself in considerable financial trouble. When he died in February 1866, the estate was seriously involved. He had married a daughter of Lord Arundell of Wardour (a niece of Lady Doughty), and he had left no living issue, but three months after his death, his widow gave birth to a son, Henry Alfred Joseph Doughty-Tichborne, who thereupon inherited everything.

One person refused to accept that Roger Tichborne was dead, however – his mother Henriette, the dowager Lady Tichborne. Psychologists have argued that when she heard of her elder son's disappearance, her grief was tainted by bitter regret that she had let their relationship deteriorate, and the possibility that he might still be alive seemed to offer an end to her feelings of guilt and an opportunity to redeem herself.

Be that as it may, she became obsessed with her belief that Roger was still alive. She pursued every rumour of shipwrecked mariners, she kept a light burning all night in the hall at Tichborne House to guide her son home, and she had a welcome and a sovereign for every down-and-out sailor with a cock-and-bull story. Her long-suffering husband could do nothing to combat this obsession. When he died in 1862, his elder son Roger would have inherited; the question of the inheritance came up with renewed urgency, and Henriette could indulge her obsession even more freely. From 1863, she placed advertisements in several newspapers in South America and Australia, but without success. In May 1865,

having read in *The Times* of a Mr Cubitt, who ran a 'Missing Friends' agency in Sydney, she wrote to him to ask him what he could do. On her behalf, Mr Cubitt inserted a somewhat inaccurate advertisement in the *Melbourne Argus*:

> A handsome reward will be given to any person who can furnish such information as will discover the fate of Roger Charles Tichborne. He sailed from Rio Janeiro on the 20th of April 1854 in the ship *La Bella* and has never been heard of since, but a report reached England to the effect that a portion of the crew and passengers of a vessel of that name was picked up by a vessel bound to Australia, Melbourne it is believed. It is not known whether the said Roger Charles Tichborne was among the drowned or saved. He would at the present time be about 32 [actually, 36] years of age, is of a delicate constitution, rather tall, with very light brown hair [actually, black] and blue eyes. Mr Tichborne is the son of Sir James Tichborne, now deceased, and is heir to all his estates.

On 9 October 1865 – 11 years after Roger Tichborne's disappearance – word reached Mr Cubitt in Melbourne from a Mr Gibbes, an old acquaintance who was an attorney in the provincial town of Wagga Wagga, New South Wales, that the latter had 'spotted R.C. Tichborne'. Thus began one of history's most celebrated cases of disputed identity.

Enter the claimant: Thomas Castro

The man 'spotted' as being 'R.C. Tichborne' was a client of Gibbes who called himself 'Thomas Castro'; he owed the lawyer a great deal of money. Castro was a big, brawny man whose butchery business was facing bankruptcy. Gibbes knew that 'Castro' was an assumed name; his client had told him that he was the eldest son of a distinguished family in England and the heir to a title. His story was that after the *Bella* had foundered off Rio de Janeiro in April 1854, he and other survivors had

been rescued by a ship called the *Osprey* and taken not to the nearest port but all the way to Australia.

When Gibbes saw the advertisement in the *Melbourne Argus* he leapt to the conclusion that he had found the missing Tichborne heir; his suspicions were reinforced when he saw Castro smoking a pipe inscribed with the initials 'R.C.T.'. On 19 October 1865, he wrote a letter to the grieving dowager Lady Tichborne that her missing son had been found, alive and well, in Australia.

For several weeks, a correspondence mainly concerned with finance was conducted between the dowager and Gibbes, mediated by Cubitt. To the dowager, Cubitt insisted on the necessity of a remittance; Lady Tichborne, for her part, under the advice of her friends, held back until she received something more conclusive than the snippets of information which Cubitt had sent her. Meanwhile, Gibbes declined to produce his man from the seclusion of Wagga Wagga until a satisfactory arrangement had been reached. Eventually, Gibbes, convinced by Castro's story, resolved to take matters into his own hands: he persuaded Castro to write a personal, somewhat illiterate letter to his mother:

Wagga Wagga, January 17th, 1866

My dear Mother,

The delay which has taken place since my last Letter, Dated 22nd April 54, Makes it very difficult to Commence this Letter. I deeply regret the truble and anxsity I must have cause you by not writing before. But they are known to my attorney and the more private details I will keep for your own Ear. Of one thing rest Assured that although I have been in A humble condition of Life I have never let any act disgrace you or my Family. I have been A poor Man and nothing worse . . .

Nonetheless, he went on to mention 'the Brown Mark on my side' and 'the Card Case at Brighton' (of which the dowager later admitted she had no recollection),[3] and asked his mother to send him £200 to pay

for his fare to England and a further £200 to allow him to settle some outstanding debts.

It had been nearly 13 years since Lady Tichborne had taken leave of her elder son, in Paris in March 1853. While the letter from Castro was on its way to her, she suffered another bereavement: the death of her recklessly extravagant younger son, Sir Alfred Joseph Doughty-Tichborne. The Tichborne baronetcy was now in a precarious position – her daughter-in-law was pregnant, but no one knew whether she was carrying a boy or a girl. The letter from Castro, when it arrived, must have seemed positively providential – to find a long-lost son just after losing another one. Without a moment's hesitation, on 25 February 1866, Lady Tichborne wrote to Castro as 'my dear and beloved Roger', unreservedly accepting the identity of the claimant and imploring him to come back to his poor afflicted mother; she assured him that the necessary funds would be found and signed her letter 'H.F. Tichborne'. She also wrote to Gibbes: 'I think my poor, dear Roger confuses everything in his head, just as in a dream, and I believe him to be my son, though his statements differ from mine.'

Castro replied to his 'Dear and Beloved Mother' on 24 May 1866: 'I hardly know my Dear Mother how you have borne the suspense of not knowing my fate so long. You must not blame me mother for I believe fate had A great deal to do with it.' But the money did not arrive (the dowager had also written to Cubitt declining to send any money without further satisfactory assurances about the claimant's identity), and the claimant was now in serious financial straits, totally reliant on the generosity of Gibbes, his attorney. Moreover, he had recently married a young and illiterate domestic servant named Mary Ann Bryant, who was now pregnant.

But the dowager had supplied a window of opportunity to the claimant's supporters in a further couple of letters to Cubitt. She told him that there was 'a man of colour' living in Sydney named Bogle, who had been valet to Roger's uncle Sir Edward Doughty and knew Roger well; she also sent Cubitt (and Gibbes) much more explicit details of Roger's early life. This second letter caused Gibbes considerable concern, because the dowager's

account differed greatly from the version he had heard from Castro. But it was too late: Castro had already left Wagga Wagga for Sydney in order to raise a loan from the Australian Joint Stock bank and had made a will, which left his inheritance to his wife and some non-existent properties elsewhere to various other beneficiaries (including his mother, whom he named 'Hannah Francis' – not Henriette Felicité – Tichborne).

Armed with the new information from the dowager, Castro was able to persuade the bank of his bona fides. He now had unlimited credit (based on the prospect of inheriting the Tichborne rent-roll of £15,000 a year). He became a local celebrity, part of the Sydney social whirl. Having learned from the dowager's letter that the Tichbornes were Catholics, he also took the precaution of remarrying his wife with the full rites of the Catholic church.

The man Bogle, whom the Dowager had mentioned as having been valet to Roger's uncle, had been taken by Sir Edward from the West Indies as a boy and had remained with him as valet and general factotum until the baronet's death in 1853. He had married the Tichborne schoolmistress, and since Sir Edward's death, he had been living in Sydney with his grown-up sons on a generous allowance from Lady Doughty. When he read in the Australian newspapers that the missing Roger Tichborne had been 'found' and was staying at the Metropolitan Hotel in Sydney (which he had just bought on credit for £10,000!), Bogle hurried across to meet him; despite the fact that Castro was a much larger man than Roger Tichborne had ever been, Bogle apparently had no difficulty in recognising him as the missing baronet. He now became Castro's closest friend and confidant, irrevocably committed to his cause (especially when Lady Doughty stopped his annuity on hearing of his involvement with Castro).

On 2 September 1866, the claimant eventually set sail for England via Panama and New York, travelling as 'Sir Roger Tichborne'. With him went his wife and baby daughter, along with the former valet Bogle, who had become a vital part of his entourage and who would have coached him in the rudiments of the role which he was preparing to play in England.

The claimant in England

The claimant arrived in London on Christmas Day, 1866. His arrival was keenly awaited by his mother, the dowager, and no less keenly by the large group of relatives with whom Roger Tichborne had been intimate in his earlier life. Not a single one of the wide family circle shared what they all considered the dowager's delusions about her missing elder son. They had much to lose, of course. The widow of Sir Alfred and mother of the infant baronet stood to lose most, perhaps, but all of them would be affected by the arrival of a kinsman who would create painful family turmoil at the very least.

The dowager was well aware of the problems, and she urged the claimant to come straight to her in Paris without mixing with any of his father's relatives. But what was the first thing the claimant did? He went straight to Wapping, in London's East End, and visited the Globe Inn to make inquiries about a family called Orton; he purported to be a friend of the family. Next morning, he was back in the East End checking up on some addresses he had been given, including that of the sister of a man named Arthur Orton, a Wapping butcher who had deserted ship at Valparaiso, in 1849, and settled in Australia, in 1854, under the name 'Thomas Castro'. And with that, almost before it had begun, the imposture began to unravel.

The claimant followed the East End visits with a flying visit to Tichborne House; he stayed in the Swan Inn at Alresford as 'Mr Taylor', hidden under voluminous layers of wraps. Next morning, the innkeeper drove him to Tichborne House, which was then let to a Colonel Lushington. At Tichborne, the claimant revealed his 'real' identity: Sir Roger Tichborne. Despite his imposing girth (he weighed more than 20 st., compared to the 9 st. missing aristocrat), he obtained two important allies to his cause: Edward Hopkins, the old family solicitor, and Francis J. Baigent, a Winchester antiquary who was intimately acquainted with the Tichborne family history.

It was only now – more than a week after his arrival in England – that the claimant decided to make the crucial visit to Paris to meet the

dowager Lady Tichborne. With a small retinue of friends, he arrived in Paris on the evening of 10 January 1867. Next morning, however, he declined to go to his 'mother' when she sent for him, pleading illness. So the dowager, who had summarily dispensed with the services of her closest adviser (who had consistently counselled caution from the start), went to the hotel herself to see the man she had already convinced herself was her long-lost son.

The long-awaited reunion of mother and son, after an absence of 17 years, could hardly have been more bizarre. It was a dark, murky afternoon; the blinds were half-drawn. The claimant was lying huddled on the bed with all his clothes on and his face turned to the wall. The dowager bent over him and kissed him, saying, 'He looks like his father, and his ears are like his uncle's.' Reassured by this enthusiastic welcome, the claimant spent the next week in her company. The claimant's solicitor triumphantly announced that Lady Tichborne had recognised her son and promptly wrote a letter to *The Times* announcing the fact and declaring that he was taking the necessary legal steps to enforce it. Lady Tichborne accepted the claimant's illiterate wife and baby daughter, and she transferred to the claimant (until he should obtain possession of his estates) the £1,000 a year out of her jointure which she had hitherto allowed to her daughter-in-law, the mother of the infant baronet, Sir Henry Alfred Joseph Doughty-Tichborne. She also handed over to him the diaries and letters sent to her by her son from South America; from these documents the claimant could inform himself about his role in more detail.

Although the circumstances of the Paris reunion were bizarre, even more so was the old lady's wilful refusal to be shaken by the alarming inconsistencies which her 'son' displayed. It turned out that, in spite of having been a native French speaker, he did not know a word of French. He failed to recognise friends from his boyhood days in Paris or remember the names of his relatives. He was confused about his mother's name (he called her 'Hannah Francis' and could not remember her maiden name). He said he had served briefly as a ranker in the army and

referred to his old school, Stonyhurst, as 'Winchester'. Roger Tichborne had been a slight, delicate, dark-haired youth with a tattoo on his left arm; the claimant was big and burly, grossly overweight, had reddish-brown hair, and did not have any tattoos on his body. Roger Tichborne was described as having piercing blue eyes; the claimant had grey eyes.

There were all manner of other glaring disparities, but the dowager Lady Tichborne had made up her mind: her son had been found, and her unshakeable conviction that he was who he claimed to be outweighed for many people the more compelling objective evidence against him. The things he had forgotten – such as his mother tongue – could be attributed to stress, illness and amnesia.

Back in England, a house was taken for him at Essex Lodge, Croydon, near the offices of his solicitor. Bogle was given a room of his own. The dowager came over from France in February to take up residence with the claimant and his family at Croydon but soon found life in the household intolerable. There was never a quiet moment with the constant human traffic of solicitors and moneylenders and down-and-out ex-soldiers tramping in and out at all hours to sign affidavits and enjoy raucous drinking binges in return. Essex Lodge had become the headquarters for the claimant's campaign to win legal recognition. She also found the constant calls on her financial help unacceptable and went back to Paris towards the end of April.

The battle lines were being drawn. The claimant's promoters realised that they had to amass witnesses who would swear that they recognised him. To that end they despatched legal teams to woo members of the Hampshire gentry who had known him and former members of his regiment (now based in Leeds) who had served with or under him. After copious hospitality, many of his old regimental comrades signed affidavits that he was who he claimed to be (and several of them were taken into the Croydon household as servants); several officers, too, signed affidavits to that effect, although many others comprehensively denied it. Local businessmen and tradesmen from Alresford, and villagers from Tichborne, were similarly entertained, evening after evening, in the

Swan Inn and their affidavits procured. All these affidavits were printed in book form and widely distributed.

Meanwhile, the family made a last attempt to give the claimant an opportunity to prove his story by meeting them face to face. But after the claimant failed to recognise Katharine Doughty (now Mrs Radcliffe), the love of his life, and called her 'Lucy', his solicitors would only allow strictly controlled access to him. The family (except, of course, the dowager Lady Tichborne) was more than ever convinced that the claimant was a complete fraud and recognised that they would have to go to court to block his attempt to win control of the lucrative Tichborne estates. The family's legal team now concentrated on the mysterious link between Castro and the 'Arthur Orton' of Wapping, whose family Castro had tried to contact on his very first evening in England. Revealing the true identity of the claimant would be crucial to their cause.

Arthur Orton

Arthur Orton was born in Wapping on 20 March 1834; he was the youngest of twelve children (eight sons and four daughters), scion of a once-prominent family of East End butchers. He was unable to attend school regularly due to a nervous condition then known as St Vitus's Dance (Sydenham's chorea, associated in childhood with rheumatic fever); but although his schooling was rudimentary, he had a quick mind, a fluent tongue and a vivid imagination. From an early age, he would hint to others that he was born of a titled family, whose name he was bound to keep secret, and that one day he would inherit great wealth.

At the age of 15, Orton was sent to sea by his father in the hope that his childhood ailments would be cured. He was apprenticed to a Captain Brooks on the 160-ton brig *Ocean*, but the hard life of a ship's apprentice did not suit him, and in 1849 he jumped ship in Valparaiso. He made his way to the town of Melipilla, where the locals took pity on the teenager; an English doctor named Hayley and his Chilean wife took the boy into their home and looked after him for several months,

until he engaged himself on board a ship bound for England and arrived home in June 1851.

Back in London, he went to work in his father's butcher shop alongside his elder brothers. He was a big-boned, brawny lad who liked hard work, and he quickly became an expert slaughterman, known as 'bullocky Orton'. He became engaged to Mary Ann Loder, a local girl, but he still had dreams of making his fame and fortune abroad, and in 1852 an opportunity of going to Australia presented itself. A man in Hobart, Tasmania, wanted a couple of Shetland ponies, which Mr Orton, senior, could supply, and Arthur agreed to sail in charge of them on board the *Middleton* and act as ship's butcher. Without another thought, he abandoned his sweetheart and his secure, if lowly, job in Wapping and set off to make a new life for himself in Australia. He reached Hobart in May 1853 and got a job as a slaughterman with a local butcher, before becoming a drover and stock-keeper.

That was the last news he wrote about to his family and friends. He then disappeared from their sight. He apparently became an outlawed member of a sheep-stealing gang, after which he changed his identity and wandered around Australia until he turned up as a butcher in Wagga Wagga, calling himself Thomas Castro. It was there, in 1865, that he came across Lady Tichborne's advertisement. Orton was about to file a bankruptcy petition when he 'confessed' to his solicitor that he had property in England and that he was the survivor of a shipwreck. The solicitor, who had also seen the advertisement, put two and two together and assumed that Castro was the missing baronet, Roger Tichborne . . .

Battle lines

The dowager Lady Tichborne died of heart failure in a London hotel on 12 March 1868. The gloves were now off with a vengeance. The claimant promptly declared that her death had been due to poisoning. From his point of view, the dowager's death was a severe financial blow, because his £1,000 annual allowance came to an end. Knowing that the claimant would move to claim the dowager's assets, the Tichborne

solicitors made a pre-emptive strike: they launched a Chancery suit (*Tichborne* v. *Castro*) which would force the claimant to seek remedy through the courts – if he dared.

The Tichborne solicitors knew that any court battle would be long and acrimonious and spared no expense in seeking evidence to support their case. They hired teams of investigators in Australia and South America to try to trace Castro's earlier life. They discovered that in Tasmania, where he had worked as a butcher, he had been known as Arthur Orton, and scores of people in Hobart identified a photograph of Castro as being a likeness of Orton.

The heaviest blow to the claimant's case, however, came from within his own family – his ne'er-do-well brother, a butcher named Charles Orton, who had discovered that the claimant had been secretly giving his widowed sisters £5 a month each. Charles tracked his brother down and demanded money for himself. When the link between Thomas Castro and Arthur Orton broke in the popular press, the claimant hotly denied that he was the Wapping-born butcher. To deal with the blackmail, the claimant's solicitors persuaded Charles Orton (who bore a marked resemblance to Arthur Orton) to sign an affidavit to the effect that he did not know the claimant; the claimant thereupon increased his brother's allowance on condition that he moved away and took an assumed name.

The Orton identification, however, had damaged the claimant's standing in the public eye. The claimant responded with a series of 'Tichborne Defence Fund' rallies to denounce the identification. But the claimant was now in serious financial difficulties and could no longer afford to keep paying the allowance extorted by his brother Charles. Charles threatened to sell his story to the press or to the Tichborne solicitors, and the claimant promised him £1,000 to keep quiet. But Charles was not to be fobbed off: he went straight to the Tichborne solicitors and signed an affidavit retracting his previous statement, affirming that the claimant was his brother Arthur Orton. Moreover, he told the solicitors the names of old friends in Wapping and put them on

the track of Mary Ann Loder, to whom Arthur Orton had been engaged in 1852 before he went to Australia and who would identify him in the subsequent court proceedings.

With his legal fees and other costs escalating out of control, the claimant now embarked on a very hazardous course: selling 'Tichborne Bonds'. At public rallies, he encouraged supporters to invest in him for a percentage of the money and assets he expected to obtain from the Tichborne estates. The bonds consisted of a promise signed by the claimant to pay the holders £100 within a month of his getting possession of the estates; it was a sporting flutter at excellent odds of £20 or £30 a throw. He played on the anti-capitalist feelings of his audiences – mostly poor and underprivileged – and their gambling instincts. The bonds were widely taken up: although the target of £100,000 was not reached, they raised £40,000. Within 18 months, all the money had gone.

(Incidentally, the old £100 Tichborne Bonds are now 'collectible', as the parlance goes: in 2005, one was bought on eBay by the great-great-great-grandson of the claimant's brother Charles – Shaun Orton. He paid £53.08 for it.)

The first trial (10 May 1871 – 7 March 1872)

Public interest in the case was overwhelming – it was the legal story of the century. Victorian society was divided firmly along class lines: the upper classes were appalled by the suggestion that a high-born baronet could have lowered himself to becoming a colonial butcher and marrying an illiterate serving girl, whereas the common people were outraged by the suggestion that there was anything wrong with being working class.

The claimant's most dedicated supporter, the dowager Lady Tichborne, had died in March 1868, but he decided to press on nonetheless; perhaps he thought he was in too deep to withdraw. On 23 June 1868, an order was obtained, directing an issue to be tried by the Court of Common Pleas as to whether the claimant was, or was not, the heir to Sir James Doughty-Tichborne; and on 29 June 1868, a writ was issued by the claimant against Colonel Lushington,

the tenant of Tichborne Hall, with the nominal object of evicting him but with the real object of establishing the claimant's title as landlord of Tichborne Park.

Months went by as inquiries were pursued all over the world; it was not until 10 May 1871 that the case of *Tichborne* v. *Lushington* was called in the Court of Common Pleas. The trial aroused huge public interest throughout the 102 sitting days it was to last. Both sides had engaged a powerful team of barristers. The leading advocate for the claimant was Sergeant Ballantine, supported by Hardinge Giffard, QC (a future Lord Chancellor). The defendants were led by the Solicitor-General, Sir John Duke Coleridge (later the Lord Chief Justice of England), backed up by Henry Hawkins, QC, reputed to be the most ruthless cross-examiner in England.

The claimant's team depended heavily on the unchallenged evidence of his identification by the dowager Lady Tichborne and produced more than 100 witnesses to testify under oath that the claimant to the Tichborne baronetcy and estates was the man they had known as Roger Tichborne. The witnesses called included some 30 of Roger's fellow officers and men from his army days, plus the family solicitor and an assortment of magistrates.

After ten days of hearing witness after witness being interminably cross-examined, the jury (which consisted mainly of upper-class gentlemen) grew restive and demanded to see the claimant in the witness box. This was what everyone had been waiting for. For two days, Hardinge Giffard, QC, took him through a carefully rehearsed and coherent story; when the name of Arthur Orton came up, the claimant declared that he had met Orton in Australia, working as a stock rider, and had become very friendly with him.

It was now time for the cross-examination, by the Solicitor-General, Sir John Coleridge. For 22 days, Sir John hammered away at the claimant in the witness box, intent on demolishing the entire fabric of his story, episode by episode. His plan was to show that the claimant differed from Roger Tichborne in physiognomy, style, habits, taste, language and

education, and that he showed woeful ignorance of Roger's life and the extended Tichborne family; what little knowledge he had could have come from careful coaching, from gossip or from documents to which he was given access.

Under the relentless cross-examination, the claimant became flustered and started contradicting himself. He was no longer sure that the ship which had rescued him from the wreck of the *Bella* in 1854 had been called the *Osprey* (of which no trace had ever been found). He was asked why, if he really was Sir Roger Tichborne, had he not sent word to his family upon his arrival in Australia to tell them that he was safe and sound? His reply sounded uncharacteristic of the prolific letter writer Roger Tichborne had been:

> I thought I would come home one day and surprise them. I was
> in the saddle at six in the morning until eight or nine at night. I
> used to feel tired, and even on Sunday I was often obliged to go
> to neighbouring stations. So the time passed, and I never wrote
> at all. It was certainly from no motive that I didn't write. It was
> more from carelessness and neglect.

But it was when he was asked about his courtship of his cousin Katharine Doughty, and the sealed document about her which he had given to his confidant Vincent Gosford, that he made perhaps his greatest mistake. At first he refused to answer, on the grounds of chivalry and delicacy; but Coleridge was insistent, and the claimant alleged that he had had intimate relations with her. Such an aspersion against the virtue of a lady was considered an outrageous libel in Victorian society, and the claimant thereby forfeited any sympathy the jury might have felt for him – especially as the lady herself was sitting in court with her husband by her side.

As the trial dragged on for day after weary day, it became overwhelmingly obvious that the claimant's cause was lost. In his opening speech for the defence, John Coleridge rammed home the evidence against him in the

longest address ever made to an English jury (15 January to 21 February 1872):

> The first sixteen years of his life he has absolutely forgotten; the few facts he has told the jury were already proved, or would hereafter be shown, to be absolutely false and fabricated. Of his college life he could recollect nothing. About his amusements, his books, his music, his games, he could tell nothing. Not a word of his family, of the people with whom he lived, their habits, their persons, their very names. He had forgotten his mother's maiden name; he was ignorant of all particulars of the family estate; he remembered nothing of Stonyhurst; and in military matters he was equally deficient. Roger, born and educated in France, spoke and wrote French like a native and his favourite reading was French literature . . .
>
> The physical discrepancy, too, was no less remarkable; for, while Roger, who took after his mother, was slight and delicate, with narrow sloping shoulders, a long narrow face and thin, straight, black hair, the claimant was of enormous bulk, scaling over twenty-four stone, big-framed and burly, with a large round face and an abundance of fair and rather wavy hair.

He ended by presenting all the compelling evidence indicating that the claimant was not Roger Tichborne, nor 'Thomas Castro', but none other than Arthur Orton. Then he started calling a long list of witnesses to demolish the claimant's case. As the claimant's fortunes waned inexorably, his legal team privately advised him to withdraw his suit and flee the country, but he refused.

After 102 days in court, the jury had heard enough and were convinced of the claimant's true identity – Arthur Orton (although he wasn't legally identified as such). They declared that they required to hear no further evidence, and on 7 March 1872 Sergeant Ballantine elected to be 'non-suited' – he withdrew the claimant's suit, and the action collapsed. The

judge, Sir William Bovill, expressed his entire concurrence with the course taken by the jury. He stated that in his opinion the claimant had been guilty of wilful and corrupted perjury and that there was reasonable ground for directing him to be prosecuted on that charge; he therefore committed the claimant to be detained.

The claimant, who had not bothered to attend much of the latter part of the trial, was not in court at the time. He was promptly arrested in his hotel and whisked off to the grim confines of Newgate Prison. Seven weeks later he was released on bail of £10,000.

A year was to pass before he was brought to trial. Witnesses had to be traced and brought over from Australia and Chile. Meanwhile, the claimant used the time to raise support and appeal for funds for his defence. Huge and enthusiastic public rallies were held all over Britain, attacking the authorities for persecuting an innocent working man.

The trial for perjury (23 April 1873 – 28 February 1874)

Because the claimant had not been legally identified as Arthur Orton, he was tried under the name of Thomas Castro (*Regina* v. *Castro*). There were two charges: the first indictment listed twenty-three separate charges of perjury during the previous trial; the second perjury indictment included the charge of forgery associated with the issue of the Tichborne Bonds. The three judges were led by Sir Alexander Cockburn, the Lord Chief Justice. The prosecution team was led by Sir Henry Hawkins, QC, who had been second barrister for the Tichborne family in the first trial. Orton's defence team at his first trial was summarily dismissed; instead, his leading defence counsel was a controversial and volatile Irish-born barrister named Edward Kenealy, who in the event would do neither his client nor his own career any good by his recklessly intemperate conduct. The jury (in contrast to the first one) consisted mainly of tradesmen from West London.

Orton's trial at the Bar in Westminster Hall lasted for 188 days. Hawkins remorselessly went through the evidence for eight days in his opening address to the jury, intent to prove that the claimant was

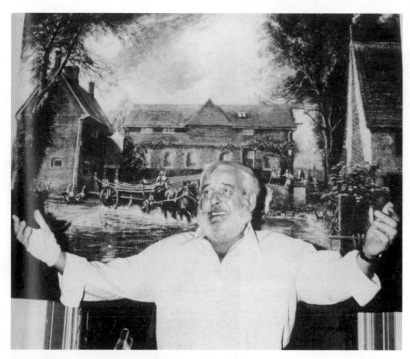

Tom Keating at his press conference on 27 August 1976. In the background is his pastiche *The Hay Wain* in reverse. (© Associated Newspapers)

John Myatt explains to Magnus Magnusson how he painted *Landscape* by Georges Braque. (© Christine Moorcroft)

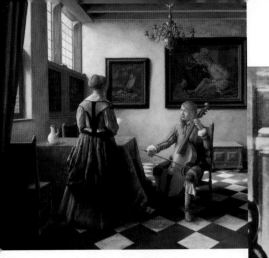

Above: *Two Figures in an Interior*: an 'invention' in the style of Vermeer by Leo Stevenson (www.leostevenson.com). (© Leo Stevenson)

Right: Van Meegeren in the dock, 29 October 1947, two months before his death. One of his forgeries, *Isaac Blessing Jacob*, hangs in the background. (© Ullstein Bilderdienst)

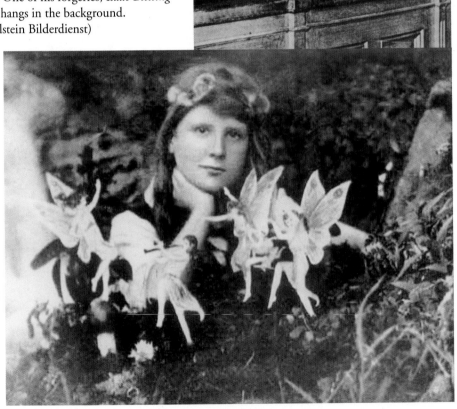

Frances Griffiths with the fairies, taken by Elsie Wright in July 1917 with a Midg camera. Distance 4 ft; time 1/50 second.

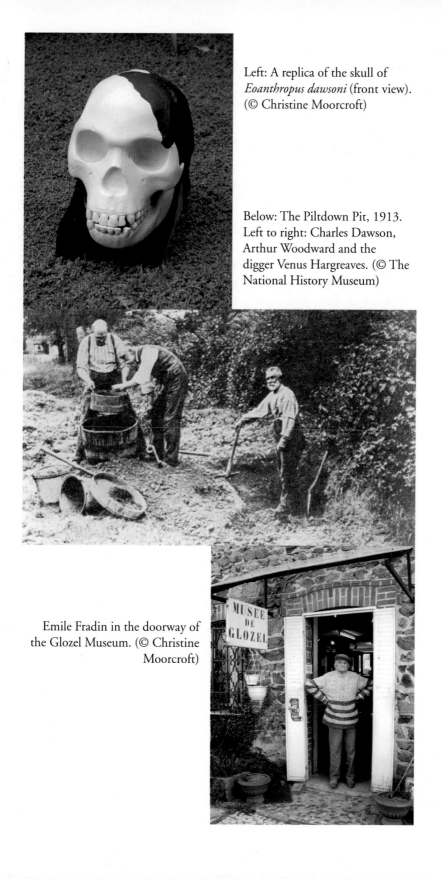

Left: A replica of the skull of *Eoanthropus dawsoni* (front view). (© Christine Moorcroft)

Below: The Piltdown Pit, 1913. Left to right: Charles Dawson, Arthur Woodward and the digger Venus Hargreaves. (© The National History Museum)

Emile Fradin in the doorway of the Glozel Museum. (© Christine Moorcroft)

Above: Display case of bone objects in the Glozel Museum. (© Christine Moorcroft)

Below: The Vínland Map. (Courtesy of the Beinecke Rare Book and Manuscript Library, Yale University)

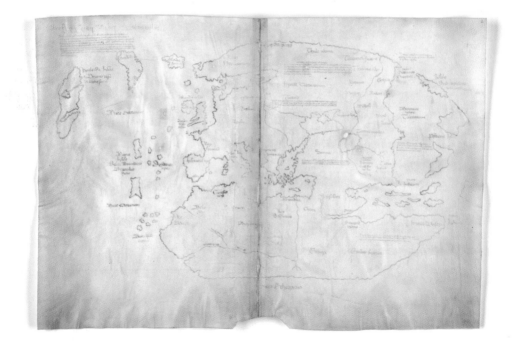

The Cardiff Giant shown in *Harper's*, December 1869.
(Photograph courtesy of the Farmers' Museum, Inc.)

Arthur Orton.

Roger Tichborne in Santiago, January 1854.

Top left: Frontispiece of *Running a Thousand Miles for Freedom* by William Craft.

Top right: Racknitz's theory of how the Turk worked. Once the doors were closed, the operator sat up and worked the automaton. (© AKG London)

Bottom right: Portrait of George Psalmanazar from the frontispiece of his memoirs. (Courtesy of the National Taiwan University Library)

Above: *The Death of Chatterton* by Henry Wallis, 1856. (Courtesy of Tate Britain)

Left: *Ossian: In Memoriam James Macpherson, 1736–96.* Colossal bronze, 1996 by Alexander Stoddart. (By permission of the artist)

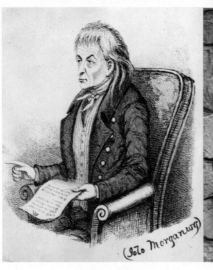

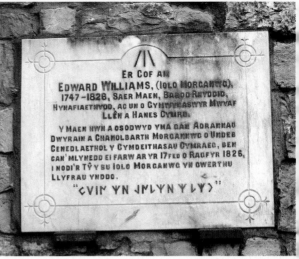

Portrait of Iolo Morganwg – a photograph, by John Thomas, of a print. (Courtesy of The National Library of Wales)

Plaque marking the site of Iolo Morganwg's shop, Main Street, Cowbridge. (© Christine Moorcroft)

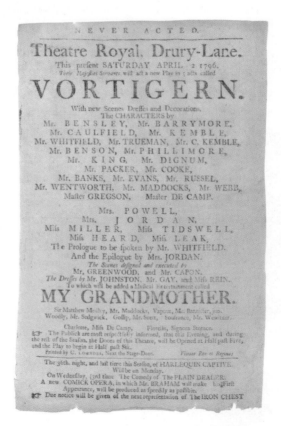

Playbill for the opening and only performance of *Vortigern and Rowena* at the Drury Lane Theatre, London. (Courtesy of The New York Public Library)

Arthur Orton and hammering at all the inconsistencies in the stories the claimant had told. He then called some 215 witnesses. Under English criminal law at the time, the accused could not give evidence, so he sat at the table opposite the judges, unable to speak or be questioned, and seemed to take very little interest in the proceedings. Certainly, he refused to help Edward Kenealy, who was constantly at a disadvantage from having been briefed only a few weeks before the trial. As a result, Kenealy grew more and more reckless in his attempts to discredit the prosecution witnesses, accusing the government, the Tichborne family (past and present) and their solicitors, and the authorities of Stonyhurst of all manner of sins and criminal tendencies. He even claimed that the Jesuits were trying to poison him. In his turn, he called some 300 witnesses, mainly to rebut the suggestion that the claimant was Arthur Orton and to prove that he was, in fact, Roger Charles Tichborne.

At the end of the marathon trial, after a summing up by the Lord Chief Justice which lasted all of 22 days, the jury took less than half an hour to find Orton guilty on all counts. The jurors were agreed that the defendant was not Roger Tichborne but Arthur Orton and that he had committed perjury about Mrs (now Lady) Radcliffe. He was sentenced to fourteen years' penal servitude – seven years (the maximum sentence possible) for the first count of perjury and a further seven years for the second, the two terms to run consecutively.

The sentence aroused unease in legal circles. Many lawyers thought that it was illegal and contrary to the intention of Parliament, which had fixed the maximum penalty for perjury at seven years. They thought that the court had arbitrarily chosen to award a further seven years on the second indictment simply because it did not think seven years a heavy enough punishment.

The verdict also released a storm of popular protest. Outside the courtroom a huge crowd had gathered, wanting to carry Orton in triumph to his freedom; instead, he was smuggled from the courtroom via the lobby of the House of Commons and thence to Millbank Prison. There he insisted on being registered under the name Castro, the name

under which he had been prosecuted. He lost weight with dramatic rapidity, and, within a few months, he shrank from 24 st. to 10 st. At the end of the year, he was transferred to Dartmoor Prison as 'prisoner number 10539, Thomas Castro'. The stern regime there caused his health to fail, and, in April 1877, he was moved to the milder conditions of Portsea Prison, Portsmouth, where he would spend his last seven years behind bars.

Throughout this time, there were demonstrations and rallies by his supporters in the Tichborne Defence Association. Edward Kenealy, QC, founded a weekly paper entitled *The Englishman* with a startling initial circulation of 140,000, which promoted the claimant's cause with virulent attacks on the government, the judiciary and the establishment. Meanwhile, Queen Victoria sent a warm congratulatory telegram to Lady Radcliffe on the clearing of the slur on her good name.

Arthur Orton served ten and a half years of his sentence in the horrendous Victorian penal system, before being released on parole ('ticket of leave') on 11 October 1884. He was a changed man. His weight had gone up again but not to his previous gross girth. His writing (grammar, syntax, spelling and handwriting) had improved almost beyond recognition. And he had apparently become a committed Christian, having spent his last years in prison reading and meditating on the Scriptures.

After his release from jail, despite the strict terms of his parole, he undertook a tour of public meetings all over the country in an attempt to harness public sympathy again; his twin objective, he said, was the repeal of the Tichborne Estates Act, which had declared Roger Charles Tichborne dead, and a royal commission to reopen the whole case. He appeared in music halls and circuses (where, to his dismay, he was frequently pelted with rotten fruit). In the summer of 1886, he went to New York, saying that he had come to raise funds to restart his case. But the American public, and especially the American press, showed little interest in him. He went on exhibition in a Chatham Square liquor saloon in an insalubrious neighbourhood between the Bowery and

Chinatown. He worked as a bartender and tried to sell articles about his life in Australia, but without success, and by the end of 1887 he returned to London. There he found another wife, Lily Enever, whom he had met on the music-hall circuit (although there is no record of his having divorced his first wife, Mary Ann, who was unfaithful to him and bore two children while he was in prison). Eventually, in the summer of 1895, more than ten years after his release from prison, he sold his 'confession' in six instalments to the *People* newspaper for a reputed £4,000. He blamed nobody except himself:

> The reason I wrote the letter [to the dowager Lady Tichborne] was because I was so pressed for money at the time, and I thought that if she was fool enough to send me money, so much the better. I could go to Sydney and take the steamer to Panama where I could join my brother, and nobody would ever hear anything from me. I learned about the Tichborne family in *Burke's Peerage*, which I saw in Goulburn, and enabled me to converse about different members of the family . . .
>
> Bogle thoroughly believed I was Sir Roger; he used to converse very freely with me about the family, giving me the whole history of it . . . I was pumping him all the time as to names and habits and customs of various members of the family. I have always been a good listener and by listening quietly and patiently for hours, to statements which have been made to me by, I suppose, I may say hundreds of people, all of whom gave information concerning the Tichborne family, I learned such facts that really induced me to prosecute my claim. I found by listening to others the story built itself and grew so large I really could not get out of it . . .
>
> I could not get away from those who were infatuated with me and firmly believed I was the real Sir Roger . . . Of course I knew perfectly well I was not, but they made so much of me, and persisted in addressing me as Sir Roger, that I forgot who I was,

and by degree I began to believe I really was the rightful owner of the estates. If it had not been that I was fêted and made so much of by the colonialists in Sydney, I should have taken the boat and gone the rest of my days to Panama with my brother.

'The Confession of the Tichborne Claimant' reads as if much of it had been 'ghosted' from the prosecution speeches. The confession cut no ice with anyone, neither his supporters nor his opponents, but no matter – Orton used the money to set up in business as a tobacconist in Islington. Resilient as ever, he now repudiated his confession, saying that he had only signed it for money to pay off some urgent household bills.

However, his fortunes gradually dwindled again; the tobacconist's shop went under, and a venture in selling ham and beef also failed. Orton had no other recourse than to exhibit himself in public houses and sell autographs at two pence a time.

Arthur Orton died penniless on 1 April 1898; the cause of death was given as a weak heart and feeble circulation. He was buried, at the undertaker's expense, in a grave in Paddington Old Cemetery. A huge crowd, estimated at 5,000, gathered to watch the funeral of the public celebrity. On the coffin was inscribed the name 'Sir Roger Charles Doughty-Tichborne'; the Tichborne family had granted permission for this but not for a gravestone, so his grave has remained unofficially unmarked to this day. But it is known that the grave in Paddington Old Cemetery was lot no. 1490 in section 2A; today it is marked by an unobtrusive pink peg.

Epilogue

There were no winners in the Tichborne Claimant affair – except, perhaps, the parasites and hangers-on who milked the claimant for all he was worth. Everyone else suffered: Edward Kenealy, QC, for instance, was disbarred because of his conduct of the defence – but was then elected to Parliament as a radical independent MP (1875–80). The major loser, of course, was Arthur Orton himself, who lost his freedom because of

his claim, but so too was the Tichborne inheritance. It is ironic to reflect that even if Orton had won his case, the debts which had accumulated over the preceding eight years were so enormous that the Tichborne estates would have been immediately repossessed and liquidated, leaving him penniless again.

But perhaps the principal loser was the Tichborne family itself. Although the family won the case and secured its ancestral heritage, it was hit very hard financially. The estates had already been seriously undermined by the reckless extravagance of Roger's brother, Sir Alfred Tichborne, who had drunk himself to death leaving vast debts to moneylenders. The annual rent-roll of the Tichborne estates was officially estimated at £25,000: the legal costs alone were £91,677 (in today's money, more than £4,000,000), and all the expenditure on private investigators and other lawyers probably doubled that figure.

The verdict on Arthur Orton by Victorian England seems clear-cut enough, but it did reveal significant fault lines in that society. The rich didn't believe Orton and sneered at him because he looked coarse, because his hands were calloused, because he spoke with a common accent and because he didn't accord to their concept of a 'gentleman'. The poor believed in him for those very reasons. Indeed, there are still people to this day who argue that the verdict of the court was a dreadful miscarriage of justice: that the claimant really *was* Roger Charles Tichborne.

As in the two trials, people believed what they wanted to believe – and they still do. The vast and growing literature on the Tichborne case shows no sign of abating. The story was made into an entertainingly tongue-in-cheek feature film (*The Tichborne Claimant*) in 1998, starring John Kani and Robert Pugh and cameo appearances from a host of stalwarts such as John Gielgud, Robert Hardy and Stephen Fry. And there is a brisk trade in Tichborne memorabilia in auction houses whenever items come on to the market – letters, documents, commemorative Royal Worcester ware and so on.

There was only one way, it seemed, in which the story could be settled, once and for all – through DNA. There is a lock of the claimant's hair in

the Black Museum at New Scotland Yard, cut off when he was shorn for prison; and Sean Orton (the great-great-great-grandson of the claimant's brother Charles) agreed to have his own hair tested by a DNA expert in that specialised field. But to no avail: the hair in the Black Museum was in such poor condition that it failed to yield any viable DNA. So the mystery remains – as does the fascination of this extraordinary yarn.

3.2 – Escape from Slavery: Ellen and William Craft[4]

Having heard while in slavery that 'God made one blood all nations of men', and also that the American Declaration of Independence says that 'We hold these truths to be self-evident, that all men are created equal; that they are endowed by their Creator with certain inalienable rights; that among these are life, liberty, and the pursuit of happiness', we could not understand by what right we were held as 'chattels'. Therefore, we felt perfectly justified in undertaking the dangerous and exciting task of 'running a thousand miles' in order to obtain those rights which are so vividly set forth in the Declaration.

This book is not intended as a full history of the life of my wife, nor of myself, but merely as an account of our escape, together with other matter which I hope may be the means of creating in some minds a deeper abhorrence of the sinful and abominable practice of enslaving and brutifying our fellow creatures.

William Craft, *Running a Thousand Miles for Freedom: Or, The Escape of William and Ellen Craft from Slavery* (Preface), 1860

In 1848, two black slaves in Georgia made a daring dash for freedom which enthralled America and much of Europe. It made them criminals in the eyes of those who supported slavery and heroes in the eyes of those who campaigned for abolition. Against all the odds, they succeeded.

Ellen, who was born in 1826 in Clinton, Georgia, was the illegitimate daughter of a wealthy plantation owner, Major James Smith, and his mulatto house slave, Maria. Major Smith's wife was, not surprisingly, irritated by the presence in her household of her husband's daughter by a slave – a girl, moreover, who was so light skinned that she was often mistaken for a member of the family. To get rid of her, Mrs Smith gave Ellen away at the age of 11 to her daughter Eliza as a wedding present.

So Ellen was sent to live in the town of Macon, Georgia, as the slave of her white half-sister.

William and his family were owned by a slave master who gradually sold the family, member by member, in order to pay off his debts. Thereafter, William worked for several masters and eventually learned carpentry in a cabinet-maker's shop in Macon – hence his given surname, 'Craft'.

William and Ellen met in Macon in the early 1840s. In 1846, when they were both 20 years old, they married in a slave wedding ceremony which was not recognised as legal or binding in the southern states of America. Their lives were comparatively comfortable – their masters were tolerably kindly people – but they were haunted by the fear of being separated and sold at a master's whim, and had decided not to have children while they were still enslaved. Instead, they decided that they must first somehow escape to freedom, come what may.

It was a daunting thought. Any plan was fraught with seemingly insurmountable difficulties. They knew that it was unlawful in the southern states for any public conveyance to take them as passengers without their master's consent. They knew that runaway slaves were hunted down with the utmost ferocity, with bloodhounds baying on their tracks – it was a sport as much enjoyed in the southern states as fox-hunting and stag-hunting were in England. They also knew that captured runaway slaves could be put to death after torture, as an example to discourage others from attempting to escape.

Were they prepared to take this appalling risk? Yes, they were – anything to free themselves from lifelong bondage. It would involve a hazardous, 1,000 mile journey to the north across the slave states.

The plan they eventually formed was that Ellen, with her light skin, should pass herself off as a wealthy young white cotton planter called 'Mr Johnson', with William posing as her personal servant. But how were they to get hold of the male attire which Ellen would require for the imposture? The couple had managed to save a little money, but it was unlawful in Georgia for a white man to trade with slaves without their masters' consent. However, there was an illicit market for clothing as for

everything else in society. William contrived to buy the necessary outfit piece by piece, in different parts of the town and at various times. In that way they collected everything except for a pair of trousers; Ellen, who was a lady's maid and a favourite in the household, solved that problem by making them. The precious clothes were then locked away in a chest of drawers which William had made for Ellen in his spare time.

There was another major problem: neither Ellen nor William was literate. It was unlawful in many states to teach slaves to read and write – to do so could result in a heavy fine and imprisonment. How was Ellen to deal with this when she had to sign hotel registers or customs clearances? She hit on a plan for that eventuality, too . . .

Some of the best slave-owners would grant favoured slaves a few days' holiday at Christmas, to visit friends or relatives, if they could afford such a luxury. Ellen wheedled a pass from her mistress, allowing her to be away for a few days, and the cabinet-maker for whom William worked gave him a similar pass.

Ellen and William sat up all night on the eve of their Christmas leave talking over their plan. Early next morning, Wednesday 21 December 1848, they got ready for the escape. William cut Ellen's hair square at the back of the head. Then Ellen put on the outfit they had collected. As an excuse for being unable to write, she bound up her right arm in a sling. Then, to avoid having to speak very much, she made a poultice and placed it in a white handkerchief to be worn under the jaw and tied over the head – this was to indicate that she was suffering from severe toothache and was unable to speak. Then she put on a pair of green-tinted spectacles which William had bought for her.

They reckoned that Ellen, with her face muffled by the poultice, would have a plausible excuse for avoiding conversation with any fellow passengers. But any white man would have the right to question peremptorily any black person he found at large (particularly at night or on Sundays) without a written pass, signed by the master or someone in authority – or without duly stamped freedom papers, certifying that the

person was the rightful owner of himself. Any black person who refused to answer could be beaten and if he tried to defend himself, could be killed with impunity on the spot.

When the time came for the couple to set out, before dawn, they blew out the candles, knelt and prayed to God to assist them, as he had done to his people of old, to escape from their cruel bondage. As they tiptoed through the door into the outside darkness, Ellen's nerve cracked and she burst into a paroxysm of tears. She soon recovered, however; they shook hands and set off in different directions for the railway station. William got there first and entered the 'negro car' in which he would have to ride; his master (as he would have to call his wife from then on) arrived with the bulk of the passengers and bought a ticket for 'himself' and one for his slave to Savannah, the first port, about 200 miles away. The master then had the luggage stowed and stepped into one of the best carriages.

Just before the train moved off, William peeped out through the window and, to his horror, saw the cabinet-maker on the platform; he had apparently had a presentiment that the two slaves were up to something. After questioning the ticket-seller, the cabinet-maker was now looking rapidly through the windows of the carriages. Mercifully, he did not recognise Ellen in her male disguise, and just before he reached William's carriage the bell rang, and the train began to move. It was to be only the first of many heart-stopping moments on their epic journey.

'Mr Johnson' settled herself unobtrusively in her carriage. As the train moved off, Ellen looked up and was horrified to find, sitting opposite her, a certain Mr Cray, an elderly friend of her master, who had dined with the family the day before. She jumped to the conclusion that he was there for the express purpose of capturing her. When Mr Cray made an innocuous remark about the weather, she feigned deafness lest he recognise her voice. Mr Cray repeated the remark more loudly, and when Ellen still paid no attention, he grew irritated and said, 'I will make him hear!' and almost bellowed his remark: 'It's a very fine morning, sir!' Ellen turned her head at this, gave a polite bow and mumbled, 'Yes,' and carried on gazing out of the window.

One of the other passengers in the carriage remarked that deafness must be a great deprivation, and Mr Cray said, 'Yes, and I shall not trouble that fellow any more'; whereupon the others turned the conversation to the three great topics of discussion in first-class circles in Georgia – namely, 'niggers, cotton and abolitionists' . . .

The train reached Savannah early that evening. The two runaways boarded the omnibus which took them in due course to the steamer bound for Charleston, South Carolina. Soon after going on board, Ellen turned in. William started preparing the poultices and a patent medicine called Opodeldoc to explain her early withdrawal from the company. There was no sleeping accommodation for 'coloured passengers', so while Ellen stayed in her cabin, William had to find a warm spot for himself on top of some cotton bags near the funnel, where he huddled until morning.

At breakfast, William saw to Ellen's needs at the captain's table as usual. And now attention focused on William, not Ellen. The captain said to Ellen, 'You have a very attentive boy, sir; but you had better watch him like a hawk when you get him to the North. He seems all very well here, but he may act very differently there. I know several gentlemen who have lost their valuable niggers among them damned abolitionists.'

A hard-featured slave-dealer named John C. Calhoun was sitting opposite. He leaned back, hooked his thumbs in the armholes of his fancy waistcoat and joined in: 'I wouldn't take a nigger to the North, under no consideration. I have had a deal to do with niggers in my time, but I never saw one who ever had his heel upon free soil that was worth a damn. Now, stranger,' he went on, 'if you have made up your mind to sell that here nigger, I am your man; just mention your price, and if it isn't out of the way, I will pay for him on this board with hard silver dollars. What do you say, stranger?'

'I don't wish to sell, sir,' said Ellen. 'I cannot get on well without him.'

'You will have to get on without him if you take him to the North,' Calhoun went on. 'I can tell ye, stranger, as a friend, I am an older cove

than you; I have seen lots of this here world, and I reckon I have had more dealings with niggers than any man living or dead. I was once employed by General Wade Hampton, for ten years, in doing nothing but breaking 'em in; and everybody knows the general would not have a man that didn't understand his business. So I tell ye again, stranger, you had better sell, and let me take him down to Orleans. He will do you no good if you take him across Mason and Dixon's line; he is a keen nigger, and I can see from the cut of his eye that he is certain to run away.'

Ellen replied, 'I think not, sir. I have great confidence in his fidelity.'

The acute irony of the situation was becoming more and more intense as others endorsed John C. Calhoun's braggart talk about niggers and how to treat them. A young Southern army officer had a warning for her: 'You will excuse me, sir, for saying that I think you are very likely to spoil your boy by saying "Thank you" and "If you please" to him. The only way to make a nigger toe the mark, and to keep him in his place, is to storm at him like thunder and keep him trembling like a leaf.'

The steamer reached Charleston later that day. Ellen stayed in her cabin until all the other passengers had disembarked. It had been the intention to take a steamer from Charleston all the way to Philadelphia, but the vessels did not run during the winter. Instead, Ellen and William decided to take ship to Wilmington, in North Carolina, and then catch a train on the overland mail route from Wilmington to Philadelphia.

Buying tickets for the steamer to Wilmington presented another unexpected hurdle. At the custom house, which was crowded with passengers buying tickets, Ellen asked for a ticket for herself all the way to Philadelphia and one for her slave. The chief officer looked at the pair suspiciously and said to William in a fierce tone of voice, 'Boy, do you belong to that gentleman?'

'Yes, sir,' replied William.

When the tickets were produced, the chief officer said to Ellen, 'I wish you to register your name here, sir, and also the name of your nigger, and pay a dollar duty on him.'

Ellen paid the dollar and, pointing to her arm in its sling, asked the

officer to register her name for him; this the man flatly refused to do. William was forced to plead for his master, saying that she was in terrible pain with toothache and needed to get to Philadelphia to see a dentist. At this point, the young Southern army officer, somewhat the worse for brandy, intervened. He shook hands effusively with Ellen like a long-lost friend and said, 'I know Mr Johnson's kith and kin like a book.' And because he was well known in Charleston, and was stopping there, his breezy recognition of Mr Johnson created a good impression. The captain of the steamer, a jovial-looking man, perhaps not wishing to lose a couple of potential passengers, airily said that he would register the names himself: 'Mr Johnson and slave'.

They reached Wilmington the next morning and took the train for Richmond, Virginia. In those days, railway cars in America had a little compartment at one end with a couch on each side for the convenience of families and invalids. Mr Johnson was allowed to enter one of these compartments at Petersburg, Virginia, where an old gentleman and his two daughters also got in. The old gentleman thought the invalid should lie down and have a rest. The two young ladies were greatly taken with the handsome young invalid; they made a pillow with their shawls and solicitously draped his fashionable cloth cloak over him.

At Richmond, a stout elderly lady entered the railway car and took a seat near Ellen. She glanced through the window and saw William hurrying along the platform; she sprang up and bawled, 'Bless my soul! There goes my nigger, Ned!'

'No,' said Ellen, 'that is my boy.'

When William turned to look at her, the woman realised her mistake and apologised to Ellen: 'I beg your pardon, sir, I was sure it was my nigger. I never in my life saw two black pigs more alike than your boy and my Ned.'

In the course of a prolonged rant about slaves and their ingratitude, it emerged that Ned had run away from her 18 months previously and she had 'lost' several others. She was still incandescent with rage: 'Blast them! If I ever get them back, I'll cook their infernal hash and tan their

accursed black hides well for them! God forgive me, the niggers will make me lose all my religion!'

The rest of the journey to Baltimore was less eventful. Baltimore was the last important slave port of call at which they stopped; they arrived there on Saturday, 24 December – Christmas Eve. They had been travelling for four days and three nights and had scarcely slept a wink throughout. There was only one lap to go: Baltimore to Philadelphia. If all went well, they would be there at 5 a.m., Christmas Day. They were so very near to their destination, but they knew that it could still go horribly wrong – and it very nearly did.

The authorities at Baltimore were particularly watchful to prevent slaves from escaping into Pennsylvania, which was a free state. William had ensconced Ellen in one of the best carriages and was about to step into his own, when a Yankee officer tapped him on the shoulder and said harshly, 'Where are you going, boy?'

'To Philadelphia, sir,' replied William humbly.

'What are you going there for?'

'I am travelling with my master, who is in the next carriage, sir.'

'Well,' drawled the Yankee officer, 'I reckon you had better get him out, and be mighty quick about it, because the train will soon be starting. It is against my rules to let any man take a slave past here, unless he can satisfy them in the office that he has the right to take him along.'

The officer passed, leaving William trembling with terror on the platform. He went into Ellen's carriage to break the bad news. Ellen was thunderstruck, but somehow they summoned up their courage and hurried to the office. There, the chief officer demanded 'security' – proof of the master's identity and that of the slave. The other passengers murmured against this detention of the invalid slave-holder; the officer recognised that the mood of the crowd was against him and now wanted to know if Ellen were acquainted with any gentleman in Baltimore who could vouch for the fact that the slave belonged to his master. Ellen, with a brave show of feigned indignation, retorted, 'I bought tickets in Charleston to pass us through to Philadelphia, and you have no right to detain us here.'

'Well, sir,' said the chief officer, 'right or no right, we shan't let you go.'

For a few moments, there was a deathly silence in the crowded room, until the conductor of the train they had just left came in; he confirmed that the couple had travelled with him from Washington, where he had first boarded. Just then the bell rang for the train to leave, electrifying the silence. And all at once the chief officer ran his fingers agitatedly through his hair and said, 'I really don't know what to do! I reckon it's all right. As he isn't well, it would be a pity to stop him here. We'll let him go.' He told the clerk to run and tell the conductor to let the couple pass. Ellen thanked him and hobbled across the platform as quickly as possible. William bundled her unceremoniously into a carriage and leaped into his just as the train was moving off.

Safe at last! As the tension ebbed, William allowed himself the luxury of closing his eyes for a few moments; instead, he fell into a deep, deep sleep. When the train reached Havre de Grace, all the first-class passengers had to get out of their carriages and into a ferry to be transported across the Susquehanna River; they would then take the train on the opposite side. The luggage vans were rolled onto the boat and off on the other side – including the sleeping William. When Ellen left the train to board the ferry, there was no sign of William, who was usually so attentive to her every need. Once again, Ellen was terror stricken. Had William been kidnapped by a slave-dealer? Had he been killed on the train? She asked the conductor to see if he could find William, but the conductor, who was a bit of an abolitionist at heart, replied, 'I am no slave-hunter, and as far as I'm concerned, everybody must look after their own niggers.'

Ellen was in despair. She had the train tickets, but William was carrying all their money, on the assumption that a slave's pocket would be the least likely target for a pickpocket. Ellen was in a quandary, trying to decide whether to abandon the train to look for William or to carry on to Philadelphia in the hope that William would somehow manage to get there, too. In the end, she decided to stay with the train.

When the train was well on its way to Philadelphia, the guard went

into the baggage car and gave the sleeping William a violent shake and bawled in his ear, 'Boy, wake up!' William was frightened out of his wits. 'Your master is scared half to death about you. He thinks you have run away from him.'

William hurried off to see Ellen, to reassure her. When he got back, he found the guard and a few of the passengers discussing him. 'Boy,' said the guard, 'let me give you a little friendly advice. When you get to Philadelphia, run away and leave that cripple, and have your liberty.'

'No, sir,' replied William, 'I can't promise to do that. I shall never run away from such a good master as I have at present.'

Later, William met a 'coloured gentleman' on the train who recommended to him a boarding house kept by an abolitionist.

Early on Christmas morning, the engine of the train started emitting a series of strident whistles. Opening the window, William saw a mass of flickering lights in the distance. Philadelphia! As soon as the train pulled up at the platform, William hurried out of his carriage to his 'master'. Ellen and William got into a cab and drove to the boarding house which had been recommended to them. Ellen burst into tears and wept like a child on William's shoulder. When they reached the boarding house, she was so weak and faint that she could scarcely stand – and this time she was not feigning illness. In their room on that sabbath Christmas morning, they fell to their knees and poured out their heartfelt gratitude to God for enabling them to overcome so many perilous difficulties to escape from the jaws of the wicked.

The flight to England

The fugitive couple were not out of danger yet, however. In their lodgings in Philadelphia, Ellen discarded her disguise as a young white cotton planter, and William felt bold enough to claim his rightful status as her husband. They had been intending to make their way to Canada, via the so-called 'Underground Railroad',[5] but they were advised by leading abolitionists in the city that Canada would prove too cold for them in the depths of winter and that they would be better to settle in Boston.

They were told that Massachusetts had become a bastion of anti-slavery and that it was almost impossible for anyone to abduct a slave from out of the state.

Before they left Philadelphia, they were given shelter in a 'safe house' owned by a Quaker farmer named Barkley Ivens, who lived some distance up the Delaware River. There Ellen was nursed back to health, and Mrs Ivens and their three daughters undertook to teach the escaped couple to read. By the end of three weeks, they could spell and write their names quite legibly, and although the family begged them to stay longer, Ellen and William were anxious to go somewhere where they could start to earn their own livelihoods. So off they went, via the Underground Railroad, to Boston.

In Boston William found employment as a cabinet-maker and furniture broker, while Ellen got a job as a seamstress. All went well for nearly two years. They became involved in the abolitionist movement and made speeches at anti-slavery meetings. Their story was featured in newspaper articles which were syndicated far and wide – as far as Macon in Georgia, where the couple had started their dash for freedom.

Then, in September 1850, their lives were thrown into turmoil again. Congress passed the Fugitive Slave Law, which William was to call in his book 'an enactment too infamous to have been thought of or tolerated by any people in the world, except the unprincipled and tyrannical Yankees'. It made it a federal crime to aid a fugitive slave.

The abolitionists in Boston were not prepared to tolerate such an inhumane Act. On 4 October they formed a group called the League of Freedom to resist the new law. William Craft was elected vice-president; the president was a former slave named Lewis Hayden, who had escaped via the Underground Railroad to Boston. Ten days later, another group was formed: the Committee of Safety and Vigilance. Its declared purpose was 'to secure the colored inhabitants of Boston from any invasion of their rights'.

A month after the passing of the Fugitive Slave Law, the Crafts' former masters in Macon sent two slave-catchers (Hughes and Knight)

to Boston to retrieve their 'property'. The Crafts were the first fugitives in Boston to be sought under the new law. One of the bounty-hunters from Macon found William at his place of work and tried to capture him, but the attempt was foiled. As a result, Ellen was taken to a safe house outside the city, while William went to stay with Lewis Hayden in his home on Beacon Hill. With a number of armed men inside the house, and two kegs of gunpowder next to the front door, Hayden was prepared to blow up his house rather than surrender the fugitive.

The bounty-hunters were harried by members of the Committee of Safety and Vigilance; they were arrested on charges of conspiracy to kidnap and defamation (for calling William and Ellen 'slaves') but were soon released on bail. The committee members then warned the slave-hunters that they would not be safe if they remained in Boston. They refused to leave, but later in the afternoon they became so alarmed that they left the city by an indirect route, evading the attentions of the committee members.

The slave-owners in Macon now wrote to Millard Fillmore, the President of the United States, asking for his intervention on their behalf. The President agreed that William and Ellen should be returned and authorised the use of military force to take the couple back south.

It was becoming clear that not even the protection of the Committee of Safety and Vigilance could guarantee the couple's liberty; William and Ellen had become figureheads in the abolition struggle and were always going to be targets for bounty-hunters bent on vengeance. The elderly senator for Massachusetts, Daniel Webster, was trying to promote 'compromise' measures on slavery, which would, however, still leave them vulnerable to abduction.

It was now decided that William and Ellen would need to escape to England, where slavery had been abolished in 1833.[6] Before leaving Boston, the couple were officially married at Hayden's house, with a religious service and a lawful marriage certificate. Among the wedding presents they received were a Bible and a bowie knife, for self-protection.

They did not dare attempt to board a ship at Boston, because every vessel was being watched by law officers; instead, they set out on the long, arduous and expensive overland route to Halifax, the chief seaport of Nova Scotia in Canada, for the transatlantic voyage to Liverpool.

They first made their way to Portland, in Maine, only to find that the steamer they had intended to take to New Brunswick had run into a schooner the previous night and was in dock for repairs. The couple had to wait there, in trepidation, for three days. The ship eventually sailed and landed them safely at St John in New Brunswick. From there a steamer took them to Windsor, where they found a coach bound for Halifax.

Racial prejudice was still prevalent in Halifax at that time. William had to travel on top of the bus, in pouring rain. Within seven miles of the town, the coach slid off the muddy track and overturned. Scratched and bruised, the fugitives eventually reached Halifax after nightfall – just two hours after the steamer for England had departed. They had to wait there for a fortnight, until the next sailing across the Atlantic on the *Cambria*.

The landlady of the boarding house in which they took a room was flustered to discover that this seemingly white woman's husband was, in her words, 'a nigger'. She told the couple that she herself had 'no prejudice – I think a good deal of the colored people and have always been their friend; but if you stop here we shall lose all our customers, which we can't do no-how'.

Ellen and William refused to leave unless the landlady found them alternative lodgings. Eventually, she gave them the addresses of some 'respectable colored families' who might be induced to take them in. William thereupon called upon a good-hearted churchman, the Revd Mr Cannady, who received them at once, for only a minimal charge.

Both Ellen and William had been unwell when they left Boston and had developed a chill on the journey to Halifax. They were laid up with the Cannady family, under doctor's orders, for most of the fortnight they had to wait for their crossing. Ellen was still very poorly when they

boarded the *Cambria* for Liverpool – so ill, indeed, that William was concerned that she would not survive the voyage. But survive it she did, although she was bedridden for two weeks in Liverpool before she began to recover her health.

England at last

> It was not until we stepped ashore at Liverpool that we were free from every slavish fear. We raised our thankful hearts to Heaven and could have knelt down, like the Neapolitan exiles, and kissed the soil.
>
> William Craft, *Running a Thousand Miles for Freedom: Or, The Escape of William and Ellen Craft from Slavery*

They were free, at long, long last. A few days after they landed, they were collected by a friendly church minister and his wife, who tended Ellen with great solicitude and nursed her back to health. They were then invited to Bristol by another sympathiser, Mr Estlin, and his daughter.

Ellen and William spent seventeen years in England, during which time they had five children. In London they continued their work, lecturing and speaking at public meetings, greatly influencing British attitudes to slavery and the slave trade; they were also joined in the city by William Wells Brown, a noted black abolitionist and novelist who had achieved fame with his autobiographical *Narrative of William W. Brown, a Fugitive Slave* (1847). The Crafts extended their education by attending the Ockham School, an agricultural college in Surrey, and they established themselves in business. For much of their time in England they lived in Hampstead; there is a blue plaque to this effect on Craft Court, the office of the Shepherds Bush Housing Association.

In 1860, William and Ellen published the book of their escape, *Running a Thousand Miles for Freedom: Or, The Escape of William and Ellen Craft from Slavery*. It was an immediate success, going through two editions in two years. It is a remarkable document. It recounts their backgrounds and the story of their escape, interspersed with comments

and observations on slavery and the attitudes of people they met on their journey. William's portrayal of slavery is expressed with great passion in the concluding paragraphs of the book:

> In the preceding pages I have not dwelt upon the great barbarities which are practised upon the slaves, because I wish to present the system in its mildest form, and to show that 'the tender mercies of the wicked are cruel'. But I do now, however, most solemnly declare, that a very large majority of the American slaves are over-worked, under-fed, and frequently unmercifully flogged.
>
> I have often seen slaves tortured in every conceivable manner. I have seen them hunted down and torn by bloodhounds. I have seen them shamefully beaten, and branded with hot irons. I have seen them hunted and often burned alive at the stake, frequently for offences that would be applauded if committed by white persons for similar reasons.
>
> In short, it is well known in England, if not all over the world, that the Americans, as a people, are notoriously mean and cruel towards all coloured persons, whether they are bond or free.

Between 1862 and 1865, William made a series of journeys to Dahomey, in Africa, to teach Christianity and agriculture to the Africans there and to promote trade. The Dahomey scheme did not work out well, however, leaving the Crafts deeply in debt. In 1868, unemployed and in financial straits, they decided that it was safe to return to the United States. The President, Abraham Lincoln, had issued the Emancipation Proclamation in 1863. The American Civil War had been over for three years.

The Crafts took two of their children with them. They bought the Hickory Hill cotton plantation in Savannah, Georgia, where ex-slaves could come and work to escape the hard labour system in which they remained trapped, despite emancipation. But reconstruction-era Georgia proved a hostile environment for their idealistic project; the old barriers and animosities had not gone away. In 1870, the plantation was burned

down by the Ku Klux Klan, destroying the house, the barn and the crop they had planted. Undeterred, they took a lease on Woodville, a plantation outside Savannah in a county where the majority of the population was black, and opened a cooperative farm and a school (at one time they had as many as 75 students) so that workers and their families could live in a true community. There was no further overt violence to contend with, but they were dogged by perpetual white hostility, discrimination and debt for the rest of their lives.

Ellen Craft died in 1891 at the age of 65 and was buried, in accordance with her wishes, under her favourite tree on their farm. The farm, however, had never been a financial success and had to be sold by auction to pay off the debts. Soon afterwards, William moved to Charleston in South Carolina, where he died in 1900.

It was ultimately a sad ending to a story of great courage in appalling circumstances. Their gallant imposture was of an altogether nobler kind than the other subterfuges described in these chapters. Certainly, it served to save their lives, but their purpose was also to blaze a trail for other slaves – and in this they succeeded triumphantly.

3.3 – The Turk in the Cabinet: The First Chess Automaton[7]

For two weeks early in 2003, chess maestro Garry Kasparov played a series of six matches against a computer named Deep Junior at the New York Athletic Club. It was a contest which was billed, under the auspices of the World Chess Federation, as the first 'Man v. Machine' world championship.

Garry Kasparov, born in the former Soviet republic of Azerbaijan in 1963, had become the youngest-ever world chess champion at the age of 22 and had held his title for 15 years, before losing it to his former pupil, Vladimir Kramnik, in 2000. Deep Junior, built by two Israeli programmers, was the world's strongest chess programme for personal computers, capable of analysing three million moves per second. It had already seen off all electronic rivals and was the three-time chess computer world champion.

In October 1989, Kasparov had won, convincingly, a two-match challenge from a powerful computer named Deep Thought. In May 1996, an IBM supercomputer named Deep Blue offered another challenge, this time to a full six-match contest in Philadelphia. Deep Blue was an unimaginably powerful machine, capable of evaluating 100 million positions per second. Despite losing in the first match, Kasparov came back strongly, winning three and drawing two of the remaining games.

A rematch was held the following year in New York. Deep Blue was upgraded and was now twice as fast as it had been the previous year, capable of evaluating 200 million moves per second. But Kasparov was at the peak of his powers as world champion. He won a hard-fought first game, but in the second game he seemed to lose confidence and resigned when he could have forced a draw. The third, fourth and fifth games were drawn. In the sixth and final match Kasparov made an elementary

error and was trounced in under an hour. For the first time in history, a computer had beaten a world-class chess player.

The Deep Junior challenge, six years later, could be regarded as a return match or a grudge match, according to taste. This time Kasparov went straight for the kill and mauled the computer with a fine display of power and clinical technique to win the first match. He was all set to crush 'Deep Junior' in the second game, too, but then made an error and the game was drawn. In the third game Kasparov continued to go hard for Deep Junior, but the computer defended flawlessly, and Kasparov blundered as he went for a draw and resigned after 33 moves.

The fourth game was perhaps the most fiercely contested of them all, filled with tension and strategic manoeuvring, until it ended in a draw. Kasparov had chances to win in Game 5, but seemed to have lost his killer instinct and the game ended in a quick and tame draw.

After five games, the match score was level at 2½–2½, and the final game attracted enormous attention, with an estimated TV audience of 200 to 300 million viewers. The tension built up as Kasparov attacked relentlessly and, on the 23rd move, achieved what match commentators perceived to be a winning position. Then, to everyone's surprise, Kasparov offered a draw. Deep Junior turned down the offer but offered its own draw five moves later. So the match ended in a draw at 3–3.

What had made Kasparov retreat from his strong position? Had he become spooked? Kasparov, who had said that he was representing the human race against machine intelligence, later defended his decision to play safe. Perhaps he was remembering that in his earlier match against the Deep Blue supercomputer the score was tied going into the final game and he had lost. He said that his overwhelming desire was not to lose; he would have pressed for a win in a similar position against a human opponent, but he was afraid that even the tiniest mistake would have been severely punished by the computer, whereas against a human it was always possible to recover from a mistake. It was, perhaps, the ultimate difference between man and machine: the machine did not know the meaning of fear.

But was Deep Junior, or Deep Blue, or indeed any computer, capable of genuine thought? Can a computer have a 'real' brain? Can a chess-playing computer be any better than its engineers and programmers? Can a robot be endowed with artificial intelligence? Or is the whole idea of a thinking automaton basically fraudulent?

These are questions which have been in the air for a long time, at least since the appearance in 1770 of an ingenious chess-playing automaton – 'The Mechanical Turk'. Its inventor never claimed, in so many words, that 'The Turk', as it came to be known, could play chess unaided (and outplay human chess-players unassisted), but he never denied it, in so many words, either.

The Turk conceived

The Turk was designed and built in 1769 by a Hungarian inventor and engineer named Wolfgang von Kempelen (1734–1804) and exhibited in 1770 at the imperial court of Maria Theresa (1717–80), empress of Austria-Hungary, in the Schönbrunn Palace in Vienna. ·

Wolfgang von Kempelen was little short of a prodigy – brilliant, accomplished and extremely good-looking. He was born in what is now Bratislava, in Slovakia, the son of an officer in the royal customs service. He studied philosophy and law in Vienna and quickly became fluent in several languages. His main interest, however, was in scientific investigation, technology and engineering – and mechanical inventions.

In 1755, at the age of 21, he was formally introduced to the Viennese court by his father and made an instant impression on the empress Maria Theresa. Promotion was swift: Wolfgang was soon appointed a court counsellor. In 1758, he became controller of the imperial salt mines in Transylvania, and in 1766 he was promoted to the position of director. Here he put his technological expertise into practice and devised a pumping system to prevent flooding in the mines.

Two years later, in 1768, he was put in charge of coordinating the settlement of the mountainous Banat province in Hungary. It involved

planning villages and designing new houses for the thousands of families who were to settle in the region. He spent most of his time in Banat but was required to make regular visits to the court in Vienna to report personally on his progress.

Empress Maria Theresa had never lost touch with her clever young protégé. She was now a widow (her husband, Emperor Francis, had died in 1765) and was applying her energies to social reform – updating the law and the harsh penal policy, developing a poor-law system and introducing compulsory primary education; at the same time, she was encouraging the architectural and cultural development of Vienna as a great European city. In her latter years, she had become fat and was often ill, but she had not lost her intellectual vigour or her fascination with science and medical progress.

On one of von Kempelen's periodic visits to court, in the autumn of 1769, the empress invited him to attend a display of 'magnetic tricks' which was being presented to the court by a visiting French savant named Pelletier. The display seems to have been a pot-pourri of conjuring illusions, chemical reactions, demonstrations of magnetism and tricks involving automata, and the empress wanted von Kempelen to sit beside her and explain how Pelletier's feats worked.

Von Kempelen was distinctly unimpressed. After the show, the empress invited him to give what was probably intended to be the vote of thanks, but von Kempelen, to everyone's surprise, announced that he believed himself to be capable of constructing a much more ingenious and mystifying machine than anything Pelletier had just demonstrated. The empress could scarcely ignore such an audacious challenge – especially since national pride was now at stake. Von Kempelen was given leave from his official duties and was commanded to return to court within six months with the spectacular invention he had promised to produce.

The Turk unveiled

In the spring of 1770, von Kempelen returned to court. He had spent the previous six months in his workshop beside his library, where he

had laboured on the task he had set himself, constructing a cabinet crammed with machinery and a life-size wooden mannequin operated by clockwork.

Empress Maria Theresa, her court and a select company of invited guests gathered for the performance. They waited expectantly as von Kempelen wheeled in his contraption with a flourish (he was nothing if not a showman). One member of the audience that evening was Carl Gottlieb von Windisch, a friend of von Kempelen's, who described the scene in his book *Inanimate Reason; or a Circumstantial Account of That Astonishing Piece of Mechanism, M. de Kempelen's Chess-Player* (1784).

The contraption consisted of a maplewood cabinet (122 cm long, 76.2 cm deep and 91.5 cm high), mounted on four brass castors; the front of the cabinet had three doors of equal width, with a long drawer underneath. The carved wooden mannequin – 'The Turk' – was seated behind it, dressed stylishly in an ermine-trimmed robe, loose trousers and a turban; its right arm rested on the top of the cabinet, while the left hand grasped a long Turkish pipe.

Von Kempelen stepped forward as theatrically as any stage magician and announced that he had built an automaton which was capable of playing chess. First, he said, he would display the inner workings of his mechanical toy. With a flourish he produced a set of keys and opened the left-hand door at the front of the cabinet to reveal a compartment crammed with a mass of wheels, cogs, levers, gears and a large horizontal cylinder covered with protruding studs like a musical box. He now moved to the back and opened a door directly behind the machinery and held a burning candle whose flickering light could be discerned by the audience fleetingly through the dense clockwork; then he closed and locked the rear door. He returned to the front of the cabinet and pulled out the long drawer to reveal a set of red and white ivory chess pieces, which he placed on top of the cabinet. Next, he opened the centre and right-hand doors at the front, revealing a main compartment which was empty apart from a few metal wheels and cylinders and two horizontal brass structures resembling quadrants. Once again, he went behind the

cabinet and opened a rear door to let the audience see through the main compartment. The contraption now had all three front doors and two of the back doors open, as well as the large front drawer. Von Kempelen then rotated the contraption so that it would be seen from all sides. It was the familiar routine of a stage magician, to assure the audience that no human being was concealed within the cabinet.

Finally, von Kempelen turned the contraption so that The Turk had its back to the audience and opened a couple of small doors in its back and thigh to reveal the clockwork mechanisms within the mannequin itself. He then announced that his automaton was ready to play a game of chess against anyone prepared to challenge it. A volunteer from the audience stepped forward – a courtier named Count Cobenzl. Von Kempelen produced a large key and wound up the clockwork mechanism with a loud ratcheting sound. There was a dramatic silence, followed by whirring and grinding noises. The mannequin turned its head from side to side, reached out its left arm and moved one of the chess pieces forward. The game was on. The Turk proved to be a fast and aggressive player and demolished its opponent within half an hour.

It was a sensational debut. Everyone – including the empress – was amazed and baffled. Von Kempelen, it seemed, had built a mechanical automaton whose clockwork mind could respond, under its own initiatives, to unplanned moves in a game of chess and 'out think' its human opponents. Artificial intelligence indeed, with a vengeance!

At Maria Theresa's request, von Kempelen put his automaton through its paces at court on several occasions in order to impress eminent visitors. Discussion raged about how it worked. A French traveller named Louis Dutens, who was given a demonstration at von Kempelen's home and allowed to examine the cabinet closely, wrote a lengthy description for the journal *Le Mercure de France* in October 1770, which was soon translated into English for the *Gentleman's Magazine*. 'Notwithstanding the minute attention with which I have repeatedly observed it, I have not been able in the least degree to form any hypothesis [about how it worked] which could satisfy myself.'

Europe may have been agog, but von Kempelen was rapidly losing interest in his contraption. Indeed, he became so irritated with the constant stream of visitors to his house that he said The Turk had been dismantled. For him, it had served its purpose; the empress had rewarded him handsomely by recalling him from Banat and doubling his salary. She also gave him the opportunity to exploit his engineering skills in addition to his duties as a civil servant: he designed bridges and canals, as well as a hydraulic system for the fountains at the Schönbrunn Palace – and a mechanical bed to help the empress with her health problems. He declined all but the most pressing invitations to demonstrate The Turk in action. He was pleased that no one had yet guessed its secret and refused to sell it to anyone. Eventually, he did dismantle the machine and tried to forget about it. But no one else did.

The Turk revived

Maria Theresa died in November 1780, to be succeeded as emperor by her son and co-ruler Joseph. Joseph's first state visitor to Vienna, in September 1781, was to be the Grand Duke Paul of Russia (1754–1801), the son of Catherine the Great (1729–96) and the future emperor. Emperor Joseph II wanted to make the visit of Grand Duke Paul and his wife memorable, so von Kempelen was ordered to reconstruct his automaton for the occasion. It was such a success that the Grand Duke proposed that The Turk should be taken on a tour of Europe's courts and capital cities, and the emperor gave him two years' leave from Vienna for the purpose. Von Kempelen did not like the idea of becoming a travelling showman but had no option but to obey, and in the spring of 1782, he set off for Paris.

The queen of France at the time was Joseph's sister, the ill-fated Marie Antoinette (1755–93), wife of Louis XVI, and so von Kempelen had no difficulty in obtaining an introduction to the court at Versailles. The Turk took Versailles, and the city of Paris, by storm, and von Kempelen, despite his reluctance, scored some welcome personal successes. One such coup was meeting the statesman and inventor Benjamin Franklin (1706–90) and exchanging scientific ideas with the great American.

Franklin, who was in Paris as the US envoy to France, was a chess fanatic: 'Chess is so interesting in itself that those who have leisure for such diversions cannot find one that is more innocent, but advantageous, to the vanquished as well as the victor.'

Franklin agreed to play against The Turk at the Café de la Régence, where he, too, became one of the vanquished.

Another publicity coup was arranging for The Turk to play against Europe's leading chess player of the time, the French master Françoise-André Philidor (1726–95), author of the classic guide to chess strategy *Analysis of the Game of Chess* (1748). Philidor won with some ease. The Turk had not won all its matches, but its secret remained intact, despite close scrutiny from the intellectual savants of Paris.

In the autumn of the following year (1783), The Turk hit London. The capital city of England was a richly fertile target at that time. Technological inventions and elaborate automata were all the rage as the Industrial Revolution burgeoned across the country. Novel mechanical techniques were being harnessed for industrial purposes: new machine tools, steam engines, and so on. Technological ingenuity was what would now be called distinctly 'sexy', and The Turk was the sexiest of them all.

While critics poured scorn on the idea that The Turk itself was playing and thinking its way through a game of chess (even though none could show precisely how it was done), others found it an inspiration. One man in particular – Edmund Cartwright (1743–1823), the Leicestershire country clergyman and poet – found it such an inspiration that he went on to invent the power loom in 1785. He saw The Turk operating in London in 1784 and reasoned that if it were possible to construct a machine to play chess, it should be just as feasible to construct an automatic weaving loom. Thereupon he set about creating his power loom, changing the face of the textile industry and giving a tremendous boost to the Industrial Revolution.

In the autumn of 1784, von Kempelen and The Turk left London to end their European tour via Germany and Holland. Once again, despite mounting criticisms of the claims made for it, its secret remained intact.

Von Kempelen himself, however, had never claimed that The Turk really played chess; he always called it his 'illusion'. He said it was 'a very ordinary piece of mechanism – a bagatelle whose effects appeared so marvellous only from the boldness of the conception and the fortunate choice of the methods adopted for promoting the illusion'.

His duty to his emperor done, von Kempelen packed his bagatelle in wooden crates and put it into storage. He was tired of his creation, however sensational it had proved to be. While The Turk mouldered in its crate, and legends about its exploits grew more and more far-fetched, von Kempelen put it out of his mind. He had other, more important, researches to conduct – particularly into the mechanics of human speech and the refinement of a 'speaking machine' on which he had been working for many years.

This speaking machine was perhaps von Kempelen's most significant invention and has earned him the title of the 'first experimental phonetician'. In 1791, he published an important book on his work and theories about the nature of communication (*Mechanismus der menschlichen Sprache nebst Beschreibung einer sprechende Maschine* – 'The mechanism of human speech, with the description of a speaking machine'). The final version of his 'speaking machine' is now in the Munich Museum of Science and Technology.

This machine was reconstructed by the English physicist Charles Wheatstone (1802–75), the inventor of the electric telegraph. When he gave a demonstration of his own version of the machine in London in 1861, a 14-year-old boy named Alexander Graham Bell was in the audience. Bell's father challenged him to construct his own 'speaking machine', using tin, rubber and pieces of cotton. Bell would say later that it was working on this talking machine which started him along the path that led to his invention of the telephone in 1876.

The Turk resurrected

Von Kempelen died in 1804, but The Turk did not die with him. On the contrary, it was given a second and even more lurid lease of life.

Not long after von Kempelen's death, his son sold The Turk for 10,000 francs to a remarkable showman: Bavarian-born musician, engineer and inventor Johann Nepomuk Maelzel (1772–1838), best known as the deviser of the metronome in 1816. He turned out to be a much less scrupulous operator than von Kempelen had been.

As an engineer and creator of automata, Maelzel was acclaimed as the equal of von Kempelen. He created a massive musical automaton (first displayed in Vienna in 1805) which he called a 'Panharmonicon'; he later gave an improved version of it another name – the 'Orchestrion'.[8] It consisted of an entire mechanical orchestra, including trumpets, clarinets, violins, cellos and percussion; he sold it in 1808 for a reputed 60,000 francs. He also perfected an automaton trumpet player which could be programmed to play different pieces.

In 1808, Maelzel was appointed engineer to the Viennese court at the Schönbrunn Palace. It was probably then that he restored The Turk which he had bought from von Kempelen's son. Certainly, it was in full working order by the time Napoleon Bonaparte, emperor of France, marched into Vienna and established his headquarters at the Schönbrunn Palace in May 1809. Maelzel was one of the scientists summoned to appear before the French emperor to discuss inventions – including a number of artificial limbs he had designed for soldiers wounded on the battlefield. Napoleon was impressed by these prostheses – but he was even more intrigued when Maelzel mentioned that he had in his possession an automaton which could play chess; Maelzel knew well that Napoleon rather fancied himself as a chess player.

There are various stories about Napoleon meeting The Turk (and losing to him) in Berlin and elsewhere, but all of them turn out to be apocryphal. The only authenticated occasion when the emperor played The Turk was in Vienna in 1809. The meeting took place in the apartment of Prince de Neufchâtel, one of Napoleon's favourite generals. Napoleon's valet, Louis-Constant Wairy (known as 'Constant'), described the encounter in his ghosted memoirs, which were published in Paris in 1830 (*Mémoires de Constant, premier valet*

de chambre de l'empereur sur la vie privée de Napoléon, sa famille, et sa cour).

Napoleon was clearly determined to test his opponent's defences by the use of shock tactics. As soon as the game opened, the emperor deliberately made a false move. The Turk bowed, picked up the emperor's piece and put it back in its place. When Napoleon played another false move, The Turk bowed again and confiscated the piece. When Napoleon cheated for a third time, The Turk shook its head and dashed all the pieces off the table. Napoleon, Constant alleged, 'complimented the mechanician highly'. It is not clear whether or not this was the only game they played against one another.

Soon afterwards, The Turk was bought from Maelzel by Napoleon's stepson Eugène de Beauharnais (1781–1824), the son of Napoleon's wife Josephine by her previous marriage. Eugène was one of Napoleon's most trusted followers, a Prince of France and Viceroy of Italy in Milan, and he shared the emperor's enthusiasm for chess. He, too, was intrigued by The Turk and demanded to be told its secret. Maelzel demurred and said he would only divulge it if Eugène agreed to buy the automaton – for 30,000 francs. But as soon as he had bought it, Eugène lost interest in The Turk, which languished forlornly in his palace in Milan for years until the Bonaparte dynasty fortunes crashed at the Battle of Waterloo in 1815; thereupon Eugène de Beauharnais retired to Munich, taking The Turk with him.

Maelzel, meanwhile, remained immersed in his form of show business, exploiting his automata and his musical skills. He prepared a lavish diorama (a mechanically animated panoramic painting) depicting the conflagration of Moscow – the destruction of the city by its residents in September 1812 to prevent it from falling into Napoleon's hands – with specially composed music by Beethoven: 'Wellington's Victory'. With this device he planned a triumphant tour of European capitals, starting in London. But he felt that he also needed The Turk to complete the bill, so he went to Munich and either purchased or leased von Kempelen's automated chess player from Eugène de Beauharnais. The Turk was due to emerge from retirement.

Once again, The Turk took London by storm – and not only London but also Edinburgh, Liverpool and Manchester. It won nearly all the hundreds of games it played during its three-year tour of Britain (1818–21). But Maelzel was now in serious financial difficulties, harassed by lawsuits brought by creditors and disgruntled former associates (like Eugène de Beauharnais). In December 1825, he gathered up his collection of automata, including The Turk, and fled to New York.

America, the fabled land of opportunity and energy, of hucksters and hustlers, was the perfect place for a man such as Maelzel and a creation such as The Turk. They both enjoyed huge success and even adulation as they toured in New York, Boston, Philadelphia, Baltimore, Richmond, Charleston, Pittsburgh and New Orleans. From there, in February 1837, he embarked for Havana in Cuba, but it was here that the carousel was to grind to a halt.

The Turk unmasked

There had been feverish speculation about how the contraption actually worked, ever since The Turk was first unveiled by Wolfgang von Kempelen in 1770. Most of it was excitable babble, much of it was ill-informed. It was all done by magnets, some claimed. Or it was operated by pulling on tiny threads, like a puppet. There were early suggestions that there must be someone or something inside the cabinet – a small child, perhaps, or a midget, or a legless ex-serviceman, or even a chess-playing monkey (the sultan of Baghdad was said to own such a marvel). But no one could explain how a human being could be concealed within such a small compartment which was open to view by the public before each performance. The prevailing opinion was that von Kempelen was controlling the automaton himself, but no one could provide a satisfactory explanation of how he was doing it – 'an unknown directing force'.

During von Kempelen's London visit in 1783, the intelligentsia of the day clearly recognised that it was a 'fraud':

That an Automaton may be made to move its hand, its head, and its eyes, in certain and regular motions, is past all doubt; but that an AUTOMATON can be made to move the Chessmen properly, as a pugnacious player, in consequence of the preceding move of a stranger, who undertakes to play against it, is UTTERLY IMPOSSIBLE. And therefore, to call it an Automaton (a self-moving engine, with the principle of motion within itself) is an imposition, and merits public detection; especially as the high price of five shillings for each person's admission induces the visitor to believe that its movements are REALLY performed by mechanic powers.[9]

Philip Thicknesse (1719–92), the author of this diatribe, urged his readers not to be taken in by von Kempelen's diversionary tactics on stage: the conjuring routines which deluded the audience into believing that he was secretly controlling the automaton 'by some incomprehensible and invisible powers'. Thicknesse insisted that the automaton was being controlled by an operator concealed within the cabinet – a child, say, of 12 or 14 years old ('and I have children who could play well at chess, at those ages'). Thicknesse was close but not close enough, and his pamphlet did nothing to tarnish The Turk's popular appeal.

In Germany, a book published by Joseph Friedrich, Freiherr zu Racknitz, in 1789[10] provided a thoughtful and detailed analysis of the Turk. Friedrich had observed several of The Turk's performances in Dresden in 1784 and had talked at length to von Kempelen. What is more, he had constructed a series of models of the Turk in order to test his theories about how it might work. With careful logic he discussed all the various hypotheses which had been proposed by others (magnetism, hidden strings and so on) and came to the conclusion that the clockwork mechanism, as exposed to the audience, simply did not look complex enough to enable it to play by itself for even a handful of moves. Racknitz surmised that the machine was operated by a hidden dwarf, but he, too, failed to find a plausible answer to the major questions: if a

hidden operator were involved, how did he or she get inside the cabinet and how did he or she operate The Turk during a game of chess?

On The Turk's second visit to London, in 1819, a young undergraduate named Robert Willis, who shared Maelzel's enthusiasm for music and mechanics, attended one of The Turk's performances and became fascinated by it as an intellectual challenge. Over the next few months, accompanied by his sister, he went to see The Turk in action on several occasions, observing the operation with meticulous care and even (secretly) taking detailed measurements of the cabinet with his umbrella. Then he sat down and wrote an essay, 'An Attempt to Analyse the Automaton Chess Player of Mr de Kempelen. With an Easy Method of Imitating the Movements of That Celebrated Figure', which was published in *The Edinburgh Philosophical Journal* in 1821. Robert Willis was then 20 years old.

Willis worked on the assumption that a purely mechanical device could not, by definition, play chess:

> The phenomena of the chess player are inconsistent with the effects of mere mechanism, for however great and surprising the powers of mechanism may be, the movements which spring from it are necessarily limited and uniform. It cannot usurp and exercise the faculties of mind; it cannot be made to vary its operations, so as to meet the ever-varying circumstances of a game of chess.

Ergo, there had to be a human intelligence controlling the moves individually. But whose? Willis analysed Maelzel's actions during the performance and showed that they were stage 'business', not genuine explanations of what The Turk was about. He noted that:

> The glaring contradiction between eager display on the one hand [before the performance] and studied concealment on the other [during the performance] can only be reconciled by considering

the exhibition of the mechanism as a mere stratagem, calculated to distract the attention, and mislead the judgement, of the spectators.

Based on his detailed measurements of the cabinet, and the detailed sequence of Maelzel's displaying of the interior of the cabinet, Willis was able to demonstrate, with scale drawings, that an adult human being could fit into the compartment and how he or she could be rendered invisible to the audience by means of movable partitions while the inside of the cabinet was being displayed – the oldest trick in the magician's repertoire.

Robert Willis had solved the puzzle in all its major particulars. But in explaining the illusion and mechanism involved, he emphasised that his purpose was not to denigrate Wolfgang von Kempelen or his achievement; on the contrary, he intensely admired von Kempelen's ingenuity in constructing a contraption which had kept the world guessing for so many years.[11]

But Willis's essay, which had theoretically solved the mystery of The Turk, did not finish it off as a public attraction; it was simply considered to be yet another theory. When Maelzel took The Turk to the New World in the mid-1820s, 'this wonderful piece of mechanism', as it was called by the newspapers, continued to delight – and baffle – audiences, and speculation about how it operated continued apace. The *New York Evening Post* commented that a dozen different theories about The Turk's mechanism had been advanced within a week of its first performance. It was all grist to Maelzel's busy publicity mill.

The cat was very nearly let out of the bag, in June 1827, when the *Baltimore Gazette* carried a story headlined 'The Chess-player Discovered'. The story reported the account of two boys who had been climbing on the roof of a shed next to the exhibition hall of the Fountain Inn on Light Street and claimed to have seen Maelzel opening the top of The Turk's cabinet after one of its performances – whereupon a man climbed out. Luckily for Maelzel, the story was pooh-poohed as a publicity stunt by Maelzel himself, and the story died a quick death.

Much has been made of the role of Edgar Allan Poe (1809–49), the pioneer of the modern detective story, as the man who finally unmasked The Turk. When Poe first saw The Turk in action, in December 1835 in Richmond, Virginia, he was a promising 26-year-old journalist and short-story writer, and newly appointed editor of the *Southern Literary Messenger* in Richmond. He studied The Turk in operation evening after evening, noting and analysing every move made by the presenter; then, in April 1836, he published a long essay entitled 'Maelzel's Chess-Player' in the *Messenger*. What has excited the interest of literary historians is that Poe presented his conclusions in a format which was the prototype for the abstract reasoning featured in his later mystery and detective stories, rather than because of the quality of his detection processes. In fact, Poe used most of his article to give an account of what earlier commentators (especially Robert Willis) had surmised, without adding much himself – apart from naming Maelzel's French assistant, an able chess player named William Schlumberger, as the likely operator hidden in the cabinet.

Despite some factual errors, and some flawed reasoning, Poe's essay caused a real stir, and Maelzel, for one, realised that the game was up – in the United States at least. Early in 1837, he packed up and left for Cuba at the start of what he hoped would be a South American tour with The Turk. But nothing went right for Maelzel. He ran out of money (again), and his faithful assistant William Schlumberger died of yellow fever. Then, in July 1838, after borrowing money from a business friend in Philadelphia named John Ohl, Maelzel took ship from Havana – but he was a broken man. On 21 July 1838, he was found dead in his cabin after a six-day solitary drinking binge and was buried at sea off Charleston.

The Turk's operators

But who had been the operators who played the games on The Turk's behalf? Certainly not children, or midgets, or legless ex-servicemen, or chess-playing monkeys. Certainly not von Kempelen or Maelzel

communicating directly with the clockwork machinery inside the cabinet by some arcane means. No, they were normal human beings with one thing in common: they were uncommonly good chess players.

Being the 'man in the machine' was an excruciatingly uncomfortable job in the cramped and stuffy confines of the cabinet, and the human chess players could not work inside the contraption for more than an hour or so. And who were these contortionists? No one knows now who operated The Turk during von Kempelen's lifetime. The first operator whose name is known was a Viennese chess master named Johann Allgaier, who was employed by Maelzel and who operated The Turk during the match with Napoleon in Vienna. During his first visit to Paris, Maelzel recruited a succession of strong chess players at the Café de la Régence. In London, the operator was a young man named William Lewis, who would make his name as a chess theoretician and writer.

In the north of England, Maelzel employed a Frenchman named Jacques-François Mouret (1787–1837, grand-nephew of the great Philidor), who held the job for a year but apparently became addicted to alcohol. Mouret was the only operator who ever betrayed the secret of how the automaton worked; in order to keep himself in drink, he spilled the beans to *Le Magasin Pittoresque* in Paris in 1834. The anonymous article referred to the operator sitting 'on a shelf with castors' – a direct reference to the action of the long drawer inside the cabinet. The article did not receive the attention it deserved. The Turk was in the USA by then, and by the time the article was reprinted in the *National Gazette* in America in 1837, The Turk's long game was already up.

In the USA, the main operator was Schlumberger, a regular from the Café de la Régence who became Maelzel's trusted lieutenant and secretary for the rest of his life. Indeed, it was Schlumberger who had been spotted by the two boys as he exited the cabinet in Baltimore in 1827.

In all, some 15 eminent chess masters occupied the machine during its working life as a lucrative sideshow.

Epilogue

Maelzel's death, in 1837, was greeted in the USA with genuine regret and affectionate respect. His obituaries lamented the loss of 'the ingenuity which seemed to breathe life into the work of his hands' and 'his unsurpassed genius for curious mechanism'. By now, Wolfgang von Kempelen, The Turk's original creator, had been all but forgotten: The Turk had become Maelzel's exclusive creature.

After Maelzel's death, his chief creditor, the Philadelphia businessman John Ohl, took possession of the deceased's property and put it up for sale at public auction. Ohl bought The Turk for $400, hoping to sell it on at a fat profit. No offers materialised, and six months later, he sold it to a Dr John Kearsly Mitchell, a professor at the Jefferson College of Medicine, who happened to be the Poe family's doctor. Mitchell spent months trying to work out how it had been operated; it was not until September 1840 that he succeeded in reassembling The Turk. He staged a private exhibition, with his son Silas Weir Mitchell inside the cabinet, and carefully explained to the onlookers precisely how it had worked.[12]

Dr Mitchell soon tired of his toy. He donated the automaton to the Chinese Museum in Philadelphia, where a few half-hearted attempts were made to give public performances. But it failed to excite public interest and was soon relegated to a corner of the museum under a back staircase.

On the evening of 5 July 1854, a fire broke out in the National Theater in Philadelphia, on the same street as the Chinese Museum. The flames spread rapidly, and soon the museum was engulfed. Silas Weir Mitchell arrived on the scene just too late to save The Turk. And with that, the first 'chess automaton' was reduced to ashes. It was the end of one of the most spectacular stories in the long history of the blurred interface between reality and illusion, between fakery and fraud.[13]

Envoi

The Turk has generated an enormous amount of literature since it was first unveiled by Wolfgang von Kempelen at the Viennese court in 1770.

One of the most intriguing is a poem by the American writer Hannah Flagg Gould (1789–1865). In 1826, after seeing The Turk in action in Boston, Massachusetts, she wrote this whimsical poem – the first known text on chess by an American woman. 'Address to the Automaton Chess Player' was first published in the *Saturday Evening Gazette* in November 1826:

Thou wondrous cause of speculation,
Of deep research and cogitation,
Of many a head and many a nation,
 While all in vain

Have tried their wits to answer whether,
In silver, gold, steel, silk or leather,
Of human parts, or all together,
 Consists thy brain!

When first I viewed thine awful face,
Rising above that ample case
Which gives thy cloven foot a place,
 Thy double shoe,

I marvelled whether I had seen
Old Nick himself, or a machine,
Or something fixed midway between
 The distant two!

A sudden shuddering seized my frame:
With feeling that defies a name,
Of wonder, horror, doubt and shame
 The tout ensemble,

I deemed thee formed with power and will;
My hair rose up – my blood stood still,
And curdled with a fearful chill,
 Which made me tremble.

I thought if, e'en within thy glove,
Thy cold and fleshless hand should move
To rest on me, the touch should prove
 Far worse than death;

That I should be transformed, and see
Thousands and thousands gaze on me,
A living, moving thing, like thee,
 Devoid of breath

When busy, curious, learned and wise
Regard thee with inquiring eyes
To find wherein the mystery lies,
 On thy stiff neck,

Turning thy head with grave precision,
Their optic light and mental vision
Alike defying, with decision,
 Thou giv'st them 'check!'

Some say a little man resides
Between thy narrow, bony sides
And round the world within thee rides;
 Absurd the notion!

For what's the human thing would lurk
In thine unfeeling breast, Sir Turk,
Performing thus, thine inward work,
 And outward motion?

266

Some whisper that thou 'rt he, who fell
From Heaven's high courts, down, down, to dwell
In that place of sulphury smell
 And lurid flame.

Thy keeper then deserves a pension,
For seeking out this wise invention
To hold thee harmless, in detention,
 Close at thy game.

Now, though all Europe has confessed,
That in thy master Maelzel's breast
Hidden, thy secret still must rest,
 Yet 'twere great pity,

With all our intellectual light
That none should view thy nature right,
But thou must leave in fog and night
 Our keen-eyed city.

Then just confide in me, and show
Or tell, how things within thee go!
Speak in my ear so quick and low
 None else shall know it.

But, mark me! If I should discover
Without thine aid, thy secret mover.
With thee for ever all is over,
 I'll quickly blow it!

3.4 – The False Formosan: George Psalmanazar[14]

The young man was a mystery. A flamboyant, quick-witted alien. A handsome, exotic oddity. An erudite, reformed cannibal. A man without a verifiable name; a man without a verifiable nationality. A blond, blue-eyed and fair-skinned man claiming to be an Oriental. For a few bizarre years at the beginning of the eighteenth century, a man calling himself George Psalmanazar and purporting to be a young Formosan nobleman held literary and social London in his thrall.

In London in 1704, Psalmanazar published a sensational book about the island of Formosa (now Taiwan), off the south coast of China, entitled *An Historical and Geographical Description of Formosa*. It was an instant bestseller. What gave its readers a thrilling frisson were the gory chapters about Formosa's 'barbarous' tribal practices – including polygamy, mass infanticide and the ritual sacrifice (to the elephant god) of 18,000 young boys a year. This resulted in an acute shortage of males, which explained the need for polygamy. It was this aspect in particular which captured the popular imagination.

In 1705, after seeing the effect he had created, Psalmanazar produced a second edition of his book, with even more lurid versions of the wicked practices which were supposedly carried out in the unknown hinterland of Formosa. The big new idea introduced by Psalmanazar, to keep the pot boiling (so to speak), was cannibalism:

> We also eat human flesh . . . tho' we feed only upon our open Enemies, slain or made captive in the Field, or else upon Malefactors legally executed; the flesh of the latter is our greatest dainty, and is four times dearer than other rare and delicious meat; we buy it of the Executioner, for the Bodies of all publick capital Offenders are his Fees; as soon as the Criminal is dead, he cuts the Body in pieces, squeezeth out the Blood, and makes his

House a shambles for the Flesh of Men and Women, where all People that can afford it come and buy.

I remember, about ten Years ago, a tall, well complexion'd, pretty fat Virgin, about 19 Years of Age, and Tire-woman to the Queen, was found guilty of High Treason for designing to poison the King; and accordingly she was condemn'd to suffer the most cruel Death that could be invented . . . her sentence was, to be nailed to a Cross, there to be fed and kept alive as long as possible; the Sentence was put in execution, when she fainted with the cruel Torment, the Hang-man gave her Strong Liquors, etc. to revive her, the sixth day she died: Her Long-Sufferings, Youth and good Constitution, made her Flesh so tender, delicious and valuable, that the Executioner sold it for above eight Taillos, for there was such thronging to this inhuman Market, that Men of great fashion thought themselves fortunate if they could purchase a pound or two of it.

Literary London lionised him – but his notoriety did not last for very long. Within two or three years his celebrity had faded, as most people began to realise that he must be an impostor – and a preposterous one at that. Yet some people still believed in him and even subscribed to a fund to provide a pension for him. It was only many years later, when he had become a Grub Street hack churning out academic historical texts, that he acknowledged the imposture, however obliquely; and it was only after his death, in 1763, that his full confession of the imposture was allowed to be published.

My own 'discovery' of Psalmanazar came about during a conference on 'Fakes and Forgeries, Conmen and Counterfeits' which was held at Durham University in July 2002. There, a young American scholar named Michael Keevak delivered a paper on Psalmanazar – 'the most well-known obscure figure in eighteenth-century studies', as he called him.

I was immediately intrigued by the idea of this extravagant European

phoney who had forged such an exotic Asian identity for himself and had fabricated such an extraordinary account of the culture of a remote island about which he knew absolutely nothing. I was agog with eagerness to find out more. How had it all come about? How had he got away with it? And how did today's scholars regard it? I didn't have far to go to start my quest: just a few yards from the conference rooms in Durham University, in fact, to the Palace Green Library.

The books

The Palace Green Library dates from the fifteenth century, but with a nineteenth-century extension built to serve as the university library. Inside the special collections department a book-rest, carefully wedged with sponge foam, is placed before you. The book you want is placed, open, on the book-rest, with weighted cords ('snakes') to hold the pages open. This is a book sanctuary, and old books are treated with exemplary care.

Then the requested book arrives, bound in dark-brown textured leather with a dark gold spine, about the size of an average paperback. This is it:

AN

HISTORICAL AND GEOGRAPHICAL

DESCRIPTION

OF

FORMOSA,

AN

Island subject to the Emperor of Japan.

GIVING

An Account of the Religion, Customs,

Manners, &c. of the Inhabitants. Together

with a Relation of what happen'd to the Au-

thor in his Travels; particularly His Confe-

rences with the *Jesuits,* and others, in several

Parts of *Europe.* Also the History and Rea-

sons of his Conversion to Christianity, with his
Objections against it (in defence of Paganism)
and their Answers.
To which is prefix'd
A PREFACE in Vindication of himself from
the Reflections of a *Jesuit* lately come from *China*,
with an Account of what passed between them.

By GEORGE PSALMANAAZAAR,
a Native of the said Island, now in *London*.

Illustrated with several Cuts

LONDON:
Printed for Dan. Brown, at the Black Swan without *Temple-Bar*; G. Strahan, and W. Davis, in *Carhill*; Fran. Coggan, in the *Inner-Temple-Lane*; and Bernard Lintott, at the *Middle-Temple Gate* in *Fleet-Street*. 1704.

Yes, this is the book I am after. It is floridly dedicated to his patron, 'the Right Honourable and Right Reverend Father in God, Henry' (Henry Compton, Bishop of London), and it includes 16 copperplate engravings, drawn to Psalmanazar's outline sketches, depicting images of religious practices, styles of clothing and funeral ceremonies. One of the illustrations purports to show a temple with 'the Gridiron upon which the hearts of the young Children are burnt' and 'the pit in which their Blood and Bodies are placed'. There is also a chart of Psalmanazar's inventive version of the Formosan alphabet.

The *Description* turns out to be an absorbing and highly entertaining read, written in an uncompromising, in-your-face style. In his preface, Psalmanazar asserts that his objective was to correct the 'obscure and various Notions' about the Far East in general and Formosa in particular

– 'but the prevailing Reason for this my undertaking' was to counter the 'gross Fallacies' spread about Formosa (and himself) by the Jesuits. The tone is set: the *Description* is to be a sustained polemic against the Jesuits, and other forms of Christianity (including Calvinism and Lutheranism), in favour of Anglicanism.

The book starts with a lengthy introduction about 'The Author's Conversion'; it is a melodramatic account of how he, an innocent heathen native of Formosa, was seduced by undercover Jesuit missionaries and taken to Europe, where every effort was made to convert him to Christianity (Jesuit-style). However, the boy Psalmanazar refuted all their theological arguments and, having escaped from the Jesuits, did the same with militant Calvinist and Lutheran proselytisers into whose clutches he later fell. It was not until he was introduced to the tenets of Anglicanism that he found the true haven for his conversion.

The body of the book is about the geography and culture of Formosa itself – its history, form of government, penal laws (convicted murderers were hung upside down and shot full of arrows), religion (sun and moon worship), ceremonies, manners and customs, clothes, housing, lifestyles, commodities, food and drink, coinage, weapons, musical instruments, and 'Liberal and Mechanical Arts'. It also contains a discourse on 'The Language of the Formosans', to be read from right to left, as in Hebrew; Psalmanazar describes (and illustrates) the language's 20-letter alphabet, grammar and syntax, and helpfully adds examples:

> But that the Reader may have some Idea of the Formosan Language, I have here subjoin'd the Lord's Prayer, the Apostles' Creed and the Ten Commandments in that language, printed in Roman Characters.

The Lord's Prayer starts, 'Amy Pornio dan chin Orhnio viey, Gnayjorje sai lory . . .'. For Michael Keevak, Psalmanazar's invented Formosan language was the most enduring and perhaps the most important aspect of the whole imposture.[15]

The other book to be laid carefully on its cushioned rest in the Palace Green Library bracketed Psalmanazar's career like a posthumous bookend; it was not published until 1764 (the year after his death):

<div align="center">

MEMOIRS of * * * *

Commonly Known by the Name of

GEORGE PSALMANAZAR:

A

Reputed Native of FORMOSA

Written by himself

and ordered to be published after his Death,

CONTAINING

An account of his Education, Travels, Adventures,

Connections, Literary Productions, and pretended

Conversion from Heathenism to Christianity, which

last proved the Occasion of his being brought over

into this Kingdom, and passing for a Proselyte, and

a Member of the Church of England.

</div>

This was Psalmanazar's long-prepared deathbed repentance, composed during the last decades of his life and embargoed for publication until after his demise. In it, he disavowed completely *An Historical and Geographical Description of Formosa* as 'a mere forgery of my own' and described it as being 'hatched in [my] own brain, without regard to truth and honesty'. He called it a 'scandalous romance', a 'vile and romantic account', a 'scandalous imposition on the public'.

The memoir gave a more plausible account of his boyhood in France and his education. But, significantly, it gave no hint of his true identity or his place of birth. These are still the great unknowns in the story of George Psalmanazar, despite more than two centuries of assiduous scholarly research. We do not even know where he was buried. So what *do* we know, or think we know?

The Psalmanazar story

'George Psalmanazar' was born in 1679, probably somewhere in the south of France – Gascony, perhaps. Both his parents were Roman Catholics; his father's family was 'antient but decayed'. He never revealed his real birth name; his pseudonym was taken from the Biblical name of Shalmaneser in 2 Kings – the Assyrian king who, as in Byron's memorable phrase about Sennacherib, 'came down like the wolf on the fold' of Samaria.

His parents, he said, were separated: it is assumed that his mother lived in France, while his father lived in Germany. He was educated in the neighbourhood of his birthplace, attending in turn a free school kept by two Franciscan monks, a Jesuit college and a school taught by the rector of a small Dominican convent. It was a rigorous classical education, which gave him a good grasp of Latin, a bit of philosophy, a smattering of theology and a fund of general knowledge – he had, he claimed, 'a ready and retentive memory, and quick apprehension'. He left school at about the age of 15, and after a spell of private tutoring (during which he says he successfully resisted the advances of the young mother of his pupils), he decided to return home to his mother. To this end he secured a passport in which he described himself as 'a young student in theology, of Irish extract, going on a pilgrimage to Rome'. Thus armed, he embarked on a career as an itinerant mendicant. He stole a pilgrim's cloak from a church and set off, begging all the way in impeccable Latin. He had chosen Irish nationality because Ireland was the farthest point in Europe he could think of; however, never having been to Ireland, he was in constant danger of exposure by people who knew the country.

When he reached his mother's house he found that she had no means of support for him; instead, she sent him on an 800 km walk in search of his father in Germany. When he reached his destination, however, he found that his father was even more poverty-stricken than his mother, and he was sent off in the general direction of Holland. This time he changed his nation of birth to somewhere far more remote

and exotic, on the other side of the world: Japan. Why Japan and not some other remote place in Europe? Michael Keevak thinks it was due to his education. He had been taught by Jesuits and Dominicans who would tell him about the world of Jesuit missionary work. But at that time, nothing at all was known about Japan: Westerners had been barred from entering the country since 1640, so all knowledge about Japanese language and culture had dried up. It was perhaps for this reason that he decided to become an Asiatic rather than a European.

When Psalmanazar set off on his travels again it was as an erudite but pagan young Japanese man who spoke fluent Latin, living off raw flesh, roots and herbs. He was not yet 16 years old. His travels now landed him in a series of picaresque adventures. In Landau in the Rhineland he was thrown into jail as a spy. At Aix-la-Chapelle (Aachen) he got a job as a waiter in a coffee house. In Cologne he enlisted in the Buchwald regiment of the Duke of Mecklenburg, where he entertained his comrades with colourful stories of his previous life. In 1702, the regiment was ordered to the Netherlands, as mercenaries in the Dutch Army, which was engaged in a struggle to regain the former Spanish territories now claimed and occupied by the French.

This was the period of the War of the Spanish Succession, when British armies under the charismatic Duke of Marlborough were engaged in war on the Continent against France and Spain. In February 1703, when his regiment had been posted to Sluis, in the south-western region of the Netherlands, Psalmanazar came to the notice of the Revd Alexander Innes, an ambitious young churchman who was the chaplain to Brigadier George Lauder, commander of the second regiment of the Scots Brigade which was posted nearby. Psalmanazar claimed that he had been abducted by Jesuits from his native land and had been converted to Catholicism under duress. Innes, as it turned out, was a rogue himself – he would later, in 1728, publish another man's manuscript under his own name. He was intrigued by Psalmanazar's claims about his Japanese nationality but soon rumbled the deception through a simple ruse: he asked Psalmanazar to translate a passage by Cicero into Japanese, and

Psalmanazar obliged with a page of gibberish; when Innes later asked Psalmanazar to translate the same passage again, he was unable to replicate his earlier rigmarole.

Instead of exposing the fraud, however, Innes merely advised him 'to take care to be better provided for the future'; he saw his chance of achieving preferment in the Church and now became Psalmanazar's guiding confederate. He professed to have wrestled mightily with Psalmanazar's conscience to convert him to Anglicanism and to have baptised him into the Church of England. The godfather at the christening, in March 1703, was Brigadier George Lauder, who bestowed his own baptismal name on the young impostor. Thereupon, Innes bought Psalmanazar's discharge from the army, because he had plans for him in London. But Psalmanazar needed grooming to play the role intended for him: Innes apparently persuaded him to change his alleged birthplace from Japan to what he considered an even more remote and relatively unknown island, Formosa. It seems to have been a completely arbitrary choice and turned out to be a serious mistake, because quite a lot was known about Formosa at that time. But Psalmanazar didn't know that. He didn't check anything, and he didn't read any of the source material available.

Innes, however, prepared his scam with considerable care. He wrote to Henry Compton, Bishop of London, who was a leading luminary in the Society for the Propagation of the Gospel in Foreign Parts and an outspoken opponent of all things Roman Catholic. He was one of the most powerful prelates in the Church of England (he also had charge of military chaplaincies), and his anti-Catholic zeal was popular during the wars on the Continent. Innes told Bishop Compton that Jesuits had abducted Psalmanazar from his native island and had carried him to Avignon. There the young man had withstood all persuasions to become a Roman Catholic, and the Jesuits, angered by his obstinacy, had threatened him with the tortures of the Inquisition. The bishop fell for the story; he commended Innes for his zeal and asked him to bring his young convert to London.

In the summer of 1703, Innes brought the 'Formosan nobleman'

to Bishop Compton, and Psalmanazar presented the prelate with a translation of the Church of England catechism into 'Formosan' – the cryptographic form of alphabetic writing which he had invented.

Psalmanazar soon became an object of excited curiosity in London social circles. In his Formosan role he not only told tall stories and fantastic tales – he positively lived the part of the civilised savage. Yes, he had practised cannibalism in his homeland, where husbands were entitled to eat their adulterous wives (a 'barbarous' custom which he owned was 'a little unmannerly'); but in England he contented himself with eating his meat raw and very heavily spiced.

The Royal Society, Britain's oldest scientific society (founded in 1600), took an interest. According to the Society's minutes, Psalmanazar was 'permitted to be present' at a routine meeting on 11 August 1703 and informed the society that he was writing an account of Formosa. At its next meeting, on 2 February 1704, a learned Jesuit astronomer named Father Jean de Fontaney, who had just returned from China, was invited to take part in a debate on the Formosan's credentials. Psalmanazar later gave his account of the confrontation in the French edition (1705) of his *An Historical and Geographical Description of Formosa*. Fontaney remarked that 'the pretended Formosan is a young man of about 22 years of age; he has blond hair, a ruddy complexion, and speaks the languages of Europe without any Asiatic accent; he appears to be Flemish or Dutch'. But in Psalmanazar's account, he claimed that the Jesuit tried to unmask him not by doubting his physical appearance but by asking him to whom Formosa belonged (Psalmanazar doggedly claimed that it belonged to Japan, not China), by engaging in a ludicrous debate over whether any Chinese word ended in a consonant and, above all, by wondering how Psalmanazar could eat meat, contrary to Fontaney's own experience in China.

The debate seems to have degenerated into a sterile slanging match. That may well have suited Psalmanazar more than Fontaney: the mere fact that Fontaney was a Jesuit worked against him in the atmosphere of anti-Jesuit, anti-'papist' sentiment which was prevalent in English

society at the time. A Jesuit was an enemy and, almost by definition, a liar, and the mere fact that Psalmanazar had 'chosen' Anglicanism and had been so warmly embraced by the High Church Bishop of London was doubtless enough to sway many onlookers. Psalmanazar thus gained credit as the standard-bearer of honest Anglicanism against the sneaky speciousness of the Jesuits.

That same evening, we are told, the new president of the Royal Society, Isaac Newton, conducted another interrogation of Psalmanazar. The society wheeled out its intellectual heavyweights for the occasion, led by the astronomer Edmund Halley. According to Psalmanazar, Halley asked him questions designed to expose his ignorance of Formosa's geographical location, such as how long his shadow was during the summer, how long the twilight in Formosa was and how long the sun shone at various times of the year. Then came the crunch question from Halley: 'Does the sun ever shine all the way down the chimneys in Formosa?' The point of this astronomical question was that since Formosa lay between the tropics, the sun would be directly overhead for a time. 'No,' replied Psalmanazar. Halley reckoned he had taken a trick with that question, but Psalmanazar trumped him. 'The chimneys in Formosa twist and turn on their way down,' he said, 'so the sunlight never reaches the bottom.'

A very different version of the occasion is to be found scribbled on the flyleaf of a second edition copy of *An Historical and Geographical Description of Formosa* (now in the British Museum):

> This book contains in many particulars the most ingenious imposture on the Publick, but the whole was detected and the author brought to shame by a very few Questions, put to him by the very ingenious late Dr Halley, who inquired concerning the duration of the Twilight and how long the Sun shone down the chimneys every year in Formosa. His Philosophy here failing him, he was detected never to have been in the Island.

When challenged by other interlocutors about the whiteness of his skin,

Psalmanazar put it down to his noble rank in Formosa. As he explained in his posthumous memoirs, 'I soon hatched a lucky distinction between those whose business exposes them to the heat of the sun, and those who keep altogether at home, in cool shades, or apartments under ground, and scarce ever feel the least degree of the reigning heat.' The idea that 'colour' was the result of long-term exposure to the sun in torrid climates – a sort of permanent suntan – was widely held at the time; indeed, all Asiatics were called 'white'.

Psalmanazar was delighted by his own quick-witted improvisations. The learned members of the Royal Society had some knowledge of Formosa, because the Dutch had maintained a small mercantile enclave on its west coast for 40 years and had published information about it (although Psalmanazar had not read a word of it). However, the eastern, mountainous part of the island was still *terra incognita*, and Psalmanazar could always evade questions by claiming that he was talking about the real Formosa, the Formosa of the aboriginal tribal hinterland – which people might find suspect, but which no one was in a position to dispute.

After the session, the Royal Society did not issue a public statement about the outcome of the confrontation. Most of its members were in no way convinced by Psalmanazar's performance and, indeed, did not take it seriously – although one member said they were 'much entertained' by it. It may be that the society, aware of its reputation as a hotbed of unpopular freethinkers and religious sceptics, did not want to court further unpopularity by publicly castigating this charismatic 'noble savage' who had converted so spectacularly to Anglicanism.

The crest of the wave

With the help of his accomplice, the Revd Alexander Innes, Psalmanazar now exploited his celebrity by publishing, in April 1704, *An Historical and Geographical Description of Formosa* (originally written in Latin by Psalmanazar, who had it translated into English). It sold well, but doubts about the Formosan were beginning to circulate in the capital's

intellectual circles, no doubt fuelled by gossip about the Royal Society meetings. But for many, the declared patronage of the respected Bishop of London was still a strong factor in Psalmanazar's favour.

Bishop Compton was zealous to promote Psalmanazar's prospects, hoping to groom his young protégé for missionary work on his return to his 'native' Formosa. The bishop arranged for him to be given a place at Christ Church, Oxford, to study divinity and to translate religious literature into Formosan – and thereafter, perhaps, to lecture on Formosan language and culture with a view to educating future missionaries. Psalmanazar went up to Oxford in the early spring of 1705. There he played his 'noble savage' role to the hilt and became a celebrity. He did no teaching; however, he was assigned a tutor in divinity (who seems to have been Samuel Reynolds, father of the painter Joshua Reynolds). To give everyone an impression of tireless, round-the-clock industry he kept a candle burning in his room all night and slept in a chair.

During his sojourn in Oxford, he also revised and restructured *An Historical and Geographical Description of Formosa* for a second edition, with a new preface. He added lurid chapters on cannibalism and devil worship, to emphasise the more brutal aspects of Formosan religion, and relegated his account of his own conversion and wanderings in Europe to the end of the book. Psalmanazar and his publisher had clearly seen what had made the book a bestseller, and they now offered even more of the same. In the new preface, Psalmanazar defended himself robustly against those who were claiming that *An Historical and Geographical Description of Formosa* had been a total fabrication:

> He must be a Man of prodigious parts, who can invent the Description of a country, contrive a religion, frame Laws and Customs, make a language, and Letters &c. and have these different from all other parts of the World; he must have also more than a humane Memory that is always ready to vindicate so many feign'd particulars, and that without ever so much as contradicting himself.

These were perhaps the truest words he ever wrote: George Psalmanazar was certainly 'a Man of prodigious parts'.

Decline and fall

Psalmanazar did not matriculate at Oxford; he stayed there for only a term before returning to London, in June 1705. Back in the capital, in order to maintain his celebrity, he had to present himself as an even more embellished figure – this time as a reformed cannibal. His public lectures and dinner-party appearances became more and more exaggerated, like the second edition of *An Historical and Geographical Description of Formosa*, which was duly published in 1705. The unscrupulous Alexander Innes had by now left England – he had been appointed Chaplain-General to the British troops in Portugal. In his memoirs, Psalmanazar would accuse Innes of 'notorious and bare-faced immoralities' and 'an almost insurmountable propensity to wine and women'; be that as it may, Psalmanazar was now left to his own devices without the benefit of his procurator's devious promptings.

The disappearance of Innes coincided with Psalmanazar's downfall. The second edition of his book was sneered at for its glaring contradictions and untruths. The sheen of his celebrity now began to dull; his novelty value had waned. Common talk in London was saying that Psalmanazar was nothing but an amusing impostor, after all. True, he had never been publicly exposed, but he was now dismissed as a ridiculous has-been; he was already a non-person on the London social scene. For Psalmanazar, the game was up. He was no longer able to make a living from his masquerade and was becoming more and more destitute. In the early part of 1706, Psalmanazar fled from London to a country hideaway for a few months, fearful of an alleged plot to kidnap him and send him back to Formosa ('pressed to sea') where, he claimed, his life would be in danger. He returned to London, in June 1706, and lived off any benefactors he could find.

In 1707, Psalmanazar tried to revive his literary fortunes with a pamphlet entitled *A Dialogue Between a Japanese and a Formosan.*

This was designed as an answer to rationalists who attacked revelation and miracles. The 'Japanese' shows how rational and independent of priestcraft Japanese society is, but the 'Formosan' (a traditional believer in the necessity of revealed religion) gets the best of the argument, calling reason 'a short-leg'd Jade . . . led by Interest, Self-love, and other such Blind and Sinister Riders'.

In a final effort to restore Psalmanazar in the public eye, the year 1707 also saw the publication of an anomynous *Enquiry into the Objections against George Psalmanazar of Formosa: In which the Accounts of the People, and Language of Formosa by Candidius, and other European Authors, and the letters from Geneva, and from Suffolk, about Psalmanazar, Are Proved Not to Contradict His Accounts.* This is perhaps the most important of all the Psalmanazar texts and has been the subject of much debate. It is supposed to have been written by several authors of little education – 'we are *Plebeians,* and the utmost of our Education has been confined to Grammar School'. Was it a loaded report compiled by a committee of pro-Psalmanazar enthusiasts? Was it written by Psalmanazar himself, even, pretending to be this 'group of gentlemen'? Michael Keevak thinks that it was, indeed, a genuine scholarly overview which sought to investigate whether Psalmanazar's Formosa (beyond the mountains, an area which had never been penetrated by Western travellers) could be reconciled with the actual Formosa known from the accounts of missionaries and other travellers.

The *Enquiry* concluded not that Psalmanazar's description was false but that it did not contradict other Western reports and that Psalmanazar *might* be who he claimed to be. It left to the end the vexed question of Psalmanazar's blond appearance:

> And here we confess ourselves at the greatest loss. His hair should be black; his face yellow, or Olive, or Tawny; his Mien a little more diverse from any, to denote him such a stranger as he pretends.

The *Enquiry* concluded that skin and hair colour were not reliable markers of one's origin, since there were 'some fair in Africa, some black in England', and that Psalmanazar's *soul* was surely Japanese – at least, not European.

Hackwork in Grub Street

The *Enquiry* failed to vindicate Psalmanazar unequivocally. So what was he to do now? First, like any fading TV star of modern times, he tried to exploit his former fame for commercial purposes, lending his name to a scheme to manufacture a white enamel work called 'White Formosa Work' ('as improved according to the right japan way by Geo. Psalmanazar'). Alas, it failed to find sufficient buyers. He then tried to market alternative medicines based on arcane Formosan remedies but, again, without success. He tutored private pupils in modern languages and Latin, he taught fortifications to an officer's son and, finally, he acted as a clerk with a regiment of Dragoons. This took him to Scotland during the suppression of the botched 1715 Jacobite Rising in favour of the 'Old Pretender'.

On his return to London, he tried his hand at painting fans. Strange but true, there were still people in the capital who believed in him. In 1716, a well-wishing clergyman organised a collection, or pension, whereby a diehard group of supporters committed sums totalling £20 a year in order to provide Psalmanazar with what was barely a subsistence allowance, and this continued for many years, until all the members were dead.

Nonetheless, Psalmanazar was not earning enough to keep body and soul together and turned (perforce) to what was then considered the last resort of the educated scoundrel – writing for 'Grub Street'. Grub Street was the former name of a street in London's Cripplegate, an area which housed many small booksellers in Paternoster Row and Little Britain and which came to represent 'hack' writing in the way in which Fleet Street would for journalism. In his *Dictionary of the English Language*, Dr Samuel Johnson defined it as 'Much inhabited by writers

of small histories, dictionaries and temporary poems; whence any mean production is called Grub Street'. Indeed, Grub Street was deliberately renamed Milton Street, in 1830, to escape its notorious connotations of literary hackwork. (It is now Fore Street, near the Barbican.)

Very little is known about Psalmanazar during the immediate years after his disappearance from the London social scene, but it seems clear that he underwent some sort of 'conversion' in the late 1720s. He felt increasingly embarrassed at the falsity of his position and came to regret his imposture and all the deceptions he had practised; he privately dissociated himself from his Formosan persona (but not the name). His contrition appears to have been sincere.

Certainly, to be a Grub Street hack in those days might be deemed penitence enough. The work was ill-paid and unrelenting – practically slave labour. Psalmanazar would spend the last 40 years of his life trapped on this literary treadmill.

Echoes of the imposture still sounded, however. In 1729, Jonathan Swift (1667–1745), the author of *Gulliver's Travels*, published a mordantly satirical pamphlet against the English hegemony in Ireland entitled *A Modest Proposal For Preventing the Children of Poor People in Ireland From Being A Burden To Their Parents or Country, and For Making Them Beneficial to The Public*. The 'Modest Proposal' was that the Irish should eat their own children to solve the problem of Irish overpopulation. In the pamphlet, Swift credited this 'inspired expedient' to 'the famous Psalmanazar' and his stories of infanticide and cannibalism in Formosa.

The spiritual change in Psalmanazar was given a new emphasis, at about this time, through Pietism. He relates in his memoirs how he chanced upon a devotional book on the subject by a clergyman named William Law entitled *A Serious Call to the Devout and Holy Life*, which was first published in 1728:

> Let any man but look back upon his own life, and see what use
> he has made of his reason, how little he has consulted it, and
> how less he has followed it. What foolish passions, what vain

thoughts, what needless labours, what extravagant projects, have
taken up the greatest part of his life.

Psalmanazar read and re-read this book avidly, and in it he found a
profoundly satisfying new focus in religion for his wrecked life. He
was deeply impressed with the systematic programmes of prayer and
concentrated self-examination which William Law advocated and
followed them rigorously for the remaining decades of his life.

But what of his literary activities in Grub Street? In his memoirs,
Psalmanazar wrote that he worked as a translator – probably from
French – during his early years in Grub Street. The first recorded work
with which he was involved was *A General History of Printing, from Its
First Invention in the City of Mentz, to the First Progress and Propagation
through the Most Celebrated Cities in Europe*, which was published in
1732. Psalmanazar contributed to the work and eventually oversaw its
production, although the printer Samuel Palmer (who died before its
publication) was credited with its authorship.

The most important work in which he took part was a mammoth part-
work entitled *An Universal History from the Earliest Account of Time to the
Present*, which appeared in seven volumes at yearly intervals from 1736
to 1744 (a revised edition was published in twenty-one volumes from
1747 to '54). As part of his spiritual conversion, Psalmanazar had studied
Hebrew, which, with his remarkable linguistic abilities, he assimilated
very quickly. His knowledge of Hebrew made him a suitable candidate
for contributing to the material on Jewish history in the *Universal History*,
including 'The History of the Jews, from the Birth of Abraham to the
Babylonish Captivity' (volume two) and 'The History of the Jews, from
their return from the Babylonish Captivity, to the Destruction of Jerusalem
by Titus Vespasian' (volume three). He also contributed to the sections on
the history of the Celts and Scythians; Ancient Greece; the empires of
Nice and Trebizon; the ancient Spaniards, Gauls and Germans; the sequel
of Theban and Corinthian history, including the retreat of Xenophon; and
the continuation of Jewish history to the present.

In the early months of 1741, Psalmanazar found time to compose a chapter for the continuation of Samuel Richardson's *Pamela, or Virtue Rewarded*. This foray into the world of fiction was not a success; Richardson annotated the manuscript chapter with marginal comments such as 'ridiculous and improbable' and 'O! Mr Psalmanazar!!!', and Psalmanazar confined himself to compilation and editing from then on.

His next major Grub Street work was contributing to the writing of another encyclopaedic work: Emanuel Bowen's *Complete System of Geography*, which was published in two volumes in 1747. He chose, among other subjects, to write about China, Japan and Formosa – 'which part I chose', he would write in his memoirs, 'that I might take occasion publickly to acknowledge, as it were by third hand, the falsehood and imposture of my former account of that island'. The oblique confession in his anonymous article came in a section about the names 'Formosa' and 'Ilha Formosa':

> By these Names, which signify a beautiful Island, one must suppose it to have some particular Beauty or Excellence above all others on this sea; and so indeed one might judge, if the account we had formerly given us by a pretended Native of it, called Psalmanaazaar, had had any Truth in it. But that Author, who is still in England, has long since ingenuously owned the contrary, tho' not in so publick a manner, as he might perhaps have done, had not such an Avowment been likely to have affected some few Persons, who for private Ends took Advantage of his youthful Vanity, to encourage him in an Imposture, which he might otherwise never had the thought, much less the Confidence to have carried on.
>
> Those Persons being now dead, and out of all Danger of being hurt by it, he now gives us Leave to assure the World, that the greatest Part of that Account was fabulous (as indeed every judicious Reader must have judged it to have been, the many Absurdities with which it is stuffed seeming rather calculated to

destroy rather than inhance the credit of it); and that he designs
to leave behind him a faithful account of the unhappy step, and
other Particulars of his Life leading to it, to be published after his
Death, when there will be less Reason to suspect him of having
disguised or palliated the truth.

In this way, Psalmanazar gave advance notice of the planned (posthumous)
publication of his *Memoirs of ****, Commonly Known by the Name of
George Psalmanazar, a reputed Native of Formosa*, which he had been
assiduously writing for many years. The immediate inspiration for this
was a life-threatening illness he suffered not long after his first reading of
Law's influential *A Serious Call to the Devout and Holy Life*. The humility
he was learning through his reading of Law's book dictated that he should
not publish it for profit or self-aggrandisement but posthumously so
that he would gain no present credit from it. In 1752, at the age of 72,
he made his will, which would be printed at the head of his published
memoirs; in it, Psalmanazar noted that he had come to delight in 'a state
of obscurity and lowness of circumstance' and stipulated that his body
should be placed in an open shell and interred in 'some obscure corner' of
the common burying ground. Humility could, apparently, go no further.
Yet the advance announcement of his forthcoming confession was an
act of self-aggrandisement in itself and typically self-congratulatory:
Psalmanazar was not as humble as he liked to make out.

Psalmanazar had completed writing his memoirs by 1755. Before that,
in 1753, he had published (anonymously) a series of essays on subjects
connected with various Old Testament miracles. They were impeccably
orthodox and anti-rationalist and seem to have been designed as handy
sources for rural clergymen in constant need of material for their sermons.
It was the last work published in his lifetime.

Psalmanazar and Dr Johnson

Psalmanazar was now in his 70s, living in rooms in a house on Ironmonger
Row. Until his death in 1763, he lived the pious life of a contented

penitent, admired and respected by all who knew him. He had become the local 'holy man'. Perhaps his most unexpected admirer was the great lexicographer Dr Samuel Johnson (1709–84), the dominant literary critic of his age. Dr Johnson was the scourge of people he considered fraudsters and forgers (such as James Macpherson of Ossian fame), yet he felt nothing but reverence and affection for the ageing Psalmanazar, the reformed impostor. Dr Johnson, who had also been greatly affected in his youth by Law's *A Serious Call to the Devout and Holy Life*, did not meet Psalmanazar until quite late on in life, but the two became close cronies; they would meet regularly with a few other friends in the taverns and clubs of Old Street.

In her *Anecdotes of the late Samuel Johnson, Ll.D. During the Last Twenty Years of his Life* (1786) his beloved friend Hester Lynch Piozzi (Mrs Thrale) summarises what Dr Johnson thought of Psalmanazar:

> I forget in what year it was that this extraordinary person lived and died at a house in Old-street, where Mr Johnson was witness to his talents and virtue, and to his final preference of the Church of England, after having studied, disgraced and adorned so many modes of worship. The name he went by, was not supposed by his friend to be that of his family, but all enquiries were in vain, his reasons for concealing his original were penitentiary; he deserved no other name than that of the impostor, he said.

Mrs Thrale also noted that she had once asked Dr Johnson who was the best man he had ever known and received the unexpected reply 'Psalmanazar':

> He said, likewise, 'that though a native of France, as his friend imagined, he possessed more of the English language, than any one of the other foreigners who had separately fallen in his way'. Though there was much esteem however, there was I believe but little confidence between them; they conversed merely

about general topics, religion and learning, of which both were undoubtedly stupendous examples; and, with regard to true Christian perfection, I have heard Johnson say, 'that George Psalmanazar's piety, penitence and virtue exceeded almost what we read as wonderful even in the lives of the saints' . . . His pious and patient endurance of a tedious illness, ending in an exemplary death, confirmed the strong impression his merit had made upon the mind of Dr Johnson.

Dr Johnson's biographer, James Boswell (1740–95), who first met Dr Johnson two weeks after Psalmanazar's death, once asked him if he had ever mentioned Formosa to Psalmanazar. Dr Johnson said that he was afraid to mention even China; and when he was asked whether he had ever contradicted Psalmanazar, he replied, 'I should as soon think of contradicting a bishop.' Boswell also noted: 'He said he had never seen the close of the life of anyone that he wished so much his own to resemble, as that of him, for its purity and devotion.'

George Psalmanazar died on 3 May 1763 at the age of 84. His death went practically unnoticed in the newspapers, apart from a brief notice in the *Gentleman's Magazine* ('Mr. Pasalmanazer, in Ironmonger Row, aged 84, well-known for many ingenious performances in different parts of literature'). Soon afterwards, his will was published in several magazines, including the *Annual Register*, with a brief notice: 'He was concerned in compiling and writing works of credit, and lived exemplarily for many years'. The will itself was a document straight from the confessional: 'The last will and testament of me a poor sinful and worthless creature commonly known by the assumed name of George Psalmanazar . . .'.

The posthumous publication of his memoirs, in 1764, brought a renewed flurry of interest in him. Psalmanazar explained his reasons for having written the book:

It is true, I have long since disclaimed even publicly all but the shame and guilt of that vile imposition, yet as long as I knew there

were still two editions of that scandalous romance remaining
in England besides the several versions of it abroad, I thought
it incumbent upon me to undeceive the world, by unravelling
that whole mystery of iniquity in a posthumous work, which
would be less liable to suspicion, as the author would be far out
of the influence of any sinister motives that might induce him to
deviate from the truth.

*Memoirs of ****, Commonly Known by the Name of George Psalmanazar,
a reputed Native of Formosa* became a bestseller and went to two editions,
while tributes to him and articles about his life and work were published
in the *Gentleman's Magazine*: 'There can be no doubt of the genuineness
of this performance, or of the truth of what is contained in it.' Sixty
years after Psalmanazar had embarked on his great imposture, something
about him continued to strike a chord and to interest people – as it does
to this day.

Meanwhile, the elderly sinner had returned to the fold, and
Psalmanazar's long and painful rehabilitation was complete – in a
posthumous blaze of glory.

Chapter 3 Notes

1. A Tichborne ancestor, Chidiock Tichborne (1558–86), was implicated in the Babington Plot to murder Queen Elizabeth of England. He was arrested in August 1586 and executed the following month – hanged, drawn and quartered. On the eve of his execution, he wrote a three-stanza poem known as 'Tichborne's Elegy'.

2. Stonyhurst is the successor to the original Jesuit college at St Omer, in northern France, founded in 1593 to provide the opportunity of a Roman Catholic education for English families unable to educate their children in the faith at home. It moved into the magnificent Jacobean mansion of Stonyhurst in 1794, after it had been gifted to the Society of Jesus by a former pupil who had inherited it.

3. The 'Brighton card case' was a curious swindle which took place in the autumn of 1852; a young man named 'Hamp' was robbed of £1,500 by a gang using marked cards. A criminal prosecution ensued, which was widely reported in the press. The claimant swore that he was the man who had lost the money and that Lady Tichborne had given him £500 to help him out of the scrape. It was later proved that Roger Tichborne had not been anywhere near Brighton, whereas the man named Arthur Orton had been in England at the time.

4. This chapter is largely based on the book *Running a Thousand Miles for Freedom: Or, The Escape of William and Ellen Craft from Slavery*, by William and Ellen Craft, published in England in 1860 by William Tweedie, 337 Strand, London.

5. The Underground Railroad wasn't a railroad at all; the name was given to a loosely organised network of 'safe houses', hiding places and routes to help runaway slaves to reach freedom in the North or in Canada. It has been estimated that some 50,000 runaways were helped in this way.

6. Parliament passed the Slavery Abolition Act in 1833, a month after the death of William Wilberforce, the evangelical MP who had cam-

paigned tirelessly for the abolition of the slave trade in the British West Indies and abroad, and the total abolition of slavery itself.

7. Most of the material for this chapter was culled from printed publications and innumerable websites, but I owe a special debt of gratitude to technology journalist and author Tom Standage and his brilliant book, *The Mechanical Turk: The True Story of the Chess-Playing Machine that Fooled the World* (Allen Lane, The Penguin Press, 2002).

8. A later model of the Orchestrion, manufactured in Baden, survives in perfect working order in Kinloch Castle, on the Hebridean island of Rum. The castle was built as an opulent country mansion by the Bullough family from Lancashire around 1900 for £250,000 (£15 million in today's terms). The Orchestrion was installed in a large recess under the neo-Jacobean staircase in the galleried hall – a luxurious Edwardian equivalent of a jukebox. It is there to this day, in full working condition.

9. Philip Thicknesse, in a pamphlet entitled *The Speaking Figure, and the Automaton Chess-Player, Exposed and Detected* (1784).

10. *Über den Schachspielerdes Herrn von Kempelen und dessen Nachbildung* (*On the Chess Player of Mr von Kempelen and an Imitation of It*).

11. Robert Willis became a successful and highly respected Cambridge academic, and was appointed professor of applied mechanics there in 1837.

12. Silas Weir Mitchell published a two-part article on how The Turk operated ('The Last of a Veteran Chess Player') in *The Chess Monthly*, in January and February 1857. For a detailed and definitive description of how The Turk was worked in practice, see chapter 11 ('The Secrets of the Turk') in *The Mechanical Turk* by Tom Standage.

13. The Turk inspired a 1927 French film entitled *Le Joueur d'échecs* (*The Chess Player*) with Charles Dullin as von Kempelen. It was remade in 1938 with Conrad Veidt playing the role of von Kempelen.

14. I am indebted to Dr Michael Keevak, professor of foreign languages at National Taiwan University, for his generous encouragement and assistance with this chapter. His book on Psalmanazar, *The Pretended*

Asian: George Psalmanazar's Eighteenth-Century Formosan Hoax, was published in April 2004 by Wayne State University Press.

15. Keevak was greatly impressed by Psalmanazar's extraordinary linguistic skills. His 'Formosan' language was carefully thought out and formed on regular principles. It's a rather strange mishmash of Greek, Hebrew and other fantasy elements, based on a Latinate model but meant to sound vaguely Asiatic. He created between 300 and 400 words, all liturgical, but there may well have been many others which were unpublished. Keevak was also interested in the 'afterlife' of the imposture: long after Psalmanazar was exposed as a phoney, his invented language and alphabet continued to surface in learned books.

4

Literary Forgeries

In 1932, Rudyard Kipling (1865–1936), Britain's first winner of the Nobel Prize in Literature, published a remarkable short story called *Dayspring Mishandled.*[1] It's a bitter and sardonic little yarn about a literary forgery planned and executed with malevolent care by a vindictive expert on Chaucer in order to destroy the reputation, sanity and, eventually, life of another Chaucer expert, the pompous and self-opinionated Alured Castorley. The story relates, in meticulous detail, the methods used by the forger to create a 'lost' Chaucer manuscript and the skill with which he identifies his victim's vanity (and therefore gullibility) as the Achilles heel which makes him vulnerable to being duped and thereby humiliated.

Not that there is anything new about literary forgery. It has been rife since time immemorial. Many ancient documents, including classical writings (the fake *Consolation* ascribed to Cicero, for instance) and early Christian documents (such as the spurious letters of Jesus to King Agbarus, and of Paul to Seneca), are now recognised as counterfeit. They provoked fierce scholarly argument in their time, as learned critics sought to discredit them against the entrenched views of other experts – the 'moderns' against the 'ancients'. The most celebrated

episode involved a furious row between two eminent scholars over the authenticity of the Epistles of Phalaris, a notorious Sicilian tyrant of the sixth century BC; this dispute became the subject of a brilliant satire by Jonathan Swift, published in 1704, entitled 'The Battle of the Books'. The original subtitle tells it all: 'A Full and True Account of the Battel Fought Last Friday, between the Antient and the Modern Books in St James's Library'.

It was the media scoop of the twentieth century; or so it seemed at the time. Instead, it became the journalistic 'Oops!' of the century, a monument to monumental gullibility – all because of a jovial, small-time German forger and peddler of Nazi memorabilia named Konrad Kujau (1938–2000).

On 22 April 1983, the German current affairs magazine *Der Stern* announced that it had acquired 'the journalistic scoop of the post-war era': 62 hand-written notebooks containing the private diaries of Adolf Hitler, covering the period from June 1932 to April 1945 (*Der Stern* had paid £2.3 million for them). At the same time, the 'diaries' began to be serialised in the *Sunday Times* in Britain and *Newsweek* in the USA, both of which had bought the rights from *Der Stern*.

The story was that the journals, and many of Hitler's other personal effects, had been flown out of Berlin towards the end of the Second World War on board an aircraft which had crashed. The diaries were rescued from the blazing plane by some farmers and had lain neglected in the village of Bornersdorf, near Dresden, until they came into the hands of Konrad Kujau via an unnamed general in East Germany. Kujau had taken them to the journalist Gerd Heidemann, a staff reporter on *Der Stern*, who had instantly recognised that he had a sensation on his hands and negotiated their purchase by Gruner+Jahr, the publishers of the magazine.

Sensational it certainly was. The diaries put an apparently new slant on aspects of the history of the Third Reich: for instance, it seemed that Hitler had personally approved the 'peace flight' to Scotland by his deputy Rudolf Hess in 1941 (it was only after the event that Hitler

declared Hess to be insane). More sensationally, there was no hint in the diaries that Hitler had had any knowledge of the Holocaust – the 'Final Solution' for the Jews; instead, there was merely a suggestion that he wanted to see the Jews resettled in the East.

Der Stern assembled a panel of three German forensic specialists in handwriting and gave them old documents so that they could compare the writing in the diaries with a sample of Hitler's hand. They came to the unanimous conclusion that all the texts, including the sample Hitler holographs, had been written by the same person and were therefore authentic. Unfortunately, the samples of Hitler's handwriting were themselves forgeries – by Konrad Kujau!

Many historians, particularly in Germany, were deeply sceptical about the contents of the diaries. Other historians were prepared to endorse their authenticity, however. In Britain, the diary instalments were assembled for publication by Magnus Linklater, a senior member of the staff of the *Sunday Times*. Linklater had been a member of the paper's team which had investigated the fake 'ghosted' autobiography of the reclusive Howard Hughes, which Clifford Irving had sold to *Life* magazine ten years earlier; with the example of Clifford Irving still fresh in his mind, Linklater was uneasy about some aspects of the diaries and reported his concern. To make doubly sure of their authenticity, Rupert Murdoch (owner of the media empire which included *The Times* and its sister paper the *Sunday Times*) commissioned the eminent historian Hugh Trevor-Roper (Lord Dacre), master of Peterhouse College, Cambridge, author of the classic *The Last Days of Hitler* (1947) and editor of Goebbels' diaries in 1978, to look at the suspect Hitler diaries. Trevor-Roper was shown samples of the diaries in English translation and famously asserted that, in his opinion, the Hitler diaries were indeed authentic:

> Whereas signatures, single documents or even groups of documents can be skilfully forged, a whole coherent archive covering thirty-five years is far less easily manufactured. Such a disproportionate and indeed extravagant effort offers too large

and vulnerable a flank to the critics who will undoubtedly assail it . . . The archive, in fact, is not only a collection of documents which can be individually tested: it coheres as a whole and the diaries are an integral part of it. That is the internal evidence of authenticity . . .

(To be fair, Trevor-Roper had not been given as much time to examine the diaries as he would have wished and quickly began to have second thoughts. He tried to leave a message with *The Times* on the day before the *Sunday Times* was due to publish the story of the 'discovery' of the diaries, prior to serialisation; the message did not get through, however, and the *Sunday Times* splashed the story across several pages. The next day in *The Times*, Trevor-Roper wrote that he had come to have doubts about the authenticity of the diaries and that he had 'misunderstood the nature of their procurement'.)

Within two weeks of their publication, however, rigorous scientific tests revealed the truth about them – that they were forgeries, and very crude forgeries at that – and the *Sunday Times* abandoned the promised serialisation. But how on earth had Konrad Kujau got away with it – and more than £2 million – in the first place?

Konrad Kujau was born in Löbau, in Saxony (eastern Germany), in June 1938 and was brought up in an orphanage. He was a forger from an early age: as a child he sold fake autographs of East German politicians for pocket money. He was studying art in Dresden when he fled to West Germany in 1957, where he found work as a window cleaner. In 1967, he opened a shop in Stuttgart selling (and manufacturing) Nazi paraphernalia and mementoes. His more ambitious creations included an introduction to a sequel to *Mein Kampf,* some poems purportedly written by Hitler and the beginnings of an opera by Hitler entitled *Wieland der Schmied* (*Wayland the Smith*). A handwritten letter from Adolf Hitler, addressed to the young Kujau, hung on a wall in his house, giving him authority to 'compile' the Führer's diary after his death, for posterity; it, too, was a fake, of course.

The turning point for Konrad Kujau came when he made contact with Gerd Heidemann. Heidemann had developed an obsessive interest in the personalities of the Third Reich and an expensive appetite for artefacts associated with them, including the purchase of Hermann Göring's yacht, which he restored at considerable expense and used for entertaining prominent veterans of the Third Reich. Kujau (posing as 'Dr Konrad Fischer') had on offer a slight volume labelled 'Political and Private Notes from January 1935 until June 1935. Adolf Hitler', tied with a black ribbon and boasting a red wax seal. Kujau relayed the story of the Führer's journals being rescued from a burning aircraft which had crashed while escaping from Berlin in 1945. He said that the volume had been smuggled across the border, at very considerable risk, by his brother, who was a friend of a high-ranking East German general who had it in his keeping. What's more, there could well be other volumes available, which could be smuggled out inside consignments of pianos.

Gerd Heidemann apparently believed (or, at least, said he did) that this extraordinary volume was authentic. He told his employers at *Der Stern* about it. Amid great secrecy, the publishers gave him the funds to pay Kujau to obtain more of the diaries, if possible.

Kujau set to at once. He worked from a library of reference books, newspapers and medical records, and, for three years, he penned Hitler's daily and uniformly banal thoughts, from June 1932 to April 1945, in Gothic script into a black A4 notebook. As he finished each page, he stained it with tea to give it an appearance of age; then he would batter the volumes to make them look old and worn. Finally, he affixed two red wax seals to their covers in the form of a German eagle.

The publishers of *Der Stern* were duped by them. With such a potential world scoop on their hands, secrecy was essential. It was this obsessive journalistic desire to protect a scoop which meant that very few people could be consulted about the authenticity of the diaries. Access to the documents had to be severely limited. This meant that many glaring historical inaccuracies and anachronisms went undetected.

So, how was the scam rumbled? Staff of the Federal German Archives

were given access to the documents to carry out forensic tests on the diaries. The paper was subjected to ultraviolet light and was found to contain an additive which had only been put into paper since 1954. The ink was tested with microspectrophotometry to identify its composition; it was found that it was of a type not available when the diaries were allegedly written and that the documents had been penned within very recent years. The fibres attaching the seals contained materials only manufactured after the war. There could be no doubt about it: the Hitler diaries were fakes. Closer reading of the contents showed that most of the entries, historical errors and all, had been plagiarised from a book entitled *Hitler's Speeches and Proclamations*, written by Max Domarus, a former Nazi federal archivist.

When the forgery was exposed, Kujau went on the run. By then, he had been paid £2.3 million by *Der Stern* magazine. He was arrested by the West German police at the Austrian border on 14 May 1983 and soon confessed to the forgery. After an eleven-month trial in Hamburg for fraud, he was sentenced to prison for four and a half years. Gerd Heidemann was tried as an accomplice and was also given a prison sentence.

Kujau was released from prison in 1988, having been diagnosed as suffering from cancer. He enjoyed the notoriety his enterprise had earned him and revelled in a round of TV chat-show appearances. Resilient as ever, he continued to work as a forger – but a 'legitimate' one: he opened a gallery in Stuttgart where he sold 'certified forgeries' of Hitler's paintings and copies of paintings by Monet, Dalí, Rembrandt and van Gogh, signed with his own and the original artist's name. In 1994, he even stood for mayor of his home town of Löbau, but that was pushing his luck too far. He was no more successful when he stood for mayor of Stuttgart, but at least he got 901 votes. He then declared his intention of writing his memoirs, to be called *I Was Hitler*, and, in 1998, a book was published under his name, entitled *The Originality of Forgery* – but it turned out to be a fake!

Not that Kujau had gone entirely straight. In the year before his

death, he was arrested for firing a semi-automatic weapon in a Stuttgart bar; when police searched his house, they found a number of forged driver's licences.

Konrad Kujau died in September 2000 at the age of 62. In 1991, Thames Television broadcast a comedy-drama mini-series on his activities, entitled *Selling Hitler*, based on a book by Robert Harris. It was real fame at last.

The Scottish poet and folklorist Hamish Henderson (1919–2002) once said, 'Plagiarists of genius are the justified sinners of literature.' He was talking about contemporary poetry, but it was the eighteenth century which was Britain's 'golden age' of literary forgery. The eighteenth century is the setting for the four chapters in this final section.

Chapter 4.1 (Thomas Chatterton: The Boy Poet and the Medieval Monk) is the story of the brief but blazing life of Thomas Chatterton (1752–70), a talented Bristol youngster and budding poet. At the age of 16, he forged a series of brilliant poems which he ascribed to a non-existent fifteenth-century monk whom he named Thomas Rowley. Chatterton then moved to London to seek fame and fortune; he poured out poems and prose fables with feverish energy, but the hoped-for literary fame never materialised. Four months later, at the age of only 17, he apparently committed suicide in a lonely garret. But was it suicide, brought on by despair, poverty, neglect, rejection and broken pride? Or was it a tragic accident? Either way, he became an icon of the early Romantic movement.

Chapter 4.2 (The Ghost of Ossian: James Macpherson) traces the career of a prickly Highlander, an itinerant poet and scholar *manqué* named James Macpherson (1736–96), the translator of fragments of ancient Gaelic poetry allegedly from a lost epic work by a third-century Celtic bard named 'Ossian'. Coming in the wake of the failed 1745 Jacobite Rising, it was a bid to prove that Scotland had a deeper and older literary heritage than England. This aroused the petulant fury of that old curmudgeon, the lexicographer Dr Samuel Johnson, who

accused Macpherson of criminal forgery. In Scotland, and elsewhere, the Ossian controversy is still very much alive.

In Wales we explore the extraordinary life and achievements of an unschooled stonemason, Edward Williams (Chapter 4.3 – The Bogus Welsh Bard: Iolo Morganwg). He fabricated a vast mass of medieval manuscripts in order to create the bardic traditions of the *Eisteddfod*; in so doing, he practically reinvented Wales!

Finally, Chapter 4.4 (The Boy Who Rewrote Shakespeare: William-Henry Ireland) tells the story of an ambitious young London writer named William-Henry Ireland (1775–1835), who dared to write a number of 'Shakespeare' plays; he got away with it but only for a very short time. He persuaded his father that a benefactor, 'a wealthy gentleman in the country' (who had to remain anonymous, of course), was supplying him with copious manuscripts relating to the Shakespeare family, including some hitherto unknown plays. One of these 'discovered' plays was put on at the Drury Lane Theatre, in 1796: *Vortigern and Rowena*, the love-story of Vortigern, Prince of Britain, and Rowena, daughter of the Saxon invader Hengist. The play starred no less a figure than John Kemble, the renowned Shakespearian actor and brother of Sarah Siddons. Alas, the play flopped on its first night – even Kemble suspected that it was a forgery and let it show. Although Ireland tried to revive his career as an honest writer, his brief glory days were over.

4.1 – Thomas Chatterton: The Boy Poet and the Medieval Monk[2]

In Gallery Nine of Tate Britain in London, labelled 'Making British History', there hangs a Pre-Raphaelite painting by Henry Wallis (1830–1916), depicting a romantically tragic scene: a young poet lies dead, sprawled languidly on a pallet in a lonely London garret at 39 Brooke Street, off Holborn. The pale light of dawn shines through the casement window, illuminating his serene features and livid flesh. His wavy red hair is strewn across the pillow, torn sheets of paper litter the bare floorboards and an empty brown phial lies beside his lifeless hand. He is wearing a soiled white shirt open to the waist, blue silk pantaloons and white stockings. One shoe lies on the floor, and his maroon velvet coat is thrown over a chair. Near the head of the bed is an open wooden chest, carelessly filled with crumpled manuscripts. At the foot of the bed the smoke from a guttering candle wafts towards the open window, through which St Paul's Cathedral and the cityscape of London can be seen in silhouette.

The painting *Chatterton* (popularly known as *The Death of Chatterton*) immortalises the apparent suicide of an extraordinary boy poet and forger named Thomas Chatterton. In this celebrated painting, Chatterton is depicted as an almost Christ-like figure: the artist as a martyr of society.[3] It was Wallis's earliest exhibited work and created a sensation when it was shown at the Royal Academy in 1856. The art critic John Ruskin (1819–1900) described the work in his *Academy Notes* as 'faultless and wonderful'. The painting was accompanied by a quotation from the epilogue from Christopher Marlowe's play *Doctor Faustus*:

> Cut is the branch that might have grown full straight
> And burnèd is Apollo's laurel bough . . .

Wallis's posthumous portrait is the dominant – perhaps the only – image which most people have of Chatterton the poet. His tragically brief life became the very model of the doomed Romantic poet: the young, poverty-stricken, rebellious, suicidal genius. He was one of the literary sensations of eighteenth-century England (a century in which literary forgery was a flourishing industry) as the precocious young poet who forged the life and works of a non-existent fifteenth-century priest named Thomas Rowley. But then he faded from view, all but forgotten by the reading public and by his native city of Bristol.

However, Dr Nick Groom of the University of Bristol is doing his best to put that right. In 2002, after a three-day international conference at the University of Bristol to mark the 250th anniversary of the poet's birth, he founded the Thomas Chatterton Society. The society will encourage research into Chatterton's life and works, and seek means of commemorating Chatterton at his birthplace and other sites. It will not be a purely academic forum: Groom wants to involve local people and hopes that the society will be able to give support to creative teenagers in and around Bristol from social backgrounds similar to Chatterton's.

Nick Groom has devoted his formidable energies to researching Chatterton's career and prodigious output, and rehabilitating him as a seminal figure in English literature. He has demonstrated, for instance, that Chatterton's death wasn't suicide at all and has emphasised that the forgeries were only a small part of a dazzling outpouring of inspired writing of all kinds in his short life – even though the forgeries, and the supposed suicide, are mainly what Chatterton is remembered for today. Groom wants to distentangle the man from the myth, the forger from the plagiarist, the life from the legend:

> It's a scandal of English literary criticism that Chatterton has
> been so neglected. Chatterton should be read for the value of his
> poetry, and the life (and death) shouldn't get in the way of that;
> the only way of judging a poet is by the quality of the poetry, not

by whether he or she had an interesting life or not. The life can of itself be a fascinating biographical yarn, but it doesn't make the poetry 'better' or 'worse' – you're not a better poet just because you've had an interesting life: you write better poetry because of your skill and craftsmanship.

Nevertheless, for the Romantics, and still for a lot of people today, Chatterton's life seems 'super-authentic': he was a boy from the provinces, an autodidact, a vegetarian, an early opium eater, a libertine, a political radical and an atheist, a teenager living life to the very edge, and he died tragically young. He was astonishingly prolific, and his collected works fill two thick volumes, from reams of poetry (scathing satire, graveyard gothic, oriental eclogues and fashionable songs) to columns of political journalism. And he produced hundreds of medieval texts: forgeries.

Not all of his work was good – whose is? But he had moments of startling brilliance, and there is a handful of poems which merit a place in any anthology of English poetry.

So who was he, this Thomas Chatterton?

Childhood in Bristol

Thomas Chatterton was born in Bristol, of humble origins. The Chattertons had for many years enjoyed the patronage of the enormous gothic church of St Mary Redcliffe in Bristol, working as sextons or odd-job men. Chatterton's father (Thomas Chatterton, senior) had raised himself to the position of writing master of the church and neighbouring Pile Street free school; he was also a keen local historian and antiquarian. His most treasured possession was a small archive of fifteenth-century manuscripts which had been found in the muniment room above the north porch of the church; these manuscripts had come from a large chest of papers left by William Canynge, a wealthy merchant and five times mayor of Bristol at the end of the fifteenth century – it

was known as 'Mr Canynge's Cofre'. This and other chests had been officially ransacked for manuscripts in 1727, but much of this historical booty still lay scattered in the muniment room when Chatterton, senior, helped himself to a basketful of documents in 1750. He locked away, in two wooden boxes, those parchments which were germane to his own genealogical researches in establishing the history of his family's connection with St Mary Redcliffe church 'from time out of mind', as he put it; the rest were used as scrap paper at home and in the Pile Street school where he worked.

Thomas Chatterton, senior, died three months before his widow Sarah gave birth to their only surviving son, Thomas, on 20 November 1752; they had lost an earlier son, soon after birth, in 1751. Sarah was left to bring up baby Thomas and their daughter Mary (1749–1804) on her own. Sarah had to decamp from the school and move to Redcliffe Hill to live with an elderly relative; here she eked out a pittance as a seamstress and sewing mistress to young girls.

Young Thomas was thought to be a dunce; he was expelled from his first school (the one at which his father had worked in Pile Street) for being backward, so his mother taught him the alphabet, using the illuminated capital letters from an old French folio music book whose pages she was using to make dress patterns. Thomas now became an avid reader of the family's massive black-letter church bible. In August 1760, when he was nearly eight years old, Chatterton entered Colston's School, which was modelled on 'Bluecoat' schools like Christ's Hospital in London and where the boys had their heads tonsured in monastic fashion. Here he read even more voraciously. He joined a circulating library, and within two years he had compiled a list of seventy books he had read, including Shakespeare, Milton and (possibly) Chaucer. He also began *writing* poetry at this time – satirical verse as well as light-hearted modern fables, featuring midnight sprites and ghosts haunting graveyards.

Chatterton left Colston's School in 1767 at the age of 14 and was apprenticed to a Bristol attorney named John Lambert to be trained as

a legal scrivener, or copier. His indentures demanded that 'Taverns he shall not frequent, and Dice he shall not play. Fornication he shall not commit. Matrimony he shall not contract.' Nick Groom comments that there is no evidence that he contracted matrimony but that he doubtless broke – or attempted to break – all the other commandments.

Chatterton found his position at Lambert's, copying legal precedents, extremely disagreeable. He was treated like a servant (he had to share a bedroom with another menial), and Lambert insisted that he spend all his free time studying law. However, it gave him access to old pieces of parchment, which proved a godsend when he first became aware of the two boxes of manuscripts his father had left. Chatterton was entranced by the world of fifteenth-century Bristol these genuine manuscripts revealed, and he read anything and everything on the subject he could lay his hands on. He would regale his friends and family with inspired tales about the old city. But there was not enough to satisfy his obsessive interest in the period, so the 15-year-old apprentice began to expand the picture on his own account: he started forging manuscripts about the history and culture of the times, using strips of vellum cut from the margins of documents available at Lambert's, writing on them by moonlight late in the night. The hoard from the muniment room in St Mary Redcliffe provided not only the inspiration but also a ready-made provenance for his forgeries.

Chatterton concentrated on fabricating the works of a fictitious monk named Thomas Rowley (*c.*1400–70), which he claimed his father had recovered from St Mary Redcliffe. The invented Thomas Rowley was the erudite and sophisticated confidant, resident poet and cultural odd-job man for the historical Bristol merchant and public figure William Canynge; Chatterton re-invented Canynge as the wealthy patron of a group of non-existent writers, architects and ecclesiastics, of whom Thomas Rowley was Canynge's boon companion, scribe and business associate. Rowley wrote poems and plays, translated historical treatises from Latin, and travelled the country on antiquarian expeditions on Canynge's behalf. To lend historical proof to this vivid imaginative

structure, Chatterton forged an immense range of material – business memoirs, accounts, research notes, pedigrees, heraldry, maps and correspondence. Nick Groom comments:

> No Thomas Rowley ever existed in this incarnation: he was the brilliant, compelling and perplexing creature of Chatterton's brain. It was literary forgery, but forgery in the fullest sense of the word: these were crafted textual artefacts – original antique verse often transcribed in a crabbed and ancient calligraphy in aged ink on old vellum, frequently illuminated with naive heraldic sketches and architectural cartoons. Chatterton laced these beautifully baroque creations together with editorial comments and antiquarian annotations.

Chatterton was creating a saga of Bristol, giving the fifteenth-century city a 'Golden Age' which he imagined, or wished, had once existed: a place where piety and religion reigned supreme, a place of godliness and charity, making Bristol a veritable metropolis of goodness in the 'Good Old Times'.

'The Lunacy of Ink'

The Composition of my Soul is made
Too great for Servile avaricious Trade
When raving in the Lunacy of Ink
I catch the Pen and publish what I think

Chatterton, *The Whore of Babylon*

In the autumn of 1768, still short of his 16th birthday, Chatterton went public for the first time. A new bridge was being opened in Bristol, so Chatterton forged a medieval eyewitness account (signed 'Dunhelmus Bristoliensis') of the opening of the old bridge in 1247. This account was published in a Bristol journal on 1 October 1768 and caught the attention of George Catcott, a local pewterer and self-publicist. Catcott

interrogated Chatterton about the provenance of the manuscript and asked to see more examples from the chests in the muniment room. Chatterton obliged but only with 'transcripts', claiming that the original parchment strips were too fragile, or too difficult, to read; occasionally, when Catcott insisted on seeing the originals, Chatterton would have to scurry home and manufacture them on his strips of parchment. In this way, he provided Catcott with several works, including the *Life of Thomas Rowlie Preeste* and *The Bristowe Tragedie, or the Dethe of Syr Charles Bawdin*. The latter was a fiery ballad by Thomas Rowley, written in pseudo-medieval English and full of archaic words and spellings. It elaborates a brief fragment of Bristol lore, the trial and execution at Bristol Castle of a local worthy, and was Thomas Rowley's inaugural appearance as a poet:

> The feather'd songster Chaunticleer
>> Hath wounde his bugle horne,
> And told the earlie villager
>> The commynge of the morne.

Catcott introduced Chatterton to a retired surgeon named William Barrett, who was working on a history of Bristol (eventually published in 1789) and who gave Chatterton the run of his extensive library. Chatterton repaid the favour by supplying Barrett with scraps of medieval Bristol lore he had invented. He also obliged Catcott's partner in pewtering, Henry Burgum, with a fake pedigree tracing his descent to a Norman knight, which earned him five shillings.

Antiquarianism was much in fashion at the time. The current publishing sensation was the three-volume *Reliques of Ancient English Poetry* (1765), compiled by Thomas Percy (1729–1811); this supposedly derived from a compendious 'folio MS' of ballads and metrical romances which Percy had rescued from a basket of kindling, freely edited and adapted, and then kept under lock and key.[4] In 1764, the writer and connoisseur Horace Walpole (1717–97) – who had converted his house

at Strawberry Hill in Twickenham into 'a little Gothic castle' – had published his fake Gothic novel *The Castle of Otranto*, which purported to be a translation of an Italian original of 1529. Both books involved a reconstruction of part of the Middle Ages, and both books made their authors famous.

Encouraged by his success with the credulous Catcott and Barrett, Thomas Chatterton now decided it was time for him to 'go national' as well. In December 1768, he offered a collection of his Rowley poems to James Dodsley, Thomas Percy's London publisher, but Dodsley rejected them. Chatterton also sent some of the Rowley poems to Horace Walpole; Walpole was enthusiastic about them at first and asked to see further specimens but, after consulting others, changed his mind and (no doubt recognising a fellow spirit) wrote Chatterton a letter of gentle admonition:

> I wrote him a letter with as much kindness and tenderness, as
> if I had been his guardian; for though I had no doubt of his
> impositions, such a spirit of poetry breathed in his coinage, as
> interested me for him: nor was it a grave crime in a young bard
> to have forged false notes of hand that were to pass current only
> in the parish of Parnassus.

The rebuff disappointed and angered Chatterton, but it in no way abashed him, although it seems to have warned him off 'Thomas Rowley'; but Rowley had served his purposes already. Chatterton was now beginning to write 'Ossianics' in imitation of James Macpherson, who had recently published translations of alleged bardic epic poetry by ancient Gaelic heroes such as Ossian and Fingal. Chatterton wrote seven Ossianics in all, using themes which ranged in time from the sixth to the twelfth centuries. The first of these was published in March 1769 in *Town and Country Magazine*; it was entitled *Ethelgar: A Saxon Poem* and tells the story of Ethelgar, who becomes a monk after he jumps off a cliff, his life having been saved by St Cuthbert. Chatterton's 'Ossianics',

much more sprightly and readable than James Macpherson's efforts, were the most immediately successful of his works – six of the seven were published before his death, whereas the only 'Rowley' piece published during Chatterton's lifetime was *Elinoure and Juga*, which appeared in *Town and Country Magazine* in May 1769.[5]

The ensuing year was one of prodigious output in 'the Lunacy of Ink'. Chatterton was determined to seek fame and fortune in London, but before he set off he threw his energies into popular writing. He wrote his 'Ossianics', several elegies and much descriptive verse. He also wrote mock-heroic satires in the manner of Alexander Pope's *The Rape of the Lock* (1714); the most notable of them is a 1769 'food-fight' custard-pie epic called *The Constabiliad* (describing the aldermen and vestrymen of modern Bristol falling out over dinner), which was soon to be revised in London into a powerful satire on political life in the capital called *The Consuliad*. This work was published in the *Freeholder's Magazine* – Chatterton's first major appearance in London print (January 1770). It was essentially a 'Patriot' slapstick burlesque – that is to say, in favour of the radical firebrand John Wilkes and against the Whig administration.

He also sold to Catcott the most ambitious of his Rowley works – the play *Ælla, a tragycal enterlude*. It tells the tragic story of a Bristol hero, Aella the Saxon, warden of Bristol Castle, who marries his sweetheart Birtha but learns, during the wedding feast, that a Danish force has landed nearby. He rushes off and routs the invaders but is badly wounded. He goes back in order to die in his bride's arms, only to be told that she has left the castle with another man. Heartbroken, he stabs himself, but before he dies his bride reappears, saying that she had been lured away by the treacherous Celmonde on the pretext that she was being taken to her wounded husband. Somehow she has contrived to escape, but before she finishes her explanation Aella dies, and she collapses over his body. It is a fast-moving and racy tale, interspersed with numerous 'Mynstrelles Songes':

O! synge untoe mie roundelaie,

O! droppe the brynie tear wythe mee,

Daunce ne moe atte hallie daie,

Lycke a reynynge ryver bee;

 Mie love ys dedde,

 Gon to hys death-bedde,

 Al under the wyllowe tree.

Chatterton wrote in a bewildering number of other poets' styles: Geoffrey Chaucer, William Shakespeare, Charles Churchill, Alexander Pope, Joseph Addison, Jonathan Swift, Henry Fielding . . . According to Georges Lamoine of the Université du Mirail, 'Few authors can boast of having given the world so much, in such a comparatively short time, and at so early an age.' Within a year, Chatterton had published thirty-one titles in seven different journals, five of which were London publications.

In April 1770, Chatterton moved to the capital. He had rid himself of his apprenticeship indentures as a trainee scrivener by feigning suicidal tendencies in letters he left around, as well as a mock rhyming 'Last Will & Testament'. In London, he took lodgings with a relative, a Mrs Ballance, in Shoreditch and engaged in a hectic round of visits to publishers and booksellers. He signed contracts for several pieces of journalism and for a 'voluminous' history of England, to be serialised in the autumn, which would involve visits to Oxford, Cambridge, Lincoln, Coventry and other cities. He assured his mother in a letter: 'No author can be poor who understands the arts of booksellers.'

Chatterton also poured out political letters for Patriot opposition newspapers under the pseudonym 'Decimus', modelled on the anonymous 'Junius', who flooded the *Public Advertiser* from January 1769 with vituperative letters against the establishment.[6] Chatterton also wrote a remarkable series of three direct attacks on British imperialism; these were the anti-slavery 'African Eclogues'. They adopted the viewpoint (as Chatterton saw it) of native Africans who regarded Europeans as

alien invaders. This was Chatterton becoming what might be called 'the laureate of resistance'.

He wrote feverishly and sometimes lucratively. He composed a burletta (musical farce) called *The Revenge*, which earned him the handsome sum of five guineas. He was not always so successful: his anti-government satire *Kew Gardens* (signed 'Decimus' and modelled on one of the satires of Charles Churchill) was turned down by the pro-Patriot *Middlesex Journal*, but the same journal was happy to print his libellous political poem 'The Hag'. The *Town and Country Magazine*, which had already published several of his pieces, was always a ready fall-back and published his Ossianic poem 'Gorthmund' in September 1770. But, surprisingly, his last great 'Rowley' poem, *An Excelente Balade of Charitie*, a medieval fable based on the parable of the Good Samaritan, was rejected by the *Town and Country Magazine* in July 1770 and was not published until 1777:

> The sun was glemeing in the middle of the daie,
> Deadde still the aire, and eke the welken blue,
> When from the sea arist in drear arraie
> A hepe of cloudes of sable sullen hue,
> The which full fast unto the woodland drewe,
> Hiltring [hiding] attenes the sunne's fetive [beauteous] face.
> And the blacke tempeste swolne and gathered up apace.

Overall, however, Chatterton was doing pretty well in the cut-throat world of the metropolitan publishing trade; he was certainly making a reasonable living from his pen. In letters to his sister Mary, he boasted of his income, and to his friends of his successes with women. To celebrate, he moved from Mrs Ballance's into lodgings at Brooke Street, where he enjoyed the luxury of a room of his own. His landlady was a Mrs Angell, a dressmaker who ran a bawdy house; he boasted that he slept with her and her girls – on which account his rent was raised.

Yet within four months, on the night of 24 August 1770, he apparently

committed suicide in his Holborn garret by taking arsenic – reduced to despair, it was said, by poverty, neglect, rejection and broken pride.

The death of Chatterton

It had all the makings of a deeply Romantic tragedy. And no sooner was Chatterton dead than the mythologising began – the legend of the doomed young poet. It became the accepted view that Chatterton had been gradually starving, unable to make his living as a London writer. It was said that he had fallen into an open grave shortly before he died and that he had been refused a loaf on credit. He was too proud to accept charity at Mrs Angell's table (she said he had not eaten for two or three days).

The coroner simply reported that he had 'swallowed arsenick in water, on the 24th of August, 1770; and died, in consequence thereof, the next day'. He was declared non compos mentis (thus avoiding the humiliating public spectacle of a suicide's burial) and given a pauper's burial in Shoe Lane burying ground. But despite the 'not of sound mind' verdict, everyone assumed that his death was, in fact, a suicide.

The 'resurrection' of Chatterton began within days of his death, but not in his own right – only in terms of his fictitious fifteenth-century poet, Thomas Rowley. Chatterton had shown his Rowley works to very few people while he was alive, but now that he was dead, everyone was obsessed with them. Word about his 'lost' works quickly began to circulate. The playwright Oliver Goldsmith (1728–74) soon convinced himself of their authenticity and hastened to Bristol in 1771, where he allegedly took away scraps of old parchment lying about in the muniment room at St Mary Redcliffe. Others followed suit, and Catcott and Barrett did a brisk trade in providing copies of Rowley works.

Rowley, in fact, took over. Rowley was so erudite, so sophisticated and such an accomplished poet that it was a patent absurdity for anyone to believe that a suicidal young madman could possibly have forged his works. Chatterton himself had to be downgraded so that Rowley could be upgraded. Rowley's works were read from manuscript books in literary

salons in Bristol, Bath and London, while the Holborn garret became a grisly tourist attraction. The inaugural Rowley ballad, *The Bristowe Tragedy*, was published in 1772. 'Rowleymania' was rife.

Naturally, Chatterton's Bristol patrons, George Catcott and William Barrett, were vociferous promoters of the authenticity of the Rowley poems their protégé had found for them. But soon the doubters began to have their say. As early as September 1773, Thomas Percy, of *Reliques* fame, gave it as his considered opinion that the handwriting was manifestly spurious and done with a modern pen: the holograph manuscript he was invited to study was 'in every respect the most glaring & undoubted fraud'.

The collected Rowley poems were published in February 1777 as *Poems, Supposed to have been Written in Bristol, by Thomas Rowley and Others, in the Fifteenth Century*. The publisher and editor was Thomas Tyrwhitt (1730–86); the title betrayed an ambivalent attitude towards the authenticity or otherwise of the poems. Thomas Chatterton was only mentioned, briefly, in a footnote which gave 'the principal circumstances of his short life', since they were 'intimately connected with that of the poems now published'. The ostensible purpose of the edition was to give the public access to the material which had 'for some time excited much curiosity'. Tyrwhitt avoided revealing his own opinion about whether they had been found or forged and left it 'to the determination of the unprejudiced and intelligent Reader'. It created a publishing sensation, and in consequent reprints, Tyrwhitt, sensing the public mood, removed the phrase 'supposed to have been' from the title page. However, in a subsequent edition, published a year later in 1778, he added an appendix 'tending to prove that they were written, not by any ancient author, but entirely by Thomas Chatterton'.

At about the same time, Rowley the poet was included in the second volume (1778) of the three-volume *The History of English Poetry* (1774–81) by Thomas Warton (1728–90), professor of poetry at Oxford. Warton made no bones about his own opinion: 'None of these pieces are genuine.' He had apparently consulted a friend of his – 'an

ingenious critic and antiquary' – who had assured him that the writing was 'a gross and palpable forgery . . . not even skilfully counterfeited'. Warton allowed, however, that there was 'some degree of plausibility in the history of their discovery', that they 'had merit' and that 'many respectable critics' believed them to be authentic.

Another critic was quite unambiguous – the formidable Dr Samuel Johnson, the authoritarian colossus of literary criticism, the scourge of fakers and forgers, the man who had castigated James Macpherson over 'Ossian', and someone who demanded proof of authenticity for anything in print. Johnson, the elder statesman of printed culture, had been vigorously attacked by the young Turk, Chatterton, as 'a place man & State Pensioner'; Johnson had apparently been amused, rather than offended, by these squibs and regarded Chatterton with remarkably indulgent sympathy – he clearly admired Chatterton's qualities as a writer but deplored the way in which he had put them to use. James Boswell, Johnson's biographer, records that in April 1776, when the 'Rowley controversy' was still at its height, Johnson paid a visit to Bristol, where he met George Catcott at an inn. At Catcott's insistence, Johnson read aloud some of Rowley's verses and inspected 'some of the *originals* as they were called, which were executed very artificially'. Both Boswell and Johnson were 'quite satisfied of the imposture'. Catcott, still hoping to convert the great man to his own point of view, then persuaded Dr Johnson to labour up the long flight of steps to the muniment room in St Mary Redcliffe church 'to *view with our own eyes* the ancient chest in which the manuscripts were found'. Dr Johnson was impressed but not in the way Catcott had hoped: 'This is the most extraordinary young man that has encountered my knowledge. It is wonderful how the whelp has written such things.'

Dr Johnson was shrewd and objective enough to recognise talent when he saw it. Indeed, the 'bluestocking' poet Hannah More (1745–1833) recorded in her memoirs that when she met Dr Johnson in April 1782, he jokingly 'lamented that I had not married Chatterton, that posterity might have seen a propagation of poets'.

In 1782, the eminent literary critic and Shakespearian scholar Edmond Malone (1741–1812) published his magisterial views on the Rowley poems in his *Cursory Observations on the Poems Attributed to Thomas Rowley*, stating that they were, without any doubt, forgeries:

> If such a man as Rowley had existed, he would have had half the parchment in the kingdom at his command; statues would have been erected to him as the greatest prodigy that the world had ever seen; and in a few years afterwards, when printing came to be practised, the presses of Caxton and Wynkyn de Worde would have groaned with his productions.

The Rowley controversy, nonetheless, simmered on. It came to be not so much about whether the Rowley poems were genuine or not as about the history of English poetry and whether a poet of Rowley's ability could have existed in fifteenth-century England, bridging the gap between Chaucer and Edmund Spenser. It was only when the controversy had been settled – when the authenticity of Rowley had become an irrelevance – that Chatterton was reinstated as a poet in his own right, and Professor Warton now pronounced him 'a prodigy of genius', someone who 'would have proved the first of English poets, had he reached a maturer age'. Chatterton was reinvented as an icon of tragic genius and as such became part of the very genesis of Romanticism.

'The marvellous Boy'

There is another 'picture' of Thomas Chatterton, very different from the idealised painting by Henry Wallis: an image of the young poet as poverty stricken and mad, printed on a souvenir handkerchief (the British Museum and the Bristol Museum own examples of it). Based on an engraving which appeared in the *Westminster Magazine* in July 1782 (12 years after Chatterton's death), it is entitled 'The Distressed Poet, or a True Representation of the Unfortunate Chatterton'. In it, Chatterton sprawls on a broken chair, leaning forward over a sheet of poems spread

across a trestle table. One hand grasps a quill pen, the other is held pensively against his left cheek. He wears a cloth nightcap and an ill-fitting coat with holes in the elbow; his shoes are down-at-heel, and his stockings are crumpled round his ankles. Behind him a torn truckle bed is upended against the wall, and there is a large flask on the table.

On the right hand side of the picture is a commentary:

> The painting from which the engraving was taken of the distressed poet, was the work of a friend of the unfortunate Chatterton. The friend drew him in the situation in which he is represented in this plate. Anxieties and cares had advanced his life, and given him an older look than his age. The sorry apartment portrayed in the print, the folded bed, the farthing candle, and the disorderly raiment of the bard are not inventions of fancy. They were realities, and a satire upon an age and a nation of which generosity is doubtless a characteristic. But poor Chatterton was born under a bad star; his passions were too imperious . . . Unknown and miserable while alive, he now calls forth curiosity and attention. Men of wit and learning employ themselves to celebrate his talents, and to express their approbation of his writings. Hard indeed was his fate, born to adorn the times in which he lived, yet compelled to fall a victim to his pride and poverty!

It was this image, on a memorial handkerchief intended to mop up the tears inspired by the moral, which inspired Samuel Taylor Coleridge (1772–1834), while he was still a 17-year-old Bluecoat boy at Christ's Hospital, London, to write his first published poem – a prize-winning poem entitled 'Monody on the Death of Chatterton', which was copied into his school's Golden Book (a record of prize-winning pupils) in the summer of 1790:

> In vain I seek the charms of youthful grace,
> Thy sunken eye, thy haggard cheeks it shews,

The quick emotions struggling in the Face
 Faint index of thy mental Throes,
When each strong Passion spurn'd controll,
And not a Friend was nigh to calm thy stormy soul.

Chatterton became a spectral pre-Romantic icon for the major Romantic poets, although none of them (except Wordsworth, just) had been born at the time of his death. His death seemed to overwhelm his life, just as his forgeries had usurped his qualities as a poet in his own right. His life, work and death had a powerful effect on the Romantic imagination. His pseudo-medieval poetry was an important part of the early Romantic movement, a throwback to a nobler age at a time when the poetry of 'Ossian' was sweeping Europe. William Wordsworth, in his 1802 poem 'Resolution and Independence', gave Chatterton literary immortality[7] with the term which has become particularly associated with him – 'The marvellous Boy':

 I thought of Chatterton, the marvellous Boy,
 The sleepless Soul that perished in its pride;
 Of Him who walked in glory and in joy
 Following his plough, along the mountainside:
 By our own spirits are we deified:
 We Poets in our youth begin in gladness;
 But thereof comes in the end despondency and madness.

John Keats (1795–1821) also dedicated one of the first of his 'Early Sonnets' to him:

 O Chatterton! how very sad thy fate!
 Dear child of sorrow – son of misery!
 How soon the film of death obscur'd that eye,
 Whence Genius mildly flash'd, and high debate.

The Pre-Raphaelite poet and painter Dante Gabriel Rossetti (1828–82) was infatuated by the idea of Chatterton:

> He was as great as any English poet whatever, and might absolutely, had he lived, have proved the only man in England's theatre of imagination who could have bandied parts with Shakespeare.

In an ironic twist, Chatterton the forger became the posthumous victim of another forger, the alcoholic Bristol writer John Dix (?1800–?65). Dix was a failed medical practitioner who claimed to have been taught by Chatterton's sister Mary and who cashed in on the suicide myth by publishing a semi-fraudulent biography (*The Life of Thomas Chatterton including his Unpublished Poems and Correspondence*, 1837). Dix forged a suicide letter in the form of some 'Lost Verses' allegedly found beside his deathbed, ending:

> Have mercy, Heaven! when here I cease to live,
> And this last act of wretchedness forgive!

Dix also forged an inquest report detailing the last hours of Chatterton's life, in which he had allegedly secreted 'a bundle of papers' in some unknown hiding place; this supplied the provenance for some other forged documents which John Dix obligingly provided.

The dead poet cast a very long shadow. A hundred years after Chatterton's death, the poet Francis Thompson (1859–1907), who had become an opium addict after reading Thomas de Quincey's *Confessions of an English Opium-Eater* (1822) and was living in total destitution under the arches of Covent Garden Market, made up his mind to commit suicide with one last large dose of laudanum (tincture of opium). But he had only swallowed half of the poison when he felt a hand laid on his wrist; looking up, he saw Thomas Chatterton standing over him. Chatterton forbade him to drink the other fatal half and Thompson obeyed. The desperate poet was quite sure it was Chatterton he had seen:

> I recognised him from the pictures of him – besides, I knew
> that it was he before I saw him – and I remembered at once the
> story of the money which arrived for Chatterton the day after
> his suicide.

Thompson survived, had some of his verses published and was soon cured of his opium addiction.

Central to the iconic significance of Chatterton for the Romantic poets was his youth, his pride, his poverty, his alienation from the powers that be, his rejection by society – all the things which satisfied the image the Romantic poets had of themselves as young men. But the crowning aspect was the boy's alleged suicide, which swept into one basket all the melancholia and broken hopes of a young, doomed genius.

But does the icon match the model? Nick Groom, in *The Forger's Shadow* (2002), has argued that Chatterton did not commit suicide at all – he died as the result of an *accidental* overdose of arsenic and laudanum.[8] The circumstantial evidence is compelling: Chatterton had no reason whatsoever to commit suicide. He was *not* being spurned by the book trade. He was *not* impoverished – in fact, he was making a reasonable living from his journalism and fashionable writing. He did *not* leave a suicide note (the one said to have been found by his mythographer John Dix was a forgery). He was *not* starving in a garret. On the other hand, he certainly *was* driving himself extremely hard, sleeping little and eating less, and writing with feverish intensity, his hyperactive creativity heightened by laudanum, which was in common use as a panacea for all ailments, real or imagined. After his death, his pocketbook was found to have a deep stain on it which has been chemically analysed and shown to be that of an opium alkaloid.

So what happened? Nick Groom makes it clear that in the summer of 1770 Chatterton contracted a venereal disease – not surprising, perhaps, considering Chatterton's bragging about his frequent amorous exploits. It was a painful disease, for which the only known remedy in those days was even more agonising, as it involved heavy dosages of arsenic. A local

apothecary called Mr Cross, who sold the young man medicine, confirmed that Chatterton had 'the Foul disease, which he would cure himself, and had calomel and Vitriol of Cross for that purpose'; he had also cautioned Chatterton against the too free use of these, particularly the latter. 'Vitriol of Cross' was probably red arsenic (a preparation of arsenic and sulphur), and 'calomel' was mercurous chloride, or 'horn quicksilver', used as a purgative.

Nick Groom's thesis is that Chatterton was taking arsenic to cure himself of the disease. To counteract the pain caused by the arsenic, he was also taking opium, not in its solute form but in its raw state – a coarse powder made into sticks or flat cakes, which could only be endured by an experienced user. Grains of raw opium were found in his teeth after his death. The combination of the two seems to have produced the overdose which killed him. The 'romantic suicide' was a dreadful accident. Nick Groom writes:

> His end was senseless and tragic, but despite the juggernaut of myth which began almost immediately to roll, obliterating history, this was no proto-Romantic suicide of a starving poet in a friendless garret, his genius cruelly unrecognised ... The archetypal nature of the myth of Chatterton's suicide is almost impossible to deny, and certainly impossible after more than two centuries to disentangle from the circumstances of his life, but accidental poisoning remains the most plausible analysis of the scene.

The relics of Thomas Chatterton

The plaque on the wall of the branch of Barclays Bank in Holborn reads simply:

<div align="center">

In a House on this Site

THOMAS

CHATTERTON

died

August 24th 1770

</div>

An earlier plaque had originally been erected in the 1830s, long before Barclays Bank moved in. It is the only tangible reminder of the bawdy house at 39 Brooke Street where Chatterton rented the sixth-floor garret room in which he died; this was the room in which, for the sake of verisimilitude, Henry Wallis had painted the death scene of the young poet, almost a century after Chatterton had died in it.

Nick Groom took me on a tour of the area, conjuring up for me a picture of Chatterton's hustling, bustling Brooke Street amid the gleaming modern affluence of today. A few doors up the road was The Three Tuns, the public house in which the autopsy on his body was carried out, near the pharmacy in which he had bought the arsenic which killed him. There was a local bakery, where Chatterton bought his food, and coffee houses in which he would sit and write. It was an area much favoured by writers (Johnson's Court, in which Dr Johnson was then living, was nearby); it was only a brisk stroll down to Grub Street (now Fore Street), which was the haunt of printers and publishers and literary hacks.

It would be a search in vain for Chatterton's grave. On 28 August 1770, his body, wrapped in a winding sheet, was given a pauper's burial in a common burial ground in Shoe Lane, at Holborn Cross, in the lee of the imposing, white-painted church of St Andrew Holborn in St Andrew Street; the cemetery was connected to the workhouse which once stood there. Over the gateway to the cemetery there used to be a carving in bas-relief of the Last Judgement; this has now been affixed to an outside wall of the church. Inside the church the parish register of deaths has an inaccurate burial entry for '*William* Chatterton, Brook's Street 28'. And there the trail peters out. The burying ground has long since disappeared; the original site was built over by Farringdon Market and is now crossed by Farringdon Avenue.

It was thought that the bodies had been disinterred and reburied in other London cemeteries, but now it seems that they may all have been deposited in the crypt of St Andrew Holborn, underneath the main aisle, where they remained until fairly recently before being distributed among various burial grounds. But there are other possibilities. As

an undiseased young corpse, Chatterton might well have been dug up immediately and used for medical research – 'anatomised' for the benefit of students. There is also a (doubtless fanciful) Bristol story that his body was packed up and sent home by his uncle, a carpenter by trade, and buried by night in the churchyard of St Mary Redcliffe in his father's grave.

Fabled or not, Bristol is certainly a much more fertile destination for Chatterton pilgrims than Holborn.⁹ The first known monument to the boy poet was erected as early as 1784 in St Catherine's Hermitage on Sion Hill, the home of the cantankerous Bristol *littérateur* Philip Thicknesse; he is regarded as 'one of the most disagreeable men of letters ever to have existed', but he was Gainsborough's first patron, and he was an admirer of Thomas Chatterton. The memorial he built in his garden took the form of a romantic grotto of tufa stone with a commemorative urn and inscription; water gushed from a large opening into a pool. No trace of it now exists, alas.

The next monument to be erected in Bristol was even more eccentric and has had a chequered career. It was originally mooted in 1792, but it was not until 1838 that it was eventually built. It took the form of a tall three-stage Gothic tower (not unlike an Eleanor Cross) with a little Bath-stone 'puppet statue' of Chatterton as a Bluecoat schoolboy perched on top. The monument was designed by the Bristol architect and sculptor Samuel Charles Fripp (d.*c*.1887) and erected by public subscription in front of St Mary Redcliffe church in the corner between the north porch and the tower. Soon afterwards, however, the church authorities had second thoughts about a supposed suicide being commemorated on consecrated ground and dismantled it in 1846. A decade later, in 1857, it was re-erected on unconsecrated ground not far from the church, facing Chatterton's birthplace. The little statue suffered severely from erosion, and in 1950, the ornate masonry of the tower plinth was severely vandalised; when calls were made for it to be restored in the 1960s, the response was to place a commemorative plaque in the south transept of the church, and the monument was demolished. The

battered remains of the little statue are now in store at the Pile Street cottage where Chatterton was born.

In 1897, the Clifton Antiquarian Club placed an inscribed tablet on the façade of what was thought to be the Pile Street school Chatterton had attended; in fact, it was the school built in 1779 (nine years after Chatterton's death) as a replacement for the original. In 1939, Pile Street was demolished to make room for the construction of Redcliffe Way, but the elegant school façade (with its plaque) was moved in 1940 to the site of Chatterton's birthplace, facing St Mary Redcliffe.

Bristol has clearly woken up to a new awareness of its long-dead boy genius. There is now a Redcliffe Neighbourhood Development Plan which aims to refurbish Chatterton's birthplace and old school and their environs. Inside St Mary Redcliffe itself there is the 1967 tablet to Chatterton's memory, placed near the tomb of William Canynge, the fifteenth-century mayor of Bristol and patron of Chatterton's great invention, the monk Thomas Rowley. Above the north porch, the hexagonal muniment room, where Chatterton said he had discovered the works of Thomas Rowley, now houses a semi-permanent Chatterton display.

And in Millennium Square, a vivid new area of Bristol development, Chatterton has come into his own again. The square hosts a trio of bronze figures seated on benches, all fashioned by the American-born author, performer and sculptor Lawrence Holofcener (b.1926) and unveiled in 2000. The first of the three figures is of William Tyndale (the first translator of the Bible into English); the second is of the Quaker leader William Penn (the founder of Pennsylvania); and the third (and most attractive) statue is of a young Chatterton wearing shirt and breeches, with a couple of manuscript books at his feet.

Thomas Chatterton, 'the marvellous Boy', has come home to Bristol at last.

4.2 – The Ghost of Ossian: James Macpherson[10]

> He is to be called Oscar Fingal Wilde. Is not that grand, misty
> and Ossianic?
>
> Lady Jane Wilde, announcing the birth of
> her second son, Oscar, in November 1854

The sculptor's studio is high-ceilinged and cluttered, a former
thermodynamics laboratory in the campus of Paisley University. The rail
for an overhead crane, with block and tackle capable of carrying a ton
weight, curls round the ceiling. A jet engine which was once ensconced
in a corner has been replaced by a plaster cast of a monumental statue
of a seated Eirene (the Greek goddess of peace) with the infant Ploutos
(representing wealth); it is a commission for the city of Atlanta,
Georgia.

This is the workshop of Sandy (Alexander) Stoddart, one of the
busiest and most sought-after sculptors in Scotland. Now in his
mid-40s, he is intensely traditionalist: a neo-classicist to whom the
concepts of modernism are anathema. His most recent works include
the extensive Buckingham Palace sculpture for the Golden Jubilee of
Queen Elizabeth II – a 70 ft frieze with a Homeric motif, two angels
and a bust of the Queen; the huge neo-classical statue of the philosopher
David Hume (1711–76) in Edinburgh's High Street; and the imposing
'wayside shrine' to Robert Louis Stevenson in Edinburgh's Corstorphine,
comprising heroic-realist statues of Alan Breck and David Balfour, the
main protagonists of *Kidnapped*.

The walls of the studio are lined with early plaster versions of
completed bronzes: busts of Robert Burns and Milton, of Tony Benn
and Immanuel Kant, of the philosopher Roger Scruton and the architect
Robert Adam. But what I had come to see was something else: a plaster
cast of the gigantic head of a semi-legendary third-century Celtic warrior-
bard known as Ossian.

Today, Ossian has lost his resonance in literary circles, but when ancient 'Ossianic' poetry was discovered and published in the 1760s, it astounded the public, in England as well as Scotland, and took Europe by storm. Ossian was hailed as the veritable Homer of his time, the quintessential genius of loss and isolation, and a titan of poetry who had created a melancholy, other-worldly Celtic cultural landscape whose wild sublimity dazzled and overwhelmed the literati of the mid-eighteenth century. The man who claimed to have found and translated ancient relics of traditional Gaelic poetry and woven them into an epic masterpiece by 'Ossian' was a young Highlander named James Macpherson; he, too, is all but forgotten now except by specialist literary scholars. But, in his day, Macpherson made a tremendous impact on literary history as a precursor of the Romantic movement in Europe, and Sandy Stoddart holds him in profound reverence. It was to mark the bicentenary in 1996 of Macpherson's death that Sandy Stoddart fashioned an awesome head of Ossian, hoary-faced and windswept – because, for Stoddart, Ossian is one of the most sophisticated literary achievements of all time. His consuming ambition is to fashion a national Ossianic memorial in the western Highlands of Scotland which would outlast time itself – but more of that anon.

Macpherson the man

James Macpherson (1736–96) was a big, thickset man, 6 ft 3 in. tall, with fiery red hair. He was a Highlander born and bred, and a native Gaelic speaker. His father, Andrew Macpherson, was a crofter at Invertromie near Kingussie in Inverness-shire, in the heart of the Gaelic-speaking area of rural Badenoch; he was a close kinsman of the chief of the clan Macpherson – Ewan Macpherson of Cluny Castle. James's mother, Ellen, was also a Macpherson.

Throughout his childhood, Macpherson absorbed the traditional Gaelic culture of his community. He grew up in the heart of his clan, next door to a celebrated storyteller (Finlay Macpherson of Lyneberack), listening to the local legends and folklore which had been passed down

through generations of Macphersons in a land where innumerable mountains, streams and caves were named after Celtic heroes of yore.

Half a mile away, however, the solid Hanoverian fortress of Ruthven Barracks cast an alien shadow over that childhood (its gaunt ruins, standing on an old grassy motte, are starkly visible to the west of the A9, just south of Kingussie). It was built on the site of a demolished fourteenth-century castle, one of the lairs of Alexander Stewart Buchan, the notorious Wolf of Badenoch (a younger son of King Robert II). Ruthven Barracks was erected in 1718 by General George Wade (1673–1748), after the failed 1715 Jacobite Rising, as one of the strategic centres in the great network of roads and bridges and forts he built to control the Jacobite Highlanders – not least 'suspect' clans such as the Macphersons, whose chief had been involved in the 1715 Rising. The sight of Redcoats from Ruthven on armed patrols was a familiar part of James's childhood and a constant reminder of English occupation, albeit not a heavy-handed one, and James and his classmates indulged themselves in the safe pastime of pelting the soldiers with stones.

All that was to change catastrophically in the aftermath of the disastrous Jacobite Rising of 1745. The Macpherson clan chief had joined Charles Edward Stuart (Bonnie Prince Charlie) on his lightning march south on Edinburgh, entering triumphantly into the capital; but the euphoria was not to last. The Jacobite army reached Derby, but there it wavered and turned and headed back to Scotland, pursued by the Duke of Cumberland and his Hanoverian forces. On the way north to Inverness, the retreating Jacobite army laid siege to Ruthven Barracks, which had only a skeleton garrison at the time, and set fire to the buildings; they were never repaired and are now in the care of Historic Scotland.

After the carnage of Culloden Moor in April 1746, Cluny Castle was razed and the clan chief, Ewan Macpherson of Cluny, went into hiding (he was to remain a fugitive in his own territory for nine years before escaping to France). Cumberland's troops launched into an orgy of murder, mutilation and almost inconceivable brutality against the Highlanders – regardless of whether they were Jacobites or not. The

atrocities and indiscriminate slaughter went on for days. Detachments of troops were sent far and wide to scour the Highlands for rebels on the run. Whole glens were laid to waste. Men found bearing arms were hanged on the spot, their womenfolk raped. In the wake of the slaughter came repressive legislation: all weapons in Scotland were to be surrendered (including bagpipes, which were categorised as 'weapons of war'); the wearing of tartan was prohibited (the great plaid, the kilt 'or any part whatever of what peculiarly belongs to the Highland garb'); even the speaking of Gaelic, the language of the hearth, was forbidden. The distinctive Highland way of life was to be crushed once and for all: systematic cultural genocide, in effect. It is little wonder that the young Macpherson, brought up in this intensely Highland culture in Badenoch, should want to salvage something of the heritage which was being ruthlessly destroyed by the Hanoverian government in London.

At school in Ruthven, James Macpherson was an able pupil, and he earned a place at Aberdeen University in 1752. The old city of Aberdeen was expanding rapidly at this time, and the university (comprising King's College and Marischal College) was a hotbed of progressive intellectual thinking. He spent the first two years of his degree course at King's College, and then moved to Marischal College in the new part of the city. Here he came under the influence of the college principal Thomas Blackwell, professor of Greek and author of *Enquiry into the Life and Writings of Homer* (1735). Blackwell's thesis was that Homer's capacity to compose epics was directly related to the primitive environment in which he lived – a society unsettled politically, with constant violence and a still-fluid language – and that epic was often connected with nationalism. The analogy with the ancient culture of the Celts was unmistakable: the existence of a popular folk mythology from which poets could draw inspiration, the transmission of verse through an oral tradition and the role of the bard.

After three years at Aberdeen University, and a few months at Edinburgh University, Macpherson ended his academic studies at the age of twenty. He took up a job not far from his birthplace as teacher

in the parish school in Ruthven, where he had once been a pupil. At
Ruthven School, Macpherson spent his spare time collecting and copying
oral heroic poetry traditionally told in Badenoch; he also tried his hand
at writing poetry on his own account and had a couple of apprentice
elegies published in the *Scots Magazine*. In 1758, he left Ruthven for
Edinburgh, where he was employed as a private tutor to the family of
Graham of Balgowan. In April of that year, he published, under his own
name, a romantic heroic epic in six cantos entitled *The Highlander*,
which was set in an idealised Golden Age of invincible warriors and
women of impeccable character. The turning point in his literary career,
however, came about by chance. In October 1759, on a visit with a
pupil to the fashionable spa town of Moffat in Dumfries and Galloway,
the young Scot met one of Scotland's literary lions, the dramatist John
Home (1722–1808), whose first play *Douglas* (1756), which drew upon
Border legends for the plot, had been a huge success both in Edinburgh
and in London.

John Home was immediately attracted to the tall, red-haired young
Highlander who was not only an able classical scholar but also a collector
of ancient Gaelic tales and poems. Home asked him to translate a fragment
of Gaelic poetry about Oscar; Macpherson was initially reluctant but
eventually agreed. The outcome was the fragment he called 'The Death
of Oscur [*sic*]'; it bore little resemblance to any surviving Gaelic ballad
on Oscar's death:

> Why openest thou afresh the spring of my grief, O son of Alpin,
> inquiring how Oscur fell? My eyes are blind with tears; but
> memory beams on my heart. How can I relate the mournful
> death of the head of the people! Prince of the warriors, Oscur,
> my son, shall I see thee no more!
>
> He fell as the moon in a storm; as the sun from the midst of
> his course, when clouds rise from the waste of the waves, when
> the blackness of the storm inwraps the rocks of Ardannider. I,
> like an ancient oak on Morven, I moulder alone in my place.

The blast hath lopped my branches away; and I tremble at the wings of the north. Prince of the warriors, Oscur, my son, shall I see thee no more!

Back in Edinburgh, Home showed this and other translations to his influential literary friends, including Dr Hugh Blair (1718–1800), a Church of Scotland minister and academic who was appointed Professor of Rhetoric and Belles Lettres at Edinburgh University in 1760. Blair was greatly impressed with them as the relics of the lost bardic culture of Celtic Scotland and asked Macpherson to meet him; he wanted Macpherson to produce further translations, with a view to publication. Once again, Macpherson was reluctant: he claimed that 'no translation of his would do justice to that spirit and fire of the original'. The poetry of the Highlands was essentially oral; it was performance poetry, drawing life from its audience:

> Writing down Gaelic poetry at all was like producing song lyrics without the music; the beauty of the performance was lost and all that was left was the 'simple inanimated tale'. If this was then transferred to another language the resulting version could bear little resemblance to the original recital.[11]

Macpherson believed that the traditional poems he had heard and learned in his youth in Badenoch had been corrupted in their transmission from one generation of storytellers to the next and required restoration to their original purity before being published. Could this be properly called translation? In the eighteenth century, it was considered not only necessary but also desirable – English versions of Homer were imaginative recreations of the original rather than strict translations. Eventually, however, Macpherson succumbed to Blair's blandishments and produced a collection of 15 of his 'translations'.

In June 1760, these pieces (including 'The Death of Oscur') were published in Edinburgh in a pamphlet of 15 laments for dead warriors

331

entitled *Fragments of Ancient Poetry, Collected in the Highlands of Scotland, and Translated from the Gaelic or Erse Language.* They were wonderfully mysterious and alluring; they talked about ancient chieftains and summoned up beautiful landscapes of wind and storm and clouds, with voices resonating from one to the other. They created a huge stir with their rhythmic prose, simple dictions and striking natural imagery, seeming to reproduce the very voices of a vanished heroic age at a time when supposedly barbarous Europe was looking to Greece and Rome for its model. Reviewers raved over the new discovery, and extracts were reprinted in the July issues of *The Scots Magazine* and *The Gentleman's Magazine.* In a country which was becoming interested in 'the picturesque', Macpherson provided just that: a truly picturesque landscape of crags with figures striking dramatic poses in a stormy landscape. It was pure word-painting: the grandeur of the single solitary figure in romantically tempestuous weather, racked with torment and regret and sorrow. The poet Thomas Gray (1716–71), a close friend of Horace Walpole, waxed lyrical over the strange raptures of the verses: 'This man is the very Demon of Poetry, or he has lighted on a treasure hid for ages.' James Macpherson was then 23 years old.

But how 'authentic' were they? Only two of the poems are based closely on recognisable Gaelic ballads which can be identified. All the others seem to be a blend of Highland tradition and Macpherson's conscious efforts to produce a suitably 'ancient' style for the bardic voice, shorn of what he considered corruptions in the verses he had heard or seen.

Hugh Blair, who had promoted the publication so vigorously, contributed a preface (unsigned). In it he concentrated not on the literary quality of the fragments but on their value as historical documents from earlier times, offering rare insights into societies of days gone by. He did, however, add a tantalising foretaste of what might lie ahead:

> It is believed that, by a careful enquiry, many more remains of ancient genius, no less valuable than those now given to the world, might be found in the same country where these have been

collected. In particular, there is reason to hope that one work of considerable length, and which deserves to be styled an heroic poem, might be recovered and translated, if encouragement were given to such an undertaking.

The search for a national epic

Macpherson did not feel able to accept the challenge of going in search of this presumed lost 'national epic'; he did not have the money for it. Blair promptly arranged a fund-raising literary dinner, attended by 'many of the first persons of rank and taste in Edinburgh'. The necessary money was raised without difficulty to enable Macpherson to go to the Highlands in search of more of these 'remains of ancient genius'.

Macpherson made ready at once. In June 1760, he set off on the first of two expeditions to the Highlands and Islands. He was accompanied by his kinsman Lachlan Macpherson of Strathmassie, who had a good reputation as a Gaelic poet and was charming and classically educated to boot. They travelled to Skye and the Outer Hebrides, including Benbecula, receiving an enthusiastic welcome wherever they went, assiduously collecting old manuscripts and jotting down tales from the memories of elderly Highlanders. When Macpherson returned to Badenoch in October 1760 with a large collection of almost unreadable manuscripts, he set to work to try to recover the lost epic of Scotland he was sure he would find. He enlisted the help of a young minister friend and stayed at his house, where they could study the manuscripts in peace, for six weeks. Macpherson was indignant at what he considered the corrupt nature of the manuscripts, which had been scribed long after Ossian's time – just his 'broken poems' as he called them. Before moving on to Edinburgh, Macpherson undertook another expedition, particularly to the shores of Loch Ness, where he acquired the most important manuscript in his collection, the sixteenth-century *Book of the Dean of Lismore*, which contained several pieces attributed to Ossian.

In Edinburgh, Macpherson rented lodgings below Hugh Blair's house

in Blackfriar's Wynd. With the constant support of his patron, his task now was to fill in the gaps, giving the pieces a chronological context (much closer to current antiquarian thinking) by filling in the number of years and noting who did what and when. Plans for the publication of the great epic were quickly set in motion. Meanwhile, Macpherson made a foray to London to lobby prospective publishers; the most important contact he made was the Earl of Bute, a fellow Scotsman and one of King George III's ministers (soon to become, briefly, prime minister). Bute was a patron of the dramatist John Home and took an active interest in the arts and, particularly, in Scottish writers.

In December 1761, the promised epic was published in an impressive quarto volume as *Fingal, an Ancient Epic Poem, In Six Books: Together with several other Poems, composed by Ossian, the Son of Fingal.* It purported to be a translation of an ancient epic by a third-century Celtic bard called Ossian (the Scottish name for Oisin, a semi-legendary Irish poet), son of the warrior-hero Finn McCool (Fingal) and father of the hero Oscar – all of them familiar names in Highland folklore.[12]

The plot of *Fingal* has been adumbrated in Blair's preface to the *Fragments of Ancient Poetry.*

> The subject is an invasion of Ireland by Swarthan King of Lochlyn; which is the name of Denmark in the Erse language. Chuchulaid [Cuchullin], the General or Chief of the Irish tribes, upon intelligence of the invasion, assembles his forces; councils are held; and battles fought. But after several unsuccessful engagements, the Irish are forced to submit. At length, Fingal, King of Scotland, arrives with his ships to assist Chuchulaid. He expels the Danes from the country; and returns home victorious.

This was the narrative framework which Macpherson followed. *Fingal* plunges straight into the action:

Cuchullin sat by Tura's wall; by the tree of the rustling leaf. – His
spear leaned against the mossy rock. His shield lay by him on the
grass. As he thought of mighty Carbar, a hero whom he slew in
war; the scout of ocean came, Moran the son of Fithil.

Rise, said the youth, Cuchullin, rise. I see the ships of Swaran.
Cuchullin, many are the foe: many the heroes of the dark rolling
sea.

The basic plot was extended and embellished by numerous anecdotes
and digressions – about tragic romances which are only consummated
in death, for instance – whose relevance to the main action is seldom
apparent, causing confusion and even bewilderment. But the central
character, the man who holds it all together, is the narrator, the blind old
bard alone with his ghosts on the hillside, Ossian, son of the dead Fingal
and father of the dead Oscar:

Myself, like a rock, came down, I exulted in the strength of the
king. Many were the deaths of my arm; and dismal was the gleam
of my sword. My locks were not then so gray; nor trembled my
hands of age. My eyes were not closed in darkness; nor failed my
feet in the race . . .

When shall Ossian's youth return, or his ear delight in the
sound of arms? When shall I, like Oscar, travel in the light of my
steel? – Come, with your streams, ye hills of Coma, and listen to
the voice of Ossian! The song rises, like the sun, in my soul; and
my heart feels the joys of other times . . .

Often have I fought, and often won in battles of the spear.
But blind, and tearful, and forlorn, I now walk with little men.
O Fingal, with thy race of battle I now behold thee not. The wild
roes feed upon the green tomb of the mighty king of Morven.

Fingal caused a sensation, both at home and abroad. The epic, with its
elegiac atmosphere of drifting melancholy, its misty grandeur and its

pervasive sense of loss and isolation, aroused enormous enthusiasm when it was first published late in 1761. To Andrew Erskine, Macpherson's translations were the supreme expression of sublimity and sensibility in poetry; in January 1762, Erskine wrote effusively to James Boswell:

> It is quite impossible to express my admiration of his [Ossian's] Poems; at particular passages I felt my whole frame trembling with ecstacy; but if I was to describe all my thoughts, you would think me absolutely mad. The beautiful wildness of his fancy is inexpressibly agreeable to the imagination.

The vogue for Ossian spread rapidly to the Continent and to America. Macpherson's work was translated into 26 languages, including Bohemian, Danish, Dutch, French, German, Hungarian, Italian, Polish, Spanish and Russian.

In Germany, the complete poems of Ossian were translated as early as 1768 and had an electrifying impact on German literature, particularly on the young writers of the *Sturm und Drang* (Storm and Stress) school, which was inspired by Jean-Jacques Rousseau's (1712–78) fervent idealism and was characterised by the cult of genius and by a return to 'nature'. Foremost among these writers was Johann Wolfgang von Goethe (1749–1832). His second novel, published in 1774, was *The Sorrows of the Young Werther* – an intimate portrayal of a young man's mournful introspection which leads to his suicide. As the novel reaches its climax, in a welter of deep and romantic melancholy, the desperate young Werther reads to his beloved Lotte a translation (by Goethe) of one of the Ossian poems, 'The Songs of Selma' – the very epitome of the sonorously elegiac and feverishly sentimental world of the bards after the deaths of the great heroes.

Beethoven and Brahms, Haydn and Schubert, all wrote music scored to the tales of Ossian. More famously, Felix Mendelssohn (1809–47) created two major works inspired by the Scottish bard: the *Hebrides* overture (1830), popularly known as *Fingal's Cave* from the basaltic

cave-grotto on the Hebridean island of Staffa, and Symphony No. 3 in A Minor, the *Scotch* symphony (1842).

In France, the first Ossianic poems (from the *Fragments of Ancient Poetry*) were translated as early as 1760, and the writer and philosopher Denis Diderot (1713–84), editor of the *Encyclopédie, ou dictionnaire raisonné des sciences, des arts et des métiers* (*Critical Dictionary of Sciences, Arts and Crafts*), translated *Fingal* soon after it was published – the first of no fewer than 14 separate editions of the poems in France. Ossian's greatest admirer in France was Napoleon, who became enamoured of the poetry in his late teens after reading the Italian translation by the poet Melchiore Cesarotti (1730–1808). *The Poems of Ossian* was one of the two books which Napoleon carried with him into every battle he fought (the other was Goethe's *Werther*). He felt that the poems could inspire men to great deeds and arouse a nation's war-like spirit: 'They contain the purest and most animating principles of true honour, courage and discipline, and all the heroic virtues that can possibly exist.'

Napoleon's passion for the poetry of this 'Scottish Homer' inspired a number of artists to devote their skills to interpreting Ossian and depicting him. François Gérard (1770–1837) and Anne-Louis Girodet (1767–1824) were commissioned to decorate the reception hall of Napoleon's summer residence, Malmaison. Gérard obliged with one of his finest works, *Ossian evoking Spirits on the Banks of the Lora* (1801), while Girodet produced the complicated allegorical painting *Ossian and His Warriors Receiving the Dead Heroes of the French Army* (1802). In 1813, Jean-Auguste Ingres (1780–1867) painted the neoclassical *The Dream of Ossian*, dominated by the figure of the old bard slumped over his harp, as an oval ceiling decoration for Napoleon's bedroom in the Quirinale Palace in Rome (in the event, Napoleon never occupied the palace).

In America, President Thomas Jefferson took 'daily pleasure' in reading Ossian and considered the 'rude bard of the north the greatest poet that ever existed'. The poems had a powerful influence on nineteenth-century

American writers such as James Fenimore Cooper (1789–1851), Ralph Waldo Emerson (1803–82), Henry David Thoreau (1817–62) and Walt Whitman (1819–92). Whitman, indeed, articulated the soul of Ossianic poetry better than most, in his preface to the 1855 edition of his *Leaves of Grass*:

> Past and present and future are not disjoined but joined. The greatest poet forms the consistence of what is to be from what has been and is. He drags the dead out of their coffins and stands them again on their feet . . . He says to the past, Rise and walk before me that I may realize you. He learns the lesson . . . he places himself where the future becomes present.

In Finland, the physician-turned-folklorist and philologist Elias Lönnrot (1802–84) was inspired by Macpherson's Ossianic example to make a series of research trips all over Finland to collect old folk songs and traditional ballads. He organised them into a long narrative poem of ancient life in the far north, complete with a creation story and sundry adventures of legendary heroes. He called it the *Kalevala* ('Land of Heroes', first published in 1835); when he produced an expanded version in 1849, it came to be recognised as the national epic of Finland, akin to the works of Homer and Ossian. The *Kalevala* helped to create a distinctive sense of Finnish identity and to establish Finnish as a literary language.

In Britain, Ossian inspired a whole corpus of 'bardic' compositions by Wordsworth, Coleridge and Byron. Robert Burns called him one of the 'glorious models after which I endeavour to form my conduct'. Walter Scott's *Lay of the Last Minstrel* (1805) is full of morbid Ossianic echoes, despite his personal doubts about the authenticity of the poems. And – astonishingly, in retrospect – in 1818, in his essay 'On Poetry in General', the critic and essayist William Hazlitt (1778–1830) rated Ossian among the greatest poets in the world; he wrote:

I shall conclude this general account with some remarks on four
of the principal works of poetry in the world, at different periods
of history – Homer, the Bible, Dante, and let me add, Ossian.

Long before then, however, the initial rapture with which *Fingal* had been
received had begun to change – even in Scotland. Some of the enthusiasm,
at least, had been fired by nationalist sentiment: the Scottish literati had
for long felt a sense of inferiority towards the English, but now they had
been given a great 'national epic' which proved that the Scots had a longer
poetic history than the English. But the initial conviction soon began to
waver. In particular, David Hume, the Edinburgh-based philosopher of
the Enlightenment, began to express his anxieties about the authenticity of
Macpherson's work. In September 1763, he wrote to Professor Blair:

> I must own, for my own part, that though I have had many
> particular reasons to believe these poems genuine, more than it is
> possible for any Englishman of letters to have had, yet I am not
> entirely without my scruples on that head.

He recognised that it would prove deeply embarrassing for him and his
colleagues were *Fingal* to be proved a fake. He appealed for testimonies
to the authenticity to be provided from knowledgeable clergymen in the
Highlands and Islands. Blair promptly sent letters seeking opinions of
Macpherson's work throughout the north of Scotland. The responses
were published as an appendix to the 1765 collected edition of *The
Works of Ossian*; they were not unanimously in favour, although they
confirmed that the Ossianic poems were recognisably associated with
traditional tales in Highland folklore.

Welsh and Irish scholars were offended by the liberties Macpherson
had taken with their cultural heritage. They felt some admiration for
the poetry itself but attacked Macpherson bitterly for his pretensions
to academic scholarship and his presumptuous use of copious footnotes
and dissertations. They thought him both arrogant and ignorant.

In England, the Ossianic poems were welcomed as an inspiration; they were, indeed, a harbinger of the Romantic movement. But one formidable literary figure took an instant and ferocious dislike to them and roundly declared them to be totally bogus.

Enter Dr Johnson

The great literary figure who made no bones about his dislike for Macpherson and his Ossian was the writer, critic and lexicographer Dr Samuel Johnson. Johnson was convinced from the outset that Macpherson was a mountebank, a liar and a fraud:

> I look upon Macpherson's 'Fingal' to be as gross an imposition as ever the world was troubled with. Had it been really an ancient work, a true specimen of how men thought at that time, it would have been a curiosity of the first order. As a modern production, it is nothing . . . He has found names, and stories, and phrases – nay, passages in old songs, and with them has blended his own compositions; and so made what he gives to the world as the translation of an ancient poem.

With this ringing denunciation, Dr Johnson, the 'Great Cham' of English letters, sparked one of the fiercest literary controversies of the eighteenth century, accusing Macpherson of criminal forgery.

Dr Johnson was notoriously antipathetic towards the Scots and delighted in making provocative remarks about them (for example, his definition of 'oats' in his *Dictionary of the English Language* as 'A grain, which in England is generally given to horses, but in Scotland supports the people'). But his savaging of Macpherson was in no way a result of racial prejudice: Johnson was protecting his central principle of 'authenticity' in literature. He had set the parameters for authenticity, and anything outside these parameters was beyond the literary pale. He had a strong sense of 'improvement' and 'progress'; he believed that society and culture had their infancy and maturity, a maturity which

had come to its peak in the Augustan Golden Age of the eighteenth century.

Besides, Johnson was essentially a man of print. Throughout his professional writing career he had vehemently asserted the supremacy of the written word. He was against 'oral culture' and had no understanding of it. He was totally resistant to the idea of oral tradition, of poetry being handed down from generation to generation. He lived surrounded by books; he wrote for print publishers and a literate public. For Johnson, authenticity required physical evidence – material proof in the form of manuscripts, which Macpherson was unwilling, or unable, to produce.

Johnson's uncompromising denunciation of Macpherson came to a head when he went Ossian-hunting in Scotland in 1773 with James Boswell: an expedition recorded in Johnson's *A Journey to the Western Islands of Scotland*, published in 1775. (Boswell's account of the same journey – *The Journal of a Tour to the Hebrides* – was published in 1785, a year after Johnson's death.) In *A Journey*, Johnson was in his finest fulminating form:

> I suppose my opinion of the poems of Ossian is already discovered. I believe they never existed in any other form than that which we have seen. The editor, or author, never could shew the original; nor can it be shown by any other; to revenge reasonable incredulity, by refusing evidence, is a degree of insolence, with which the world is not yet acquainted; and stubborn audacity is the last refuge of guilt.

Johnson's comments enraged Macpherson. He was a Highlander who had been called a liar. His honour had been traduced; he was not going to take such an accusation impugning his honour lying down. He either had to issue a challenge or stay silent. He demanded a retraction from Dr Johnson, with a hint of 'or else'. Johnson replied with a letter (20 January 1775) which appeared in the newspapers of the day:

Mr. James Macpherson, – I received your foolish and impudent letter. Any violence offered me I shall do my best to repel and what I cannot do for myself, the law will do for me. I hope I shall not be deterred from detecting what I think a cheat by the menaces of a ruffian.

What would you have me retract? I thought your book an imposture; I think it an imposture still. For this opinion I have given my reasons to the publick, which I here dare you to refute. Your rage I defy. Your abilities, since your Homer, are not so formidable; and what I hear of your morals inclines me to pay regard not to what you shall say, but to what you shall prove. You may print this if you will.

Dr Johnson, by then 65 years old, liked nothing better than a quarrel or even a fist-fight. Boswell recorded with relish his purchase of a huge oaken club, 6 ft long and topped with a weighty head, which 'he kept in his bed-chamber, so near the chair in which he constantly sat, as to be within reach'; in his *Life of Johnson* (1791) Boswell noted that 'had he been attacked, I have no doubt that, old as he was, he would have made his corporal prowess be felt as much as his intellectual'.

Macpherson clearly thought better of his threat and backed off; there was no direct contact or correspondence between them thereafter. But the damage had been done: Johnson's bludgeoning condemnation of Ossian all but destroyed not only Macpherson's personal standing but any public validity in England which his Ossianic poems had been accorded.

Forgery – or not?

But how much fabrication had Macpherson been responsible for? After Macpherson's death, a special committee was established by the Highland Society of Scotland to investigate the nature and authenticity of the Ossianic poems, convened by Henry Mackenzie (1745–1831), the highly respected author of *The Man of Feeling* (1771). In its report

(*Report of the Committee of the Highland Society of Scotland, appointed to inquire into the Nature and Authenticity of the Poems of Ossian*, 1805) the committee concluded that Macpherson had based his work on the popular ballads of the Highlands, incorporating some traditional plots and passages of accurate translation, but that he had liberally added passages of his own to create his epics:

> [We are] inclined to believe that he was in use to supply chasms, and to give connection, by inserting passages which he did not find, and to add what he conceived to be dignity and delicacy to the original composition, by softening incidents, by refining the language . . . To what degree, however, he exercised these liberties it is impossible for the committee to determine.

Most modern scholars accept this view, that Macpherson drew on traditional oral sources to produce imaginative texts not modelled closely on any single identifiable original. His personal input expanded exponentially. Much of the original *Fragments* was based on genuine Gaelic lays – the characters, the turns of phrase, the basic story lines. *Fingal* also came from a genuine Gaelic tradition: there was a hero named Fingal, and there are separate lays which detail his life as a warrior. But the reader never knows when Macpherson is filling in gaps or restoring to their original purity poems which had been corrupted by oral transmission down the centuries. He called his work 'translation'; translation meant a rewriting for a new context, an imaginative recreation of what the past should have looked like. It was not just the literary purists like Dr Johnson who rejected this; the antiquarians, too, refused to accept that the Ossianic poems represented a genuine history of early Britain.

The historical framework for the Ossianic material had been heavily distorted. The historical roles of Scotland and Ireland were reversed, and viking incursions into Scotland in the ninth and tenth centuries were pushed back to the third century of Fingal and his son. This spurious framework was supported by a mass of antiquarian argument and

dissertation based on eighteenth-century pseudo-scholarship – all to demonstrate that an ancient Gaelic epic had been recovered and that Scotland was its locale. But such distortions can easily come about over centuries of oral transmission.

In the twentieth century, Macpherson and Ossian fell into oblivion: Dr Johnson's intemperate allegations of fraudulence had carried the day in most people's minds. But Ossian, once a household name in Britain, is by no means a dead issue any longer. In the last few years, there has been a revival of scholarly interest in Macpherson/Ossian and a great deal of sound research both at home and abroad. A Japanese translation appeared in 1971 and a Russian translation in 1983. A major Ossian exhibition was held in Paris in 1974. Fiona Stafford brought out her book *The Sublime Savage: James Macpherson and the Poems of Ossian* in 1988. A symposium was held in Oxford on the bicentenary of Macpherson's death in 1996. And a new and scholarly edition of *The Poems of Ossian* was published that same year – the first authoritative text available to the general reader for more than a century.

It is now clear that Macpherson was neither as honest as he claimed to be, nor as dishonest as others have claimed he was. Some of the manuscripts he collected can be reasonably identified, and many specific ballads are named, with their source (or variant sources). In *Fingal*, for instance, he used two main ballads (those of 'Garbh mac Stàirn' and of 'Mànus') for the main outlines of the plot and used another three ('Fingal's Visit to Norway', 'The Lay of the Maiden' and 'Ossian's Courtship') for specific episodes. To this groundwork of plot and episode he added a considerable superstructure. He filled out the plot with romantic episodes, emphasising the love interest and the fascination with wild nature. And he developed, from the classics, from Milton and the authorised version of the Bible, a highly distinctive and measured prose style as the medium for presenting the Gaelic material in English. His 'sin' was to have developed a third-century bardic author for the fragments he translated, edited and embellished, in order to fashion an epic which never existed as such – just as Elias Lönnrot was to do with the *Kalevala*

in Finland. Current judgement says that Macpherson's Ossian was by no means the work of a confidence trickster, bent on achieving fame and fortune through a clever hoax; nor was it what it purported to be – a literal translation of Gaelic poems which had survived unaltered since the third century. But words like 'forgery' or 'fake' are inappropriate when applied to James Macpherson of Badenoch; for him, it was fabrication in the sense of creation rather than forgery.

Sandy Stoddart has an apt neoclassical analogy: like some eighteenth-century archaeologist digging up a broken classical statue, Macpherson unearthed a long-buried broken torso of verse and repaired it, providing new limbs to replace the missing ones. Unfortunately, Macpherson didn't say that this was what he was doing.

We cannot be entirely certain of Macpherson's personal motives or intentions, but the most recent scholarship, after taking into account the literary, political and nationalistic circumstances of the time, gives Macpherson the benefit of any lingering doubt and gives Dr Johnson a slap on the wrist for being such an opinionated old Scots-baiting curmudgeon.

Macpherson's latter years

The publication of *Temora* in 1763 saw the effective end of Macpherson's poetic preoccupations, apart from the alterations he made to the collected editions of the Ossian poems in 1765 and 1773. The Ossianic poems had earned him a great deal of money. He moved south to London, where he had a town house and a villa in Putney, and lived a flamboyant life of conspicuous extravagance, lionised by society. Somehow he found time to produce some work: in 1771, he published *An Introduction to the History of Great Britain and Ireland* (which, not unexpectedly, had a strong Celtic bias), and in 1773 he produced a prose translation of Homer's *Iliad*. He courted and received favour from the Tory administration of the day, and early in 1774 he was appointed secretary to George Johnstone, governor of the Western Provinces in Florida. He spent some two years in North America and toured the West Indies. While he was abroad,

another couple of works were published: *Papers containing the Secret History of Great Britain* (1775), which is still of interest to historians, and *The History of Great Britain from the Restoration to the Accession of the House of Hanover* in the same year.

On his return to London in 1776, he retained his salary, which was converted into a pension for life on condition that he worked as a writer of anonymous journalistic articles, pamphlets and letters to rally support for the government.

From 1776 onwards, Macpherson began a new career, devoting himself to political activity and feathering his nest. In the late 1770s, he was appointed London agent for a fellow clansman who had become Governor General in India – John Macpherson, son of the minister of the parish of Sleat in Skye, whom he had visited in the early 1760s. On the side, he lobbied vigorously against the East India Company as the agent of an Indian prince named Mohammed Ali, the nabob of Arcot, who showed his gratitude with lavish gifts and purchased for Macpherson a parliamentary seat in 1780 – Macpherson became MP for Camelford in Cornwall and held the seat for the last 16 years of his life.

In 1785, Macpherson was considered of sufficient standing as a literary figure to be shortlisted for the post of Poet Laureate; the post eventually went to Samuel Johnson's friend, the poet Thomas Warton.

Towards the end of his life, his thoughts turned back to his native Badenoch. He purchased three estates to the north of Kingussie, and in 1790 he started building himself a Highland retreat, an elegant neo-classical Georgian mansion on an eminence overlooking the valley of the River Spey and the little farm of Invertromie where he had been born in 1736. The view from the front windows also encompassed the vast tract of wetland along the flood plain of the Spey which is now a Royal Society for the Protection of Birds reserve and has recently been designated a National Nature Reserve by Scottish Natural Heritage. The architects were the Adam brothers, Robert and James, the most fashionable architects of their day; the reputed cost was £4,000. Macpherson gave his country mansion the French name of 'Belleville'. It housed his portrait

painted by Joshua Reynolds and a handsome library; the lawns were enhanced by scores of trees, including a fine row of elms which had been planted in 1715 on the occasion of the first Jacobite Rising. Here the laird of Belleville (who was familiarly known as 'Ossian') entertained his friends with lavish hospitality, and he was highly regarded by his tenants and workforce for his generous treatment of them.

Macpherson would spend a few summer weeks at Belleville while it was still being built. In the autumn of 1795, however, he did not feel well enough to travel back to London. He died at the house on 17 February 1796. He wanted to be buried in Westminster Abbey; for the hazardous 18-day journey to London, his body was encased in a triple coffin: the inner one of Glenfeshie fir, the next of lead and the outer of mahogany. He was, indeed, buried in Poets' Corner, beside Ben Jonson and not far from his ferocious adversary, Samuel Johnson.

James Macpherson never married, but he had a keen eye for the ladies and enjoyed several liaisons which produced three sons and two daughters. In his will he left a sum of money to finance a memorial at Belleville – a marble obelisk bearing a now-worn medallion portrait of him. He also bequeathed £1,000 to promote the publication of the 'originals' of the Ossianic poems; this was effectively the sum which had been collected by a group of Highlanders in India and sent to Macpherson via the Highland Society of London in 1784. Macpherson had promised that he would arrange for the Ossianic 'originals' to be printed as soon as he had the time to do the work. After his death, the project was eventually brought to fruition by a group of friends in 1807 – an elaborate edition of *The Poems of Ossian* with a Gaelic text manufactured to correspond with the English version, complete with notes and essays.

Much of the Georgian mansion went up in flames on Christmas Eve 1903 but was rebuilt immediately afterwards. The name was also Gaelicised to 'Balavil House' in keeping with the Celtic romanticism of its founder; it is now run as a country-house hotel, owned by a collateral descendant, Alan Macpherson-Fletcher.

Envoi

In his hospitable dining room, Sandy Stoddart expatiates on his passion
for Ossian. On the solid sideboard sits the massive bronze head of Ossian
which Sandy made for the Royal Scottish Academy exhibition in 1996: 'In
memoriam James Macpherson'. Under a side table there is an early study
for a figure of the dead Oscar, son of Ossian – the 'Gaelic Achilles', the
greatest warrior of his age. This is the first germination of Sandy's vision
of an epic memorial to Ossian on a titanic scale: a National Ossianic
Monument, carved in living rock. Like Mt. Rushmore, it is designed to
last for ever – it will never be erased except by some passing glacier, two
miles thick, or when 'the rocks melt wi' the sun'; and like Mt. Rushmore,
it will prove a worldwide tourist attraction – most appropriate, when
you consider that Macpherson and Ossian were the first to open up the
western Highlands to tourists.

Stoddart's requirements are anything but modest. What he needs is
a sequestered mountain somewhere in the west of Scotland, preferably
Morven – and not just any old mountain: a mountain with six acres (or
more) of vertical solid granite suitable for mountain carving. Ten million
tons of stone would be removed to fashion a huge recumbent figure on
a ledge, 200 m long – the figure not of Ossian but of Ossian's constant
subject in his poetry, his dead son Oscar. And why Oscar? Sandy Stoddart
has thought it all through:

> It was the lament which Ossian sings for his son Oscar which
> brought the whole corpus of material rushing headlong upon
> Europe, which possessed Goethe and Napoleon and inspired
> Schubert and Mendelssohn. It is most important that we do not
> terminate the tradition of lamenting this hero by simply making
> a picture of the one who laments, but rather that we ourselves
> continue the perennial song.
>
> It is important, too, that the monument is described in the
> adjectival – the 'National Ossianic Monument' – because this
> indicates that Ossian is not just one thing but rather a whole

sensibility and well-spring of a particular culture. It is precisely
this power which turns so many against the phenomenon.

The whole project would take some 15 years and measureless amounts
of money – if it ever came off. Sandy Stoddart is in no doubt that there
would be furious opposition to such a scheme:

> It's hard enough to do any sort of monument to Ossian because
> of the controversy surrounding Macpherson's integrity and the
> dismissive attitudes still engendered by that. Also, in my own
> case, I am allying what is already a controversial subject with a
> controversial mode of representation. If I were to make a small
> bronze statue of Ossian for a corner of Kingussie, there would
> not be much of an uproar; some people would object to the
> subject, of course, but that would be that. But trust me to take
> the most controversial subject and propose to represent it in the
> most controversial idiom, which is mountain carving – then you
> get the band of raging mountain ecologists (mountain huggers,
> I call them) coming down on your head with death threats and
> so on.
>
> On the other hand, there are lots of people who think it a
> great idea. So what do you do? Do you give up at the first sign
> of opposition? Certainly not. This vision is too important, too
> epoch-making, to abandon without a fight.

If Sandy Stoddart's project ever comes to pass – in the depths of Morven,
perhaps – the ensuing controversy will make the Johnson v. Macpherson
showdown over Ossian's authenticity appear no more than a casual
spat.

349

4.3 – The Bogus Welsh Bard: Iolo Morganwg[13]

Opposite the town hall in the sedate Welsh town of Cowbridge, in the Vale of Glamorgan, the building at 14 High Street carries a Welsh-language plaque commemorating a mercurial Welsh stonemason and polymath named Edward Williams (1747–1826). Edward Williams is better known to posterity under his bardic pseudonym of Iolo Morganwg (originally Iorwerth [Edward] of Glamorgan but later shortened to 'Iolo'). At the foot of the inscription there is a resounding motto, *y Gwir yn erbyn y Byd* ('the Truth against the World'), written in a weird runic-looking alphabet which Iolo Morganwg himself invented. It was on this site that Iolo ran a grocery-cum-bookshop for a time in the 1790s.

Edward Williams was a remarkable and multi-faceted man – one of the wilder Welsh spirits of two centuries ago. He was a highly skilled stonemason, a poet, a musician, a (failed) businessman, a (failed) farmer, a historian, a radical, a passionate Welsh nationalist, a visionary, a theologian, a hymn-writer, and a forceful and opinionated critic. He was a man of immense erudition and astonishing versatility – a veritable walking encyclopaedia who described himself privately as 'a Rattleskull genius'. According to Professor Geraint H. Jenkins, director of the University of Wales's Centre for Advanced Welsh and Celtic Studies at Aberystwyth (see Appendix p. 395), 'He [Williams] delighted in the study of language, literature, poetry, folk songs and customs, hymnology, dialectology, architecture, agriculture, botany, geology, horticulture, politics, history, and much, much else besides.'

Apart from writing poetry of his own, Edward Williams – Iolo Morganwg – was a forger on a massive scale. He forged innumerable poems, many of them in the voice of the great fourteenth-century poet Dafydd ap Gwilym, the most distinguished literary figure of medieval Wales, a near-contemporary of Geoffrey Chaucer and forerunner of the 'Scottish Chaucerians' Robert Henryson and William Dunbar. Iolo also 'adjusted' masses of literary, historical, legal and genealogical sources.

Throughout his long and vehement life (he died at the age of 79, still in literary harness) he was, according to Professor Jenkins, one of Europe's most gifted and successful literary and historical forgers.

Iolo Morganwg's most enduring legacy is the theatrical pageantry of the bardic ceremony *Gorsedd y Beirdd*, which is now an integral part of the National Eisteddfod of Wales. Although the *Gorsedd* ritual was invented by his fertile imagination, he succeeded in passing it off as an authentic inheritance from Britain's Celtic past. This fabrication involved creating a systematic vision of the legacy of the medieval Welsh bards and Druids, which would become a nationalist manifesto for the revival of Welsh culture. In short, he invented a national past for Wales and changed Welsh culture forever. Iolo Morganwg, one might say, was the 'Man Who Reinvented Wales'.

I confess I had never heard of him until I attended the 'Fakes and Forgeries' conference at Durham University in July 2002. But the paper on Iolo Morganwg presented by Mary-Ann Constantine, of the Centre for Advanced Welsh and Celtic Studies, was outstanding and unforgettable.[14] In the long litany of counterfeiters and con-men (and con-women), of fakers and phoneys and forgers, he is, perhaps, the most fascinating faker of them all.

This man Iolo

It is no easy task to summarise the turbulent events of the long and colourful career of this scrawny, hyper-energetic little Welsh stonemason. In his time, he tried to become a farmer at Rhymney (between Cardiff and Newport) and a businessman in Cardiff – an attempt which ended in a debtors' jail in Cardiff in 1786. He ran a bookshop in Cowbridge. He journeyed all over Wales to collect material for a survey of Welsh agriculture. He haunted the libraries of North Wales in search of early prose and poetry. He lived for a time in London among the London Welsh. Although he never went to school, he became one of the best-read people in Wales. His admiring contemporaries loved his endless enthusiasm for the past and his learned discourse. He was regarded as an

erratic genius and was willingly forgiven his oddities and eccentricities, his unpredictable behaviour, his fierce and uncontrollable temper, his violent quarrels (even with his best friends). He was 'Mad Ned' to many – but it was a term of affection.

Edward Williams was born in 1747 in Penn-On, near Llancarfan in the Vale of Glamorgan.[15] He was the eldest child of a stonemason, also Edward Williams. Young Edward would always claim that his father belonged to the same family as Oliver Cromwell. Iolo's mother, Ann Matthews, was English-speaking, and everything we know about her comes from Iolo's writings. It seems that she was from one of the poorer branches of the great Glamorgan Matthews family, whose ancestral home was the now-ruined mansion of Trebererard, Boverton. As a young woman of no fortune, she had no alternative than to marry 'beneath' her. She claimed to be descended from the greatest of the bardic families of *Tir Iarll* (the 'chiefs of song') in the parish of Llangynwyd in the fifteenth and sixteenth centuries. Edward would boast that he was descended from these 'chiefs of song', the learned bards who had inherited the knowledge and traditions of the ancient Druids; as the last of their descendants, he would feel it his sacred duty to reveal the past glories of their nation to the Welsh people – with the help of some judicious forgery, where required, to fill in any gaps.

Iolo's childhood and youth were dominated by his mother, as he tells us in the preface to his collection of poems in English, *Poems, Lyric and Pastoral* (1794):

> My mother, whose maiden name was MATTHEWS, was the daughter of a gentleman who had wasted a pretty fortune: she had been well educated; she taught me to read in a volume of songs, intituled *The Vocal Miscellany*; for, I could not be prevailed upon to be taught from any other book. My mother sang agreeably, and I understood that she learned her songs from this book, which made me so very desirous of learning it. This I did in a short time, and hence, I doubt not, my original turn for poetry.

There is no truth in the old adage, *Poeta nascitur, nòn fit* ['A poet
is born, not made']; for, I will venture to say, that a Poetical and
every other Genius is *made* by some accident in early life, making
an indelible impression on the tender mind of infancy . . .

It was she who taught me to *write*, and the first five or six rules
of *arithmetic*, with something of *music*.

Iolo's parents soon moved to the nearby village of Flemingston, in the
Vale of Glamorgan, and Iolo spent most of his life in that locality.[16]
Neighbours there regarded his mother as proud, haughty and disdainful.
But she was a literate and sensitive woman who encouraged her children
to read. Edward was her favourite son, and she doted on him. He was
sickly, suffered severely from asthma and had to be educated at home; as
he wrote, 'I was so very unhealthy whilst a child (and I have continued
so) that it was thought useless to put me to school, where my three
brothers had been kept for many years.' In fact, he got a much better
education at home than his brothers who went to school; extant letters
from them, after they had emigrated to Jamaica, show that they were
barely literate. He learned the alphabet 'before I can well remember'
by watching his father inscribe tombstones; he claimed that he started
cutting letters professionally 'at the age of 9 or 10', and he soon became a
highly skilled stonemason in his own right. His mother's death in 1770,
when Edward was 23 years old, affected him deeply, but the image he
created of himself as a solitary child devoted only to his mother has been
shown to be seriously misleading.

Although he had no official schooling, he read voraciously in both
English and Welsh. As he grew up, he received an excellent informal
education in Welsh poetry and literature from local clergymen, scholars
and poets, such as the Revd John Walters, rector of Llandough, near
Cowbridge (1762–72), who published a monumental English–Welsh
dictionary in 1794.

So how did his career of forgery begin?

According to Mary-Ann Constantine, Iolo's first forgeries were lexical and grew out of his involvement with the work of local scholars and grammarians: the creation of new words in Welsh to correspond to new concepts was common practice. Iolo collected and invented words – neologisms, archaisms, dialect forms – with real flair throughout his life; he had an excellent ear for dialect and compiled lists of words he heard on his travels in (as he claimed) 'every parish of Wales'.

During the 1770s, he enjoyed the company of local bards and developed his own poetic talent; he travelled to North Wales and began copying manuscripts from private libraries of the aristocracy. This was the only way of getting access to the Welsh literary inheritance at the time. Publications of early texts had just begun in the 1760s and were very patchy; the scattered and chaotic state of the manuscripts made it relatively easy for Iolo to claim later that he had seen and copied a crucial version of a text which had, unfortunately, now vanished. He visited the 'druidic monuments' in Môn (Anglesey) and was less than impressed, but he saw the potential for a re-reading of his own Glamorgan landscape and a takeover of the Bardic crown for his beloved county. He used to walk everywhere – from Flemingston to London, to Bristol, to Bath, to Kent, to Anglesey – covering miles and miles every day, reading all the way and noting down what he saw and heard as he went. His feet at the end of a full day's walking were often agonisingly raw. It was during these walking marathons that he started to write as an English poet, composing many of the pastoral pieces which would make up much of his published collection *Poems, Lyric and Pastoral.*

To make ends meet, Edward would walk to London to work as a stonemason on various projects, dressing stone on London's Blackfriars Bridge, for instance. He was an excellent stonecutter – the crown atop St John's Church in Cardiff is his work, crafted when he was working on its renovation. After working for a time in London and Kent, Iolo was back in his native Morganwg (Glamorgan) by 1777. He was now 30 years old. Here he began developing a more coherent vision of his

county's (and his country's) past: he fathered forged medieval Welsh poems on obscure or unknown poets, often using names picked up from manuscripts seen in remote libraries in the north. From 1780, he began to develop complex bardic genealogies, often culminating with himself as the inheritor of a bardic tradition. Indeed, 'bardism' was becoming more and more fashionable, ever since the poet Thomas Gray (1716–71) had published his Pindaric ode on *The Bard* in 1757.

In 1781, Iolo married Margaret (Peggy) Roberts, a farmer's daughter. The marriage took place in the Church of St Mary the Virgin, Llanfair, in the parish of Cowbridge, and was conducted by his friend the Revd John Walters, rector of Llandough. Iolo and Peggy had four children: a boy and three girls. Peggy brought to the marriage a small farm at Rhymney, just outside Cardiff, which she inherited from her father.[17] In 1783, Iolo took up farming at Rhymney but failed to make a success of it because he was incapable of handling money – then and throughout his life. As the farming failed, he became involved in a ship-owning venture. He bought a small trading-ship boat, a sloop called *The Lion*, running between Bristol and South Wales. Bristol was the main port in the area – much bigger than Cardiff at that time. The sloop was based at Aberthaw, which was a thriving port in those days, but it ended up 'at the bottom of the sea'.

The creditors, who were for the most part local traders, began to gang up against him; one of these creditors was his father (although extant letters show that relations between father and son were amicable). Over the next few years, Iolo and his family lived in various locations (a euphemism for constant moonlight flittings) to keep their creditors at bay. In 1785, when he and his wife and children were 'in hiding' in Somerset, the long arm of the law reached them; Edward was taken to Cardiff, and in August 1786 he was sent to prison. At that time, being in jail for debt was pretty common – it was not considered particularly shameful. Many literary figures in the eighteenth century endured this fate (Thomas de Quincey, for instance, spent most of his life running away from his creditors). The captivity was not particularly arduous: as

long as the prisoners bribed the jailer and the turnkey, and kept them happy, they were more or less free to come and go as they pleased. Iolo had ample access to books and taught himself to play the flute (he fashioned his own instrument in prison). But Iolo, with his love of the outdoors and walking, could not have been happy with his incarceration; he certainly became more peevish and paranoid about everything and everyone, convinced that the world was against him.

In August 1787, Iolo petitioned the authorities for his release; it seems that his wife Peggy, who had frequently stayed with him in the prison and was pregnant, had somehow managed to pay off his debts. Iolo thereupon returned to his trade as a stonemason.

But there were other problems. Iolo's health had always been a concern. His mother had dosed him with homemade concoctions throughout his childhood, and he had to be very careful about what he ate and drank. He drank gallons of marshmallow and camomile tea, and he prepared himself potions which included elderflower, peppermint and wormwood. He seldom drank alcohol or ate meat. But he was not just a health freak or a hypochondriac: since childhood he had, perforce, been acutely conscious of his health, and in later life he would describe his symptoms in scientific detail. On his release from prison, however, he was becoming an addict of laudanum. He had first started taking it in 1773 at the age of 26 'to relieve a very troublesome cough' and continued to take it, 'often in large doses, to blunt the tooth of Pain', until his death. He was convinced that laudanum was keeping him alive; indeed, the first poem in his *Poems, Lyric and Pastoral* was in praise of 'Laudanum':

> Thou faithful friend in all my grief
> In thy soft arms I find relief;
> In thee forget my woes.

Laudanum was what one might call the aspirin or even designer drug of the eighteenth century, universally used both as an over-the-counter remedy for all manner of ailments and as a narcotic; it could be freely

bought in pill, powder or liquid form. It could have a dramatic effect on imaginative minds but could all too easily become a crippling addiction: famously, Samuel Taylor Coleridge and Thomas de Quincey both became victims of it, not to mention William Wilberforce and King George IV.

Laudanum stimulated Iolo's mind to a strange world of fantasy and deception. It eroded his critical faculties and encouraged him to mix fact with fiction. It also stopped him from finishing many of his grandiose projects: for instance, the 'perfect history of Wales' which he aspired to write never got further than a curiosity shop of makeshift drafts, chaotic essays, and bits and pieces of literary flotsam.

By the late 1780s, his antiquarian interest in the history of the ancient British Druids and his passionate local interest in bardic families were converging. At the time, it was generally accepted that the Druids were likely to have been the ancestors of the Welsh bards, but Iolo set out to show that some areas (especially Glamorgan) had preserved the ancient traditions better than others. The idea of North Wales as the jewel in the literary crown, the bastion of poetic tradition, came under attack as Iolo began to outline rival claims for this inheritance in the south; many of the necessary proofs, to be sure, were forgeries involving some subtle tweaking of the sources, but no matter. Indeed, he completely rewrote the history of his native county through a golden haze – for instance, he wrote a tale about Dafydd ap Gwilym, the fourteenth-century Welsh poet, having been born in Glamorgan. According to the tale, Dafydd's mother travelled into Glamorgan when she was heavily pregnant and gave birth to him during a storm. It was pure invention.

He also invented dozens of new saints and poets, and composed many chronicles and hundreds of notes, which provided a wealth of new 'information' about Glamorgan. He changed the names of villages and parishes (even his own parish), and wrote tales of all kinds concerning places in the Uplands and in the Vale. No other county in Wales was transformed in this way. Iolo's Glamorgan has been called 'one of the great creations of the eighteenth century in Wales'.

Various aspects of Iolo's 'Druidic Myth' were crystallising at this point, and his ideas began to spread beyond Wales. He became more closely involved with the London Welsh: he helped with an edition of Dafydd ap Gwilym's poems (published in 1789), infiltrating into the canon a dozen of his own forgeries. These poems are among his most impressive pieces of forgery and deceived scholars for 150 years.

The London years, 1791–95

In 1791, Iolo Morganwg headed for London, abandoning his wife Peggy and his children for four long years. It has to be said that he treated his loyal, long-suffering wife abominably while he was in London. He was totally self-centred and ignored all her pleas for him to forsake his extravagant and wilful ambitions and come home. Iolo was to claim that the muse of poetry left him when he married.

When Iolo went to London in 1791, it was not as an itinerant stonemason but in a quest for fame and fortune. He walked to London from Flemingston (a distance of 245 miles) with blistered feet, making detours all the time; he refused to travel by coach, because he did not think it fair on the horses. He went to London, which was the surrogate capital of Wales at the time, because the Welsh cultural establishment was there; London was the place to go if you were a young Welshman with aspirations to get on in the English-speaking world. He wanted to make a name as an English-language poet. But he also claimed that he went to London 'to ascertain the truth' of the 'Madoc theory' – the fable about Prince Madoc of Powys, who was supposed to have discovered America in the twelfth century.

It seems that what Iolo really wanted to do was to emigrate to America, the 'Land of Liberty', which he saw as an asylum for democrats in the 'Age of Terror' initiated by William Pitt. In an essay entitled 'America. By an Ancient British Bard' he praised the libertarianism of America: 'I have from the beginning been an enthusiastic admirer of your glorious and successful struggle for *Liberty*, your Republican Principles, your excellent Constitutions of Government.'

His initial motive, it seems, was to join in the quest for the 'Madogwys', the alleged Welsh-speaking Native American tribe of White Padoucas 'hid in the deepest recesses of the American Wilds'. The story, based on the Madoc legend, had first been given printed currency in 1583 (in *A True Reporte* by Sir George Peckham). This document was used to support Queen Elizabeth's claim to the New World, and in the 1790s the same story was used to bolster British claims against the French and Spanish. Iolo immersed himself in American history and geography, and in order to justify a trip to America, he busied himself with forging 'reliable accounts' of the existence of 'an Indian nation . . . speaking the Welsh language'. He embarked on a fiendishly taxing fitness programme to prepare himself for the arduous trip, which included a regime of running around in the rain and sleeping in the open, and he published a sonnet, 'To Hope: On Resolving to Emigrate to America'. But nothing came of his plans and dreams (although he never totally abandoned them – he wrote his own death notice in advance, saying that he had died in America!). Perhaps ill health made it impossible, or perhaps it was simply a vision too far for him. Whatever the reason, it was the kind of 'extravagant and wilful ambition' which his wife had begged him to give up.

One of the major Welsh societies in London at the time was the *Gwyneddigion* (Men of Gwynedd), which had been formed in 1770. It was lively and radical, and many of its members responded ardently to the War of American Independence and the French Revolution, revering the name of the radical political writer Thomas Paine (1737–1809), author of *The Rights of Man* (1791–92). Iolo joined in their meetings in London and took part in their bardic jousts and smoking contests (two poets would come together for a contest to see who could create the greatest amount of smoke from their pipes). He would sing the national anthem loudly but with different words – 'God Save Great Thomas Paine'.

This was the most significant period of his life, a crucial turning point. But he was in poor shape by that stage, doubtless dragged down

by his dependence on laudanum. Moreover, he was haunted by the ghost of 'poor Chatterton' (see Chapter 4.1), with whom he could all too easily identify: like Iolo, the celebrated young literary forger Thomas Chatterton had been a provincial poet trying to make the big time in London. He had been found dead in a garret in Brooke Street, not far from Brooke's Market, where Iolo was now living in miserable lodgings. It was a thought to encourage melancholy and morbidity, and Iolo's letters to his long-suffering wife tell how much he loathed the dirt and squalor of his surroundings in London. One of his hallucinations was that all his children were dead. Peggy wrote to say that they were all right – but then came the shattering news of the death of his favourite daughter, Lilla. He came very close to suicide:

> I have but one hope left now, which is that I shall soon die, for it is impossible for me to be relieved in any other way. Send me one letter more, and let me see in it the names of my dear little ones, I shall never see their faces again. Poor Chatterton who lived and died almost the next door to where I am, found means, like myself, to keep his distresses unknown.

Iolo's gorsedd

On 21 June 1792, Iolo Morganwg staked his claim for a place in Welsh history. In the company of a handful of Welsh compatriots, he marched up Primrose Hill in North London. Primrose Hill is an area of public parkland just above its larger and more famous neighbour, Regent's Park. In summer, its gentle slopes are dotted with picnicking families and dog walkers, and its 'summit' provides an excellent panoramic view over the cityscape of central London. In the heart of the busy, bustling city, it is an unexpected oasis of calm and quiet.

Iolo was, in his own words, a self-taught journeyman marble-mason ('never seen in liquor') who, at about the age of 20, 'was admitted a Bard in the ancient manner – a custom still retained in Glamorgan but, I believe, in no other part of Wales'. On Primrose Hill that day, he

convened a druidic moot 'in the eye of the sun and in the face of the light' and proclaimed a 'Gorsedd of Bards of the Island of Britain', using a theatrical synthesis of pageantry, history and fantasy which he claimed he had discovered in ancient manuscripts. In fact, he had invented it all himself.

As a preliminary, he laid out a circle of pebbles on the grass to represent the ancient standing stone circles, such as those at Stonehenge, which eighteenth-century antiquarians regarded as druidic temples where the Chief Druid, the 'priest of Nature', would officiate. Within this makeshift, portable stone circle, Iolo and a group of London Welsh compatriots performed his gorsedd ceremony for the first time, in both Welsh and English. The rite included 'The Gorsedd Prayer' ('The Prayer of the Gwyddoniaid') which he had composed:

> God, impart Thy strength;
> And in strength, power to suffer;
> And in the truth, all light;
> And in light, all *gwynvyd* [blessed well-being];
> And in *gwynvyd*, love;
> And in love, God;
> And in God, all goodness.
> And thus it ends.[18]

So what was it all about? The word gorsedd (literally, 'mound') is used in the Welsh laws for an open-air 'court' or 'tribunal'; Iolo hijacked the word and applied it to a gathering of bards. In the druidic tradition, the role of the bard was to mediate spirit through the word – whether spoken, chanted, sung or written on the printed page – and through music and other creative arts, such as painting, dance or sculpture. In Iolo's mind, the Druids had become idealised as apostles of freedom, wedded to sacred principles of justice, peace and benevolence, symbols of a long-lost Welsh 'Golden Age' of humanity which still survived in Glamorgan.

But the gorsedd was almost entirely invented by Iolo Morganwg, according to Cathryn Charnell-White, another member of the Centre for Advanced Welsh and Celtic Studies:

> Iolo was a terrific magpie; he read anything and everything. And his Gorsedd/druidic vision was a jigsaw puzzle of a host of elements he got from received fashionable eighteenth-century learning about Druids, and added elements of his own major interests, such as Unitarianism, pacifism, political radicalism, orientalism and the bardic tradition in Wales. So what Iolo did was to clip bits and pieces from the received learning and then, having immersed himself in genuine Welsh medieval manuscripts he filled the gaps with modern aspects such as ideals of liberty, justice and peace, and the popularisation of democratic ideals: elections, majority rule, and so on.
>
> He forged a lot of documents pertaining to the correct ritual ceremonies and the regulations of the bards – what to wear and what colour, how often they were to meet and where. These included *Llyfr y Barddas* and *Llafar Gorsedd Beirdd Ynys Prydain*. He also forged triads, *coelbren* (an alphabet), characters and mythology. It was a construct made up from the various elements; he could take something both from Caesar and from the Welsh medieval manuscripts. He had systematised it all before Primrose Hill. He was fulfilling a need to legitimise the Welsh past.

It all sounds very harmless today, but in the fevered atmosphere of the early 1790s it sounded anything but. It was a flamboyant gesture of radicalism, or anti-patriotism, which brought Iolo to the attention of the authorities as a suspected Jacobin sympathiser. This was the turbulent and politically volatile period succeeding the American and French revolutions: like many of the London Welsh in the 1790s, Iolo was an ardent supporter of Tom Paine and a pacifist. It is possible to read a 'Jacobin' agenda in much of Iolo's esoteric druidic system, and the

authorities were highly suspicious of the gorsedd he held on Primrose Hill in 1792; the threat of government action against radicals was a very real one, and various friends and acquaintances were harassed or imprisoned. Iolo would claim that his papers were seized, and he was hauled before the Privy Council, chaired by Pitt. But he had already taken the precaution of sending most of his papers back home to Wales, and he was cleared for lack of evidence of subversive material.

However, there was another setback to follow. Iolo had been desperate to publish his English poems, which he had been composing for many years in the mode of eighteenth-century Augustan poets such as Alexander Pope, William Shenstone and William Cowper. Before going to London, he had spent much of 1791 gathering subscriptions for his collection on subjects 'lyric and pastoral', courting the patronage of the rich and the literati of Bristol and Bath. The only way to publish in those days was to pay the printers by means of advance subscriptions. Iolo was under severe pressure in London; he was redrafting his poems in a more radical vein, but he was on the edge of a nervous breakdown and could barely write. Somehow he got permission to dedicate the book to the Prince of Wales, but privately he thought of all kings as warmongers. He was in a terrible quandary and wrote endless drafts of the dedication: he had to sell himself as a humble peasant poet (like Scotland's Robert Burns), but he had strong views on liberty and kingship. In the event, he managed to produce a subscription list of 366 names, consisting mainly of bishops and middle-class ladies from Bristol and Bath but no doubt 'salted' for effect with names like Thomas Paine, William Wilberforce and George Washington.

The book, *Poems, Lyric and Pastoral*, was eventually published in 1794 under his birth name of Edward Williams. It got reasonable reviews, and the book covered its costs, but all the critics thought his preface to be quite extraordinary – rambling, incoherent and peevish, crammed with antiquarian and bardic lore.

Back in Wales

In 1795, Iolo turned his back on London and returned to Wales for good. He may well have been unnerved by the political dangers which faced him in London and disappointed by his failure to make money from his book, but he was also homesick and in wretched health.

Back in Wales, he opened a grocery shop in Cowbridge in which he also sold books. Here he practised his own version of 'Fair Trade', selling East India produce 'uncontaminated by human gore' – he was passionately opposed to the slave trade and refused to sell anything produced by slave labour. His three elder brothers, stonemasons like himself, who had emigrated to Jamaica and become prosperous slave-owners, offered to help Iolo and his family financially, but he refused to accept what he called 'tainted' money.

Iolo's Cowbridge retailing venture failed after a few months, like so many of his business projects. He fell back on his trade as a stonemason, but he continued to write with unabated energy. It was at this point that another facet of this chameleon character showed itself – Iolo the agricultural improver. Dr David Ceri Jones, another member of the Centre for Advanced Welsh and Celtic Studies, who is researching the 1,300 letters to and from Iolo in the National Library of Wales, has made a particular study of this aspect of Iolo's life.[19] He told me that Iolo made some agricultural experiments on the farm at Rhymney. Although the farming venture failed after a year, Iolo had read widely and had been successful in growing two types of American maize. His writings on the subject are full of serious scientific observations on soil-types and minerals, on breeding new strains of livestock and on rotating crops. He was well ahead of his time, according to David Ceri Jones:

> The Board of Agriculture was set up in 1793, with Sir John
> Sinclair (1754–1835) of Thurso as its first president, with a view
> to improving agricultural production in England and Wales;
> Sinclair had supervised the compilation of the first *Statistical
> Account of Scotland* (1791–99), comprising a description of

every parish in Scotland. The plan was to commission reports on every county in England and Wales. Iolo got wind of it in 1796 and tried to get the commission for writing the report on South Wales, while the Revd Walter Davies applied for North Wales. Iolo listed among his credentials the trials he had carried out on his own farm, and portrayed himself to the board as a highly successful experimental farmer and an expert on agricultural practices.

Iolo's application was turned down in March 1797, however, because of his intemperately expressed radical political opinions: 'I perceive it is difficult for you to get thro' a Sheet of writing, without aiming a Shaft at Tyrants and Priests'.

Instead, Walter Davies was given the commission for South Wales as well. But because Iolo had already done so much work on the agriculture of Glamorgan, and had been on tours of inspection, Davies employed Iolo – sub-contracted him, in effect. A lot of what appeared in Davies' eventual report on South Wales was Iolo's (unacknowledged) work.

The Vale of Glamorgan, the most fertile farmland in the area, was Iolo's focus, to the detriment of the rest of Glamorgan. His hidden agenda, as always, was to promote Glamorgan at the expense of the rest of Wales.

Iolo Morganwyg went on writing and writing. He was immersed in preparing for the publication of the three-volume *Myvyrian Archaiology*, the great collection of early Welsh poetry and prose edited by William Owen Pughe and Owain Myfyr, with whom he collaborated. Iolo infiltrated many of his own fabrications into this work – particularly in volume three – including the numerous 'Welsh Triads' he passed off as originals.[20] Triads were a genuine Welsh literary genre. Iolo discovered that many of them had been composed so that pupils could memorise the teachings of the bardic schools, and he supplemented them liberally in order to promulgate his own vision of a druidic Golden Age. He

composed thousands of them – splendidly quotable adages embodying the so-called druidic teaching; he wrote Triads on the art of poetry, on bardism, on theology, on wisdom, on law, on nature, on practically everything under the sun.

Throughout this period, ironically, Iolo was always ready to castigate with his pen the work of other 'forgers', such as James Macpherson of Ossianic fame in Scotland and Thomas Chatterton, and was obsessed with notions of authenticity and truth in what he disarmingly called 'the present age of forgery'.

But he did not abandon his vision of the gorsedd he had invented. He held another gorsedd on Stalling Down near Cowbridge, the site of a battle won by Owain Glyndwr against King Henry IV in the fifteenth century; here his activities were closely watched by the local militia volunteers. He held a third one at the Rocking Stone on Pontypridd Common – a place surely tailor-made for such rituals. All these he repeated twice a year.

A few years later, in 1819, Iolo made his most determined effort to make the gorsedd an integral part of the formal Eisteddfod. The occasion was a musical festival held at the Ivy Bush Hotel in Carmarthen. Ironically, it was through an Anglican connection. The bishop of St Davids at the time was Thomas Burgess. He had been bishop for an unusually long time – 23 years. He became fascinated by the Welsh cultural past, and he appointed parsons who shared his curiosity. Burgess also tried to revive interest in the Anglican church by making it more congenial to the Welsh people. These parsons convinced Burgess that he needed to establish a society which would help to do this, so he set up the Cambrian Society and was persuaded to engage the venerable Iolo as an expert to advise on the Eisteddfod.

Iolo tramped all the way from Flemingston to Carmarthen in October 1818. He stayed overnight in the Bishop's Palace and was given free access to the library; that night, the servants saw him pacing up and down in the hall with a nightcap on his head and a candle in one hand and a book in the other, reading by candlelight.

The bishop had gathered a large group of Welsh squires and literary parsons for a meeting. They were all Anglicans. The only Dissenter was Iolo, who was a Unitarian – Bishop Burgess hated the Unitarians and had written against them in his tracts! He probably thought that Iolo had mellowed a bit and was fairly innocuous by then – but Iolo hijacked the agenda. He virtually said that they had to set up gorsedds at the Eisteddfods, they had to pay for him to come to Carmarthen so that he could act as a tutor to young poets and scholars, and they had to pay to have all the Welsh manuscripts in the British Museum published. This was his blueprint for reviving Welsh culture – and the meeting agreed. Next year, they would come back to Carmarthen in July and hold a three-day fest in Burgess's name which would be the first provincial Eisteddfod.

So Iolo went back to Carmarthen in July 1819. In the meantime, he had been adjudicating the bardic entries, being particularly scathing about the entries from North Wales. He proceeded to take over the three-day event at the Ivy Bush Hotel by sleight of hand. There were 300 people at the Eisteddfod; they had all paid to be there and all were Anglican bigwigs from south-west Wales. At the dinner on the first evening, Iolo made a passionate speech about the Welsh cultural tradition, about the cloud which had been hanging over Wales since early times and about the resurrection of the Welsh cultural past. There was prolonged and thunderous applause. Iolo appointed his friend Walter Davies 'poet laureate' of the Eisteddfod. He then went up to Burgess, taking him unawares, and pinned the white ribbon on him, thereby coopting the Anglican bishop into his quasi-radical, subversive gorsedd circle.

On the Saturday – the final day – Iolo once again laid out his portable circle of pebbles on the grass and performed his gorsedd ceremony in the garden of the Ivy Bush Hotel (he claimed that a gorsedd had been held in Carmarthen in 1450). On the first day, they had held the bardic proceedings, and on the second day, harpists had played, in order to keep the non-Welsh speakers happy. Burgess was very unhappy about the gorsedd to be held on the third day; and when he watched the preliminary

rites which Iolo was introducing – about pacifism, radicalism, equality, liberty, freedom and so on – Burgess went to him and ordered him to stop it at once. Iolo refused.[21]

After the proceedings, Burgess wrote to one of his Anglican friends to say how much he deplored what had gone on at the Ivy Bush on the Saturday morning and how angry he was about it. He ordered Walter Davies, who was to be in charge of the provincial Eisteddfod at Wrexham the following year (1820), not to hold a gorsedd ceremony – and none was held. However, by 1821 the gorsedd was back in South Wales.

These provincial Eisteddfods later developed into the Welsh National Eisteddfod in the late 1850s. The gorsedd was now an integral part of the Eisteddfod, performed within specially constructed stone circles, during which members of the Welsh gorsedd wear robes of blue for bards, green for ovates and white for Druids.[22]

The significance of this for Wales can hardly be overstated. This bogus piece of amateur theatricals caught on and is now accepted by the Welsh and everyone else as a serious literary festival with light-hearted sideshows. However false its origins (like the Up Helly Aa 'Viking' festival in Shetland), it has helped to shape the basis of Welsh culture and identity, and inspired a new revival in Welsh cultural activity.

The latter years: 1805–26

In his 50s, Iolo became more and more intolerant, and even paranoid. In 1805–06, he had a definitive row with Owain Myfyr (who, one way or another, had been helping him financially for years). He refused various offers of patronage designed to help him to complete some of his great, unfinished projects (*A History of the Bards*, for one). His radicalism became increasingly channelled into Unitarianism, the fundamental tenets of which were inscribed in the druidic system. Unitarianism, as an unofficial religion, was banned in Wales at this time (and remained so until 1813); yet, in 1802, Iolo defiantly founded the South Wales Unitarian Society. The purpose of the society at the time was to promote the cause of free religious thinking in Wales and to defend free religion

against persecution from the orthodox religious denominations. Iolo's dream was to found a society which was open to everybody who wanted to search for religious truth unhindered by dogma or creed. The original rules of the society, formulated by Iolo, state, 'Any stranger expressing a wish to speak may be admitted . . . No one is to be admitted or rejected for any religious opinion they may entertain, it being believed that truth ultimately will prevail.' He also composed hundreds of Unitarian hymns.

As an old man, he recounted his life to the Englishman Elijah Waring (1788–1857), a native of Hampshire who settled in Neath in South Wales and who wrote reports about working conditions in collieries; the resulting memoir (*Recollections and Anecdotes of Edward Williams the Bard of Glamorgan*, 1850), set the tone for all writing about Iolo for the next hundred years. It was a colourful, credulous piece of biography (hagiography, more like), full of wonderful (and often unverifiable) anecdotes which established Iolo as one of the great characters of Welsh literary tradition, as well as being an expert scholar and authority on that tradition – with, moreover, a reputation for 'rugged honesty'! Medievalists and others are still trying to untangle the legacy of his invented past.

Envoi

> 'When the legend becomes fact, print the legend.'
>
> (*The Man Who Shot Liberty Valance*, 1962,
> screenplay by James Warner Bellah and Willis Goldbeck)

In his latter years, Iolo Morganwg moved into the little cottage in Flemingston where he had been brought up ('Ambleside', see above); and there, in December 1826, he died quietly in his chair. For the last 20 years of his life he had been unable to lie in a bed because of asthma. He was writing feverishly to the end, day after day, night after night, almost illegible notes on the old druidic learning and fragments of poetry. He had never discarded a single scrap of paper on which he had ever scribbled, and when he died he was almost buried under a chaotic,

overflowing mass of a long lifetime of diligent, tireless composition.

He was buried somewhere in the churchyard of St Michael and All Angels Church at Flemingston; Iolo had asked for his grave to be unmarked, but it is believed that he was buried just outside the west end of the church. This area was later covered by an extension of the building. In 1855, an elaborate memorial wall-tablet was erected to his memory here, in the belief that 'his Remains are deposited near this spot'.

His obituary, in English and Welsh, is inscribed at length on the tablet:

> HIS MIND was stored with the histories and traditions of Wales. He studied Nature, too, in all her works. His mortal part was weak, and rendered him little able to ply his trade; but God endowed him with mental faculties – patience of research and vigour of intellect – which were not clouded by his humble occupation. He was never at school, yet he became a large contributor, of acknowledged authority, to bardic and historic literature. His simple manners, cheerful habits, and varied knowledge, made him a welcome visitor within the mansions of the rich as well as the cottages of the poor, and many there are in Gwent and Morganwg, who still have kindly recollections of him; by these, and others, who appreciate the fruits of his genius this Tablet was erected, Anno Domini 1855.
>
> He feared God, and walked meekly and uprightly with his fellow men.

Below this obituary is a similar eulogy for his devoted first-born son Taliesin Williams (Taliesin ap Iolo, 1787–1847). Taliesin, who had been named by his father after the (possibly mythical) sixth-century bardic poet Taliesin, became the custodian of Iolo's literary legacy as the curator of the thousands of papers his father had left in his cottage in Flemingston. He was a key figure in his own right in the Welsh linguistic and cultural revival of the early 1800s. Like most men of his day, he

inherited his father's trade and, in his early years, worked alongside his father as a stonemason and gravestone carver. He also inherited his father's intellectualism and Welsh patriotism, and soon left the stoneyard to become a schoolteacher at Cowbridge. In 1816, he opened his own school in the new industrial town of Merthyr Tydfil, which he maintained until his death in 1847.

Taliesin's enthusiasm for his father's work was deep and enduring. As his own reputation as a poet and scholar grew, he assisted his ageing father in the compilation of one of his last works, a book on the bardic system, *Cyfrinach Beirdd Ynys Prydain* (*Secrets of the Bards of the Island of Britain*), which was eventually published posthumously in 1829. In 1848, an edited selection of his father's papers was published posthumously as *The Iolo Manuscripts*, which unwittingly perpetuated some of the forgeries. It seems that Iolo had never confessed his forgeries to his son, and, to his dying day, Taliesin continued to argue for the genuineness of his father's work.

From 1872, however, a generation of home-grown Welsh academics at the newly founded University of Wales began to discern significant discrepancies between Iolo's gorsedd ideas and the surviving traditions from the past. Their intensive research persuaded them that Iolo Morganwg had fabricated the past, wholesale.

As a result, many people regarded Iolo Morganwg as nothing but a crafty con-man. But now the pendulum is swinging the other way. The scholars at the Centre for Advanced Welsh and Celtic Studies at Aberystwyth are trying to restore Iolo's reputation as a major scholar in his own right; they are giving context to his work and bringing out the multifaceted nature of his achievements, as a historian, a poet, a geologist, an agricultural improver, a folklorist, a musician who composed hundreds of Unitarian hymns – and, most significantly, perhaps, as a Welsh patriot. They see Iolo as a dedicated and learned patriot who was convinced that a glorious past – even an invented one – could provide a solid foundation on which to build a national future, and who wanted to restore to the Welsh people an artistic and cultural tradition which he

was convinced existed. Was it conscious deception or subconscious self-deception? Iolo Morganwg realised that history is not simply about the past – it is also about the present and the future. Iolo Morganwg's vision changed Welsh culture for ever, and his legacy is still to be reckoned with.

Amid all the scholarly confusion caused by Iolo Morganwg's long lifetime of compulsive forgery, the most enduring of his inventions was his 'retrieval', as he would have called it, of the traditions of bardism and bardic learning through his gorsedd. For Iolo, it became an obsession which he pursued, and which pursued him, right to the end. He believed that he was the continuator and mediator of the Welsh druidic/bardic tradition which embodied, as well as the art of poetry, the finest traditions of pure theology, genuine morality, 'rational principles of government' and 'the search after truth and universal peace'. This, to Iolo, was how to create a new Golden Age on earth; and the Old Welsh Triads he invented were mnemonics to show the way.

Above all, Iolo Morganwg, the bogus Welsh bard, was a messianic forger of dreams.

4.4 – The Boy Who Rewrote Shakespeare: William-Henry Ireland

Imagine, if you would, the scene at the Theatre Royal, Drury Lane, in London on the evening of 2 April 1796. The theatre had been booked solid. Would-be theatre-goers had scrambled desperately for any vacant seats. A newly found play, allegedly by Shakespeare, was to be premiered: *Vortigern and Rowena*, the love story of Vortigern, a king in Britain, and Rowena, daughter of Hengist, one of the leaders (with Horsa) of an invasion of Britain in AD 450. A star-studded cast waited in the wings. The role of Vortigern was played by John Philip Kemble (1757–1823), the renowned Shakespearian actor and brother of the actress Sarah Siddons, who was to have taken the role of Rowena before her last-minute withdrawal; the role of Vortigern's daughter, Flavia, was played by the Irish actress Dorothy Jordan, mistress of the Duke of Clarence (the future King William IV) and mother of ten of his children. It was to be the theatrical event of the year, of the decade, of the century even. In the event, it was a ludicrous fiasco. 'Shakespeare's lost play' was, in fact, the work of a young literary forger named William-Henry Ireland.

Early years

William-Henry Ireland (1775–1835) was born in London. His father, Samuel Ireland, the nephew of a bricklayer, had tried to start a business as a weaver in Spital Fields, but the enterprise had failed; he had the reputation of being a bit shady – not entirely to be trusted. He then turned to art and achieved a modicum of success as an aquatint engraver and publisher; he received a medal from the Royal Academy in 1760 for his skill in drawing and engraving, and became a self-taught dealer in art and rare books. He had an inordinate passion for Shakespeare and became an insatiable collector of Shakespearian curios and other 'association objects', which he would discreetly sell to gullible customers.

William-Henry's early education was sketchy and sporadic; he

described himself as 'very backward [and] averse to every thing like study and application', and his father regarded him as a slow-witted simpleton. He was sent to college in France for four years, before coming back to London to live with his father, his father's housekeeper (Mrs Freeman) and his sister Jane at 8 Norfolk Street, off the Strand.[23]

At the age of 17, young Ireland was articled as a conveyancer's clerk in the chambers of a Mr Bingley at the New Inn, as preparation for a legal career; it meant spending long days alone and with little to do in an office full of ancient deeds and documents. In the evenings, the family would sit and listen to Samuel Ireland reading aloud from the works of Shakespeare and talking fulsomely about him. One evening, he read instead from an epistolary novel by Herbert Croft entitled *Love and Madness*. The conversation turned to Thomas Chatterton, who was the subject of a long digression in the novel. The brief life and tragic death of Chatterton, 'the marvellous Boy', author of the Rowley forgeries, fascinated William-Henry, who would become as obsessed with Chatterton as with Shakespeare:

> The fate of Chatterton so strongly interested me, that I used frequently to envy his fate, and desire nothing so ardently as the termination of my existence in a similar cause.
>
> (*The Confessions of William-Henry Ireland*, 1805)

In the summer of 1793, the Irelands visited Stratford-upon-Avon for a week to pay homage to the Bard and to acquire any relics which might be available. They hired as a guide a self-appointed guardian of Shakespearian lore, a man named John Jordan; Jordan was a journeyman wheelwright who supplemented his meagre wages by fabricating Shakespearian curios. At a gift shop selling articles from the wood of a mulberry tree Shakespeare was reputed to have planted, Ireland senior duly purchased a wooden goblet and other carved knick-knacks (although William-Henry realised at once that they were fakes). In the Birthplace, the Irelands were shown the hearth where a 'Profession of Faith' – allegedly by Shakespeare's father,

John Shakespeare – had been found, but which John Jordan had forged. And at Anne Hathaway's Cottage, Samuel Ireland happily bought a bugle purse which the playwright had allegedly presented to Anne and an old oak chair on which Shakespeare had allegedly reclined while he was courting Anne. This chair was triumphantly installed in pride of place in the family home in Norfolk Street.

It was at this point that William-Henry Ireland found what was to become his earliest vocation. His chancery work with Mr Bingley gave him easy access to old parchments, deeds and documents with antiquated forms of writing, and he hunted assiduously for genuine Shakespearian deeds amid the mouldering manuscripts, but without success. That's how it all started, he would later claim: 'For mere frolick and diversion, I soon after formed the plan of attempting to imitate his hand, and for that purpose copied out, as nearly as I could, the facsimiles of his name . . .' (*An Authentic Account of the Shakespearian Manuscripts, &c*, 1796).

He started by making tracings of the only known Shakespeare signatures (on his will and on a mortgage deed of 1612). A friend in a printer's shop showed him how to make the kind of ink required, blended from three different liquids used by bookbinders for marbling the covers of calf bindings and darkened by holding the paper before a fire.

His first experiment in counterfeiting involved a small quarto tract, a set of prayers dedicated to Queen Elizabeth; it was bound in vellum, with the Queen's arms stamped in gold on the cover. William-Henry wrote a dedicatory epistle to the queen and planted it in the book between the cover and the endpaper, which had come unstuck. He then presented it to his gullible father and was gratified at his enthusiastic reaction.

It may have been meant as a practical joke, but it did not stop there. On a sheet of parchment cut from an old rent-roll and, using ink artificially aged, young Ireland wrote out a mortgage deed, apparently written at the Globe Theatre in 1589, between Shakespeare and his fellow actor John Heminges on the one hand, and a Michael Fraser and his wife Elizabeth on the other, authenticated by an old seal. This, too,

he presented to his father, on 16 December 1794. Ireland senior took it to the Herald Office for identification, and it was duly validated. Word of this 'find' spread rapidly, and the Irelands' home in Norfolk Street became a centre of attraction for all the literary figures of the day; not one of them cast doubt on the document's authenticity.[24]

There was no stopping young Ireland now. His next project was a tract, William Shakespeare's 'Profession of Faith', allegedly written by Shakespeare on his deathbed, proving that the Bard had been a good Protestant, not a papist. This document, too, not only passed muster in Norfolk Street but was highly praised for its literary merit by men of taste and discernment, even though the syntax was ragged and the spelling a fantastical farrago of doubled consonants and 'ees' to look suitably archaic.

But how to explain the provenance of the finds if and when questions were asked? William-Henry Ireland had to have someone ready to provide a cover story. His accomplice was a young fellow clerk turned actor named Montague Talbot, who had been articled to a conveyancer but who had broken his indenture to try his luck on the stage. This young man had suspected fraud from the outset – a suspicion which had been confirmed when he had caught Ireland preparing another manuscript. Talbot thought the whole business a jolly jape and agreed to play the part – at a hefty price, no doubt.

On 10 November 1795, William-Henry Ireland issued a formal, if somewhat incoherent, statement:

> I was at chambers, when Talbot called in and showed me a deed, signed Shakespeare. I was much astonished, and mentioned the pleasure my father would receive could he but see it. Talbot then said I might show it. I did not for two days: and at the end of that term he gave it me. I then pressed hard to know where it was found. After two or three days had elapsed, he introduced me to the party. He was with me in the room, but took little trouble in searching. I found a second deed, and a third, and two or three

loose papers. We also discovered a deed, which ascertained to the party landed property, of which he had then no knowledge. In consequence of having found this, he told us we might keep every deed, every scrap of paper relative to Shakespeare. Little was discovered in town but what was above mentioned, but the rest came from the country, owing to the papers having been removed from London many years ago.

Samuel Ireland at once checked with Montague Talbot, who confirmed the statement and claimed that he had introduced young Ireland to a gentleman of leisure known only as 'Mr H.', who wished to remain anonymous and was a descendant of one of Shakespeare's fellow actors – by implication John Heminges, to whom Shakespeare had bequeathed all his furniture and papers. Samuel Ireland was beside himself with excitement: there were only three known signatures of Shakespeare in existence, yet here was a fourth, with the hint of even more to be discovered.

Young Ireland obligingly produced more and more manuscripts from his anonymous benefactor: more legal documents, business receipts, sketches and letters, including a love poem to 'Anna Hatherrawaye' (enclosing a lock of Shakespeare's hair, tied with red silk). He even forged a letter to Shakespeare from Queen Elizabeth herself:

> Wee didde receive your prettye verses good Mastere William through the hands of our Lord Chamberlyne and wee do complemente thee onne thyre great excellence. We shall departe fromme Londonne toe Hampstowne forre the holydays where wee shalle expect thee with thy beste actorres that thou mayeste playe before ourselfe toe amuse usse bee noye slowe butte come to usse bye Tuesdaye neste asse the Lord Leycesterre wille be withe usse.
>
> Elizabeth R.

Young Ireland was not just forging Shakespeare – he was reinventing him as a gentleman of honour and integrity, impeccably mannered and acclaimed. Ireland's Shakespeare had to be whiter than white, cleaner than clean. So Ireland obtained from his father a 1608 quarto edition of *The Tragedye of King Leare* and applied himself to removing any traces of bawdiness and bad taste. Then he started on a copy of *Hamblette* but got bored with the task after only a few pages. He had even more grandiose ideas. He planned to write a series of Shakespearian plays, covering the history of England from the Norman Conquest to the reign of Queen Elizabeth.

Vortigern and Rowena

He started with *Vortigern and Rowena*. For eighteenth-century historians, the tale of Vortigern and Rowena was one of the pivotal events of early Anglo-Saxon times. Elegantly illustrated histories, such as David Hume's *History of England*, were required reading. William-Henry would claim that the theme of the play was inspired by a large painting, or print of a painting, hanging over the chimney-piece in his father's study: it was by the artist John Hamilton Mortimer (1740–79), who had lived at 33 Norfolk Street, near neighbour to the Irelands at 8 Norfolk Street. It was a romantic depiction entitled *The Meeting of Vortigern and Rowena*, which had been exhibited at the Royal Academy in 1779 (the year of Mortimer's death); the painting depicts Vortigern, wearing a simple crown, welcoming a kneeling Rowena to his banqueting table. It was copied by Samuel Ireland, who had etched many of Mortimer's pictures during his lifetime and who collected 'Mortimers'.[25] But it was a favourite subject for many eighteenth-century painters, such as Richard Westall in 1758, the Swiss painter Angelica Kauffman (1741–1807) in 1770 and William Hamilton (1751–1801) in 1793.

The legend of Vortigern and Rowena was recounted by the Welsh chronicler Geoffrey of Monmouth in his (largely fictitious) history of Britain entitled *Historia Regum Britanniae* (*c*.1136). It was taken up by the sixteenth-century historian Raphael Holinshed in his *Chronicles*,

which included his *Historie of England*; the 1587 edition of the *Chronicles*, posthumously published, was much used by Shakespeare and other dramatists.

Vortigern usurped the throne in the middle of the fifth century. In order to protect his throne he invited to Britain a band of Saxons, led by Hengist and Horsa, whom he settled on the island of Thanet. A few years later, these Saxons rebelled over their rations. Vortigern attended a peace meeting with their leader Hengist; Hengist, however, secretly armed his men with long knives and, in the ensuing massacre, some 460 British noblemen were slaughtered. A political reconciliation was arranged, in which Vortigern married Hengist's daughter, Rowena.

Ireland's play certainly felt 'Shakespearian'. Echoes abounded of Hamlet-like soliloquies and Macbeth-like crises of doubt, of political hypocrisy as in *Richard III* – a rich stew of cross-dressing and thwarted love and foolery and even hints of incest. With hindsight, the play is all-too-obviously derivative and much of the poetry is turgid; but Shakespeare was by far the most popular playwright on the eighteenth-century stage, and any 'Shakespearian' play was guaranteed a successful run.

In December 1794, young Ireland told his father that 'Mr H.' had shown him the original manuscript of an unknown play, based on Holinshed's *Chronicles*, about Vortigern and Rowena. His father, naturally, was eager to see it at once; unfortunately, his son had not completed the play and had to write the rest of it in a tearing hurry. Within two months, the play was completed; young Ireland showed it to his father in instalments in his own handwriting, explaining that he was having to copy out the manuscript.

To protect his authorship of his Shakespearian plays, William-Henry Ireland then wrote himself into Shakespeare's life: he produced a document, *Deed of Gift to Ireland*, dated 1604, in which Shakespeare bequeathed all his books and papers to a certain 'Masterre William-Henrye Irelande', who had daringly saved him from drowning in the Thames. The company's boat had been overturned by drunken bargemen, but everyone had managed to swim to shore – except Shakespeare:

Masterre William-Henrye Irelande notte seeyinge mee dydd aske for mee butte oune of the Companye dydd answere thatte I was drownynge, onn the whyche he pulled off his Jerrekynne and jumpedd inn afterre mee; withe muche paynes he draggedd mee forthe, I beynge then nearlye deade and soe he dydd save mye life.

In gratitude, Shakespeare granted to Ireland and his heirs a purse of £10 sterling plus the rights to five of his plays. It was an unlikely tale, considering that an authentic will existed which bequeathed them to John Heminges; but no one questioned it – yet.

Drama on stage

Samuel Ireland was a connoisseur of books and art, and had a large circle of acquaintances in both fields. He was an assiduous collector of curios such as a portion of Wyclif's vestment, Oliver Cromwell's buff leather jacket, part of a cloak belonging to Charles I, Sir Philip Sidney's cloth jacket embroidered with silk knotting, a pair of gloves given by Mary Queen of Scots to Queen Elizabeth, Joseph Addison's pocket fruit-knife and hair from the heads of Edward VI and Louis XVI. He had exhibited at the Royal Academy in 1874, and he published two volumes of Hogarth's sketches (1794 and 1799); he also published a series of illustrated books on English landscapes – *Picturesque views on . . .*, including the Thames (1792), the Medway (1793) and the Avon (1795), the latter entitled *Picturesque Views on the Upper, or Warwickshire Avon, from its source at Naseby, to Its Junction with the Severn at Tewksebury.*

Samuel Ireland now arranged an exhibition of the manuscripts (including *Vortigern and Rowena*) at his house in Norfolk Street in February 1795, charging the exorbitant entrance fee of a guinea. The visitors took it in turns to be enthroned on Shakespeare's 'courting chair' while handling and reading the manuscripts. Experts and critics alike were taken in by them and testified to the authenticity of the documents. James Boswell, who was a broken man by then, knelt before them and

murmured, 'I now kiss the invaluable relics of our bard: and thanks to God that I have lived to see them.' (He died a few weeks later.)

The news of *Vortigern and Rowena*, a newly discovered Shakespeare play, created a great stir in theatrical circles. There were two major theatres in the running for the rights to stage it: one was Drury Lane, the other was Covent Garden. The manager of Covent Garden, Thomas Harris, jumped in first and offered Samuel Ireland carte blanche; but Ireland was sure he would get an even better offer from Drury Lane and its manager, the comic dramatist Richard Brinsley Sheridan (1751–1816) – despite the fact that Sheridan found parts of the play puzzling:

> There are certainly some bold ideas, but they are crude and undigested. It is very odd: one would be led to think that Shakespeare must have been very young when he wrote the play. As to the doubting whether it be really his or not, who can possibly look at the papers and not believe them ancient?

He may have questioned the play's quality; the play's authenticity, however, was a very minor consideration compared with the possible profit for the theatre. The negotiations over a contract were protracted; Samuel Ireland was desperate to get the play on stage as soon as possible, whereas Sheridan could afford to wait. Meetings were cancelled or postponed at the last minute; Sheridan always had an excuse for further delays. Eventually, sometime in September 1795, a contract was agreed between Samuel Ireland on the one hand and the patentees and proprietors of Drury Lane (Sheridan and Thomas Linley) on the other:

> . . . to pay the said Samuel Ireland as a consideration for use of the said play the sum of £250 on signing these presents. And as a further consideration to pay the said Samuel Ireland one moiety or half part of all the money which shall be taken or received by or from the first forty nights of representing or exhibiting the

said play at the said theatre over and above the sum of £350 to be allowed and retained by them for each of the said forty nights.

The play was due to be staged on or before 15 December 1795, but the contract also allowed for the play, or parts of the play, to be rewritten by Sheridan and others at will: 'having power [nevertheless] to make alterations or cause to be made such alterations therein, and Additions thereto, as they shall think fit'. The rewriting proved to be very extensive, and preparations dragged on long past the original deadline; indeed, the first read-through with the cast did not take place until 11 January 1796. The delay was to prove to be critical.

Meanwhile, William-Henry Ireland set to work on his second Shakespearian play, *Henry II*, to be followed by *The Virgin Queen*. *Henry II*, by common consent, was a much better play than *Vortigern and Rowena*.[26] Hindsight would suggest that Ireland's story as a forger might have been very different if *Henry II* had been his first Shakespearian fabrication to be staged.

On 24 December 1795, Samuel Ireland published his son's Shakespearian forgeries in a lavish folio, copiously illustrated with facsimile engravings of almost all the papers, paired with generously spaced parallel transcriptions. Young Ireland had been reluctant to allow this and had tried his utmost to change his father's mind; he even hinted that the papers might not be genuine after all. But Ireland senior was adamant. He entitled his production *Miscellaneous Papers and Legal Instruments under the Hand and Seal of William Shakspeare: Including the Tragedy of King Lear, and a Small Fragment of Hamlet. From the Original MSS. in the Possession of Samuel Ireland, of Norfolk Street, London*. This tome he sold by subscription at four guineas a copy (nearly £200 in today's currency). *Vortigern and Rowena* was not included. Of the print run of 368 copies, 122 were sold; most of the rest were destroyed after William-Henry's confession of 1796.

The publication of the *Miscellaneous Papers* aroused the wrath of the eminent Shakespearian scholar and literary critic Edmund Malone

(1741–1812). Malone was a lawyer rather than a classical scholar, but his credentials as a literary critic were impeccable. He had an excellent private library, access to the collections of others, a great knowledge of archives, an extensive acquaintance with early English drama, a systematically evolved understanding of Elizabethan linguistic usage and a deep familiarity with historical practices and procedures. In 1778, he had published *An Attempt to Ascertain the Order in Which the Plays Attributed to Shakespeare Were Written*. He had edited the works of Oliver Goldsmith (1780) and the writings of the painter Joshua Reynolds (1791). He had revised Boswell's *Journal of a Tour to the Hebrides* while it was going through the press (1785) and had given great assistance over Boswell's *Life of Samuel Johnson* (1791). Moreover, he had joined the chorus of those denying the authenticity of Chatterton's 'Rowley Poems' with his *Cursory Observations on the Poems Attributed to Thomas Rowley*.

To Malone, the Shakespeare papers were an affront to his professional expertise. A year previously, on 1 April 1795, he had called the 'Shakspeare Papers' a 'very thin forgery'. On 1 April 1796, he published a massive 424-page comprehensive assault on the Shakespearian papers, entitled *An Inquiry into the Authenticity of Certain Miscellaneous Papers and Legal Instruments*. Its publication was strategically planned to precede the (delayed) premiere of *Vortigern and Rowena* at Drury Lane the following day. His professed target was not primarily the play, however – it was the extensive collection of deeds and papers in the *Miscellaneous Papers*. It was a systematic assessment of the legal validity of the Shakespearian papers, not their literary quality. Malone examined the orthography, the phraseology, the dates given and the handwriting discrepancies, to prove that not a single paper or deed was authentic. He also showed that Shakespeare had no title to his plays – they belonged to the playhouse, and, therefore, the playwright could not grant the rights to them to anyone else. Moreover, there was no such thing as paper-credit in Shakespeare's day. It was a devastating, merciless exposé.[27]

Malone's real strategy, however, was to damn *Vortigern and Rowena* in advance by damning the 'Shakspeare Papers' which purported to give

context to the play. And Malone was not alone in his single-minded attack on the authenticity of all the 'Shakspeare' documents. Other scholars had weighed in, and a pamphlet war had erupted between the 'Believers', who had faith in the Papers, and the 'Malonites', who did not.

The publication date for Malone's *Inquiry* was 1 April 1796, and it sold 500 copies on the first day. But review copies had been distributed beforehand, and newspaper columns had been rife with feverish speculation and claims and counter-claims.

On behalf of his son, Ireland senior issued a handbill in refutation of Malone's *Inquiry*, which was distributed to theatre-goers queuing for the premiere:

> A *Malevolent* and *impotent* attack on the SHAKESPEARE MSS. having appeared, on the Eve of representation of the Play of *Vortigern*, evidently intended to injure the interest of the Proprietor of the MSS., Mr. Ireland feels it impossible, within the short space of time that intervenes between the publishing and the representation, to produce an answer to the most illiberal and unfounded assertations in Mr. Malone's enquiry. He is therefore induced to request that the Play of *Vortigern* may be heard with that *Candour* that has ever distinguished a *British Audience*.
>
> *** *The Play is now at the press, and will in a very few days be laid before the Public.*

The Times reported the event two days later with careful impartiality:

> In the Annals of the Theatre, there never was such a crowd . . . There were people enough who flocked for admission, to have filled the house twice over. Many persons were waiting at the doors, so early as three o'clock in the afternoon.

Royalty was present, in the person of the Duke of Clarence, who was attending at the insistence of his mistress, Mrs Dorothy Jordan. But the

off-stage battle was already lost. The actress Sarah Siddons, who was
to have played the part of Vortigern's wife, Edmunda, had withdrawn
four days before the opening night, struck down by a mystery illness
(it was no doubt a diplomatic illness – she had voiced serious doubts
about the play's authenticity). Her brother John Philip Kemble, who was
playing Vortigern, was convinced that it was a fraud and was determined
(in a venomous conspiracy with Malone) to sabotage the performance
in every possible way. He tried, unsuccessfully, to have the opening
night brought forward to April Fool's Day (1 April); but at least he had
managed to have a farce entitled *My Grandmother* (about a gullible art
collector) included on the bill.

On the first night, Kemble was delivering a solemn monologue to
Death towards the end of Act V:

> O! then thou dost ope wide thy hideous jaws,
> And with rude laughter and fantastic tricks
> Thou clapst thy rattling fingers to thy sides;
> And when this solemn mock'ry is ended,
> With icy hand thou tak'st him by the feet,
> And upward so, till thou dost reach the heart,
> And wrap him in the cloak of lasting night.

When Kemble spoke, in a 'sepulchral tone of voice', the line 'And when
this solemn mock'ry is ended', the audience got the point at once. As
William-Henry Ireland was later to describe it, the spectators uttered a
'a discordant howl' which went on for ten minutes. When it died down,
Kemble took centre stage again for his monologue and repeated the give-
away line 'with an even more solemn grimace'.

The game was now up. The remaining scenes were greeted with
derision – according to William-Henry Ireland, 'not one syllable more
of the play was rendered intelligible'. When the curtain came down and
an actor stepped forward to announce that the play would be performed
again on Monday, the theatre went into uproar once more, this time

for 15 minutes. Eventually, Kemble came forward and announced that Monday night's performance would be Sheridan's *School for Scandal*. *Vortigern and Rowena*'s first night was also its last.[28]

The day after that disastrous premiere, the Irelands returned to Drury Lane to collect their winnings. After expenses, the theatre had earned £205.6.6. In accordance with their agreement, Samuel Ireland received half of that – £102.13.3; of that sum, he gave William-Henry £30.

The forger confesses

The Drury Lane debacle plunged William-Henry into feverish despair. An ad hoc committee of Believers prevailed upon him to produce a carefully worded statement exonerating his father from any suspicion of complicity in the forgeries:

> It is stated that the present committee is appointed to investigate Mr Samuel Ireland's concern in the business, and ease him of the calumnies which are heaped upon his head; I therefore will make oath that he received the papers from me as Shakspeare's, and knows nothing whatsoever concerning their origin, or the source from whence they came.

In May 1796, William-Henry confessed to his family that he had been the author of all the 'Shakspeare' forgeries. But they didn't believe him. In particular, Samuel Ireland refused to believe that his dim-witted son was capable of the 'genius' he had detected in the 'Shakspeare Papers'.

Soon afterwards, William-Henry left home for good; his lurid career as a forger had caused an irretrievable break with his father. He sent his father a letter declaring again that he and he alone had written the manuscripts and begging forgiveness for his misdeeds. He persuaded a lawyer acquaintance, Albany Wallis, to draw up an affidavit to this effect. This affidavit, accompanied by a specimen forged signature, exculpated his father of all knowledge of the forgeries – but, once again, Ireland senior refused to accept that his son had the intelligence or the ability to

perpetrate such a crime. He demanded a meeting with his son, but the appointment was broken.

William-Henry told his father that he was going to stay with the mysterious 'Mr H.' on his estate, with £300 a year and a cellar of good wines and a stable full of horses. This was pure fantasy; in fact, he lived by pawning his valuables and selling some rare books. He also told his father that he was getting married to a wealthy 17-year-old beauty named Miss Shaw, who had an income of £4,000 a year. Miss Shaw, alas, never existed. Instead, on 4 June 1796, he married a girl named Alice Crudge, whose social standing seems to have been somewhat questionable, to say the least.

His father was being pilloried in the newspapers and was featured in a number of satirical burlesques. He was preoccupied with the task of producing a rejoinder to Malone's savage attack: *Mr. Ireland's Vindication of his Conduct, Respecting the Publication of the Supposed Shakespeare MMS. Being A Preface or Introduction to a Reply to the Critical Labors of Mr. Malone, in his 'Enquiry into the Authenticity of Certain Papers, &c. &c'* (November 1796). It did nothing to improve his reputation, however: Samuel Ireland was now simply considered, if not a fraud, at least a fool. At the same time, in an attempt to repair his father's damaged reputation, William-Henry published the first of no fewer than three (mutually self-contradictory) confessions he was to make before his death – *An Authentic Account of the Shakspearian Manuscripts, &c.* (November 1796). He claimed that he wrote it in a state of great agitation; at any rate, it was so badly written that it gave the impression that the author could not possibly have produced the forged papers and only resulted in injuring Samuel Ireland's reputation yet further.

Separately, father and son were still doing their best to capitalise on the forgeries. Samuel Ireland tried to sell the other forged play in his possession, *Henry II*, but his negotiations came to nothing; however, he published both *Vortigern and Rowena* and *Henry II* in 1799. Meanwhile, William-Henry claimed that Thomas Harris, manager of Covent Garden theatre, had bought *Henry II* and offered him £700 for two

plays a year. This, too, was fantasy, and, eventually, William-Henry sold what he claimed to be the original manuscript of *Henry II* for a mere four guineas.

Samuel Ireland died in July 1800, still protesting his innocence, still estranged from his son and still refusing to believe that William-Henry had been anything more than an accomplice, at most, in the forgeries.

Latter years

One unexpected outcome of the fevered debate about the authenticity of the Shakespeare manuscripts, however, was that doubts began to be cast on William-Henry Ireland's paternity. Samuel Ireland had, in fact, been born 'Samuel Irwin'; there had never been a 'Mrs Ireland' (or 'Mrs Irwin'), and the three Ireland children (including William-Henry) seem to have been the illegitimate children of his housekeeper, Mrs Freeman. 'Mrs Freeman' was, in reality, a woman named Anna Maria de Burgh Coppinger, a pensioned-off mistress of the dissolute John Montagu, fourth Earl of Sandwich. Anna Maria Coppinger/ Freeman was palmed off by Sandwich onto Samuel Ireland/Irwin with a 'dowry' of £12,000. It is an extraordinary and complicated story; at all events, William-Henry Ireland began calling himself 'William-Henry Freeman' – although this was only one of at least sixteen different pseudonyms he used throughout his writing life as he tried to build a more conventional literary career.

As a writer, William-Henry Ireland was astonishingly industrious and prolific. In 1799, he produced his first novel: *The Abbess, a Romance*. It was prefaced by an audacious attack on 'the world' for having been duped by his forgeries:

> How could they suffer themselves to be thus deceived? Men of
> superior genius, of common understanding, truly, sincerely and
> firmly believed, that Shakespeare alone, and no other, wrote those
> papers. I knew they would believe it. I knew how far the credulity
> of mankind might be imposed upon. The number of plagiarisms

which I collected from all Shakespeare's plays did not deter me
– I knew this would be the last subject of investigation. I brought
forth this not-undigested medley – and success crowned my bold
attempt. I have deceived the world, you say. No, the world have
deceived themselves. Whose fault is it? . . . mine, or the world's?

The Abbess was followed by *Rimualdo; or, the Castle of Badajos* (1800);
The Woman of Feeling (1804); and *Gondez, the Monk. A Romance of the
Thirteenth Century* (1805). William-Henry wrote prose and poetry in a
variety of styles and under several pseudonyms; he was a good example
of the hack writer who could turn his hand to anything available at the
time. In the four decades after the exposure of the forgeries, William-
Henry Ireland was to publish nearly seventy works before his death
in 1835 at the age of fifty-nine. He opened a circulating library in
Kensington, and in 1802 he landed the (unpaid) job of superintendent
of the theatricals at a fête held at Frogmore in Hampshire by Princess
Elizabeth, daughter of King George III and future wife of the Landgrave
of Hesse-Himburge. Ireland wrote a pantomime for the fête under the
name of 'Cervantes', which proved a great success.

He produced his second 'confession' in 1805: *The Confessions of
William-Henry Ireland. Containing the Particulars of His Fabrication of the
Shakespeare Manuscripts: Together With Anecdotes and Opinions (Hitherto
Unpublished) of Many Distinguished Persons in the Literary, Political, and
Theatrical World.* It was a highly fanciful account of the Shakespeare
debacle, a wholly unreliable pseudo-autobiography and a much longer
work than his *Authentic Account* of 1796. In it he gave his own version
of that disastrous premiere of *Vortigern and Rowena*. He laid the blame
for its failure on two of the actors: first, Kemble, for his undisguised
contempt for the role he was playing and, secondly, Mr Phillimore ('the
late facetious Mr Phillimore, of large-nosed memory'), who played the
part of Horsus (Horsa, the other Jutish leader); when Horsus died in Act
IV he had mismanaged it so crassly that when the curtain came down it
fell across his inert body, leaving his legs exposed, until he had to get up

in full view and walk off the stage. Ireland also complained that he had received only £90 of the £403 earned from *Vortigern and Rowena*.

After the 1805 'confession', the sequence of novels continued with *The Catholic, an Historical Romance* (1807). He followed this with *The Fisher Boy* (1808), which satisfied the fashion for tales of rural life and even contained the first attempt at a poetic description of the preparation of fish and chips, when the hero prepares supper for his mother (Jane the maniac):

> And for his parent's eating, dab supplies.
> Which cleans'd – in dripping pan he dextrous fries;
> Then adds potatoes slic'd, thin, crisp, and brown,
> Whereto he sets his silent mother down;
> Praises the dish, to coax her to the meal,
> The highest earthly transport he can feel.

He then left England to live in France for a few years. There he secured a number of translating commissions and wrote several historical books. He became librarian to Napoleon Bonaparte and was made a member of the Légion d'honneur, after writing a four-volume *Life of Napoleon Bonaparte*. He also published *France for the Last Seven Years*, a history of that country interlaced with personal reminiscences, satires and street songs.

Back in London, he found employment with a publisher named Tripbrook. He published a long poem entitled *The Neglected Genius*, illustrating the untimely and unfortunate fate of many British poets, including his long-time idol Thomas Chatterton. He did well, in fact – several of his works went into second editions, and he was outselling writers like Keats and Shelley in their lifetimes.

William-Henry Ireland had been blacklisted in the theatre world for having had the nerve to fabricate a Shakespeare play, and for the rest of his life he was referred to as 'Shakespeare Ireland'. He was constantly dogged by the reputation for fraudulence which clung to him like a

shadow, but it did not stop him making money from counterfeiting. He would re-copy the 1799 printed version of *Vortigern and Rowena* into his Shakespeare-hand and sell it as an original forgery as well as making and selling endless copies of his supposedly original rough drafts. His new fabrications included *Memoirs of Henry the Great, and the Court of France During His Reign* (1824) and *Memoirs of Jeanne d'Arc, surnamed La Pucelle d'Orleans; With the History of Her Times* (1824). At the time of his death, he was planning to 'discover' unknown works by Byron, who had died in 1824.

In 1814, he published *Chalcographimania* under the pseudonym Satiricus Sculptor, a doggerel collection of entertaining but frequently inaccurate descriptions of his contemporaries. In it, he twinned himself with Chatterton:

> In autographs as ably vers'd,
> As *Chatterton* the poet erst;
> Or he that later Wielded fire-brand,
> The impudent and forging *Ireland.*

He wrote *Mutius Scævola,* a Roman play in which Mutius thrust his hand into a fire to prove his honour. He edited a children's chapbook, *Youth's Polar Star or The Beacon of Science.* He wrote 'Lines' on a balloon flight, 'Johannus Taurus, the Don Juan of England by Byronus Secundus'.

In *The State Doctors, or A Tale of the Times,* also under the pseudonym of Cervantes, he attacked the notion of patriotism and extolled the role of authors (Canto III):

> Some Authors gratify their fancies
> By writing novels and romances;
> Some rise to fame on loftier themes,
> On poems, prophecies and dreams;
> Some launch a frigate, some a shallop,
> Some 'prime – bang up' – start off full gallop;

While other Bards, whose wits are scanter,

Go gently on the road, a canter;

Some write to *fill*, some *fill* to write,

Some write thro' frolic, some thro' spite;

Some write to gain the world's applause,

And others, to employ their – jaws;

My Muse and I disdain such follies,

We write to banish melancholies,

To soothe the rugged brow of Care,

To drive away the fiend Despair,

T' expose hypocrisy and crimes,

And lash the Follies of the Times.

As 'Henry Boyle' he edited *The Universal Chronologia* (a history of the eighteenth century), in which he suggested that the performance of *Vortigern and Rowena* 'caused the greatest ferment in the world of literature'. In *Scribbleomania*, writing as 'Anser Pen-Drag-On, Esq.', he satirised Robert Southey, Robert Burns, Walter Scott, Lord Byron, Samuel Taylor Coleridge and William Wordsworth. In *Stultifera Navis (The Modern Ship of Fools)*, he described everyone from 'Venal Fools' to 'Fools who do not understand a Game, and yet will play'.

He was never averse to making fun of himself and his foibles (and his father's foibles) – particularly the collecting of 'association articles' so popular among connoisseurs and collectors in the eighteenth century. As Satiricus Sculptor in *Chalcographimania* (1814), he charted 'Infatuations of Every Description':

Samples we have of some, whose hopes

Concentrate in the *hangman's* ropes:

One rusty *armour* buys amain,

Or painted window's shatter'd pane;

The skins of birds, of beasts, and fishes,

Cups, saucers, tea-pots, dishes . . .

That *Ir-l-nd*, fam'd for picturesque,

And fond of *Hogarth's* keen burlesque . . .

To parent now the *son* let's add,

Of ancient lore, *impostor* lad.

In 1832, he presented his third 'confession', in the form of a preface to a new edition of the *Vortigern and Rowena* play: *Vortigern: An Historical Play. With An Original Preface. Represented at the Theatre Royal, Drury Lane, on Saturday, April 2, 1796, As a Supposed Newly Discovered Drama of Shakespeare.* He made no bones about his role as its forger; but now he railed bitterly against those who criticised him:

> . . . the shafts of persecution have been so relentlessly levelled against me for upwards of thirty years . . . every inimical feeling, which now remains, is but the foul lees of rancour, malice and uncharitableness.

Envoi

William-Henry Ireland spent his latter years living quietly in a house in Sussex Place, in Southwark Bridge Road, St George's Fields,[29] and died on 17 April 1835. He was buried at the church of St George the Martyr, in Southwark, on 24 April 1835; the burial register of the church gives his age as 61.[30]

The church of St George the Martyr is an imposing landmark in the local cityscape. It is the third church of that name to stand on this site: the orignal building, dating from 1122, was rebult in 1390, but by 1732, it was in such a ruinous state that it was 'dangerous for the Inhabitants of the Parish to attend the Worship of God therein' and had to be rebuilt. The new church was smaller than its predecessors; it was opened in 1736, with numbered pew seats allotted to 404 parishioners and their families.

Today, the church of St George the Martyr is once again in parlous condition. It looks desolate and abandoned, with litter piling up around

it, but is still in use. It has a small but loyal congregation, although their use of the church is severely restricted by the fact that the building is literally cracking apart; the area in the central nave, for instance, cannot be used in case the roof falls in. The present incumbent, the Revd Tony Lucas, who has been there since 1991, calls it 'a funny old church'; but it and its surroundings are resonant with historical literary echoes.

Hard by, in Tabard Street, was the original Tabard Inn, where Chaucer's pilgrims foregathered at the start of their pilgrimage to Canterbury. Not far away, just off Borough High Street, stands the George Inn, London's only surviving galleried coaching inn; plays were performed in the courtyard before the Globe Theatre opened in 1599, and it is believed that Shakespeare himself performed there from the back of a cart. Close by the church stands one remaining wall of the old Marshalsea Prison for debtors; indeed, the church is known locally as 'Little Dorritt's Church' because Little Dorritt, the eponymous heroine of the Dickens novel who was born in the prison, was married in the church in the last chapter of the novel. A church with such an eloquent past deserves to have its voice preserved, and now major restoration works are in hand, part-funded by the Heritage Lottery Fund: at a cost of £3.6m, the whole church will be underpinned with new foundations to support it.

Even on the day of William-Henry's funeral, on 24 April 1835 (the day after Shakespeare's birthday), controversy still assailed him: apparently, a young woman appeared on the scene and claimed that Ireland had been her lover for many years and was the father of her four children . . .

In the shadowy, illusory world of fakers, forgers and phoneys, truth is the most elusive and the deepest delusion.

Appendix – Chapter 4.3

Aberystwyth Centre

The Centre for Advanced Welsh and Celtic Studies at Aberystwyth is dedicated to the study and publication of Iolo Morganwg's huge collection of papers held by the National Library of Wales.

The Director of the centre is Professor Geraint H. Jenkins, who has been working on Iolo's political radicalism; and there are four full-time researchers.

Dr Mary-Ann Constantine is preparing a comparative study of Romantic forgery, exploring Iolo's vast oeuvre in the light of a phenomenon which spread across Europe in the wake of James Macpherson's Ossian: the invention – part retrieval and part imaginative recreation – of a national past.

Dr Cathryn Charnell-White is working on Iolo's druidic vision and the development of the rituals of the gorsedd. Her study of the 'survival' of ancient bardic wisdom (of which Iolo himself claimed to be the last direct heir) involves tackling some of his more esoteric interests: Sanskrit and Brahmanism, ancient alphabets and palmistry.

Dr David Ceri Jones and Dr Ffion Jones have been preparing Iolo's correspondence for publication. Letters to and from a wide social range of people throw light on the literary networks of the period, on the links between Wales and London, and the cultural life of Iolo's native Glamorgan; they offer fascinating details of the hunt for early manuscripts and of Iolo's often stormy relations with family and friends.

The Iolo papers are a gold mine for those interested in the late eighteenth century and early decades of the nineteenth century, and not only in Welsh or Celtic studies. The Aberystwyth project aims in the next few years to produce publications in all these areas; a composite volume is also under way, with contributions from a wide range of specialists on topics such as Iolo's Unitarianism, his poetry in Welsh and English, and his agricultural interests.

Chapter 4 Notes

1. *Dayspring Mishandled* is published in *Limits and Renewals* (House of Stratus, 2001).
2. This chapter is closely based on the work, both published and unpublished, of Dr Nick Groom, reader in English literature at the University of Bristol. I am indebted to him for permission to pillage his ideas, and for his generous encouragement and assistance with the preparation of this chapter.
3. The model for the figure was the novelist George Meredith (1828–1909), then in his late 20s.
4. The subject of Nick Groom's doctoral thesis at Oxford was 'The making of Percy's *Reliques*' (published by the Clarendon Press, Oxford, in 1999).
5. *Elinoure and Juga* is a melancholy duologue in which two young women mourn the death of their lovers in the Wars of the Roses.
6. The identity of 'Junius', which he concealed with great skill, was never conclusively established.
7. Immortality of a different kind had been bestowed on the dead Chatterton by a literary charlatan named Herbert Croft, who in 1780 published an epistolary novel entitled *Love and Madness: A Story Too True*. It purported to be a true account of the sensational murder of Lord Sandwich's mistress Martha Reay by the Revd James Hackman, a lovelorn clergyman. Croft had no access to the letters Hackman was supposed to have written to Martha Reay, so he simply made them up. More than that, in one of Hackman's fictional epistles, he used letters which Chatterton had written to his mother and sister, and which Croft had stolen during a visit to them in Bristol in 1778. Croft had paid the mother and daughter one and a half guineas for the privilege of simply *reading* the letters and had then made off with them. It was a result of the revelation of this scandal that Coleridge's friend Robert Southey (1774–1843), who became Poet Laureate in 1813,

published a charity edition of *The Works of Thomas Chatterton* with Joseph Cottle (the publisher of *Lyrical Ballads* by Wordsworth and Coleridge) in 1803. The proceeds of the publication were dedicated to providing for Chatterton's impoverished sister Mary (Mrs Newton). She died the following year, leaving £300 for her only daughter, Mary Ann Newton, who died in 1807. Mary Ann was the last of the direct Chatterton line.

8. This theory was first proposed in a novel about Chatterton by Neil Bell called *Cover His Face* in 1943. The first serious argument for accidental death was put forward by Richard Holmes in an article ('Thomas Chatterton: The Case Reopened') in *Cornhill Magazine* in 1970 and elaborated in Donald F. Taylor and Benjamin B. Hoover's monumental two-volume edition of *The Complete Works of Thomas Chatterton* (Oxford University Press, 1971).

9. I am grateful to Professor Douglas Merritt, the author of *Sculpture in Bristol* (2002), for providing me with copious research notes about Chatterton memorials in Bristol.

10. This chapter owes much to the scholarly works of Fiona Stafford (fellow and tutor in English at Somerville College, Oxford), author of *The Sublime Savage: James Macpherson and the Poems of Ossian* (1988), and of Howard Gaskill (senior lecturer in German at the University of Edinburgh), editor of *Ossian Revisited* (1991). Howard Gaskill also edited *The Poems of Ossian* in 1996, with an Introduction by Fiona Stafford.

11. Fiona Stafford, *The Sublime Savage: James Macpherson and the Poems of Ossian.*

12. Some 18 months later in 1763, Macpherson would produce a second epic 'translation' entitled *Temora, an Ancient Epic Poem in Eight Books: Together with several Other Poems composed by Ossian, the Son of Fingal,* which was an even longer composition; it was dedicated to the Earl of Bute. In it he included genuine Gaelic lays telling tales of Fingal; there were hosts of lamenting females; and Macpherson once again filled in the gaps. A 'carefully corrected, and greatly improved' edition of all the works was published in 1765, in two volumes, as *The Poems*

of Ossian, the Son of Fingal. Translated from the Gaelic Language by James Macpherson.

13. I am particularly indebted to Dr Mary-Ann Constantine, of the Centre for Advanced Welsh and Celtic Studies (an institute of the federal University of Wales, Aberystwyth), and her colleagues for invaluable assistance in preparing this chapter.

14. The Centre for Advanced Welsh and Celtic Studies at Aberystwyth is dedicated to the study and publication of the huge and chaotic collection of Iolo Morganwg's papers (80-odd volumes of papers and letters) held by the National Library of Wales.

15. The precise location of his birth cottage at Penn-On is no longer known. Two modern dwellings are said to have been built on its site: a handsome, white-painted house named 'Bryn Iolo' and a smaller house across the road, 'Penn-On Cottage'.

16. The cottage in Flemingston to which Iolo's parents moved no longer exists, but the site is believed to lie under the garden of a house named 'Ambleside'; the house was built next to a barn, later demolished, which covered the site of the old cottage. This was where Iolo lived as a boy and where he spent his old age until his death.

17. Peggy's father had died in May 1780. Iolo, who was presumably courting Peggy at the time, carved an ornate memorial slab inscribed to his memory; it is now to be seen at the west end of the nave.

18. From *The Great Book of Margam*, published by the Welsh MSS Society, Llandovery, and by D.J. Roderic, London (Longman, 1862).

19. 'The Board of Agriculture, Walter Davies (Gwallter Mechain) and Cardiganshire *c.*1794–1815', by David Ceri Jones, in *Ceredigion*, Vol. 14, No. 1, 2001.

20. One of my favourite Iolo Triads reads, 'The three requisites of Genius are an eye which can see Nature; a heart which can feel Nature; and a Boldness which does follow it.'

21. At the 1974 National Eisteddfod in Carmarthen, a commemorative 'Gorsedd Window', created by John Petts, was installed in pride of place in the bar of the Ivy Bush Royal Hotel.

22. Many prominent Welsh politicians, rugby players and other celebrities have agreed to be accepted into the Order of Bards at a gorsedd, including the present Archbishop of Canterbury, Dr Rowan Williams, while he was still Bishop of Wales.

23. There is no trace now of a Norfolk Street anywhere near the Strand; it must have disappeared under the massive building developments which changed large areas of old London.

24. It is worth noting that the Globe Theatre was not built until ten years after 1589.

25. *The Meeting of Vortigern and Rowena* remained in Mrs Jane Mortimer's hands until she sold it at auction in May 1807 in Bowyer's Historic Gallery sale.

26. According to Nick Groom, author of *The Forger's Shadow*, 'Ireland's *Henry II* is not a bad piece of eighteenth-century drama – one can easily imagine it being staged.'

27. Malone, however, was privately much taken with *Vortigern and Rowena* and attended the premiere incognito. He reasoned that had *Vortigern* not been offered in 'the *pretended* handwriting of Shakespeare' it might have passed for 'a genuine old play' by someone other than Shakespeare.

28. The first contemporary performance of *Vortigern and Rowena* was staged at the Bridewell Theatre, London, in November 1977.

29. As with Norfolk Street, where Ireland spent his boyhood years, there is no trace now of a Sussex Place in Southwark Bridge Road. There was also a terrace named Sussex Place in the Old Kent Road, which fell in the parish of St Giles, Camberwell, to the south of the church of St George the Martyr.

30. I am indebted to Stephen Humphrey, archivist at the Local Studies Library in Borough High Street, Southwark, for tracking down this information.

Index